CAMERA
AND LENS

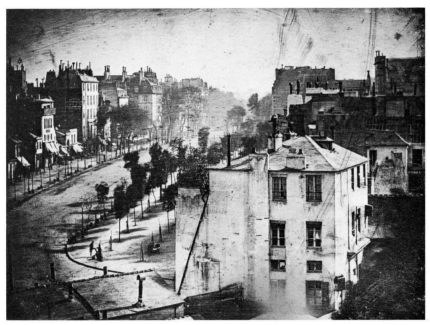

1. THE BOULEVARD DU TEMPLE, PARIS, 1839. Daguerreotype made by Louis Jacques Mandé Daguerre, and sent by him to the King of Bavaria. The long exposure obliterated the movement of traffic, but a man (lower left area) standing for his shoeshine is recorded. This is probably the first photograph of a human being. In addition to the extraordinary precision and interpretation of substance and texture, the blue light-sensitive daguerreotype emphasized the atmospheric "recession" which gives an additional effect of depth.

Photograph courtesy of the National Museum, Munich, and George Eastman House, Rochester, New York.

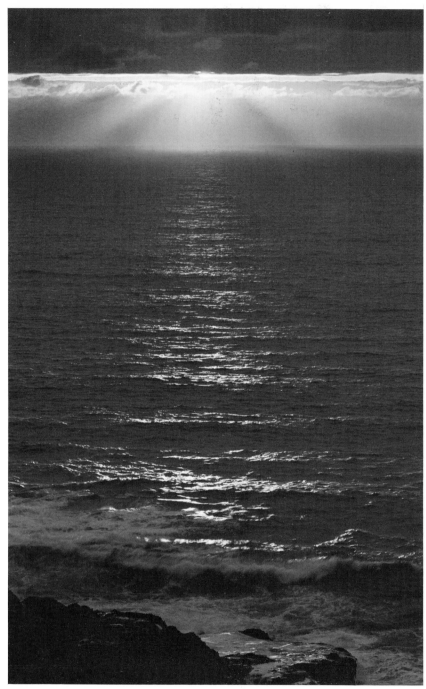

2. SUNSET, CARMEL, CALIFORNIA.
8x10 View Camera. Cooke 12-1/4" Series
XV lens. Made on Ansco film, ASA 64
speed, developed in Pyrocatechin (compen-
sating formula). Lens coating minimized
flare from bright sun and reflections.

CAMERA AND LENS

THE CREATIVE APPROACH STUDIO, LABORATORY AND OPERATION

ANSEL ADAMS

BASIC PHOTO ONE

MORGAN & MORGAN, INC., Publishers
Hastings-on-Hudson, New York
The Fountain Press, London, Agents for Great Britain

MORGAN & MORGAN, Inc.
Publishers
400 Warburton Avenue
Hastings-on-Hudson, N.Y. 10706

International Standard Book
Number ISBN 0-87100-056-3

Library of Congress
Catalog Card No. 48-2069

Printed in U.S.A.

ACKNOWLEDGMENTS

Space does not permit complete acknowledgment of the contributions, advice
and encouragement from the many individuals and institutions who so kindly
assisted me with this project. I am pleased to thank Belle Mettler, who clarified
and typed the text; Liliane De Cock, my general assistant and very capable
photographer; Jeffrey Gholson, photographer; and my wife, Virginia, who
helped in the reading of the text.

Also, I wish to express deep appreciation to the several institutions and firms
who cooperated most generously in providing equipment for study and gave
valuable specific information. Among them are:

Polaroid Corporation, Cambridge, Mass.
Calumet Manufacturing Company, Elk Grove Village, Illinois
Zeiss Ikon—Voigtlander, Stuttgart and New York
Victor Hasselblad Aktiebolag, Sweden (Paillard, Inc. Linden, N.J.)
Eastman Kodak Company, Rochester, N.Y.

PICTURE CREDIT: Victor Hasselblad Aktie: Figs. 3, 12, 13, 18, 31, 48, 59, 60,
70, 71, 77, 78, 79, 80, 84, 127, 135; The Regents, University of California
and the McGraw-Hill Book Company: Figs. 37, 81, 82, 88, 109, 141;
Polaroid Corporation, Figs. 107, 112, 120, 143, and all pictures of cameras
and of Colton Hall adjustment examples (Type 55 P/N).

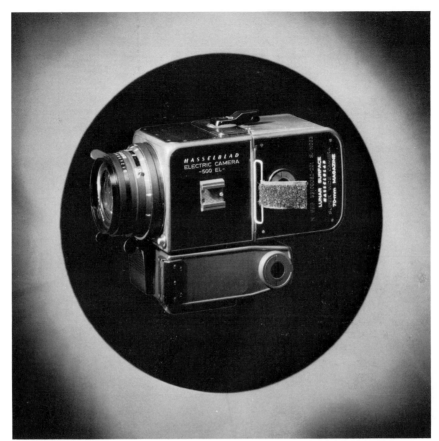

3. HASSELBLAD LUNAR SURFACE MODEL. This is a modified 500EL Camera with special 70mm Magazine.

The vast expansion and involvements of photography in all aspects of human life is without parallel in the cultural history of the world.

From the world of the daguerreotype to the world of lunar exploration is a "vast leap" indeed. We stand in awe of the scientific, technical, production and performance feats of the Apollo flights. The magnificent photographs obtained reflect the grandeur of this achievement.

Note on 2nd Printing: A number of typographical and factual errors found in the first Printing have been corrected and some clarifications of the text have been inserted. Omissions are inevitable; as many as possible will be corrected in future revisions. The author and publisher will deeply appreciate critical comment from readers.

DEDICATION

I dedicate this book to my many friends, students and colleagues who have contributed much to the art and craft of photography. Without their interest and support this book (and what it may represent as an approach to the medium) would not have been possible.

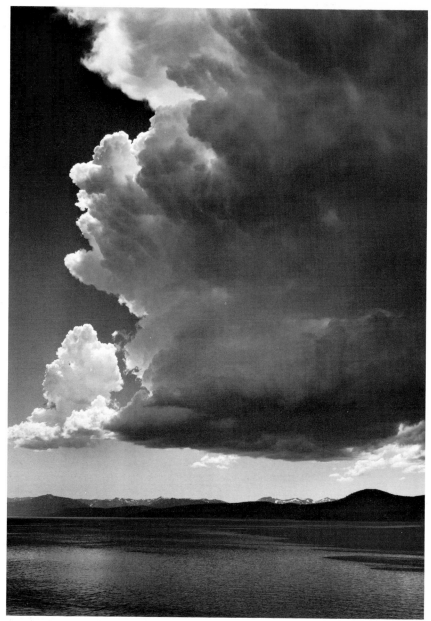

4. THUNDERSTORM, LAKE TAHOE, CALIFORNIA, 8x10 Camera, 10″ Kodak Ektar wide-field lens, Wratten G filter. No film or developer data available. Exposure was ample to retain massive values of dark clouds and development was less-than-normal to control contrast.

A wide angle of view, coupled with a low horizon line will yield a feeling of great space. As there are no vertical lines, convergence from the up-pointing camera is not apparent.

FOREWORD

*Photography Is a Language.** The concept underlying this phrase is a very important one indeed. It leads to a better understanding of the scope and power of photography as a varied medium of expression and communication. Just as in the media of the written word we have poems, essays, scientific and journalistic reports, novels, dramas and catalogues—so with photography we touch the domains of science, illustration, documentation and expressive art.

The literature of photography is replete with repetitions of errors and questionable or obsolete formulas and procedures. New devices, systems, equipment and materials applicable to all aspects of the process have supplanted those which were considered effective decades ago. The fundamental principles of optics and sensitometry remain unchanged. Our present-day problem is to function as simply as possible, to adapt to new concepts and procedures and to understand the *performance* of new equipment and materials. Except in purely automatic photography, systems designed for automatic or semi-automatic operation may confuse our creative objectives if *controls* are not provided.

There is no such thing as reality in graphic expression. A picture of a house is not a house; it may simulate some visual aesthetic, emotional or informational aspects of the house. What is important is how the photographer "saw" the house and how he visualized the final print. Consciously or intuitively we create our statement of the external world within the limitations of the medium employed.

It is the function of this revised edition of *Camera and Lens* not only to discuss the practical aspects of the essential instruments of photography but to suggest concepts of approach and application. The more photography expands in every domain, the more confused our understanding may become. Today it presents an enormous variety of applications with attendant complexities of technique, style and content. For the most naive snap-shooter, through the journalist, professional photographer and technician, to the creative artist (whose work may touch all fields in some way), the photographic industry has provided tremendous resources of equipment and materials—so varied and complex that no one can fully comprehend them. We find it difficult to make optimum selections of equipment and materials in any field of photography. We must always remember that the ultimate objective of photography is the *picture*, not the manipulation of equipment and systems.

A certain simplicity of approach is essential. The photographer and his work must dominate his equipment, not the other way around. Blind devotion to any particular equipment—or to any group of films, developers, papers, etc.—can have deleterious results. The photographer must have a flexible viewpoint on the physical aspects of his profession (or avocation) and be willing to change, partially or totally, his technical means and methods in reference to the needs of his functional or creative work.

Information through photography is abetted by aesthetic factors; *expression* depends upon adequate techniques. There should be a little art in the most practical applications of the medium, and the technical elements must be fully developed in all.

*The title of a book by John R. Whiting (Ziff-Davis Publishing Co., Chicago and New York, 1946).

The *mechanics* of photography are self-evident: operation of cameras, lenses and shutters, accessories and laboratory devices; the problems of exposure and development of the negative (and associative processes); the problems of printing, enlarging, toning and "presenting" the final picture—these represent the basic steps of the process. Variations are involved in color photography, slides, motion picture photography and Polaroid Land photography, but in all cases basic principles are applied and the understanding of these principles will assure a more efficient command of all aspects of the medium.

Technique is the application of mechanical, physical and chemical principles and is modified by the requirements of the particular photograph. Distinction between mechanics and technique is important; mechanics have little or no meaning in themselves but are often exaggerated beyond reason in photographic literature and sales effort. Edward Weston produced his magnificent images with only the bare essentials of equipment and a stern selection of materials and method. The present-day professional photographer, however, faced with varied and difficult projects, must have adequate equipment and resources of materials. He must build his own technical systems in reference to his needs.

The function of all of the *Basic Photo Series* books is to present a philosophy of mechanics and technique. Every statement is set forth with the hope that the photographer and serious student will use it as the basis for personal experiment and for the development of a personal approach. Photography in the final analysis can be reduced to a few simple principles. Unlike most arts, it seems complex at the initial approach. This seeming complexity can never be resolved unless a fundamental understanding of both technique and mechanics is sought and exercised from the start.

Photography is more than a medium for factual communication of ideas; it is an exalted profession and a creative art. Therefore, emphasis on technique is justified only insofar as it will simplify and clarify the statement of the photographer's concept. These books are designed to present a working technique; they do not relate to advanced sensitometry or technological and scientific photography. *Repetitions in the text are intentional.*

Mere restatement of items of general knowledge has been avoided as much as possible; only essential formulas are given, and physical and chemical data have been presented only in elementary form. There are many sources of complete technical information; frequent reference may be made to the *Photo-Lab-Index,* edited by Ernest M. Pittaro (Morgan & Morgan, Inc.), which is the most comprehensive formulary in existence. Every photographer should have this work and keep it up to date through subscription to the Quarterly Supplements.

Book I deals primarily with the functions of the camera and lens, but it is by no means a treatise on photographic optics. It will acquaint the photographer with the capacities and limitations of the camera and its various adjustments (or lack of them!) and the capacities of the lens in practical use, such as angle of view, coverage, depth of field, perspective, transmission, contrast, etc. "Practical use" implies far more than mere mechanical applications; the aesthetic factors are constantly involved, and problems of visualization, composition, scale, etc. will be related to the physical properties of equipment.

Particular equipment and materials mentioned in this book have been selected because of the writer's familiarity with them. There is no implication of inferiority of other equipment and materials; the field is too vast to mention more than *typical* examples. The writer has, however, freely expressed his choice of certain *types* of materials and equipment as being more favorably oriented to his particular philosophy of photography.

TABLE OF CONTENTS

ILLUSTRATIONS

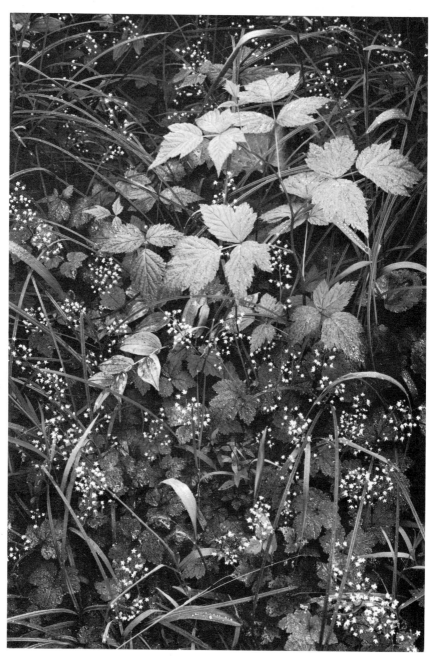

5. TRAILSIDE, NEAR JUNEAU, ALASKA. Made with a 9x12 cm Zeiss Juwel, fitted with the *Graflex* 3-1/4 x 4-1/4 inch back and a 5-3/4 inch Zeiss Protar on Kodak Super XX filmpack. As the camera was very close to the subject, the smallest lens stop was used for maximum depth-of-field. The plane of sharp focus was about 6 inches beyond the nearest leaves. The exposure was nearly 2 seconds at f/45; fortunately there was no wind to contend with. Light fell from a heavy gray sky; the exposure was based on an average reading and development was Normal-plus-1. The high values are textured throughout.

12

THE CREATIVE APPROACH

THE EXTERNAL EVENT AND THE INTERNAL EVENT

This section heading derives from a statement by Samuel Taylor Coleridge (about 1812) that "all art is the balance between the external and the internal." From the start we should consider the basic philosophy of photography as suggested in this quotation. The *external event* – phenomena of space and time in the external world – is of basic interest to the majority, and it is safe to assume that most photography relates thereto. A prime example of this approach is found in the photography of the National Geographic magazine, wherein factual and very competent presentations of the external world of places, people and events are stressed. At the opposite point we have the highly subjective photography (such as that of Minor White, for example) in which the *internal event* – the imaginative, "equivalent" approach – is emphasized. Between these extremes we find a tremendous variety of photographic expression revealing in varying degree both the external and the internal events. Only in the *photogram* (which does not employ the image of the lens) can we divorce ourselves completely from the realities of the external world. It is safe to assume that *no* photograph can represent *only* the external or the internal event. With the most "realistic" pictures (except perhaps those produced by completely automatic systems) I cannot think of an example in which some element of selection or interpretation is not involved.

THE ART OF PHOTOGRAPHY

Photography is an analytic medium. Painting is a synthetic medium (in the best sense of the term). Photography is primarily an act of discovery and recognition (based on intention, experience, function and ego). The photographer cannot escape the world around him. The image of the lens is a dominant factor. His viewpoint, his visualization of the final image (print or transparency) and the particular technical procedures necessary to make this visualization valid and effective – these are the essential elements of photography. The painter, on the other hand, more freely creates his own world and the world which exists upon the surface of his wall, canvas or paper. While he may be stimulated by the world around him, and receive cues, clues and excitements therefrom, he is a creature of great liberty and freedom. Or so thinks the photographer! The truth is a simple one: any art, to be good art, demands the utmost of the artist.

As the photographer can change the aspect of the world only by changing his point of view, his distance and the focal length of his lens (not counting at this point the controls of values, contrasts and textures which are peculiar to photography), he must accept the limitations, as well as the satisfactions, of his medium. Within these limitations he can build a great art – but he cannot accomplish this by imitating other forms of art. In the past photography has been largely plagued by imitation, apology and pompous defensiveness. The "salonist" continues the sham of the turn of the century. The photo-journalists (some, not all!) are "non-art" people, turning to the factual experiences of life as their anchor to reality. The advanced subjectivists reject the world and develop inner awareness – of their inner beings. Some even pursue photography as a form of therapy – directed to themselves and to others as well. And there are

thousands of photographers who happily claim to be "nuts and bolts" practitioners and revel in their opacity. But there are, fortunately, a growing number of men and women who practice photography at a fully adult level. Their world is important, and the external world is important; they relate to humanity and to the goals and problems of a creative society.

The true artist sees the world in the strongest possible way—let us say, in the most penetrating and revealing way. The art of photography is the art of "seeing," and the effectiveness of photography depends upon the strength and integrity of this "seeing." Hence, the so-called "rules" of photographic composition are, in my opinion, invalid, irrelevant and immaterial—nothing but obscurations between the spirit and the revelation of the world of nature and of man.

People are *afraid* to admit they "see" something all on their own. They are constantly making comparisons. This is a phenomenon of the Virtuoso Age; the few extraordinary craftsmen—and sometimes creative artists—stand clear and aloof, terrorizing the lesser gifted but nevertheless highly expressive individual. We need a return to the spirit of the madrigals, of the communal participation and joy of creating beauty in every form. True, "the perfect is the enemy of the good"; complete perfection can lead to total extinction. But the good has to be *good.* Perhaps we can say good composition is directly related to conscience! It is affirmed here that there are no *rules* of composition in photography; there are only good photographs!

Triangles, S-curves, centers of interest, leading lines, etc.—these are accessories after the fact. Most great photographers violate "pictorial rules." In fact, I doubt if the term *composition* ever entered their minds in reference to their work. They *see.* They *visualize* (each in his own way). And they *produce.* The astonishing thing is that vast numbers of people with cameras could do exactly this if they were given the required confidence and could develop an adequate technique. They might not all be great, but many could be very good—and they could also be very happy in their accomplishment!

REALITY VERSUS DEPARTURE FROM REALITY

We have become accustomed to think of the photograph as a somewhat "real" impression of the world around us. Aborigines sometimes have difficulty in "reading" or understanding a photograph; they cannot recognize the world they know in the two-dimensional patterns and varied values of the photographic print. Once these patterns and values are accepted and understood as symbols or simulations, the images become valid. The meaning of visual symbols is a vast field, and we should not forget that the so-called "literal" photograph contains specific symbols to which we have become accustomed and have accepted as a bridge to reality.

Countless photographs are dull and unrewarding simply because they convey only the surface light and shadow of the world—not the substance or the spirit. Why is an Edward Weston photograph of a rock vastly more exciting than a very competent informational or technical picture of the same rock? The chances are that the latter might be physically "sharper," and may reveal to a geologist certain physical facts in all aspects that the Weston picture cannot do. The difference between the creative approach and the factual approach is one of purpose, sensitivity and the ability to visualize an emotionally and aesthetically exciting image. To further verbalize on this is futile; it can be explained only through the photograph itself. It is a safe assumption that aesthetic and emotional factors accent the informational content of any image; they create *interest,* and this spurs the desire for *comprehension.*

14

The picture we make is never made for us alone; it is, and should be, a communication—to reach as many people as possible without dilution of quality or intensity.

Visualization depends not only on subject potential, point of view and value relationships but very considerably on a sense of camera and lens function and control, as well as on the characteristics of the sensitive materials. It is futile to visualize the mechanically impossible; we cannot perform something on the violin and expect the sounds of a full orchestra. Visualization is a very complicated "feedback" of perception and experience. Both are gained through disciplines in no way inferior to those of any older established art or craft. No art can advance without them—photography included! The most precious element is the individual concept and spirit which must not be trapped in conventionalized routines and standards. Art, if it is to be of any value to our world (and to the artist!), must reach far beyond the narcissistic and the therapeutic and stir the spirit of the individual and of society. All art of lasting consequence has done just this; mere amusement or decoration is not enough.

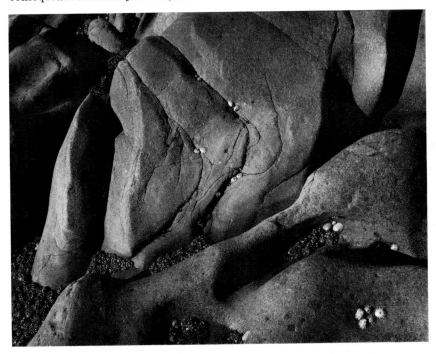

6. ROCKS AND LIMPETS, POINT LOBOS STATE RESERVE, CALIFORNIA. 4x5 Sinar Camera, 8" Kodak Ektar lens and Polaroid Type 55 P/N 4x5 Land film. The engraving was made directly from an 11 x 14 enlargement, which shows the subject at almost actual size. There was a considerable depth-of-field control required; tilts for near-and-far planes, and back-swing for left and right planes. (See page 147 et seq.).

As mentioned in the text, it is rewarding to practice "dry shooting"; turning the camera upon a great variety of subjects and experimenting with "seeing" in the compositional sense. Not only should we practice composition and camera manipulations but we should project exposure and development procedures to achieve the desired visualized effects of value and texture.

15

7. DETAIL, MADRONE BARK, CALI-FORNIA. Made with 4x5 Korona View Camera, 12-inch Goerz Dagor lens. Lens extended to about 15 inches. Tree trunk was curved, but distance and focal-length of lens gives a somewhat flat impression. These random shapes (there were many possible configurations on this tree) were "formalized" by enclosure within the picture format. Such compositions are matters of individual visualizations. It is important to stress the fact that the view camera offers a tremendous range of controls; the lenses used and the camera adjustments available give us the ability to "manage" the image; add to this facility the factors of texture, value and contrast control and it is obvious that photography can be a very flexible art.

16

SOME SEMANTIC CLARIFICATIONS

SHAPE AND FORM

Admitting the hazard of making one's own definitions of long-existing terms, we can perhaps clarify the meaning of *shape* versus *form* in terms of photographic visualization.

The world is chaotic. Natural shapes are infinite in number; not only are there an almost infinite number of things but also an almost limitless number of aspects of each thing, revealed as we vary our viewpoint—up and down, right and left, near and far positions. A rock, person, tree, building or cloud can be thought of as a *shape,* each subject to endless variations as we change our position in reference to it, and also subject to variations of intensity and direction of lighting.

Figs. 11, 14, 16, 37 As we change our point of view in visualizing the desired image, the camera position must change in equivalent ways. Our visual equipment is in constant movement; impressions of the external world accumulate in time. The lens of the still camera is fixed, and in a structural sense the image it produces is also fixed at the moment of exposure. Hence, our visualization does not relate to just what we see with our eyes or envision in our mind but to the actual image which the lens projects on the film.

The problem of the photographer is to conceive and create configurations out of the chaos about him. When he visualizes his photograph, considers the format, the textures, the subtle interrelationships of shape, light and shadow, he actually produces a *form.* He has established a formal relationship with his subject.

To speak of "forms" in nature does not seem to make sense when we consider the creative process. The contemporary painter creates "objects" and forms in his painting—often entirely free of subject connotations. The eye of the painter or photographer brings form into the surrounding shapes. The nature of photography does not make it possible to avoid some domination of subject. As an analytic art, it is somewhat bound to the physical qualities and aspects of the world—but also liberated by the eye and mind of the photographer.

We must not overlook, however, that the shapes of the external world are basic to our existence. They can create deep emotional response and a sense of wonder. Yosemite Valley, for instance, is a magnificent occurrence of the natural scene; to merely record its configurations cannot be art. To transcribe its qualities (as visualized with emotional and aesthetic perception) represents a function of creative photography.

The eye has enormous selective power. For example, consider a deer in an expanse of meadow; our interest and excitement in the subject compels our full attention on the deer; it fills the field of our attention. Without thinking, we point the camera in the direction of the deer and expose. We find that our lens does not share our excitement and selectivity; it merely records—with faithful observance of the geometric rules of perspective, image size, etc.—the deer as a small and quite inconsequential object in a large area of meadow! Once we are aware of the deer, we must visualize the *picture of the deer*—not just the deer itself as seen by the eye. Based on this visualization, we then change our position (moving toward the deer—who may not appreciate our proximity!) and/or use a lens of long focal length. If we cannot move in, and if we do not have such a lens, we may approximate our visualization by resorting to great enlargement of the negative (probably with loss of image quality). Through visualization we learn how to create pictures and we discover what cameras can and cannot do!

17

NEAR-FAR ORGANIZATION

Much photography we see does not have physical or emotional "presence." The picture-content is remote, nothing can be touched—either physically or emotionally. The world portrayed appears to be behind glass, such as the displays in a store window! Certain subjects, of course, are quite satisfactory as frank two-dimensional organizations, but, in the main, the world is a vast configuration of shapes and spaces, in depth as well as in two-dimensional relationships.

Most of the elements of the world before us are "touchable" in the sense that they have meaning in the physical and spiritual (emotional) domains. A mountain landscape, for instance, is tremendously enhanced in impact if we not only "see" the near rocks, grasses or pine needles but have the assurance of their "touchability"; in other words, we receive an impression of the *presence* of the near objects.

Physically, this may be just a problem of perspective and depth of field requiring the adjustable view camera for adequate controls. But it is also an aesthetic, compositional problem involving relative scale, emotional emphasis, *Figs. 8, 20, 41,74,* awareness of space, etc. Numerous examples of this near-far approach are *76, 83, 135* illustrated throughout this book. Clear visualization is *essential* in this kind of photography.

The adjustments of the view camera—important as they are in this near-far approach—are not static. The effect of the adjustments upon the image may reveal the need for further adjustments, resulting in an expansion of our *Fig. 69* visualization. In the picture of the Bodega Church we see the effect of one phase of visualization leading to another one which further served to enhance the impression of height and "lift." And an even greater effect is illustrated in the *Fig. 72* picture of the Water Tower.

THE "ARROW OF TIME"

We perceive the world in three material dimensions, plus the dimension of continuation (time). It is safe to say that nothing in the world remains the same from one moment to the next, but the limitations of our own time-sense give us the impression of changeless endurance, or of fleeting motion too rapid for our eyes and mind to arrest. Somewhere in between we can perceive motion as something tangible; objects change position, but we can still be aware of their structure and details, as well as follow their movements—across space and in time. Time-lapse motion pictures show us in a few seconds the movement of growth of a plant over a month's or a year's span of time. Such movement is far too slow for our visual and mental equipment to be aware of in "real time," but the time-lapse photographs are, in their own frame of time-reference, entirely real and valid. Conversely, an object such as a bullet—invisible in flight to the human eye—may be clearly arrested by an extremely short exposure, such as produced by spark or strobe lights (1/1,000,000 or 1/10,000,000 of a second—10^{-6} or 10^{-7}/sec. or shorter). A sequence of these extremely short exposures at very short intervals (again 1/1,000,000 or 1/10,000,000 of a second or shorter) compose an image of the subject in space and time which may be termed a "4-dimensional realization."

Again, as Wynn Bullock has so beautifully demonstrated, long exposures of things in motion create another kind of world; the incoming surf, for example, can be made to appear as a vast expanse of mist. All moving objects on a busy

Fig. 1 street can be made to disappear by a prolonged exposure. Fractional exposures within the long general exposure will give "ghost" images. All, in their own way, are "real" but they do not agree with our common experience.

The subjective approach, combined with the space-time configurations mentioned above, leads us to muse upon additional "dimensions"—the endurance of the space-time dimension through another parameter of the world.

Photography reaches out far beyond the ordinary experience of man. With equal power, although with different means, it can achieve an equal *mystique* with the most vital expressionist paintings. If the artist can visualize, he can produce!

THE MOMENT OF TRUTH

Cartier-Bresson calls this "The Decisive Moment." Here we have the full flower of intuition, the unconscious and immediate visualization. The camera becomes a part of the total living human organism. This is no easy accomplishment, however; it is not accidental or casual. It is the product of hard work, continuous perception and evaluation, continual success and failure, and always patience and dedication.

Contrast with this the austere approach of a T. H. O'Sullivan—with a large wet-plate camera poised for a western panorama, his darkroom tent set up near his camera, unruly mules impatiently awaiting the next trek, disaster to glass plates threatening at every turn of the trail. Beautiful images result—or can result—from any approach, provided the photographer *knows* his objectives and can visualize his results. The mechanical differences are far less important than most realize.

PICTORIAL VERSUS STRAIGHT

We should seek to understand what the photographer desires to achieve in his photograph. If he wants a stark moment of the human scene, an austere landscape in the Sierra, a tender love affair of a few leaves and flowers or a well-oiled nude with a halo of spotlight back of her hair and a breast competing with the Sahara Dunes—all these are at his command, and all are possible through the logical processes of visualization. Photography does not impose moral restrictions, but it can reveal, to a remarkable degree, the differences between good and bad taste, awareness or opacity of the spirit.

When confronted with good architecture or works of art, the photographer has a certain obligation to respect the forms already created.

PURIST VERSUS PICTORIALIST

Edward Weston once said, "I don't care if you make a print on a bathmat—just so long as it is a *good* print!" The so-called pictorialist has been falsely accused of being what he is because he uses fuzzy techniques and tries to imitate the qualities of other art media. It should be clearly understood that the surface effects are secondary to the deep realizations. John Brook employs soft-focus techniques—anathema to the so-called purist—and yet his photographs have persuasive power and great aesthetic quality. If this is what he visualizes and expresses with the full power of conviction and realization, he stands the equal of all the glossy 8x10 practitioners. Indeed, the glossy print can often reveal a dull mind and spirit.

19

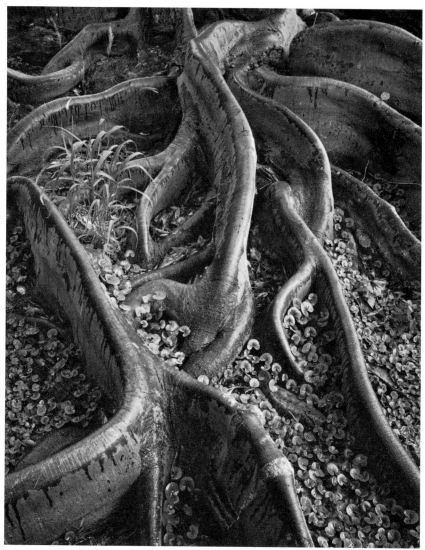

8. ROOTS, FOSTER GARDENS, HONOLULU. Made with Calumet 4x5 View Camera, with 5-inch Ross Express Wide-Angle lens. The camera was pointed down and the depth of field obtained by tilting the camera back. In addition a small lens-stop was used. The nearest root-shape is less than 3 feet from the camera and the farthest root about 12 feet distant.

It is not simply a matter of achieving great depth of field; that can be done with a brick walk image; with a short-focus lens we could encompass 1 foot to "infinity," as the walk would be merely a flat plane to which the plane of the ground-glass and the negative could be adjusted. The "near-far" approach offers far more than just sharp focus in depth; it enables us to amplify and accent qualities of scale and gives us the opportunity to reveal and clarify shapes in terms of form. In this picture we see the roots and we are aware of their tortuous shapes. But this is far more than the eye would normally perceive. When we visualize a photograph we think of the *image*––not merely of the visual experience. This picture is designed to suggest the essence of the subject in terms of "shape-to-form" movement and substance.

The subject was very "contrasty" (possessed a long luminance scale). The exposure was more than normal and N − 1 development was applied to the negative.

20

THE INCEPTION
OF A PHOTOGRAPH

The steps in making a photograph may be simply outlined as follows:

1. *Need,* or *desire,* to photograph. This attitude is obviously essential. Sometimes just going out with the camera can excite perceptive interests and the desire to work. An assignment—a *purpose*—can be the greatest stimulus for functional or creative work.

2. *Discovery* of the subject, or *recognition* of its essential aspects, will evoke the concept of the image. This leads to the *exploration* of the subject and the optimum point of view.

3. *Visualization* of the final picture is essential in whatever medium is used. The function of the photograph as well as the limitations of equipment and of the process will naturally modify the visualization. The term "seeing" can be used for visualization, but the latter term is more precise in that it relates to the final picture—its scale, composition, tonal and textural values, etc. Just as a musician "hears" notes and chords in his mind's ear, so can the trained photographer "see" certain values, textures and arrangements in his mind's eye. The visualization of a photograph involves many extremely swift observations and evaluations, motivated and controlled by intuition and experience. With practice, the placement, adjustment and operation of the camera (and lens) are accomplished with instinctive facility, as are the elements of exposure determination, etc. In fact, for the experienced photographer all of the factors discussed in 1, 2 and 3 above function more or less together as a perceptive-creative system.

The visualization of a practical, informative image and of a poetic-subjective image is basically the same, except that the first requires greater emphasis on the factual aspects of the subject. Whatever the motivation of the photograph, the photographer who is trained in visualization is in a much more favorable position than he who relies on empirical (trial and error) procedures and who must reduce or ameliorate his errors by "bracketing" his exposures or by manipulations in his darkroom. Naturally, as experience grows, the empirical method becomes more efficient. However, confronted with new problems and situations, the empirical photographer can find himself in real difficulties.

As experience and facility with equipment and procedures develop, the making of a photograph becomes more intuitive and immediate. Visualization, and the conscious application of fundamental techniques, does *not* inhibit the creative-intuitive faculties; it protects and augments them. The creative-intuitive forces must dominate from the start in all expressive work. If not, the whole concept of photography as a creative medium of art would be invalid. But a sloppy performance of a photograph is as obnoxious as a sloppy performance of music. Subject alone—or any mere simulation of reality—cannot support a work of art in any medium.

In conventional color photography the direct-positive materials (such as Kodachrome, Ektachrome, Anscochrome, etc.) yield a positive *transparency* which is usually visualized as a *projected image.* Prints and reproductions can be made from them. With color-negative materials (Kodacolor, Ektacolor, Agfacolor negative film, etc.) the characteristics and limitations of the *color negative* and the characteristics and qualities of the *prints* and reproductions made therefrom must be considered. Polacolor gives us a direct print of great subtlety; Marie Cosindas has demonstrated the amazing potential of this new medium. Obviously, because of the relative complexity of the color processes, visualization is more difficult with color than with black-and-white photography.

4. *Execution.* After visualization of the picture is accomplished (and this is frequently an almost instantaneous event), the technical procedures are brought into play. These involve:

(a) Selection of optimum viewpoint (camera position and stability)

Pages 91, 107 (b) Selection of lens (required type and focal length)

Page 174 (c) Required camera adjustments (if any)

Page 69 (d) Exposure meter readings (subject luminance evaluations)

(e) Basic exposure determination and notation of required development

Page 122 (f) Application of filters, polarizer, etc. (if any)

(g) Actual exposure (and *processing* of a Polaroid Land picture)

Page 132 (h) Recheck of all data on the Exposure Record

(i) Development of the negative

(j) "Corrections" (reduction or intensification of the negative; spotting of the negative if required)

Page 258 (k) Cataloguing of the negative

(l) Making proof, print or enlargement; toning (if required)

Pages 262, 263 (m) Mounting, spotting, etc. of the print or enlargement

Page 271 (n) Presenting the finished print or enlargement (in portfolio, framed, on exhibit, etc.)

It is very important to realize that photography relies upon many interdependent factors which, separately, may have little meaning. In even the most representational work the addition of aesthetic and fine-craft factors is certain to augment meaning and information. Photography can be compared to a chain of situations; the collapse, or misunderstanding, of one link in this chain will cause failure in varying degree.

THE ZONE SYSTEM

My approach to photography relates to visualization of the end result—the print—prior to the moment of exposure. This requires a good understanding of the process in its technical and aesthetic aspects. What I describe as the Zone System is a practical interpretation of sensitometry; it makes use of the basic parameters of exposure and development of the negative to achieve optimum negative quality in reference to the desired results in the print or transparency. The Zone System is presented in the other books of the *Basic Photo Series*, is

Page 132 outlined in the *Exposure Record,* and is described in relatively simple terms in the *Zone System Manual* by Minor White. It is also presented in reference to the Polaroid Land process in the *Polaroid Land Photography Manual.*

Visualization is not restricted to image values; the entire process of photography is involved. In this revised Book I (*Camera and Lens*) I will not only describe some basic properties of equipment but will show that through thoughtful application of optical principles and adjustments of the camera, etc., important elements of visualization are accomplished. Actually, all elements of visualization function together; the position of the camera in relation to the subject is modified by the tonal, textural and contrast qualities desired. However, in the study of photographic visualization all the elements must be clarified separately, then combined in actual practice. This is somewhat similar to the study and performance of music.

Hence, a short description of the principles of the Zone System in relation to visualization, etc. is in order:

Recent clarifications of the terminology of the Zone System limit the use of the term *Zone* to the Exposure Scale, which we divide into nine or more sections, each relating to the other by a factor of 2 or 1/2 (geometric progres-

sion). This progression is the same as with the series of lens stops, as well as the series of shutter speeds on modern shutters. Therefore, we can describe the relative value of the zones as follows:

ZONE:	0	I	II	III	IV	V	VI	VII	VIII	IX
EXPOSURE UNITS:	1/2	1	2	4	8	16	32	64	128	256
RELATIVE STOPS:	f/64	f/45	f/32	f/22	f/16	f/11	f/8	f/5.6	f/4	f/2.8

ZONE:	REPRESENTING:
0	Total black in print (no negative density, except filmbase-fog density).
I	First step of value above black; first visible density above film-base-fog density.
II	Print value and negative density sufficient to reveal some texture.
III	Low shadow values with textural content.
IV	Normal shadow value on skin, dark foliage in sun, etc.
V	Middle gray ("pivot value"); 18% reflectance (the gray card); Negative Density V is "pivot" density for development time determinations (after effective film speed has been established by Zone I exposure values).
VI	Average skin value (in sun or shade). This represents about 36% reflectance.
VII	Light skin values; light gray objects.
VIII	Highest values in which some texture is discernible.
IX	Approaching pure white (Zone IX or higher, represents little or no density of the print image although negative density values can be anything higher than optimum density for Zone VIII exposure).

The above table approximately relates to the normal and visual interpretation of the 10 Zones of the Exposure Scale (9 Zones if we omit Zone 0). Frequently we will expose at higher zones but adjust development time to reduce negative densities to relate to the high densities of the normal scale (the negative densities obtained from Zones VIII and IX exposure and given "normal" development). Details of the Zone System tests and procedures will be found in other volumes of the *Basic Photo Series* and in the *Exposure Record*.

To many the Zone System is merely a short-cut to technical proficiency. This is partially true as it represents a simplified application of sensitometry and can assure a high order of technical results. But this is only a part of the problem of creative photography. As the Zone System implies *visualization* (seeing, in the mind's eye, as it were, the final expressive image) it transcends the technical.

The expressive image is rarely the factual simulation of reality. It is quite feasible to set up a camera, adjust an automatic meter-shutter exposure system to give an exposure which a computer might recognize as "correct," and proceed to make sharp, informational and functional photographs. If a photograph gives a clear impression of "reality" we may say we have accomplished the "Photometric Equivalent" or rendered a restatement of the "External Event."

Page 14

23

In effect, the values of the subject, perceived by the eye as the External Event and distilled through the mind and spirit as the Internal Event, are visualized as print values (or transparency values) in terms of the final expressive result. Once the visualization is accomplished and the Zone placements of subject luminances established, the evaluation of subject luminances, the actual exposure procedures, and the degree of development indicated are all purely technical steps which will give us a negative of the desired quality. The foregoing may be clarified in the following sequence:

Subject Values	Exposure Zones	Negative Density Values	Print Values
(measured in c/ft^2)	On which Luminance values are placed (or fall)	Obtained by the desired degree of development	Observed as brilliancies (reflection densities)
Perceptive-Emotional	Technical	Technical	Receptive-Emotional

In other words, we react to a subject in our personal way and visualize the image we desire to attain. While we "see" this image in more-or-less total effect, we must start with the lower values (shadow values) and determine their proper placement on the Exposure Scale. The old adage—"expose for the shadows and let the high values take care of themselves"—makes good sense except that while we must get the shadow values *on* the scale (at least above Threshold), we must also take care of the high values. We *place* our significant shadow values on the desired lower zones of the scale (usually Zones II or III) and we observe where the high values *fall* on the scale. The steps of the Exposure Scale (as set forth in the exposure record) are geometric; each Zone moving upwards with a factor of 2, and downwards with a factor of 1/2. Thus, if 25 c/ft² is placed on Zone III, 100 c/ft² *must fall* on Zone V and 800 c/ft² *must fall* on Zone VIII. (Note the terms PLACE and FALL; to PLACE means to initiate a sequence, and any FALL is restricted to its logical and geometrical position on the exposure scale.) If a high value falls on the exposure zone to which we think it "belongs" (flat skin on Zone VI, light-gray paper on VII, etc.) we can then rely on NORMAL development for that negative. This "normal" relates to a number of modifying controls; the personal concept of the image, the performance of cameras and lenses, the type of enlarger illumination used, etc. If we visualize an important shadow value as rightfully belonging on Zone III and if we find that skin in sun falls on Zone VII (a ratio of III to VII, or 1 to 16) the indications would be to give NORMAL MINUS ONE (N − 1) development. This yields a negative density for the Zone VII exposure similar to the density obtained with a Zone VI exposure of skin, and developed normal. In other words, we have reduced the contrast of the negative in reference to the contrast of the subject. Likewise, if the skin value fell on Zone V we would give NORMAL PLUS ONE (N + 1) development and get Density Value VI for Exposure Value V. The lower zones change relatively less in density with more or less development than do the higher zones. Please note: with direct-positive processes such as Kodachrome, Polaroid Land *prints,* etc., we start our procedures by first placing the *high values* on the exposure scale. All this is fairly complicated and is discussed in other volumes of this series.

24

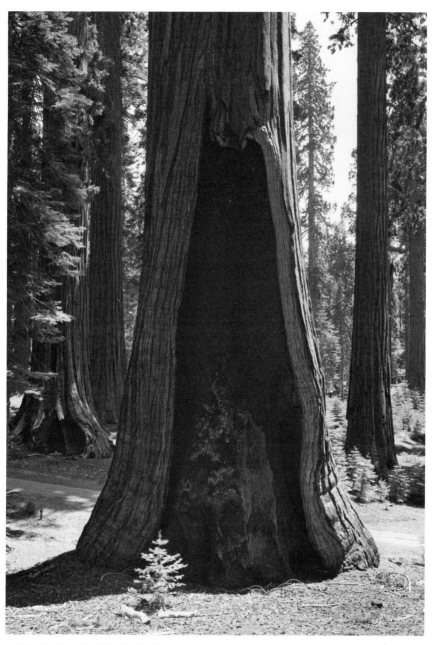

**9. MARIPOSA GROVE OF GIANT
SEQUOIAS, YOSEMITE NATIONAL PARK,
CALIFORNIA.** Made with 8x10 camera and
Kodak 10-inch wide-field lens. Rising front
used to limit. The contrast of the scene was
extremely high; sunlight on the ground 250
c/ft^2 and deepest shadow in burn-blackened
interior of tree about 2 c/ft^2. While it is
difficult to accurately show all the values of
a full-scale print in reproduction, the descrip-
tion of the subject, the objective of the photo-
graph (the visualization) and the application
of the zone system approach, should give
the reader adequate information.

Placing the deepest shadow value on
Zone II (resulted in 16 c/ft^2 falling on
Zone V) determined the basic *exposure*.
The high values then *fell* on Zone IX. As I
wanted these high values to have about Zone
VII–VIII value, Normal minus 1 (N−1)
development was indicated. The feeling of
light was preserved in the original print.

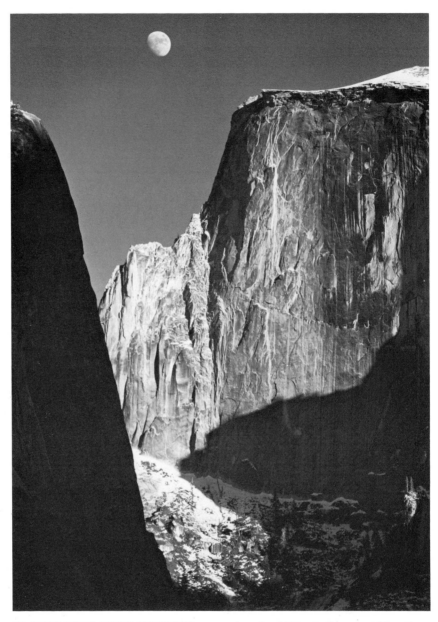

10. HALF DOME, MOON, YOSEMITE NATIONAL PARK, CALIFORNIA. Made with Hasselblad 500C Camera, 250mm lens and orange filter on Panatomic-X film. The subjects are huge and it required considerable change of camera position to alter the arrangement of the subject. The Moon is several days before full and low sunlight is falling on the cliff. To the eye, considerable detail appeared in the shadow areas, but the visualization called for a very strong scale of values. In addition to the orange filter, the exposure was about 2 Zones less than normal and the development about Normal plus 1. The luminance of the Moon is about 250 c/ft^2; it was placed on Zone VI-1/2 and the basic exposure was about 1/100 at f/5.6. This, plus factor of 6 for the filter, gave an exposure of 1/2 sec. at f/16.

GETTING ACQUAINTED WITH THE CAMERA

From the first, we must try to understand what the camera sees—a quite different vision from that of the eye. The eye has a tremendous range of view because of its ability to *scan* the field; however, concentrating upon a particular detail of a subject, the motionless eye has an angle of sharp vision of only a few degrees (but with a large peripheral unsharp vision). The eye, without moving the head, can rove over about 70% of the field, achieving sharp vision at every point scanned. The free movement of the head permits complete scan of the environment.

The small camera, held in the hand, can scan the subject freely, as directed by the eye and hand, but the view camera—fixed on the tripod—"sees" only the area of the field covered by the lens within the format of the negative. Changes can be made by turning or tilting the camera on the tripod head or moving the entire assembly, but such adjustments are much more cumbersome than the free positioning of the hand camera. On the other hand, the fixed position of the view camera (and of any camera used on the tripod) leads to greater precision of composition and higher optical quality of the image. Proponents of the small hand-held camera argue that the intuitive perceptions of the eye and mind will determine the optimum point of view and select the "decisive moment" with far greater efficiency than the tripod-bound camera will. Let us assume that both approaches are valid within their appropriate fields. Let us also assume that the view camera—with its varied adjustments—can best provide the fundamental knowledge of the camera-lens complex, its capacities and its limitations.

Actually, it is the lens which "sees" the world in terms of the photograph; the camera is the vehicle in which the lens functions. One of the most difficult things for the photographer to learn (and be convinced about) is how the lens sees in relation to what the eye sees. The human eye is an extremely sensitive and adaptable instrument. When we consider *vision,* we must think of the entire psycho-visual complex—the eye-brain phenomena of perception, interpretation, "computation" and feedback—a system which makes of the relatively simple retinal image an extraordinary revelation of the external and internal worlds and stimulates the intuitive-creative awareness of the artist.

What we "see" in our mind's eye must be re-evaluated at the lens-level of perception. Putting it another way, one of the parameters of visualization must be the lens-vision with its manifold limitations. Standing at any one spot we may perceive a vast landscape; then we see within it a single tree or rock or minute details of these objects. We can visualize photographs of the great vista or the intimate details; the eye "sweeps" the vista and can narrow down to the relatively small fields of rock and tree, or the finer structure. Our vision depends largely upon the time element and the mobility of the eye. Hence, what we see is not just the impression of a moment or a series of moments in space and time but a smooth progression of countless events organized and coordinated by what we term *vision*. We know that a wide-field lens, perhaps appropriate to the larger vista, would also show the tree and rock but in the relative (and probably unexciting) scale of the "surround." Without altering our camera position, we can use increasingly long-focus lenses, gaining larger and larger images of selected parts of the scene. This direct increase of image-size, plus the possibilities of further enlargement of the negative, obviously extends the power of the camera (with suitable lenses) to approach the requirements of our visualization. What is generally overlooked is that our reaction to the scene as a whole modifies our visualization of the component parts. It is necessary, therefore, to

visualize specifically: to think of a particular image without being influenced by the "surround." Of course, moving in to the subject presents new and different aspects. The use of a black cut-out card to frame the subject is most helpful when one is developing the sense of visualization. Moving the card away from or close to the eye gives respectively narrower or wider fields of view, corresponding to lenses of longer or shorter focal length (assuming the eye and camera remain at the same distance from the subject). But this is only part of the problem; in a subject of great scope and variation of light and shadow, those parts within the shadow areas naturally appear lower in luminance and internal contrast in comparison with the brightly illuminated areas. The eye makes these determinations automatically, adjusting both areas to the "luminance mean" of the entire scene. Now look at the shadowed areas through a fairly long black (mailing) tube, viewing only those areas and excluding the bright areas. Immediately the shadowed areas take on an elevated brightness and contrast, and shapes and textures come to life. The same effect would be partially obtained when we move in close to these areas. Measuring the true luminance values with an exposure photometer from the camera position would indicate values quite different from what we think we see!

Figs. 78, 79, 80, 84 Using lenses of various focal length allows us to command different configurations of the subject; problems of perspective and relative scale influence our working distance from the subject. Modern lenses with optical anti-reflection coating produce very little, if any, flare; if the interior of the camera is relatively flare-free, there should be little or no effect on the contrast of the image no matter what the proportion of bright to shadowed areas might be. However, not only does the eye have some flare-quality but the subject contrast is modified by the psycho-visual effect discussed above. Hence, visualization is a "mind's eye" phenomenon, and our procedures are based more on the evaluation of actual subject luminances than on the visual appearances.

Figs. 44, 45 A normal lens of a given focal length (distance from the rear nodal point of the lens to the plane of the negative when focused at infinity) will project an image of a certain size on the focusing screen or negative. This image is circular; depending upon the quality of the optical image, squares or rectangles (the camera format) can be defined within this circle, limited in size only by the resolution of the lens over the entire format area (including the far corners—see *Page 92* the description of lens coverage). In normal position, the lens is centered in relation to the focusing screen or negative; the axis of the lens can be thought of *Fig. 86* as a straight line perpendicular to the plane of the lens and to the plane of the negative, impinging upon the center of the field of view and the center of the image. The focal length of a normal lens for any size picture format is equivalent to the diagonal of the format. For example: with a 4x5-inch format we would have $4^2 + 5^2 = 16 + 25$, or 41. $\sqrt{41}$ = about 6.4 in. Hence, the normal lens for a 4x5 camera would be of about 6.5-inch focal length (165mm). Lenses are designed to cover larger than normal fields; these are designated as wide-field, wide-angle and extreme wide-angle up to the "fish-eye" lenses which may cover more than 180°! Other lenses of the telephoto type are of long-focus and cover narrow angles of view. Apart from the "speed" of a lens and the ability of a lens to "cover" a given field, *all lenses of the same focal length give images of the same size.* (See Retrofocus and Wide Field, etc., pages 83 and 84).

What is most important to the creative photographer is that he will undoubtedly "see" a different picture of any "event" than another person would see. There are no rules or regulations to encompass this; only a good command of equipment and procedure will enable him to realize *his* visualization.

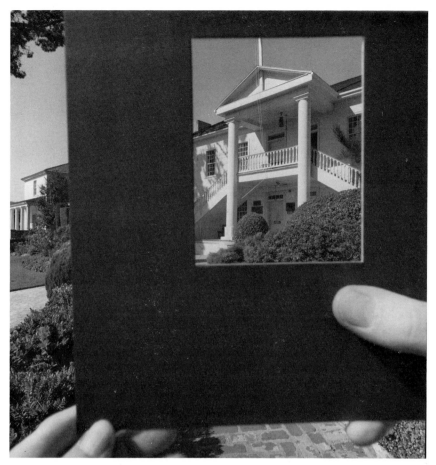

11. EXPLORING WITH THE BLACK CUT-OUT CARD. Colton Hall, Monterey, California. The card *suggests* possible compositions, creating "configurations out of chaos." We do not necessarily (if ever) place the camera where the card was held! Distance from the subject, and distance of the card from the eye make profound differences in subject appearance.

This picture was made with Hasselblad 500C and 40mm Distagon lens (on tripod).

Lenses of greater than normal angle of view give the impression of increased space (and reduced image size), and lenses of less than normal angle of view give

Figs. 80, 84 the impression of reduced space (and larger image size). Lenses of less than normal focal length for any given format size are most helpful in "near-far"

Figs. 8, 20, 56, 76, compositions where great depth of field and/or intentional variations of sub-
81, 83, 103, 135 ject-image scale are required.

It is obvious that "command" of the camera-lens complex has much to do with the visualization of the photograph. Visualizing, composing, studying the effects of camera position and lenses of varying focal lengths, etc. will, in time, give the photographer facility in efficient operation of his equipment. The experienced photographer can project on his subject an imaginary "frame" representing what the particular lens used will project in his camera. Naturally, with a number of cameras and lenses of varying sizes this "frame projection" can be somewhat confusing. A 12-inch lens on an 8x10 camera gives the same angle of view as a 6-inch lens on a 4x5 camera. A 12-inch lens on a 4x5 camera

Fig. 84

gives half the angle of view (1/4 the area) as does the 6-inch lens on the 4x5. The perspective effect with any lens at the same distance from the subject remains the same, but the field of view changes as the focal length of the lenses vary in relation to format size. The closer the subject-distance focused upon, the narrower the field of view of the lens becomes (just as the effective focal length increases as the lens is focused on near objects). Using a 6-inch lens on a near subject, we may find that the extended focal length of the lens must be 9 inches for optimum focus. The angle of view of the 6-inch lens at 9-inch extension is the same as that of a 9-inch lens at infinity setting. The 6-inch lens at 9-inch extension requires an exposure increase of $6^2/9^2$, or 36/81, or approximately 2-1/4x. The 6-inch lens at 12-inch extension requires a 4x exposure factor.

The standard lenses usually supplied for 2-1/4x2-1/4 and 35mm cameras are of the same general ratio of focal length to picture size as the standard lenses for larger cameras. In round figures, the normal lenses for 4x5, 5x7 and 8x10 cameras would be, respectively, 6-1/2 inches, 8-1/2 inches and 12 to 13 inches. With square format cameras such as the Hasselblad, the standard lens is the 80mm f/2.8 Zeiss Planar, with an angle of view of 52°. Other lenses for the Hasselblad are:

40mm Zeiss Distagon	88° (f/4)
50mm Zeiss Distagon	75° (f/4)
120mm Zeiss S Planar	36° (f/5.6)
150mm Zeiss Sonnar	29° (f/4)
250mm Zeiss Sonnar	18° (f/5.6)
500mm Zeiss Tele-Tessar	9° (f/8)

The 38mm Zeiss Bigon on the Hasselblad Super Wide camera has an angle of view of 90°; this is similar to the Zeiss 21mm lens for the 35mm Contarex and the 90mm wide angle lens for 4x5 cameras. Other manufacturers may list lenses of slightly different focal lengths for their 2-1/4x2-1/4 and 35mm cameras.

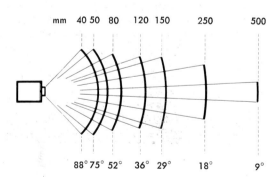

12. DIAGRAM. Showing angle of view of lenses of varying focal lengths (courtesy of Victor Hasselblad, Aktiebolag, Goteborg, Sweden). This relates to the angle of view of these lenses in relation to the 2-1/4 x 2-1/4 negative size. A 150mm *wide angle* lens will give the same size image as the Hasselblad 150mm lens for their camera, but, of course, would cover a larger field of view.

The new Zeiss Planar f/3.5 100mm lens has an angle of view of 43°.

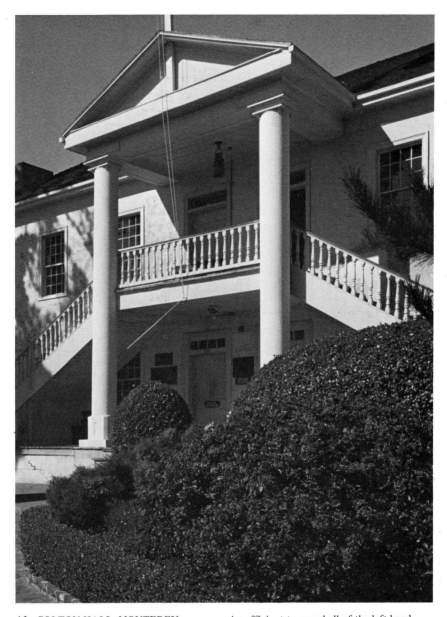

13. COLTON HALL, MONTEREY, CALIFORNIA (one of the fine early buildings of the area, now the City Hall). This suggests the picture invited by scanning the scene with the black cut-out card. On pages 34, 35 and 36 another example of the use of the black cut-out card is illustrated. And on page 176 et seq. the use of camera adjustments in relation to this subject is presented.

Visualizing is not just "getting the scene on the film," but involves a careful exploration of shape and edge, "merger" of lines, etc. The height of the camera in this picture is sufficient to reveal all of the left-hand column beyond the bushes, and the roof-line below the left-hand porch beam. Had the camera been moved a little to the right, the entire window might have been seen behind the column. Actually, a hedge prevented movement to the right but the lens could have been shifted to the right (sliding-front adjustment—page 187) for the same effect, if the covering-power of the lens was adequate.

The more lenses and cameras the photographer has, the more difficult it becomes to visualize the various related fields of view.

We must be aware not only of the field of view of the lens from a given position but also of the relative positions of near and far objects within the field of view. Many refinements of composition depend upon these relationships; an object impinging upon or obscuring another object, mergers of lines and shapes, intrusions of unwanted details, etc.—all such must be managed from the viewpoint of the lens (or as seen on the ground glass of the view camera and in the finders of the single-lens reflex cameras). The photographer standing above, or by the side of, his camera sees a different relative position of near and far objects in the field of view, and the viewing lens of the twin-lens reflex camera *Figs. 14A, B* also sees differently from the taking lens. Off-axis finders (where the finder is above or to one side—or both—of the taking lens) further exaggerate this difference. This difference between the image of the taking lens and of the viewing lens or finder is termed the *parallax effect*. A ground-glass view camera and a single-lens reflex camera (such as the old Graflex, the Hasselblad, Contaflex, Leicaflex, etc.) enable the photographer to see on the focusing screen or in the prism finder exactly what the lens is seeing and what the picture will contain; there is no parallax effect at any distance focused upon.

Direct mirror-reflex cameras (Hasselblad, Bronica, etc.) show the image upright but reversed. The penta-prism (usually built into 35mm cameras but available for 2-1/4x2-1/4 cameras such as Hasselblad, Rolleiflex, etc.) "rectifies" the image; that is, it is not only upright but gives the correct left-to-right position (not a mirror-image).

Modern cameras with separate view finders incorporate ingenious parallax-compensators; as the lens is focused on near objects, the optical system of the finder automatically adjusts to bring the picture area *on the plane of the subject focused upon* accurately within the field of view. But this is a limited correction! Objects before or behind the plane focused upon retain their relative positions in space *as seen by the lens.* Subtle compositions involving near and far objects are seriously affected by the parallax effect.

For accurate close work or near-far work with the Hasselblad Super Wide camera, twin-lens reflex cameras such as the Rolleiflex and other cameras where the finder is directly above the lens, we must, after composing through the *Fig. 18C* finder, raise the camera an amount equivalent to the distance from the center of the taking lens to the center of the finder lens. This will place the taking lens on the same axis as the finder lens, and the camera will "see" what we saw in the finder. In the case of the Hasselblad Super Wide camera, the camera must be raised 3 inches to overcome the parallax effect. This is necessary when near-far *Figs. 18A, B* objects are in the scene or when very near objects are photographed; the parallax effect is inconsequential when all planes of the subject are 15 or 20 feet distant. A tripod with an elevating center post is essential for this, or a special elevating device can by used (such as the one made for the Mamiyaflex).

With cameras having parallax-compensating view finders compostions must be worked out at infinity focus. Focusing is then done and the camera raised as described above. We must remember that as we focus on near objects, the lens is *Figs. 77A, B* somewhat extended and the field of view narrowed.

Even with a single-lens reflex camera held at waist or chest level, the world as *Figs. 14A, B* seen by the lens can be quite different from that seen by the eye! Of course, *Figs. 18A, B* looking down into the viewing screen would show the lens-view of the subject, but since the photographer is standing, he will naturally accept the subject as seen from eye level and may not be aware of the subtle differences in the composition as seen by the camera at a lower level. With a view camera set at

32

14A. FISHERMAN'S WHARF, MONTEREY, CALIFORNIA. Taken with the Hasselblad Super-Wide C camera. This is what the eye saw in the finder; the Wharf is clearly revealed above the spiked leaves of the plant. But the axis of the taking lens, positioned 3 inches below the axis of the finder lens, saw the picture as in Fig. 14B below. This same effect obtains with any twin-lens reflex camera (see page 38).

14B. SAME AS ABOVE. Composed as desired in the finder, the scene was recorded by the taking lens as seen here. To be certain of getting the actual picture as viewed in the finder the camera must be, in this instance, elevated 3 inches, so that the axis of the taking lens coincides with the former axis position of the viewing lens. Then the camera records accurately what the finder "saw."

**15. DETAIL, COLTON HALL,
MONTEREY, CALIFORNIA.** This is a
section of the subject as seen by a 4x5 Arca
Camera and a Zeiss Protar 5-3/4" lens. The
camera was leveled and aligned (approxi-
mately) with the newel post. One good
feature of the "seeing"—the second railing
post neatly revealed the window frame. The
newel post itself is well-seen in relation to
the steps. The tree shadow on the window
on the left is disconcerting. The general
disposition of the masses is awkward. The
picture is merely informative, but incom-
plete and disorganized.

However, there was something "there"
of interest to the photographer; some signif-
icance of subject, aesthetic quality and/or
emotional response. The photographer
begins to "visualize," to "see" images in
reference to shape and form, scale, depth,
values and textures—all in reference to the
format of his camera or—better—to the for-
mat which is part of his visualization. The
cut-out card will help.

heights other than eye level, the photographer must get into the lens position or check all parts of the ground-glass image to be certain he is taking nothing for granted; no matter how carefully we scan the ground glass we can overlook small but important details of subject relationships. The rectifying pentaprisms (roof-prisms) which can be attached to the Hasselblad, Rolleiflex, etc., permit eye-level viewing with, of course, no parallax effect. However, with the old-type separate-finder cameras the photographer can learn intuitively to shift his camera to approximately compensate for the parallax effect at the moment of exposure.

It is important to explore the effects of various points of view on any one subject. Careful study of the subject from a variety of positions may reveal image possibilities of unexpected power and interest.

At this point I can make a plea for what I call "dry shooting." In a way, this is similar to practice with a musical instrument; one or more problems are worked out without attempting to inject fully expressive elements. Practice with

16. DETAIL, COLTON HALL, WITH CUT-OUT VIEWING CARD. We start exploration with the black cut-out card held before us at varying distances from the eye and at various directions to the subject. We begin to see relationships, simplifications, organizations. We recognize the unimportance of most of the scene and the true importance of selected areas. In this subject there were 8 or 10 possibilities, but the newel post seemed to have the greatest potential. The first view was a very "tight" arrangement, as we see here. To be effective it would have to be much narrower in format. (Proceed to Fig. 17.)

35

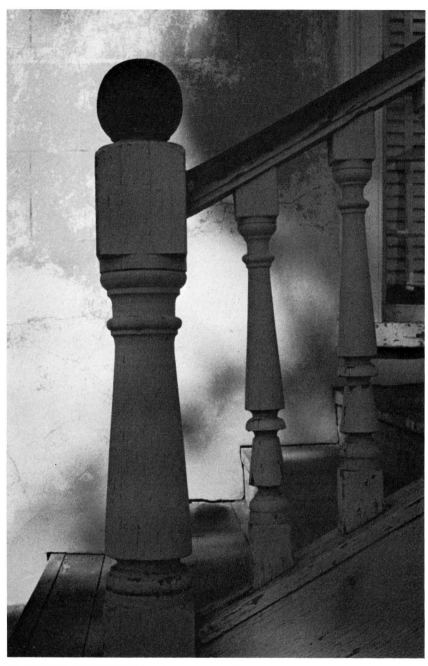

17. DETAIL, COLTON HALL. After continued exploration with the cut-out card (Fig. 16) this arrangement of the newel post was selected, and confirmed by adjusting the image on the ground glass. The camera position was not changed as the original "seeing" of the post and railing against the right-hand window was adequate). If the lens (or the camera) had been moved to the right, to show more of the window frame, the railing posts would have cut into the stair risers; if moved more to the left, the railing post would have obscured the window frame. Perhaps moving the camera a bit farther from the subject (only 2 or 3 inches) would have opened the space a little.

the camera is essential for adequate development of the intuitive command of the medium. The photographer should constantly practice "seeing" images, establishing shape relationships, exploring relative scale of subject and space, avoiding mergers of edge and shape, etc., in the world about him. The next step is to select something that presents both an opportunity and a problem: visualize, set up the camera, compose, focus, read the luminances, determine exposure and related development, etc.—but you do not have to actually make the picture! In other words, you are *practicing,* increasing your facility, sharpening your perceptions. Dry shooting is especially important with the 35mm camera where constant training in perception and *anticipation* is of great importance. The truly capable photographer is no more conscious of the physical presence of his camera than the musician is conscious of his instrument or the good driver conscious of the mechanical operations of his car, but achievement of this creative independence requires discipline and practice.

Part of the difficulty of "getting acquainted" with the camera lies in the hiatus between the taking of the picture and evidence of the final print. Here is where the Polaroid Land process spans the gap; intelligence, knowledge and appropriate techniques are required—but the Polaroid Land approach gives the photographer the most immediate realization of his ideas and intentions. It is therefore, by inference, the most effective *teaching* medium we have. To become truly acquainted with the essential elements of the medium, the view camera, with the Polaroid 4x5 Land Film Holder, will provide the most efficient approach. In photography we are confronted with a multiple situation: whatever we do with the camera is reflected in the print through a system of perception, visualization, execution and presentation. Our "acquaintance" *must* be projected through all these domains.

Composition, as Edward Weston so clearly stated, is "the strongest way of seeing." Pictorial "rules" are not compatible with the validity and strength of honest photographic perception. Composition is not just the disposition of shapes, edges and values on a few planes of the subject but relates to a complex of relationships in depth where consideration must be given to juxtapositions of near and far elements of the subject, to scale and perspective effects and to the general effect of space. Everything should be visualized as it will appear in the final print.

A close inspection of many photographs will suggest the camera position and the focal length of the lens used. It is rewarding to study photographs of all kinds, making an effort to "visualize in reverse"—that is, to imagine the orginal subject in its many aspects of scale, distance from the camera, tonal and textural values, etc., and then to *re-visualize* on your own terms. This is most valuable practice! In a given picture you may note an intrusion of one object on another, a disturbing merger of lines and edges, etc., and then estimate how much you might have to move the camera in one direction or another to overcome the defects. You can also think of ways and means to enhance scale and depth, control convergencies, augment textures and control values.

Any point of view other than the normal eye-level position will result in a certain "departure from reality," which may—or may not—help the photographic statement. Trick angles or obviously unconventional points of view are questionable unless they relate to the validity of both the subject and its interpretation. It is obvious that the use of certain types of cameras can form point-of-view habits that are not always applicable to particular problems and which, in many cases, may dominate or even frustrate the expressive capacities of the photographer.

18A. MARBLE HEAD. Made with Hassel-blad Super-Wide Camera, 38mm lens. Lens axis directed to point about 1/3rd height of head. The "effect" is normal and pleasing.

18B. MARBLE HEAD. Same camera, but with lens axis lowered to base of the object. There is a very different emotional and aesthetic effect. (See Figs. 14A, B, p. 33.)

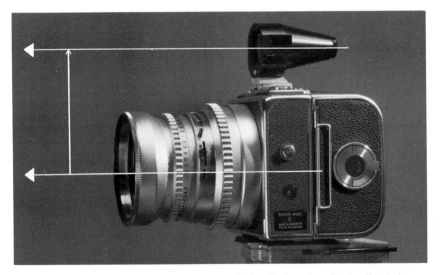

18C. HASSELBLAD SUPER-WIDE CAMERA. In order to be certain the film is "seeing" what the eye sees in the finder, the camera must be raised 3 inches so the lens axis is brought into the position of the finder axis. (Refer to pages 32 and 33 and Figs. 14A, B.)

This adjustment applies to all twin-lens reflex cameras as well.

38

CAMERA AND
LENS EQUIPMENT

For nearly a century there has been a surfeit and duplication of photographic equipment, much unnecessary, but some of enduring and useful quality. Discounting the obviously poor items, the great variety and volume of, and fantastic turnover in, equipment produced, advertised and sold in recent years has been both bewildering and confusing to the photographer. He has been saved, in a way, by his ability to learn some discrimination with the vast array of equipment and materials currently available on the market. No one has time to fully evaluate the many cameras, lenses, exposure meters, enlargers and general accessories (to say nothing of negative and printing materials, etc.) in relation to real needs, and it is admittedly difficult to become acquainted with equipment before it is available or owned. The photographer must therefore reject the obviously inadequate or inappropriate items, investigate more or less generalized *kinds* of things, make the best selection he can (often with conflicting advice from friends, colleagues, advertisements and dealers) and proceed to master the operation of his final selections.

It is difficult (if not dangerous) to give anyone positive advice on equipment and materials. One can only *suggest,* and such suggestions should be made with some understanding of the intentions and style of the photographer. Hence, we shall discuss here only basic *types* of equipment.

As time goes on, the photographer should refine—or at least alter—his equipment to meet his changing requirements. Rare is the photographer who will periodically clean out the deadwood or who will employ new techniques or equipment to attain some bright new approach to "seeing." Photographers are creatures of habit and fixations!

Maximum simplicity is always desirable. Edward Weston's field and darkroom equipment was almost spartan, but he chose a relatively narrow world of personal expression in which to make his unmatched contribution to creative photography. Other photographers, because of the demands of scope and interest and the particular approaches they find necessary for their creative or professional work, may need quite varied and complicated equipment. Three basic requirements should always be considered: quality, function and durability. There is a great illusion among photographers that creative work *depends* upon equipment. On the contrary, equipment is something to be selected for a specific *purpose.*

Edward Weston, working among the rocks and cypress trees of Point Lobos, found the 8x10 camera ideal for his purpose; he limited himself to 8x10 contact prints. A museum photographer might prefer the same equipment, but an industrial photographer or a photographer of architecture might prefer the 4x5—or smaller—equipment. Many photographers feel completely comfortable with the flexible 4x5 view camera. Much great work is done with 2-1/4x2-1/4 instruments such as the Hasselblad. Henri Cartier-Bresson and W. Eugene Smith depend upon the 35mm systems for the adaptability and physical freedom which their work requires. Photographers of architecture must use view cameras, with their varied adjustments, to properly align their subjects, control complex angles of view, achieve great depth of field, etc. An increasing number of professionals *Page 66* and amateurs use the Polaroid Land materials—Type 55 P/N 4x5 film, for example, which can be used in any standard press or view camera and which

39

offers not only a good print but a very fine grained negative.

While a well-trained photographer can often "make do" with inferior equipment if the occasion demands, equipment of optimum quality is a very great advantage. It is certainly inhibiting to adhere blindly to any existing equipment if one can change to a better selection; it is poor economy to continue use of equipment on a purely habitual basis.

There is no doubt that one "sees" differently with 8x10 and 4x5 cameras in spite of the assurances that with modern film and processing methods an 8x10 enlargement can be made from a 4x5 negative which, for all practical purposes, is indistinguishable from an 8x10 contact print. Again, one "sees" quite differently with a 2-1/4x2-1/4 and a 35mm camera. Using a camera on a tripod implies a more contemplative approach than with a hand-held camera. With the 35mm camera the photographer may search, through many exposures, for the desirable balance of the *external* and the *internal* "events"; with the 8x10 camera on a sturdy tripod we may achieve the desired image with a single exposure. Moreover, indiscriminate "banging away" with a small camera can be very destructive. The photographer should know exactly what he wants and how to achieve it. The fleeting nature of some subjects, however, may demand constant probing for the appropriate and vital moment in which a truly fine image occurs. To make 36 exposures with the hope that *one* will turn out may result in one being somewhat better than all the others, but this is of no real consequence because there was little or no visualization or projected control.

It is significant that the greatest creative photographers use simple basic equipment—everything of adequate quality, nothing that is unessential. If the photographer will first think of the camera in its most elementary terms, he will better understand what equipment is most suitable for his needs. Rather than work from the complex down, it is better to work up from the simple!

PINHOLE CAMERA

The simplest camera of all is a light-tight box with a pinhole at one end and something to hold the sensitive film at the other end. The pinhole image is always "in focus" (but never truly sharp) no matter how far it is from the

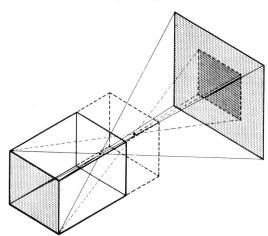

19. DIAGRAM: PINHOLE CAMERA. As the pinhole is advanced from the film, the image becomes larger, the field of view smaller and the effective aperture decreases (diameter of pin hole/extension equals the effective f/number). For composing, a large pinhole (1/16-1/8 inch diameter) can be used.

40

**20. RAKE AND ROOF, PINHOLE
IMAGE.** The pinhole was about 1/64th inch
in diameter and extended to about 10
inches from the negative (effective aperture
about f/640, requiring an exposure 400 x
that for f/32). If the exposure was 1/20
second at f/32 it would be 20 seconds for
this situation. *Caution:* observe the reciproc-
ity effect for long exposures (refer to Book
II et seq.).

The near prongs of the rake were only 2
feet from the pinhole and the tree-top about
200 feet distant. Note that the definition is
equal at all points and that the perspective is
accurate. Too small a pinhole will produce
diffraction effects (with loss of definition).
The pinhole must be of very thin material;
gold-leaf punctured evenly and accurately to
the right diameter and mounted in a metal
plate is best. Or a thin plate of metal,
smoothly drilled and routed on both sides
will be adequate. A thick plate (1/16 inch or
more) will cause vignetting of the image.
The edge of the pinhole must be smooth
and dust carefully removed. Keep pinhole
thoroughly protected when not in use.

41

pinhole; "sharpness" is increased as the diameter of the pinhole is reduced and the distance from the pinhole to negative increased. As with the lens, the greater the pinhole-to-negative distance, the smaller the angle of view and the larger the image size. Adapting a lens to this simple light-tight box would give us the prototype of the ordinary box camera. Further, add a roll-film winding mechanism, a view finder and a simple shutter mechanism, cover the box with some attractive material, give it a handle and perhaps a case, and we have the old basic Kodak or Ansco box camera! Add a better lens and a synchronized flash accessory and perhaps an exposure meter (and a little chrome and plastic), and we have a modern amateur hand camera. For more than half the photography done in the world today this camera would be adequate! The "folding" camera is a variation of the box camera; focusing devices can be added to the lens or to the bellows extension systems. The new Polaroid Automatic Colorpack Land cameras represent the latest development of the simplest camera principles plus the addition of an extremely sensitive and dependable automatic exposure *Pages 66,79* system. Most of the 35mm cameras and the twin-lens and single-lens reflex cameras are glorified examples of the box-camera prototype. They possess a vast array of fine interchangeable lenses and accessories; some have exposure control systems and synchronized flash attachments. Two 35mm cameras possess the Perspective Control lens; the Nikon F and the Leicaflex. This lens can be raised, lowered and moved sideways, giving the equivalent of moderate rising, falling and sliding-front adjustments of a view camera. It is very useful with architectural subjects and all subjects requiring rectilinear images. The Rolleiflex SL, with its bellows component, permits tilting the lens for depth of field control. Some 35mm cameras and the Hasselblad EL cameras are provided with high-quality electrical equipment for shutter release and reset, and film advance (permitting remote-control operation). Underwater camera housings are available for many models. The press and view cameras are further extensions of the basic concept of the light-tight box camera. New devices are constantly appearing: for example, electronic shutters, remote controls, etc.

Photographers are restless, questing individuals and in some ways sublimate their urge for accomplishment into the desire to possess superior equipment. Without intending to depreciate the magnificent equipment available today, it is suggested that the photographer think first about what he "sees" and what he wants to "say" before he launches into acquisition of advanced equipment. If a man has something to say, he *could* say it with a box camera with a pinhole for a lens! (But, of course, it could be said more often, more dynamically and more efficiently with a Hasselblad or a Contarex or a Calumet view camera.)

Let us assume a person entertains the idea of becoming a professional photographer; it will require at least a year or so of basic study before he can imagine the direction and scope of his creative and professional interests. While the casual amateur can get along quite well with the simpler hand cameras, the serious student should explore his world from the start with the classic view camera, as the view-camera adjustments permit simultaneous solutions of more image problems than is possible with any other instrument. It is very important to emphasize that with the view-camera adjustments in use the covering power of the lenses must be adequate.

A small camera does not imply low cost; a *good* small camera is necessarily expensive, and a good enlarger (also expensive) is essential for fine results. Actually, the least costly and most effective equipment in terms of results for the serious student would be a 4x5 view camera (the regular and/or wide-field Calumet models, for example) with one or two lenses and the essential accessories. They can frequently be picked up used, but they are not extravagantly

priced new. The old Korona wooden 4x5 view camera (available only as used equipment now) is a perfectly adequate camera to start with. Its basic alignments should be checked, and the attachment of good small levels to both front and back assemblies will serve to check further the alignments at any extension.

It is of first importance to learn what the basic photographic equipment and procedures can accomplish; then we can better understand the limitations of specific equipment and procedures. If you understand what can be done with the standard view camera, you can better grasp what *cannot* be done with, for example, the Hasselblad—and vice versa! In truth, what we "see" is severely modified by our equipment; the problem is to see as strongly and appropriately as possible with the equipment and materials we are using. For example, with Kodachrome or with Polaroid PolaPan Type 52 4x5 Land film we cannot photograph subjects of high contrast without supplementary illumination; the scale of the materials is favorable to medium and low contrast subjects. Accordingly, we learn to "see" and to visualize images within the limitations of the materials used. Likewise, we can "see" certain images with a view camera that we could not "realize" with a Rolleiflex or a Leica.

When the basic principles have been grasped and mastery of the view camera has been achieved, attention can be directed to other types of cameras—giving them the same amount of thought and practice—with the assurance that their characteristics will be fully understood.

It is surprising how many photographers own elaborate equipment without ever achieving a real acquaintance with it. As the photographer branches out into his chosen fields, his objective should be to acquire the simplest but most efficient equipment for his purposes, always with the intention of possessing—sometime, somehow—appropriate equipment of highest quality.

With increased knowledge of the medium the photographer may naturally gravitate to a smaller camera, such as the Hasselblad 2-1/4x2-1/4, or to the 35mm cameras (Contarex, Nikon, Leica, etc.). [*Note:* It is impossible to name all of the good cameras here; omission does *not* imply inferior quality.]

We cannot discount the potentialities of the very small format cameras such as the Minox (it is not a toy but a precise and well-made instrument).

On the other hand, the photographer may wish to explore the large camera format and investigate the 5x7 and 8x10 sizes. Some good used cameras in these sizes are occasionally available. The Calumet 8x10 is probably the best obtainable in this size within a moderate cost range (new or used). An honest dealer will equate quality and cost and would not recommend an inferior camera to a serious customer just because it is cheap. However, a few dealers like to unload the most expensive equipment—often far beyond the abilities of the beginner to utilize.

Investigate the *rental* or *lease* of equipment; this might be an economical way to try out different cameras and lenses and lead to greater assurance of need and performance when purchases are made.

New lenses for the larger size cameras are usually much more expensive than lenses for the 4x5 size, but good bargains in used lenses are not infrequent.

Cameras such as the Sinar, Cambo, Arca and Linhof are of superior quality—quite costly, but worth every dollar if one can afford them. The Sinar is an especially handsome camera with many unique accessories.

Today's tendency is to manufacture camera "systems" rather than just cameras and accessories. The Graflex XL system, for example, comprises a number of combinations of interchangeable components—camera bodies, lenses, backs, sheet film and roll film holders and magazines (as well as the Polaroid Model 227 Land Camera Back) and general accessories. While costly in their entirety—and tempting

to the photographer—these systems are quite economical in the end, as the basic equipment can be expanded in any direction by the addition of essential parts rather than the acquisition of separate and complete equipment.

Equipment in the small camera field *must* be of high quality, otherwise results will be disappointing. The dealer is often called upon to act as counselor; he is in a difficult position, as the customer is probably steeped in advertising claims and the glib how-to-do-it articles and glamorous fanfare in the popular magazines and may have preconceived notions of "instant success" dependent upon the equipment he buys.

Some students feel that, along with basic technical and aesthetic studies, a free expression of "seeing" and appreciation of the moments of life around them is essential for a balanced development. This is a healthy attitude, provided they do not permit the "candid" approach to weaken the attention and disciplines of the basic studies. This usually implies a 35mm camera in addition to the basic outfit. The Polaroid Land pack cameras (Model 180 and the 300 series) also have a very important place in this domain. With the Polaroid Land systems we can make immediate explorations into the world around us with the added advantage of constructive repetition of images to refine and intensify our seeing. In addition to producing beautiful photographs in its own domain, I wish to stress the creative and functional potential of the Polaroid Land system. The use of the system as a testing or pilot facility is certainly rewarding, but this represents only a small area of the possible applications where it can serve as a helpful adjunct to all fields of photography.

Page 67

Facility of operation of the camera comes only with practice; manipulation of the camera in the dark or with the eyes closed will be helpful in giving the "feel" of the instrument at its different settings. For instance: what is the position of the front assembly of the camera with a given lens at infinity focus? What at 10 feet? Are there any structural elements on the camera bed which can be points of reference therefor? How many turns of the focusing knob will bring the camera into 10-foot (or 5-foot, etc.) position? Such an approximate setting can be made quickly; refined settings follow. How can you set by "feel" the stops or speeds on the shutter (some shutters have "click-stops" for both)? Even if these adjustments are roughly approximate, they save time. Such familiarity with the instrument will assure rapid basic operation and assist in capturing the fleeting scene before us.

As may be gathered from the general nature of this book, camera and lens equipment is as important as negative and positive materials in the attainment of photographic objectives. In fact, the photograph begins with the visualization of the image controlled by the camera and lens complex. Rather than think of the camera and lens as just mechanical devices, we should consider them creative tools—essential elements of the entire process.

In the following section I shall describe the various types of cameras, together with their adjustments (if any), special features and selections of typical models. I write, necessarily, through experience. I shall mention certain kinds and makes of equipment and materials which satisfy *my* requirements. In describing these I do not mean to imply inferiority of other makes of equipment and materials. I have been a consultant to the Polaroid Corporation for many years and have the greatest confidence in the advance of this domain of photography. I have also employed the Zeiss Contax-to-Contarex cameras since the 1930s and the Hasselblad since its appearance in 1948. I wish to express my appreciation for the magnificent cooperation I have had from these firms, as well as for the advice and counsel of Eastman Kodak Company, Calumet Manufacturing Company and other manufacturers.

44

CAMERAS

Definitions, Adjustments (if any), Special Features and Typical Models

Page 40 **PINHOLE CAMERA.** The simplest camera; a box with the sensitive material at one end and a pinhole at the other. Actually, this is the prototype of all cameras.

VIEW CAMERA. The "classic" camera with a great variety of adjustments (see below). Modern view cameras, usually of monorail construction, offer a diversity of attachments and accessories, such as extended rail (bed), additional bellows, "bag" bellows for short-focus lenses, bellows-type lens shades, revolving or reversible backs, interchangeable lensboards, etc.

View Camera Adjustments. Rising and falling front assembly, tilting and swinging front assembly, sliding front assembly, tilting and swinging back assembly, sliding back assembly, sliding and rotating bed (monorail cameras), sliding bed (regular and some monorail cameras).

[*Note:* Some view cameras have all of the above adjustments; others have only rising and falling front assembly, tilting and swinging back assembly and sliding front assembly. Be certain to check before purchase.]

Typical Models. Calumet (standard 4x5 and 8x10; wide field 4x5), Sinar (4x5, 5x7, 8x10), Cambo (2-1/4x3-1/4, 4x5, 5x7, 8x10), Graphic View II (4x5), Deardorff (4x5, 5x7, 8x10), Linhof (2-1/4x3-1/4, 4x5, 5x7, 8x10), Plaubel (2-1/4x3-1/4, 4x5, 5x7, 8x10), Arca (3-1/4x4-1/4, 4x5, 5x7, 8x10, etc.).

PRESS CAMERA. Conventionally, a camera with a "drop bed" for wide angle or short-focus lens work, bellows and interchangeable lensboards. It is supplied

21. STANDARD CALUMET VIEW CAMERA, 4x5. As shown, the camera is fully extended and all adjustments are in normal position. Both front and back tilts are on Lens Axis (As are the front and back swings). The monorail bed does not rotate (as does that of the Sinar) but the back is *revolving;* hence the image can be adjusted to any horizontal angle of view (Fig. 22, page 46).

45

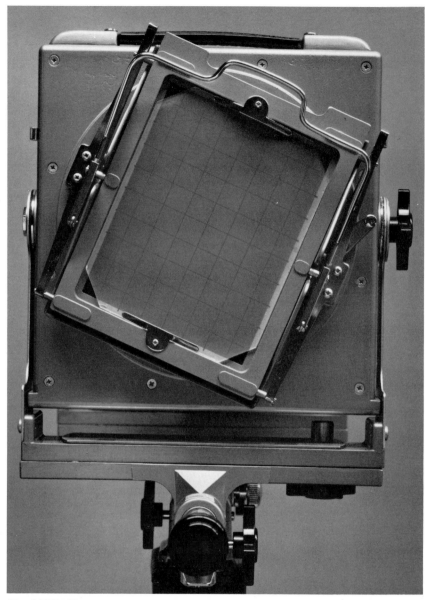

22. REVOLVING BACK, 4x5 CALUMET VIEW CAMERA. The *reversible* back (one that can be placed in *either* vertical or horizontal position) requires a 5x5 inch bellows for a 4x5 format. The *revolving* back (which can rotate to any position) requires a 6.5 x 6.5 inch bellows for a 4x5 format. This avoids the need for a rotating monorail camera bed, or for a horizontal tilt of the tripod head.

When in use on the Calumet Camera, the horizontal camera level can be taken from the edge of the revolving back rather than from the camera itself. Be certain the back is clamped securely in position; insertion of the film holder may displace an unsecured back.

With the Polaroid No. 545 Land Film Holder, the roller housing may impinge on the knurled knobs of the Calumet Camera back when in horizontal position. Setting the knobs at 45° should clear them. It may be necessary to change the set-screw position to assure adequate tightening at this 45° position.

The 545 Holder will not fit the back when in other than horizontal or vertical position.

with or without focal-plane shutters and seldom is equipped with a lens without a shutter. Modern press cameras are far more elaborate than the classic Speed Graphic and are produced in a wide range of styles and sizes.

Press Camera Adjustments. Rising front, drop bed, tilt front (tilt backwards).

tilt back (from bed—a situation derived from the tilt front).

[*Note:* Cameras with rising front, drop bed and tilt front are designed to take wide angle lenses without the camera bed intruding on the field of view. A few press-type cameras have the tilt back.]

Typical Models. Graphic (Speed Graphic, Crown Graphic, Super Graphic 45), Linhof.

REFLEX CAMERA. A camera with a mirror which reflects the lens image upward to the ground-glass focusing screen; the operator looks down into the reversed "mirror" image. The prototype of the reflex camera was the Graflex (actually a single-lens reflex—SLR—see below). Varieties of the basic reflex are:

Twin-lens. The Rolleiflex is typical; the viewing lens and the taking lens are accurately matched for focal length, and the image is composed and focused through the viewing lens via a mirror. The taking lens is entirely separate, and there is no direct connection with the viewing system. These cameras have no adjustments except for focusing. Recent models have parallax-control devices which bring the area focused upon into "center" in the field of view. Unfortun-

Figs. 14A, B, 18C ately, the true parallax effect is quite apparent as close as 6 to 8 feet and increases at shorter distances. The effect is this: if the viewing lens is 2 or 3 inches above the taking lens, we have, with near-far objects in the field, a different vertical relationship of the near-far elements with each lens, no matter if the "centering" facility is used.

Special Features. Some have only one focal length lens assembly, but supplementary lenses can be attached. Some have several lens assemblies—"taking" and "finding" lenses of equivalent focal lengths (the Mamiyaflex, for example). Pentaprisms may be attached.

Typical Models. Rolleiflex, Mamiyaflex.

Single-lens (SLR). Similar to old Graflex, the lens image is directed upward to focusing screen; at moment of exposure the mirror swings upward, and the shutter operates. The mirror is then replaced in position with the same mechanism that advances the film. In the Bronica Camera the mirror *drops* and a shutter device covers the viewing screen.

Further developments of the basic SLR system include the pentaprism (or "roof-prism") over the focusing screen. This "rectifies" the image (left-to-right is seen as left-to-right and, of course, the image is upright). Hence, when the camera is held to the eye, we see what the taking lens is seeing without parallax of any degree. The Hasselblad, Bronica and Rolleiflex SL 66 have, as an accessory, this feature in the 2-1/4x2-1/4 domain, and such cameras as the Zeiss Contaflex and Contarex, the Leicaflex and many other fine 35mm cameras have it as part of their basic design and structure, together with range-finders and built-in exposure meter systems.

Most 35mm cameras are now of single-lens reflex design with a variety of focusing screens and devices. (The Leica M4 and M2 35mm cameras, not of SLR design, are the exception.) A great variety of interchangeable lenses and accessories are available, and some 35mm models have interchangeable backs. Practically all have the rectifying pentaprism finder system mentioned above. Filters, polarizers, lens shades, etc., are available in great variety.

47

Typical SLR Models. Hasselblad (500C, and 500EL), Bronica, Rolleiflex SL 66, Plaubel, Makiflex.

Typical 35mm SLR Models. Leicaflex, Zeiss (Contaflex and Contarex), Nikon, Beseler Topcon, Honeywell Pentax.

SPECIAL CAMERAS. These include the various Polaroid Land cameras (and accessories) and the Graflex XL system. It also includes the large portrait and commercial cameras, underwater cameras, industrial cameras (such as. the Polaroid MP-3 Multi-purpose Industrial View Land camera), miniature cameras (the Minox, for example), aerial cameras and a great number of cameras for scientific and technical purposes.

Page 66

Page 266

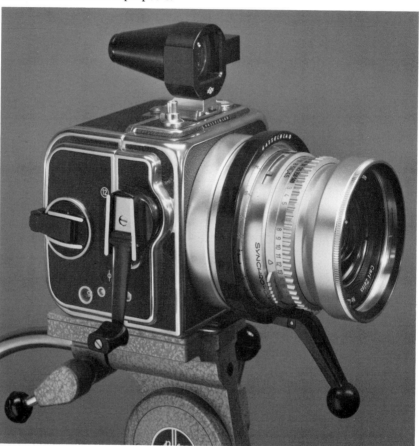

23. HASSELBLAD SUPER-WIDE CAMERA. With Magazine A-12 and Rapid Winding Crank, Quick-focusing handle on the 38mm Biogon and the Standard Super-Wide Finder It is shown on the Bolex Tripod. Note: The accessories as listed, while specific for the Hasselblad, have some counterparts in other makes: it is obviously impossible to list all the available accessories in this book.

It is absolutely essential when working with rectangular subjects, or when distortion must be avoided, to have the wide-angle camera precisely *level.* The Optical Finder has a built-in central-bubble level adjacent to the field of the finder. For many subjects in nature, precise leveling is not so important, but with the wide field of view (90°) distortion may be produced with almost any recognizable object, Advantages of the short-focus, wide-angle lens includes great depth-of-field; the 38mm Distagon at f/22 yields a depth-of-field of 26 inches to infinity.

48

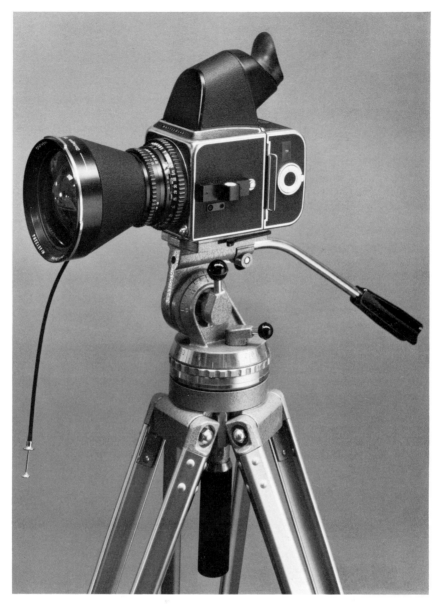

24. HASSELBLAD 500C CAMERA.
Shown with 40mm Distagon lens, standard
Magazine and eye-level prism Finder (NC-2).
The level (attached to the left side of the
camera) is a Hasselblad accessory. The
Tripod shown is the Bolex No. 772. The top
is of ball-joint construction, controlled by
the black-handle grip below the tripod head.
This is primarily designed for motion-
picture cameras, but is suitable for the
Hasselblad and similar cameras in the field
or studio. However, it does not have a
center-post which permits the camera to be
elevated without changing position or length
of the tripod legs (see page 60).

It is *essential* that the camera be
accurately leveled when using wide angle
lenses to prevent obvious distortion of the
subject. This is especially important with
architectural subjects or subjects with rec-
tilinear shape, horizons, etc. The rectilinear
grid available for the ground-glass focusing
plate assists in securing a good level position
of the camera with lenses of moderate and
long focal length, but an accurate level on
the camera must be used with short-focus,
wide angle lenses.

49

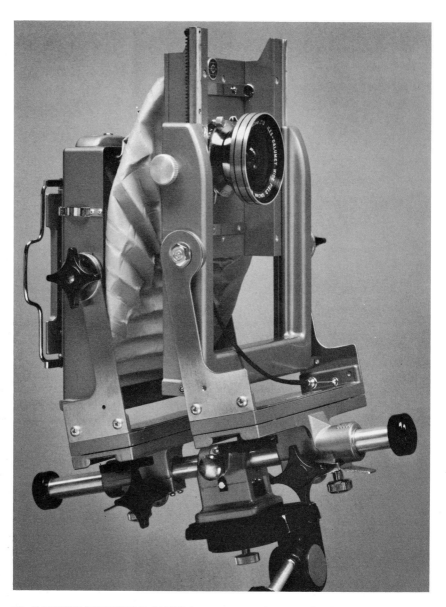

25. CALUMET WIDE FIELD CAMERA.
This is a version of the standard 4x5
Calumet View Camera, equipped with
flexible bellows permitting short-focus, wide
angle lenses to be used with all camera
adjustments.

The Rising-front and the Tilting-back
and Front adjustments shown herewith
appear rather extreme, but with the
Calumet wide-field Caltar lens (90mm) the
negative was fully covered. Other lenses,
such as the Schneider Super Angulons
(60mm, 90mm and 121mm focal lengths)
can be used with this camera.

The Arca Swiss, Cambo and Sinar

cameras have "Bag" bellows which function
on the same principle (see page 121).

Accurate leveling of the camera is
essential for precise work. The camera back
must be not only level horizontally and
vertically, but parallel to the subject (archi-
tectural work, copying paintings, etc.) in
both vertical and horizontal directions.

Under conditions involving such extreme
adjustments, special care must be taken to
avoid inclusion of the front end of the
monorail bed, and vignetting of the picture
by lens shades, filter adapters, etc.

BELLOWS

The Hasselblad, Bronica and practically all 35mm cameras of today do not employ bellows (except with close-up devices). The Rolleiflex SL 66, the Polaroid 300 series and all view and press cameras of conventional design have bellows, and this part of the camera deserves attention. In principle, the bellows serve as an adjustable light-tight "box," allowing for movement of the lens toward and away from the negative when focusing on objects at different distances. The average view camera bellows extend sufficiently to function with lenses of varying lengths under normal working conditions.

With view cameras such as the Sinar additional (supplementary) bellows are available supported by an accessory frame. If a single bellows is extended to a degree far short of its limit, it may sag and "vignette" or cut off the image. This can be taken care of by having hooks or grommets attached to the bellows at frequent intervals; when pulled forward and attached to the front assembly (usually with a spring hook), the bellows are drawn more tightly to the camera front and the tension prevents sag. Sag seldom occurs when the bellows are extended to maximum and are under tension.

However, the conventional bellows have limitations of extension and contraction. When the bellows are at minimum extension, they limit the focal length of the lens used and a recessed lensboard may be necessary to accommodate a short-focus lens. Many faults of modern camera bellows derive from the currently popular square shape (uniform size from one end to the other). The old "pyramidal" bellows—small at the lens and widening to at least the size of the negative at the other end—had less tendency to sag simply because it didn't weigh as much for a given length. (Such were found on the prewar Zeiss Juwel, Linhof and Century Universal cameras and are currently employed on the Polaroid 300 series Land cameras.) This type of bellows "nested" its folds and could close more tightly than the square bellows.

At, or near, minimum extension the bellows become rigid and do not allow for camera adjustments. This severely limits the functions of the view camera. The longer the extension capacity of the bellows, the greater the number of folds and the larger the minimum extension. With the most modern extreme wide angle lenses (such as the Super Angulon) their full advantages are not realized unless camera adjustments can be used. The recessed lensboard helps somewhat, but nothing is as good as the "bag" bellows, which are well described by the term. They allow for extreme closeness of the front and back assemblies of the camera and also for extensive adjustments in all directions. The Calumet Wide-Field 4x5 view camera has a special bellows with almost all the advantages of the "bag" bellows. The older view cameras, and some of the new ones, do not have detachable bellows as do the "module" cameras such as the Arca, etc.

With conventional bellows we should be careful to note any sag which can be seen on the ground glass with careful examination. If a sag appears and if there is no tension hook, we can align the bellows by placing a lightweight block or a stiff card between the camera bed and the lower side of the bellows, thus lifting the bellows into normal position.

With the bag bellows we must be very careful to note any fold or pucker inwards which could, of course, severely cut off the image. We can take off the camera back to see if such trouble exists. Or we can merely pull out the bag bellows at each corner and check on the ground glass image. The more extreme the adjustments employed, the greater the risk of cutoff. Some bag bellows have internal supporting parts which minimize sagging (Cambo, Arca, etc.).

Page 121

51

With cameras having "tight" bellows, extended coverage with a short-focus lens can be obtained by using an "off-center" position of the lens on the lensboard (allowing for clearance of the inner and outer parts of the lens and shutter and for adequate security at the corner of the lensboard itself). The edges of the lensboard may have to be changed in shape so that the board will fit in all four positions (one edge is usually shaped to contact the spring pressure bar which holds the lensboards firmly in the front assembly of the camera). The different positions allow for the equivalent of a small degree of rising and falling front, and sliding front, effects (but, of course, only one at a time). The lens should be reinserted in the center of a regular lensboard for normal use. The lens could, however, be left in the off-center lensboard and the above-mentioned adjustments employed to center the lens (or to gain additional rising, falling and sliding front effects).

If the corners are trimmed from the ground-glass focusing panel there is no suction or pressure developed when the camera bellows are extended or compacted. But visibility of the image at the corners of the field is impaired; I have found distracting details in the corners of my negatives that I was not aware of when focusing. A drilled central hole (or several holes) in the focusing screen

Page 55 allows for the escape of air and a fine reticle can be placed over the hole (on the ground-glass side—on the focal plane), allowing for very sharp focus on the aerial image.

CAMERA FLARE

The problem of camera flare is an important one; the bellows can reflect and scatter a considerable amount of light. Ideally, the lens shade should cut off all the image a short distance beyond the edge of the picture (but not so close as to allow any part of the fuzzy penumbra to intrude on the edge of the negative). This can be approached by use of the bellows lens shade which allows for positioning in reference to the lens position on the rising, falling, sliding or tilting front. In other words, it is far more precise and effective than the ordinary lens shade on the lens itself. The more we keep light from extraneous areas of the subject from the bellows, the less flare we will have in the camera. When the bellows are only slightly larger than the negative size, the flare can be severe and can be concentrated along the edges of the picture. Both Edward Weston and I had serious trouble with our 8x10 cameras in this respect; the obvious density increases along the edges of the negative were erroneously attributed to fogging, heat effects, even radiation! Whenever possible, have *oversize* bellows (such as the bellows for the 5x7 Sinar with the 4x5 reducing back); this assures a significant reduction in flare. An internal light-baffle frame about 1/4 to 3/8 inch before the negative will help in "tight" cases. We must remember that flare is seldom a direct glancing reflection from the bellows to the negative but a complex of random internal reflections from bellows, camera body parts, the lens and from the negative itself. Without adequate lens shades light will fall upon the bellows and generate the greater part of internal flare. A typical situation: a bright streetlight just beyond the margin of the picture format!

FILM HOLDERS

The standard sheet film holders, film pack holders and some roll film holders employ a dark slide which is inserted through a "light-trap" at one end of the holder and protects the sensitive material from light. A common source of negative fog is a defect in or disintegration of the light-trap material (usually a

52

velvet-covered pressure plate). Or the slide may be of the wrong size and might not sufficiently "seat" at the other end; if too narrow, light might enter from either or both sides of the slide through the light-trap. The slide should be inserted parallel to the end of the holder, *not* pushed in at an angle. Occasionally a slide is cracked or punctured; holding it up to the sun will reveal such defects.

The standard sheet film holder has a cloth-hinged flange at the end opposite the slide slot; this opens up and out to admit the sheet film (which slides under narrow flanges on each of the long sides within the holder). When the film is fully inserted, this hinged flange is closed and fits flush with the face of the holder. When the slide is inserted, the flange is held securely. Sometimes this fabric hinge deteriorates and admits light. Holders of recent manufacture have tubular metal hinges on the flange, and these are, of course, superior. Sometimes the holder has been dropped, and a crack appears. Light entering the holder itself will create fog or light streaks at the *edge* of the film and can be traced.

Page 294 See also "Checking for Light Leaks" for methods of tracing light leaks around holder and camera back.

Obviously, the film holders must be kept clean. Convention dictates that the top ("handle") of the slide have the *white* (and "ridged") side *outwards* when the film is unexposed and the black side out when the film is exposed or the film holder is empty. Confusion here will lead to tragic results!

Film-pack holders are somewhat similar to the sheet film holders except the film-pack itself is quite lightproof in every respect and only the slide light-trap of the holder can give trouble. Of course, if the seating of the holder and the camera back is faulty, fog and light streaks will result.

Roll film holders for standard camera backs are usually well-constructed and lightproof, but, again, there is always the possibility of light leaks in the slide light-trap (and possible trouble with the "seating" of the holder into the back).

Film magazines, such as for the Hasselblad, etc., give very little trouble. If the slide becomes bent, or is roughly inserted, a failure of the light-trap may result. If the prongs (or the "hooks") which serve to secure the magazines in close contact with the camera body are damaged, light leaks might result.

With precision equipment it is urgently advised that only well-trained camera mechanics be involved in repair or adjustment!

The Polaroid 4x5 Land Film Holder is light-tight, but fog and light streaks can occur with faulty seating or operation. With some 4x5 camera backs there is a tendency for the Polaroid Land Film Holder when inserted vigorously into the camera back to "bounce" or slip beyond the bottom flange of the back. This, of course, means that the film holder is in poor contact with the back and fog is inevitable (the light-trap ridge on the Adapter is not resting *in* the groove on the camera back). When the envelope of the Polaroid Land packet is pulled out prior to exposure, be sure to pull straight up—not exerting pressure backwards—as this may tend to pull the film holder away from the camera (if the springs are weak and/or if the film holder is not secured by the clamps on the Graflok-type back).

The Polaroid No. 545, 4x5 Land Film Holder *must* be kept absolutely clean; the rollers must be frequently examined and all traces of dirt, accumulated developer fluid, etc., removed. *Never* put the holder on the ground where it may collect dirt and sand (this is important with *all* equipment).

With conventional sheet film holders be certain that they are frequently cleaned and that the narrow spaces under the side flanges are free of dust or "scrapings" from the sheet films previously inserted. A slight roughness of these flanges may cause trouble in this respect.

53

ELECTRIC MOTORS FOR CAMERAS

Certain top-quality cameras such as the Hasselblad, Nikon, Leica, etc., can be equipped with motor-driven devices which advance the film, cock the shutter and make the exposure. The Hasselblad 500EL and 500EL/70mm cameras are typical of the finest available equipment in this domain. The motor is integral with the camera and is powered by one or two rechargeable batteries (each adequate for 1,000 exposures on a single charge). Recharging units for 110/120-volt circuits are provided, as well as a dry cell power source for charging the camera batteries used in the field. The Hasselblad EL can be remotely controlled by cords or by a radio device made especially for the 500EL or 500EL/70mm camera.

The advantages of the remote control, electrically operated camera in nature, scientific and industrial photography are obvious.

The more technically complex our equipment becomes, the more attention and care are required with maintenance. Batteries, chargers, wires, connections, etc. all must be in perfect operating condition. Certain drains on the power supply must be anticipated and battery-charging planned in advance (or fresh batteries should be on hand). In damp climates, special care must be taken with electrical equipment.

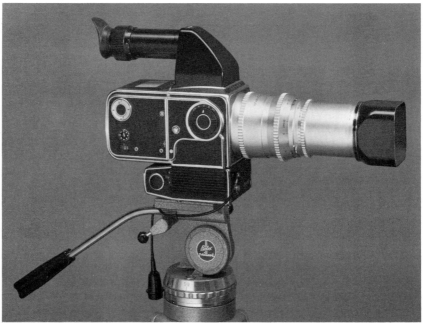

26. HASSELBLAD 500EL/70 CAMERA. This shows the Electric motor (and battery) device which operates the shutter, resets it, and winds the film. Also shown are the 70mm Magazine, the 250mm Sonar lens (with appropriate lens shade), and the Eye-level Prism Finder (HC-3/70). The latter is designed to function with the 70mm Magazine, but can be used on any of the standard Hasselblads (and, with the Ground-glass adapter, can be used with the Super Wide). It magnifies 4x and has an adjustable ocular for ± 5 diopters.

Electrically operated cameras have certain great advantages when working with animal photography, or under situations where time-lapse or remote control requirements are important. Accessories include chargers, extension cords, timers, remote-control devices, etc.

54

CAMERA ACCESSORIES

FOCUSING MAGNIFIERS: (for the image on the ground glass of view cameras)

For ground-glass cameras a good magnifier (such as the Schneider 6x or 8x type) is essential. Those who need glasses for infinity focus should use them for most magnifiers, unless the eyepiece is *adjustable*. The lens image is brought to focus on the inner surface of the ground glass (the ground surface). The "grains" of the ordinary ground glass are easy to focus on, but some special ground glasses have a very fine texture and black lines sharply drawn thereon will help in establishing the focal plane as well as lining up the image. Focusing on the aerial image is, of course, the most precise, but the aerial image must be "fixed" at the focal plane. This is accomplished by having one or more clear areas on the ground glass engraved with "cross hairs." The cross hairs are sharply focused with the magnifier, and when the image is sharp behind them (actually, "on the same plane *with* them" would be a better term), we can be sure that the picture is in sharp focus.

Modern small cameras have range-finder focusing, very finely-ground focusing rings, etc. These are observed through the eyepiece of the finder, and it is essential that the eyepiece be corrected for the eye of the user. Supplementary correcting lenses of the proper diopter power can be inserted in front of the eyepiece which will enable the user to see the image and the range-finder sharply without his regular glasses. Magnifiers for the Rolleiflex, Hasselblad, etc. may present the same problem, although the Hasselblad magnifying hood does have *Figs. 26, 27* an adjustable eyepiece, as does the Hasselblad eye-level prism finder HC-3/70.

A solution to large-camera ground-glass focusing problems may be found in special eyeglasses of two types:

(1) For those with perfect distance vision: a simple frame with a hinged pair of "reading" or magnifying glasses that can be moved down before the eyes.

(2) For those who require "distance" glasses: a similar hinged pair of lenses which, when brought down before the regular distance glasses, combine to form strong "reading" or magnifying glasses at the close distance of the ground glass. The advantage of this system is that the photographer, with the magnifying glasses raised, sees the world with the usual clarity and without the confusion of bifocal lenses. He can then flip down the outer pair of lenses and scan the ground glass within a few inches. The combined glasses can be figured to work at normal reading distance or to within any desired distance. If planned for only a few inches from the ground glass, they may be impractical for more normal distances—as when setting the shutter, etc. Obviously, the preparation of these glasses is a job for a trained optician or (preferably) an ophthalmologist. Any basic eye defect might be exaggerated by the use of poorly-designed glasses.

A problem with conventional bifocal lenses is that while the "reading" lenses are in proper position for scanning the ground glass, they are definitely wrong when picking one's way over rough terrain, especially when carrying a camera. Changing from one pair of glasses to another is bothersome; if two pairs are necessary, they can be suspended on the chains or cords made for that purpose.

With cameras having ground-glass viewing and focusing screens, it is *essential* that the ground-glass side of the glass face the lens (or mirror of the reflex camera) and that it be at the exact distance therefrom for perfect focus. With conventional view cameras, the backs, focusing screens and film holders must meet ASA standard specifications. If the ground glass is positioned with the

55

Page 86 ground side outward, imperfect focus will result. Grid lines and the Fresnel screen must be on the *ground* side.

FOCUSING HOODS

Some view cameras have ingenious focusing hoods which attach to the back of the camera. These are used with magnifying lenses and, of course, free the operator's hands from holding a magnifier and trying to adjust the swings and tilts and focus all at the same time. The Arca camera focusing device has a plane mirror; the image can be viewed directly along axis or at an angle employing the mirror. The Arca also has a complete reflex camera unit with focal plane shutter, etc. Some camera adjustments are possible with this unit—unique for reflex camera design.

Cameras such as the Hasselblad have a collapsible hood with magnifier as *Fig. 64* standard equipment. The Hasselblad has a variety of accessory focusing devices, *Fig. 27* including a magnifying hood which enlarges the ground-glass reflex image 2-1/2 *Fig. 24* times, two pentaprism finders which magnify about 2-1/2 and 3 times (one for horizontal viewing at eye level and the other, also at eye level, but with a *Fig. 26* sighting angle of 45°). A third prism finder, designed especially for the Hasselblad with the 70mm film magazine, magnifies 4 times and has a very precise ocular adjustment. All three finders show an upright and rectified (proper left-to-right position) image.

Pentaprisms are also available for cameras such as the Rolleiflex and other twin-lens reflex cameras. These are especially useful because they permit the camera to be used at eye-level position instead of the low-chest view required with the ordinary viewing hoods.

Many photographers, because of eye conditions, problems with glasses, etc., design their own hoods (not the complicated finder-prisms!), and some are very ingenious. I once had a collapsible cloth-covered heavy cardboard hood for a Rolleiflex about 12 inches high with a magnifying lens placed near the top. This gave a splendid image magnified several times, and the hood cut out practically all of the external light falling upon the focusing screen.

When using magnifiers in focusing, be certain that they are adjusted to sharp focus on the ground glass or on the reticules engraved on the *ground-glass side* of the focusing screen. The image on the ground glass can be brought to accurate focus with minimum effort. If a small circle of the ground-glass area can be polished clear and "cross-hairs" engraved thereon, we can use these cross-hairs to establish the plane of focus and then focus the *aerial image*. Parallax focusing is a very positive method.

Focusing Cloths

A good focusing cloth is a rare item! For view cameras the focusing cloth should not be too large, but it *must* be large enough to really shield the light from the ground glass, heavy enough to keep it in place in a light breeze and really opaque. Most focusing cloths are too thin, too small and too "flappy" in the wind. One side should be a dull black fabric, and the other side should be *white*. With the white side outward the photographer is shielded from the sun's heat. The white side can be used also as a reflector for strengthening the shadow areas of near objects, etc. The corners can be weighted to help hold the cloth down in the wind, but these weights can be dangerous if whipped around by wind or fast movement and strike the eye. Most lightweight synthetic-fiber fabrics are fine for blackness and whiteness but are usually very slippery and easily slide off the camera and the head and shoulders of the photographer. Some view cameras have clamps to secure the leading edge of the focusing cloth to the top of the

56

camera (usually the top of the back assembly of view cameras, or the leading edge of the body on press cameras). If the camera is not equipped, ordinary spring clamps can be used. Or small hooks can be attached to the camera and the focusing cloth made secure with grommets.

Variable View Finders

A most helpful extension of the cut-out-card viewing device is the variable field

Figs. 11, 16 view finder. There have been several excellent models manufactured under the following categories:

 (a) Turret system finders, in which a variety of objective lenses (lenses representing various focal lengths) are rotated to the viewing axis, giving the field of view of each lens relative to the 35mm format; Zeiss made a very fine one of this type for the Contax camera.

 (b) Variable magnification finders in which the format remains the same size but the image is enlarged or reduced as the equivalents of lenses of different focal lengths are "dialed" in.

 (c) Variable format finders in which the image remains the same size but the format is reduced as the finder is adjusted for lenses of longer focal length. The problem here is that when the long-focus lens field is shown, it is so small as to be hard to see!

Most of these finders have a tilting device which (when attached to a camera)

Page 32
Figs. 14, 18 permits adjustment for the parallax effect (on the plane focused upon) when the lenses are focused on near objects. When used as a "scanner" no tilt is required.

27. HASSELBLAD 500C CAMERA. With 120mm lens, appropriate lens shade, exposure meter, etc. This picture shows the focusing lens hood; not an "eye-level" finder, but excellent for a variety of work. The image, of course, is upright, but not rectified (proper left-to-right position on the ground glass.)

57

THE TRIPOD

It has been said that photographic equipment represents one long chain of semi-frustrations, and the tripod is one of the significant links! Use of the view camera demands an adequate tripod, and with all cameras we frequently have occasion to use tripods of different kinds—from the simple monopod (a single "leg" to which the camera is attached—helpful with small cameras since it allows a certain amount of freedom while giving stability) to the most complicated and massive studio camera stands.

The tripod is basically three legs, usually extendible in 2, 3 or 4 sections, attached at the top to a "head" or platform. On this platform rests the camera—or the "top," with various adjustments—on which rests the camera. There is nothing complex about this in principle, but a description of the various parts and their functions will indicate that the tripod is a rather exasperating, yet very important, part of the photographer's equipment.

Tripod legs. These can be single or multiple elements of wood or multi-extendible rods or tubes of metal. Vast engineering effort has been applied to the design of tripod legs that will have maximum strength and minimum weight. In some tripods the legs are designed with braces attached to a central post. These have great rigidity but are primarily for studio, flat-floor use. Tripod legs terminate with spikes, fixed or retractible, or rubber tips. Spikes are favored for outdoor work, rubber or plastic tips for interior use. With the spikes there is a firm unelastic contact with the ground; with rubber tips a certain amount of *Fig. 29* vibration is inevitable; any movement of the tripod can create a small "bounce" even if the camera is very heavy. The harder the rubber or plastic tips, the less the vibration. Vibration spells camera movement, and camera movement degrades image sharpness.

28. DIAGRAM. DIRECTION OF ONE TRIPOD LEG AND LENS AXIS. The axis of the lens should coincide with the direction of one leg of the tripod (leg can point forewards or backwards). Vertical level can be obtained with movement of this leg without disturbing horizontal level of the camera.

The height of the tripod can be adjusted by extending the legs, or placing them at wider or narrower angles to the ground, or employing the elevating center post. A certain amount of up- or down-tilt—and side-tilt as well—can be achieved by changing the length or angle of the legs. Obviously, there are limits to these adjustments.

Tripod leg stops. With earlier tripods the legs were free and could be spread fully (resulting in collapse on smooth surfaces such as floors). Braces were available to clamp the legs in any position, or floor fans or dollies could be used. These tripods worked well outdoors (except on smooth rock pavements) and were easy to put into position in the roughest terrain.

With most tripods of today the legs are "stopped"; that is, are limited in their spread. This is fine for smooth floors but not efficient outdoors where free and varied positioning of the legs is required. Under the direction of a skilled mechanic the stops can be altered or removed—but there must be no weakening of the leg-head assembly. Some tripods have easily adjustable or removable stops.

Tripod head (platform). Designed in myriad forms (some flat, some with center post accommodation, some combined with tilting and rotating tops, etc.), the head is a vital part of the ensemble. The tripod legs should be attached with as wide a pivotal base as possible; this reduces torque and assures maximum rigidity. Many tripod heads are very small, and it is difficult to obtain a really tight attachment of the legs. The old wooden Crown tripod had a head about 6 inches in diameter, and the attachment points for each leg section were about 4 or 5 inches apart. There was no perceptible torque.

Tripod size does not have a direct relationship to rigidity. Assuming that the legs are firm enough not to bend or twist under normal pressures, the attachment of the legs to the top is the most important key to rigidity. Torque (the rotating, twisting movement) is related to the strength of the materials used and the area of the contact parts of tripod legs and top support. The smaller the tripod head, the more chance of torque. Massive bearings and "axles," with little or no chance for play or side-shift, are essential for stability.

Actually, as the tripod leg has to move outward and inward from the center axis, the problem of rigidity is a severe one. There must be ample contact area and a considerable lateral pressure applied. This is certain to produce wear in time, and provision for tightening this contact is important. Lateral movement or "wiggle" of the leg is bad, but the torque effect on the head as a whole can be worse.

Tripods with firm center posts and braces between post and legs are, of course, very rigid. The problem is one for the engineers, but the photographer should be skeptical and test every tripod for obvious rigidity (or lack of it).

There is a simple test for stability: set up the tripod on a firm surface (rubber buttons on the ends of tripod legs save floors but can produce vibration) and place the hand firmly on the top. Bearing down, try to twist the top; if it yields under reasonably high pressure, you may be sure the tripod is inadequate for a normal-size view camera. A more definitive test: place the camera on the tripod and extend it for, say, twice the focal length of the normal lens used. Exert pressure and twist on the camera bed; there can be a slight response to pressure, but there should be an immediate rebound to original position. The heavier the camera, the more rigid (and, usually, the heavier) the tripod must be.

Tilting tripod top. Attached to the head (platform) or to the center post, this device permits vertical, horizontal and rotational positioning of the camera. Some tops have only the vertical tilt, some have both vertical and horizontal tilt (the horizontal tilt is sometimes limited to half the 180° movement). With

tripods such as the Majestic the top will tilt fully either to the right or left. Vertical tilts are usually 90° down-tilt but restricted in up-tilt because the projecting tilting-top rod may strike the tripod head (in such cases, reverse the position of the camera on the top). The camera can be rotated on any ordinary tripod by simply loosening the tripod head screw and turning the camera. Some tripod heads have engraved degree circles matched with pointers on the revolving top. The revolving top can be tightened into position. This is very useful when working in restricted areas where there is not enough space to get in front of the camera to set the shutter, etc. (When the picture is composed, the degree-point is noted and the camera rotated for the settings, then returned to the original position.) The fulcrum of the tilting top should be central to the weight of the camera for maximum rigidity.

Center Post. This can be rigid (only for strength) or slide up and down with friction clamps (often difficult to secure) or be elevated and lowered by a crank-and-gear system, then securely tightened at any position. This is the best system; it provides ease of control and, if properly designed, good stability. The Majestic tripod has an additional elevating post of the friction type.

Tripods with center posts can be adjusted to hold the camera near or actually on the floor or ground. This is an important facility when a very low viewpoint is desired. The Majestic tripod, for instance, has an "arm" which can be attached to the bottom of the center post and will hold the camera at any position. (The adjustable tripod head can be removed from the tripod top and set on the arm; the arm can also be used laterally to shift the camera from the center post axis.) Some tripods have special devices which can attach to the legs and serve the same purpose as the Majestic arm.

Tripods such as the Quick-Set, etc. are designed so that the center post can be completely removed and inserted upside-down; the camera is attached to the tripod head as usual but, of course, in upside-down position. View cameras such as the Arca (with tilts and swings on lens axis) can be freely adjusted with the camera in any position.

CHARACTERISTICS OF TRIPODS

Weight. Apart from massive television, movie and professional tripods, the range in weight of general field and studio tripods is extensive. The Gitzo tripod extends to about 12 feet and weighs 19 pounds! It has many ingenious features; the legs can be "stopped" at three angles, one giving almost horizontal position. (When the tripod is fully extended, a small stepladder is necessary.) This tripod will handle a heavy 8x10 camera with ease. The Majestic tripod weighs about 12 pounds (with aluminum legs) and will support 8x10 cameras (without wind) and certainly 4x5 and 5x7 cameras with ease. The Tiltall tripod weighs about 6 pounds, has a center friction post and will hold a 4x5 camera (without wind) or smaller cameras such as the Hasselblad with ease. The Diawa SV tripod (Japanese) weighs less than 4-1/2 pounds and has all adjustments, including an elevating center post. It will support a light 4x5 and all smaller cameras. Calumet Manufacturing Company makes a variety of excellent tripods, including the C-31 (for 4x5 view cameras), the C-21 (primarily designed for 8x10 cameras but which also works beautifully with 4x5 cameras) and the C-23 (a traveling elevator tripod similar to the C-21 only more portable). These are only a few of the many excellent tripods on the market of all weights, kinds and functions. Remember: it is not so much the *weight* of a tripod but its *rigidity* that is important; if a heavy tripod or tripod head is structurally loose, the camera obviously will not be stable and will move and vibrate in the wind, etc. A truly

rigid tripod can carry a lot of weight—but we must always check for the *moment* (the tendency to revolve about a point or axis—see below).

Sway. Sometimes with the elevating post fully extended (and in the case of the Majestic tripod with the second friction post extended as well) there is certain to be some "sway"—especially in wind. Hence, it is always advisable to first extend the legs as far as possible for height (which will retain stability) and then employ the elevating posts.

Vibration because of wind, etc. The suspension of a weight from the center of the tripod will create some inertia and help stabilize it. Also, a *steady* pressure of the hand on camera or tripod will be effective.

Vibration because of moment. Although many tripods both light and heavy are rigid and capable of supporting considerable weight they may be subject to a kind of vibration that has little to do with gross stability. This is loosely termed the effect of *moment*: the harmonic response of the ensemble to minute vibrations due to a slight breeze, operation of mirror and shutter with single-lens reflex cameras, etc. This tendency to produce motion about a point or axis can be as disastrous to image sharpness as the gross sway of a loose tripod. I once had an enlarger with a heavy, apparently rigid support frame. Firm as it was, it had an harmonic vibration that would persist for 30 seconds after any movement or adjustments were made. This vibration was dampened by winding the structural parts with a heavy plastic tape which, in effect, "deadened" the waves. Sometimes such vibrations are quickly dampened; sometimes they persist for a long time. Cameras of different weights and positions on the tripod head

29A&B. EXAMPLE (EXAGGERATED) OF THE EFFECT OF CAMERA MOVEMENT. Left-hand image shows an enlargement of a negative made with a rigid camera. The right-hand image shows the results of camera movement. The one sharp edge (lower left) indicates the direction of camera movement in this particular case; it was at an angle of about 15° in a left-to-right direction, upward or downward (see page 203).

may produce different vibrational effects; a small camera may set up such vibrations on a heavy tripod such as the Gitzo, while a low-weight tripod can carry a relatively heavy view camera without any such vibrations at all! There is only one way to be sure about these defects of *moment:* test for them. They must *not* be overlooked. An experienced photographer can hold a camera in the hand—at speeds of 1/10 second—with less vibration than may be encountered in a supposedly rigid tripod.

Page 202

TRIPOD ACCESSORIES

Tripod *dollies* are helpful in studio, industrial and architectural work; they are three-armed supports with ball casters mounted at the ends of the arms and at the center. The tripod, fully extended and with the camera attached, can be rolled across floors, sidewalks, etc., while keeping the same height, etc. A braking device should be included to keep the ensemble in place when being used.

Fig. 123

More stable than the *dolly* is the *triangle*. It is usually a y-shaped piece of flat wood or metal with clamps at the end of each arm to fasten down the tripod. It can be of one piece or hinged near the center to fold. The whole thing can be moved around on the floor without causing floor damage if it is made of smooth, soft materials or supplied with plastic sliding buttons.

When using tripods at considerable extension, it is wise to have a light aluminum *stepladder* of the required length as part of the basic equipment. The Gitzo tripod, for example, extends to more than 10 feet, and a light 6-foot stepladder is needed. (A 4-foot ladder might do, but the operator is then standing on the top of the ladder without protection.)

Extra tripod *screws* (be sure they fit the camera and are not too long or too short) as well as extra tripod leg screw-clamps, etc., which might detach and be lost, should be included in the little "emergency kit" which all photographers should have on the job. If a leg of a wooden tripod breaks, it can be splinted with a light piece of aluminum secured with strong *filament tape* (3M Scotch, No. 898, for example), a roll of which should always be carried.

"Quick-lock" devices are available—one part is attached to the camera which locks into the companion part attached to the tripod head. The elements must be *secure* and strong enough to hold the camera safely in any position.

CARE OF TRIPODS

All tripods should be kept clean—all dirt removed from the telescoping legs, etc. Parts requiring lubrication should be frequently attended to (ask a mechanic's advice on the best lubricants to use for the different moving parts). Rust-preventive treatment should be applied where required. I have one heavy tripod with aluminum alloy legs and clamps (which bind), steel rods and bolts (which rust) and plastic knobs (which break)!

Too much lubricant on telescoping legs and elevating friction posts may make them difficult to clamp firmly.

Wooden tripods, properly made of fine materials, are excellent, but the wood must be kept in good condition. Metal tripods are usually the most efficient, but they also demand care and proper cleaning, etc. Aluminum tripods—the lightest—have a tendency to "jam" unless all parts are clean.

Under damp conditions, a protective case or bag should be used to cover the tripod. When carrying tripods on auto racks or platforms, always be sure they are well strapped down and protected from the weather. Bungy cords equipped with spring hooks are ideal for securing tripods, etc., to car-top platforms.

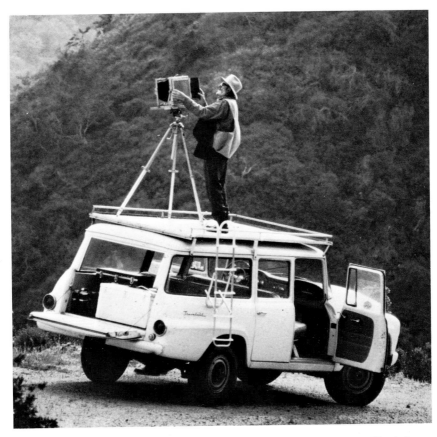

30. PHOTO-PLATFORM ON CAR: (Photograph by Angus McDougall, *courtesy: International Harvester World*). This shows the author working on the platform of his I.H. Travelall. The Platform is securely attached at six points to the top of the station wagon. (The mounting of platforms will vary according to the structure of the car.) I do not trust attachments by "gutter clamps" alone. This platform rides clear above the top of the car. The railing is for protection and can be used to secure tripods, ladders, etc. while traveling. The ship's ladder (light aluminum and plastic) can be used as above, or resting on the open tailgate. Drain holes and railing channels are required for drainage. This platform bed is a single piece of aluminum plate (diamond pattern) and had been used on four previous cars. Heavy Marine plywood is adequate.

CAMERA CASES. Camera cases are very important—and usually poorly considered. With modern equipment many items are involved in addition to the basic camera, and it is impossible to make any specific recommendations as to case design. In the discussion of "Care of Equipment" certain ideas concerning *Page 292* cases have been presented. The several *basic* points about cases are:

1. **Weight.** A case must be strong enough to protect the contents, but it should be made of the lightest appropriate materials. Hinges and locks, handles and straps, etc., must be of the highest quality. Joints must be moistureproof. The best cases are of aluminum alloys, such as the Halliburton cases. While costly, they are cheapest in the long run. These cases can be compartmentalized or filled with a firm foam rubber or plastic block in which spaces may be cut for the various cameras, lenses and accessories. All equipment should be protected against direct shock; hence, if compartmentalized, all surfaces should be covered with thick felt or rubber. The above applies to 35mm and other small cameras

such as the Hasselblad, etc. For the larger view cameras: cases are usually provided with them—or can be made of strong fiberboard appropriately partitioned and padded.

2. **Color.** Tradition implies that camera cases should be black; dark leather, fiberboard, etc. Actually all cases for camera and film should be *white,* or of a highly reflective metal or fabric material. This effectively reflects the rays of the sun (or of hot artificial lights) and the contents of the cases remain as cool as the ambient temperatures will allow. Depending upon the substances of which the cases are built the choice of paint is not only a matter of its whiteness (most glossy white paints have about the same reflectance) but of bonding characteristics. Cases which have had a baked-enamel treatment must be properly sanded and sized to retain the white paint. In the case of leather and other pliant materials a vinyl-type paint is advised. For metal and hard-surface materials a marine-type enamel paint is suggested. Consult an expert in the field of paints! Aluminum metal and aluminum-treated fabrics are less efficient as heat reflectors than a brilliant white paint.

PROTECTIVE PLASTIC BAGS. In damp climates or in rain or mist the camera can be carried around on the tripod if it is securely covered by a *strong* plastic bag fastened by a drawstring through grommets. Other bags should be used for protection of lenses, film holders, etc. These are quite essential in dusty areas. *Caution:* in humid climates plastic bags should *not* be sealed and exposed to the sun. Portable camping iceboxes (painted white) are ideal for transporting film.

Pages 22, 132
Fig. 68

NOTEBOOK. This is an extremely valuable item of equipment. It can be of the standard 3-hole binder type (which will take the 8-1/2x5-1/2″ Exposure Record sheets) or the smaller type taking the smaller (6-3/4x3-3/4) Exposure Record sheets. Regular note paper and other forms in both sizes are available. As will be

Page 132
Fig. 68

described later, the Exposure Record system is a very efficient means of recording exposures and noting development instructions. The notebook can hold essential information on equipment and materials, tables, etc. Above all, it should contain a *check list* of all equipment to be referred to before starting out on any photographic trip. All photographers have experienced the deep frustration of arriving at a distant place and discovering some essential piece of equipment overlooked or missing. All data, such as tables, check list, etc., should be made in duplicate or triplicate with one copy in the notebook.

MINOR ACCESSORIES. *Lens-cleaning fluid* and *tissue* should be at hand at all times and a *camel's-hair brush* as well. If the lens is subjected to rain, mist and especially sea spray, it should be immediately wiped off and cleaned with the lens-cleaning fluid. In dusty situations the dust should be blown off the lens before wiping! A *lens brush* with an airbulb attached is a very practical device. *Lens caps* should be kept on the lenses at all times when not in use. In working under damp conditions—especially near the ocean—or in dusty or windy environments an optically good haze filter should be over the lens at all times. (After all, filters are cheaper than lenses!)

A small *screwdriver set, pliers, extra screws* for lens flanges, extra tripod head screws, etc.; *black tape, filament tape,* a good *marking pencil,* extra *pens* and *pencils;* a good *thermometer* (when working with Polaroid Land materials, especially Polacolor); a steel *measuring tape* (in both inches and centimeters), such as the Lufkin 6-foot (2 meters) "White Clad" W146ME which is small and lightweight; and extra *plastic bags* for various items including Polaroid Land prints, etc., are extremely helpful when needed.

64

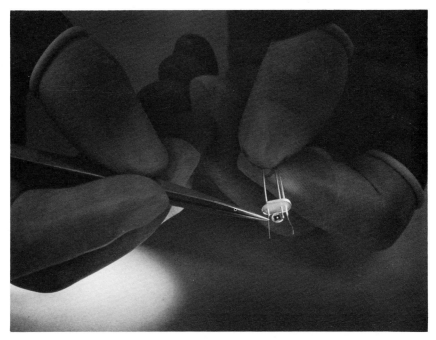

31. TRANSISTOR ASSEMBLY (courtesy I.B.M.). Made with the Hasselblad Camera and 80mm lens in an extension tube. Available room light, plus light from a small microscope spot light. As the lens was extended to about 125mm the exposure factor was 2-1/2x.

32. FUCHSIA BLOSSOMS. Made with a 4x5 Sinar Camera and a 5-3/4" Zeiss Protar lens on Polaroid Type 52 4x5 Land film. As the lens was extended to about 10 inches, the exposure factor was 3X. F/45 was used; because of the extension it functioned at about f/77.

65

POLAROID LAND CAMERAS AND FILMS

The Polaroid Land process comprises a system of equipment and materials, designed to function together with maximum efficiency. The Polaroid Land cameras have advanced to a very high level of precision and consistent function, and have many uses in practical and creative fields. The relative immediacy of results overcomes the hiatus between the exposure and the production of the print or slide in the conventional processes. This has great significance in many areas of photography.

The Polaroid 545 Land Film Holder can be used with most press and view cameras (as well as with the MP-3 camera); this permits the application of the Polaroid Land process to industrial, technical and creative fields wherein a wide variety of lenses and accessories can be used when a larger-format picture (3.5 x 4.5 inches) is required. [Refer to the *Polaroid Land Photography Manual* by Ansel Adams (Morgan & Morgan) for explicit information on the process.]

The rapid development of the Polaroid Land process has involved production of many cameras and films (as well as accessories) over the past 25 years. Constant improvements have resulted in inevitable obsolescence and elimination of many

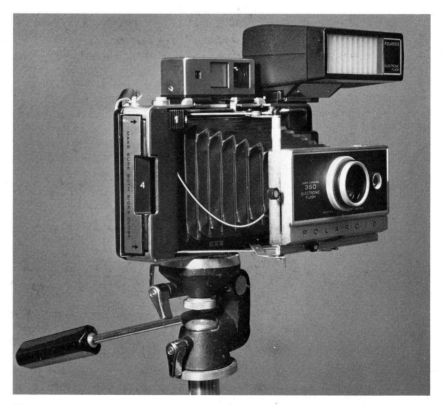

33. POLAROID MODEL 360 AUTO-MATIC LAND CAMERA. At the time of writing this is the most advanced Model of the Automatic Series. It is described on page 80. The tripod shown is the GOLDCREST 4679L; a very light and sturdy device with horizontal and vertical tilts in the tripod head, a reversible center post, elevated by a gear, a 360° reference ring, and ample locks for all adjustments, including a security pressure lock for the tripod screw. Primarily for smaller cameras, I have used this tripod for the 4x5 Arca with success (with no wind!)

66

items, with superior equipment taking their place. Roll film cameras (except the Swinger) are no longer made, but production of roll film continues (and actually has increased) to supply the special roll-film camera backs used largely with industrial and scientific equipment, including the MP-3 camera.

The following list outlines the presently available Polaroid Land cameras, backs and holders, as well as the various Polaroid Land films currently obtainable for each. Check with your dealer for information on most recent equipment and materials. Page-number references indicate further information on equipment and materials elsewhere in this book.

1. Cameras, etc. taking the Polaroid Land pack films:

Page 66
Figs. 33, 38

(a) Polaroid Model 360 Automatic Land camera, with electronic flash and charger

(b) Polaroid Models 320, 330, 340, and 350 Automatic Land cameras

(c) Polaroid Models 420, 430, 440, and 450 Automatic Land cameras

(d) No. 490 Flash Accessory for the Model 400 Series.

(e) Polaroid Big Shot Land camera

These are the latest versions of the earlier Series 100 and 200 automatic cameras; some of these earlier models may be available as used equipment.

(f) Polaroid Colorpack II Land camera

(g) Polaroid Colorpack III Land camera

(h) Polaroid Model 180 Land camera (conventional lens and shutter)

Page 266
Fig. 134

(i) Polaroid MP-3 Multi-purpose Industrial View Land camera with pack film and/or roll-film camera back. It also takes the Polaroid 4x5 Land Film Holder—see below.

(j) Polaroid M10 Automatic Land camera

Page 269

(k) Polaroid CU-5 Close-up Land camera

(l) Polaroid Special Events Land camera 223A

(m) Polaroid ED-10 Land Instrument camera

(n) Polaroid Land ID Card camera 926

(o) Polaroid Big Swinger Model 3000 Land camera

Page 267

(p) Polaroid Model 227 Land camera back for pack film (adaptable to view and press cameras, technical and scientific apparatus and the MP-3 camera).

All of the above cameras except (n) and (o) take Polaroid Type 107 (3000 speed black-and-white) and Polaroid Type 108 (75 speed Polacolor) pack film; (n) takes Type 108 film *only* and (o) takes Type 107 film *only*.

2. Cameras, etc., taking Polaroid Land roll film only:

(a) Polaroid Swinger model 20 Land camera (takes Type 20 roll film)

Page 267

(b) Polaroid Model 226 Land camera back for roll film, adaptable to view, press, industrial, technical and scientific equipment, including the Polaroid MP-3 Multi-purpose Industrial View Land camera.

The roll film Land camera back takes the following roll films: Type 42 (200 speed) PolaPan; 46-L and 146-L transparency material; 47 (3000 speed); 48 (75 speed) Polacolor; 410 (10,000 speed) PolaScope—for oscilloscope recordings, etc.

Pages 53, 267 3. Polaroid 545 Land Film Holder (adapts any 4x5 camera to the Polaroid Land process). The 4x5 Film Holder takes the following film packets:

(a) Type 51 (high-contrast; print only)

(b) Type 52 (PolaPan; print only)

(c) Type 55 P/N (negative and print)

(d) Type 57 (high-speed 3000 material; print only)

(e) Type 58 (Polacolor; print only)

4. Accessories: exposure meters, timers, filters, close-up kits, cases, etc., are available for Polaroid Land equipment.

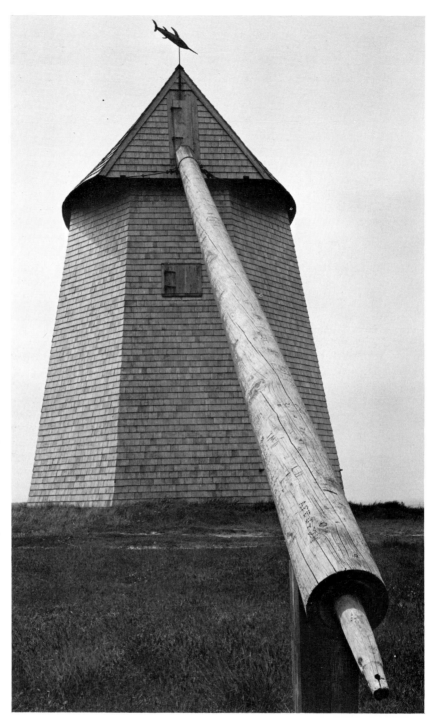

34. WINDMILL, CHATHAM, CAPE COD, MASSACHUSETTS. Made with a 5x7 Juwel camera and a 7" Zeiss-Goerz Dagor lens. The camera back was perpendicular (the subject naturally converges). The great depth-of-field was achieved by tilting the lens front and focusing on a plane about one-third in from the rear end of the shaft. If not done, the base of the structure would be out of focus.

EXPOSURE METERS

It is difficult to think of contemporary photography without exposure meters. We must remember that in the not too remote past there were no dependable exposure determination devices. The photographer learned by experience— by expensive and often frustrating trial-and-error procedures. In the days of the daguerreotype and the wet-plate process (where the negative had to be developed immediately after exposure), we saw what we had achieved and could retake if necessary. The modern Polaroid Land photography systems give us the same advantage—but within 10 to 15 seconds! When I first worked in Yosemite, we had "exposure tables" which were fairly adequate, except that everyone worked with a different table! Conditions in Yosemite are very consistent, and I soon learned the optimum exposures for a variety of subjects. But when I went to New Mexico, and then to New England, I had to start all over again in the face of unfamiliar light and contrast situations. After all, there was a certain "latitude" in the film, and we would fall back on this elusive quality (with the inevitable additional toil in the darkroom to correct what we could in the printing process). Some photographers have an uncanny sense of lighting values, some have an excellent memory for their exposures under similar situations, some are content with a certain proportion of under or over-exposed negatives, and some contrive an elaborate aesthetic justification for their errors. I prefer to have not only my instruments but my exposure values "in tune." This is essential to visualization of both "real" and "unreal" results.

Pages 13, 15, 21, 22, 24

While films have *latitude*—meaning that they give useful *negatives* from a variety of exposure levels—there is only one appropriate exposure for the best result, and this fact should be accepted as the basis for intelligent visualization. Once we *know* the optimum exposure, we can make the extensive deviations and yet preserve creative controls. We cannot anticipate physical results within 10% of the optimum, and—because of further variations and accumulations of effect—we must be satisfied, and depend upon appropriate controls in printing, with perhaps a 20% deviation from the sought-for optimum result. This statement is quite different from the jargon about a film having "2 or 3 stops latitude in either direction"!

Many systems of exposure and development of the negative have been proposed. If they do not conflict with basic sensitometry, they are useful. If they give only loose approximations, they cannot be condoned any more than we would condone discrepancies in weights, musical pitch or clocks. I have

Page 22

developed the Zone System as a practical expression of sensitometry, not just as a personal manipulation. And this approach demands an accurate exposure meter.

By "accurate" I refer to readings within 10% of the exact. In other words, I am content to be *precise*. Over the years my experience with exposure meters has been discouraging. Not only may they give erroneous basic readings but their calibrations vary according to the opinions of the various manufacturers. The worst offenders are those meters that have varying responses at various levels of the luminance scale; consistent deviation over the entire luminance scale can usually be adjusted by an appropriate change in the ASA speed setting.

I am not implying that all these deviating meters are mechanically in error. The manufacturers calibrated them according to their ideas of "average" values. A resume of practical photometry will give a better idea of just what a meter accomplishes and on what light evaluations the indicated exposures are based. Terminology differs in Europe and America and within various technologies. In

69

brief, we can say that *incident light* is measured in footcandles (ft-c) and *reflected light* is measured in candles-per-square-foot (c/ft²). How is this transition accounted for in calculations and exposure meter calibrations? Let us assume that we have 100 ft-c falling upon a maximum diffusing surface of 100% effectiveness (this is not possible except with some light-generating materials, such as papers with blancophores in their structure). Magnesium carbonate reflects about 98% of the light falling upon it. For our purpose, we can use a Kodak test card reflecting 18%. With 100 ft-c falling on this card we will have 18 foot-lamberts (ft-L) reflected from its surface at a nonglare angle of about 45°. If we divide this by pi (3.1416), we will get close to 5.7 c/ft². Candles-per-square-foot are the units which relate to the Exposure Formula (involving c/ft², lens stops, ASA speeds and shutter speeds). It is simply this: whatever

Page 22 luminance value falls on Zone V of the exposure scale, we can think of the reciprocal of this value in terms of fractions of a second and use the lens stop number which is the square root of the ASA speed. Hence, with ASA 125 film speed: 400 c/ft², placed on Zone VII, shows 100 c/ft² falling on Zone V. The basic exposure would then be: 1/100 sec at f/11 (as 11 is the approximate square root of 125). Equivalent exposures would be 1/200 at f/8 and 1/50 at f/16, etc. We would also have to make adjustments for lens extension, filter factors, etc.

We observe that the Weston meters (No. IV and Ranger 9) have the c/ft² values on their exposure scale. The Weston Master IV (and earlier meters) show the old progression of 1.6, 3.2, 6.5, 13, 25, 50, 100, 200, 400, 800 and 1600 c/ft², while the new Ranger 9 shows the new progression of values: 1, 2, 4, 8, 16, 32, 64, 128, 256, 500, 1000 and 2000 c/ft² (with fractional values down to .002 c/ft² at the same progression). This progression relates to the new geometric progression shutter speeds of 1, 1/2, 1/4, 1/8, 1/16, 1/30, 1/60, 1/125, 1/250, 1/500, etc. On the Ranger 9 the c/ft² values are in *red*. The

Page 72 light-value numbers are different from those of the Weston Master 5 meter (see table).

In my opinion the Weston meter system is the most logical; it gives actual exposure values *plus* evaluations of the true luminance values of the reflective surfaces on which (by observing the exposure formula) we can quickly calculate basic exposures without reference to the meter dial. The Weston meter can be

Page 22 efficiently adapted to the Zone System approach (the Ranger 9 has an optional Zone System scale dial).

We can determine the c/ft² values with other meters by interpolation, and we can also check on their discrepancies and the amount of adjustment needed to indicate the optimum exposure.

First let us discuss the meters in common use.

INCIDENT LIGHT METERS

(Norwood, Spectra, Weston with Invercone, etc.)
These measure the intensity of the (total) *light falling upon the subject*. The meter is held at the subject, pointing toward the camera. The meter, if properly calibrated, should indicate the same exposure as obtained with a standard reflectance meter, taking a direct reading from a gray card at the subject position and at 45° to the light. The incident light meter can evaluate (for purposes of calculation) either the sunlight *or* the shadow light; combined readings have little validity (unless we know the precise proportions of light and shadow on the subject). As the properly calibrated incident light meter should

Page 22 indicate a Zone V exposure for the gray test card, it would also place all values (under the same illumination) on the appropriate Zone of the exposure scale. The meter would also read the appropriate illumination value in shade and, in comparison with the sunlit areas, would show the *difference in illumination* between sunlight and shadow on the subject. For all "normal" use, when we think we have the optimum balance of illumination and when strict creative visualization is not involved, the incident light meters will work very well indeed. But since we do not know what the reflectances of the various areas are, we have some difficulty in establishing the exposure-development relationships, which are fundamental to the visualization-execution process.

REFLECTED LIGHT METERS

These measure the *light reflected from the subject*. The two main categories are: the normal broad-angle (around 30°) selenium cell instruments and the narrow-angle CdS cell meters or the comparison-spot photometers. These are available in many variations, including meters built into cameras.

(a) **BROAD-ANGLE METERS.** These evaluate all the light coming to the cell from a viewing angle of roughly 30°. All the light is received and interpreted as an average value; specific luminances of the subject are impossible to evaluate. After a series of nearly 1,000 trials, I found that when such a meter was held at the lens and pointed along lens axis to the subject, the exposure values obtained had to be doubled in about 75% of the cases. *This has nothing to do with the meter principle;* it is because of the natural disposition of light and shadow in most subject material. Obviously, this effect is more significant in color photography than in black-and-white. It explains why many manufacturers, concerned about customers of amateur status (without technical training), calibrate their meters to take this natural effect into consideration; most of the meters *Page 22* built into cameras are calibrated to render a Zone V exposure as a Value V-1/2 or Value VI negative density. In the case of Polaroid Land photography, the *Page 79* Electric Eye cameras will, at normal setting, give a value VI print for a single luminance value.

(b) **NARROW-ANGLE METERS.** These include some broad spot photometers, the Weston Ranger 9 (18° angle of view—actually a medium-angle meter) and the CdS cell meters such as the Honeywell Pentax 1°/21° meter. With these we can evaluate single small areas of the subject and determine the exposure that *Page 22* will interpret these luminances in terms of negative density Value V or any other value we choose. Of course, *any* single luminance of the subject scanned by the meter will be rendered as a density Value V (equivalent to a Zone V exposure placement), so unless the photographer is versed on the Zone System and visualization, his results can be bizarre indeed! For example, with such a meter a dark shadow might call for a 1/2-second exposure (and would show as a Zone V exposure and density Value V), and a bright white dress might call for a 1/1000-second exposure (and would also show as a Zone V exposure and density Value V). Obviously, the other luminances of the scene would be respectively over- and/or under-exposed. Some spot meters are intentionally calibrated to give a higher exposure value for any single luminance value; in such cases a direct reading from skin (approximately Value VI) would be correct. Of course, *all* readings of single luminance values would give negative-Value VI and print-Value VI results.

The great value of these meters lies in their ability to measure the luminances of the important areas of the subject so that we can appropriately place them upon the exposure scale. Their validity is further supported by the fact that they measure the light reflected from various parts of the subject—the light by which we see and photograph. To use a spot meter as an averaging meter is, of course, ridiculous, and yet meters of this type have been made (and some incorporated in the design of cameras) without a clear understanding that a single reading with a spot meter (except of a gray card value) cannot give an accurate exposure determination.

The best internal camera meters are those which possess a sensitivity over the entire field of the image; these are, in fact, the equivalent of the broad medium-field instruments. They have the added advantage of evaluating the total light producing the image, regardless of the focal length of the lens used. Some camera meters have both full field and spot response, which the operator can select at will.

A few narrow-angle meters are described below:

1. **The Weston Ranger 9.** This meter has a viewing angle of approximately 18° which can be observed through an optical finder. It may be described as a medium-angle meter in comparison with the S.E.I. and the Pentax 1°/21° meters. The "Invercone" which may be attached transforms it into an incident light meter. The cell allows for a 1 to 1,000,000 luminance range (.002 to 2000 c/ft^2). Broad-angle and medium-angle meters can serve as single luminance meters if the viewing area is large enough and far enough away to be fully encompassed by the meter without creating hand or body shadows. The narrow-angle meters are better in this respect, and the Ranger 9 will measure most of the small significant areas encountered in general work.

The Ranger 9 (as is the Master IV) is calibrated to directly read c/ft^2. The Master V does not have the c/ft^2 values on its dial, and it is necessary to interpolate the Weston meter numbers (*not* EV numbers!) to arrive at the c/ft^2 values. A partial table is:

WESTON V NUMBER c/ft^2	VALUE	WESTON V NUMBER c/ft^2	VALUE
16	1600	10	25
15	800	9	12.5
14	400	8	6.5
13	200	7	3.2
12	100	6	1.6
11	50	5	0.8 etc.

WESTON 9 NUMBER c/ft^2	VALUE	WESTON 9 NUMBER c/ft^2	VALUE
5	.032	13	8
6	.064	14	16
7	.125	15	32
8	.250	16	64
9	.500	17	125
10	1.0	18	250
11	2	19	500
12	4	20	1000

While the progressions are in a different *series* in the Ranger 9 in reference to the previous Weston meters, they will give accurate c/ft² but are in the modern sequence to conform to the new geometric shutter-speed progressions.

The Weston Ranger 9 (as do many other meters of this general type) has three "blocks" for each reference number; each "block" represents 0.1 (log) increase of light value. Log differences of 0.3 represent a 2x arithmetical difference. For very precise 0.1 values, the needle should point at the center of the blocks; for half-stop values, the needle should point at the line dividing the 2 white blocks.

Be certain the needle is set at Zero position (in a fairly dark room and with the case closed over the cell). Also, be certain the battery checks out accurately. In low-illumination situations depress the button for, say, 10 seconds, as with meters of this type under weak light the needle takes some time to come to accurate position.

2. **The S.E.I. Exposure Photometer.** (Salford Electrical Industries, division of the General Electric Company of England). This is a comparison spot meter of 1:1,000,000 sensitivity range with a 1° or 1/2° reference spot. The meter can be set to three luminance ranges, each with a scale of 1:100. Before use, the fixed brightness light is set to calibrated position (a red line) on the meter dial by the rheostat. The object is then viewed through the "telescope," the switch button is depressed (turning on the fixed-brightness light which illuminates the "spot"), while the variable-density neutral filter control ring is rotated until the spot matches the field it is seen against. We then take the exposure readings off the tables on the barrel of the meter.

sure values and imply that if you measure the darkest area in which you wish to preserve texture, this value will appear on the exposure scale at about Zone II position. The high values are then read and the optimum exposure worked out somewhere in between. This is a rather cumbersome method and does not take full advantage of the unusual qualities and accuracy of this device. As with all exposure meters, I consider it a luminance meter, and I must work out a system

35. ICE ON LAKE, SIERRA NEVADA, CALIFORNIA. Made with a 5x7 Sinar and 8″ Kodak Ektar lens. The polarizer was at about 1/2 normal polarizing angle; this reduced water reflections and the glare on the ice. The camera back-tilt was used for maximum depth of field.

of interpolation which will quickly give me the desired readings. Accordingly, with my S.E.I. meter I set the black dot on the movable ring against 5 on the ASA scale. I take the reciprocal of whatever exposure value lies opposite f/8 on the lens stop ring—and that represents c/ft². This is a personally selected combination; I could use any of the following combinations and get the same exposure (and therefore luminance) values:

BLACK DOT AT	LENS STOP USED
5	f/8
10	f/11
20	f/16

It must be emphasized: ASA 5 is an arbitrary value, determined by comparative tests with sensitive instruments and light sources of known value. Using f/8 implies that I am thinking of an ASA speed of 64; if so, the exposure value (fractions of a second) would be correct for the basic exposure at ASA 64 and at f/8. If it were 1/100 second, the c/ft² would be 100, and so on.

Should our exposure values be in whole numbers—2 seconds, 10 seconds, etc.—the luminance values would be 1/2 c/ft² or 1/10 c/ft², etc.

The S.E.I. meter can be augmented with an anti-flare tube to fit over the objective lens. A certain amount of flare is built into the meter (presumably to match the flare in average camera and lens systems). This is unfortunate because when photographing against the light, there is a definite false elevation of the low values. The flare tube prevents this effect, and all values read true.

3. **The Honeywell Pentax 1°/21° Exposure Meter** (Honeywell, Inc., Denver, Colorado). This is a development of the earlier 3°/21° meter and is a very satisfactory instrument. The designation—1°/21°—simply means that the entire field of view is 21°, but the sensitive area is 1°. This 1° area covers the cadmium sulfide cell, which—with the applied power from a small battery—generates sufficient current to activate the sensitive galvanometer. With selenium cells, which generate their own power, it is impossible to reach the great range and sensitivity of the CdS cell. The Pentax 1°/21° meter has an exposure range of about 1 to 32000. Both Zero adjustment and battery check should be observed frequently. "Conditioning" of the meter for accurate readings is described in the "Guide to Good Exposure" by James O. Milmoe, APSA (which is the best instruction book for any exposure meter I have ever seen). "Conditioning" for low-level illumination readings is very important with all meters operating with CdS cells. The meter must be exposed to moderately strong luminance areas prior to measuring low-value areas, and several seconds may be required before the meter needle stops "drifting" when directed to subjects of low luminance value. This does not imply any meter defect; it is typical of instruments of this type.

It is unfortunate that all meters are not calibrated to give the same exposure value for any single subject luminance value. Different concepts of "exposure" determine different calibrations; the meters may be quite perfect in their response to light (mechanically speaking) but if they do not give the same exposure value for the same luminance value (disregarding specific color-sensitivity limitations) the photographer will be justifiably confused and distressed. At the start of my annual Workshop in Yosemite Valley I set up light cards in both sun and shade (if the light is clear and consistent). My meters (Weston Ranger IX, the S.E.I. Exposure Photometer, and the Honeywell Pentax 1°/21° are all calibrated to give the same exposure value thereon—and if all

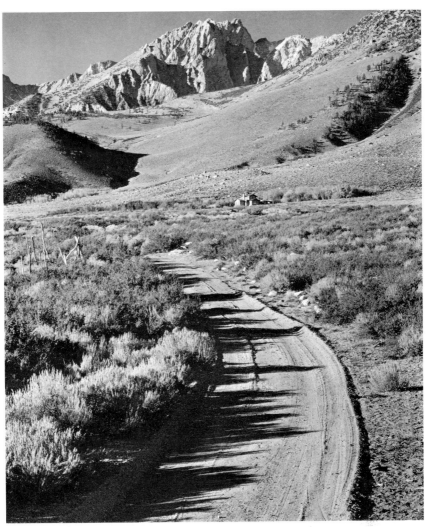

36. BASIN PEAK AREA, SIERRA NEVADA, CALIFORNIA. 8x10 camera and 12″ Goerz Dagor lens. Taken from platform on top of car (see page 63). The additional 6 feet (±) height which such a platform gives extends the impression of depth and vista. I have worked from my platform with the tripod extended to 8 or 10 feet (the Gitzo Tripod), placing the camera more than 15 feet above ground. A small step-ladder is required for this. The advantages of a high view-point in flat country are obvious. Camera and car movement must be avoided; wind can be troublesome.

three agree I can assume the readings are accurate, and that the indicated exposure from a single luminance value will yield a negative of Density Value V, or a print of Print Value V on Polaroid Type 52 Land film. The students then check their meters with mine, taking readings at the same time and at the same angle of view to the subject. If their exposure values differ, we can adjust by changing the ASA values on the meter (we might have to change ASA 64 to ASA 80 or 100—but we would still "think" ASA 64!). If the meters show different values in different parts of their exposure range there is little we can do; the meter is obviously erratic and needs repair or replacement.

SPECIAL METERS

The **Gamma Scientific Luminance Meter** (now discontinued) is worthy of mention because of its extreme sensitivity and accuracy. It was made primarily for television use—the balanced adjustment of lights, etc. Should one of these become available on the market, it would prove a worthwhile investment. This company now makes extreme-precision equipment of scientific and advanced technological interest beyond the scope of conventional photography. The Calumet Manufacturing Company, Elk Grove Village, Illinois, produces a new electronic meter which evaluates daylight and tungsten light as well as electronic flash and standard flashlight illumination.

Camera Meters. A considerable variety of meters attached to small cameras, or built in as integral elements, have come upon the market in recent years. Some are excellent. It is difficult here to give any recommendations because of constant changes and improvements. As mentioned earlier, the ideal camera meter is one that measures all the light in the field of the image, regardless of the focal length of the lens used. This is, of course, an averaging meter and would in all probability render an exposure which would place any single luminance value on about Zone VI of the exposure scale (resulting in a density Value VI in the negative for any single luminance area). Some internal camera meters have both full field *and* spot reading areas which can be selected as desired.

Some 35mm single-lens reflex cameras have the light-sensitive cells on or behind the mirror which gives an averaged reading of the light which has passed through the lens. The readings obtained take account of lens transmission factors but are not selective. Any fixed "spot" meter on the focal plane would be quite inadequate in providing an accurate general exposure value unless it were confined to the image of an 18% gray card.

We must think of the ultimate effects of modern developments and improvements; unless these involve really new and inventive aspects, they end up as refinements rather than innovations. Do not count too much on some of the glamorous items which have descended upon us in recent years. They do not neccessarily add much, if anything, to the tools of creative photography. Be especially wary of automatic devices which do not permit adjustment for other than "normal" effects.

THE SINARSIX (SINAR LTD., SCHAFFHAUSEN, SWITZERLAND)

Heretofore we have discussed meters which evaluate the light falling upon the subject (incident light) or light reflected from the subject (reflected light). We have considered reflected-light meters both as *averaging* devices (integrating all the light within a given field of view) and as *spot*-photometers with which we can measure the luminance of specific small subject areas. (Meters such as the Weston can measure single subject areas if the area is large enough to fill the entire field of view of the meter.) With these meters we establish the *basic exposure value*, which we then modify as required by the lens stop used, the extension of the lens beyond its "infinity" focus setting, etc.

The Sinarsix is an advanced precision instrument, utilizing a cadmium sulfide cell of high sensitivity and a Gossen meter of unique design. It enables the photographer to take readings from various small areas of the *lens image on the focal plane.*

The device is inserted in the camera as a sheet-film holder or a film-pack adapter would be. The Sinarsix slide is withdrawn, and the image is seen on the ground glass (slightly out of focus). The probe, which *is* on the focal plane, can

37. MULTI-DIMENSIONAL MODEL ILLUSTRATING POPULATION DYNAMICS, *Hastings Natural History Reservation, U.C.* Made with Hasselblad Super Wide camera (38mm Biogon lens). After composing in the finder the camera had to be elevated precisely 3 inches (see pages 32, 33 and 38) to assure a perfect "eclipse" of the sun by the sphere. The sphere is less than 1 inch in diameter and the camera had to be moved into position quickly to catch the "eclipse" effect. A gelatin filter was used over the lens and the reflections are obvious—but quite effective. As maximum depth-of-field was required, the lens was stopped down to its smallest aperture, f/22.

be moved to any part of the image. The slide is inserted (to prevent back-scatter of light through the ground glass), and the switch at the outside end of the probe is depressed; this removes a small blind in front of the sensitive probe cell. The reading is taken directly on the Gossen meter dial and can be set at any desired Zone. Then other readings can be taken, which will reveal the brightness scale of the image. The dial is cleverly designed to show the contrast range of the image, and the exposure is easily determined over a very wide range of film speeds and image brightnesses. Note that the term "brightness" is used in

reference to the lens image; "luminance" is used in relation to the light reflected from the *subject*.

Measuring the image brightnesses takes into account the actual transmission of the lens at any aperture or extension. It also shows the fall-off of brightness towards the corners and edges of the image with wide angle lenses. Filters of more than 2x or 3x exposure factors should not be used with the Sinarsix *Page 123* (because of the color sensitivity limitations of the probe cell). The polarizer (at non-polarizing position) can be on the lens, and the Sinarsix will read the exposure required with the polarizer in that position. The same applies to neutral density filters, diffusers, etc. The instruction book accompanying the Sinarsix is quite complete, and there is no need to repeat the details of operation here.

In what areas is the Sinarsix most functional? It will work with utmost accuracy with almost all subject material. But some subjects, such as general landscape and external architectural compositions, etc., can be adequately handled with conventional meters. The Sinarsix exhibits its remarkable powers in interior architectural work, technical photography and instrumentation, photography of painting and sculpture, photography of small objects (macro-photography), photomicrography, still-life, studio work of all types using day-light or tungsten illumination, etc. In composing advertising "sets," the luminance scale can be established by a pre-determined brightness scale of the image. In theatrical work, the usually high scene contrasts can be properly evaluated, and special development of the negatives (such as water-bath and two-solution processes) can be determined in advance.

Dials to "manage" the reciprocity effect are available; they simply slip on the basic meter case. Dials are most valuable in color photography, and the exposure effect of color compensating filters is automatically accounted for.

The Sinarsix is obviously not a device for rapid exposure evaluation! How-ever, many subject situations can be managed by the basic reading from the standard gray card (18% reflectance) at the plane of the subject and under the same light. The *image* of the gray card can be evaluated with the Sinarsix, and the placement of this value on the equivalent of Zone V of the exposure scale will usually result in a well-balanced negative (providing all the luminances—and brightness—are within the normal exposure scale of the negative material).

Lens flare and camera flare are also accounted for; no conventional meter *Page 52* (that is, a meter reading incident or reflected light) can relate to the "flare factor." While most modern lenses have no appreciable flare (as they are optically coated), the flare from the interior parts of the camera can be quite significant, and with normal procedures this flare can be anticipated only by experience. Flare usually amounts to the addition of one or two exposure units and is apparent in the lowest values of the exposure scale. With cameras having "tight" bellows—that is, bellows scarcely larger than the size of the film covered—flare can amount to two or more exposure units (especially if an inefficient lens shade is used). A 5x7 camera with a 4x5 back will have less effective internal flare than a 4x5 camera equipped with usual bellows.

The Sinarsix is also useful in making pre-exposures; the brightness of the *Page 134* card image can be accurately measured and placed on the desired exposure zone, fully accounting for the intentional out-of-focus image (to avoid possible textures) at various lens extensions. It is important to know that the Sinarsix *Page 95* readings take account of the lens extension and no further adjustment of exposure is required when working at close range (requiring more than normal bellows extension). True *subject luminance values* can be determined by setting the camera at infinity focus, the ASA speed at 64 and the lens at f/8. The reciprocal of the exposure value is the c/ft^2 luminance value.

78

The Sinarsix is very useful in checking lens stops. Direct the camera at a bright surface (with the camera set at infinity focus). Place the probe in the center of the field and take the measurement of the image brightness at the first lens stop of the full series (f/4, f/5.6, f/8—not f/4.5, f/6.3 unless the stops are

Page 95 engraved in the "European series"). As the lens is stopped down, for every stop there should be a lower number indicated on the meter scale. At the small stops inaccuracies may appear. Be *certain* to hold down the switch for at least 30 seconds to allow the cell to fully respond to the low levels of light. It is distressing to find that relatively few shutters are appropriately marked for lens stop precisions; a whole stop may be "lost" between f/22 and f/45! However, if this test shows that f/45 transmits only one-third the amount of light as does f/22 (it should transmit one fourth the light), you will know, at least, the basis of calculation of exposure at the smallest stops; more light is transmitted, hence exposure must be reduced.

DARKEN LIGHTEN

38. LENS AND "EYE" OF THE POLAROID AUTOMATIC MODEL 360 LAND CAMERA. Here the Exposure Control Ring is set at "1-Stop Lighten," giving 2x the exposure obtained at Normal setting. With this setting any single luminance value would be recorded as Print-Value VII. When set at Normal, Print-Value VI is obtained.

The Polaroid Electric Eye Meter. This is a remarkable device integral with the special shutter mechanism on Models 100, 200 and 300 and other

Page 67 Polaroid Land cameras. It is battery-powered, extremely sensitive and accurate. Technical description is too involved to present here. Two light-intensity settings are provided: one for bright light (f/50) and the other for low-value light with an aperture of about f/8.8. Speeds as high as 1/1200 second and time exposures as long as 12 seconds and more are automatically produced. Computation of the light value and operation of the shutter are sufficiently fast to photograph with the light from a normal flashlamp (not electronic flash). But here we have a problem (not a fault of the camera); suppose we are making a picture of several people standing in a large room; the flash illuminates everything within its "angle of view," and the camera "eye" averages all of the light returning from the total scene. Obviously, with a dark or distant background the near figures will be over-exposed. Hence, for effective flash pictures with these

cameras we should have our subjects in an environment of somewhat similar reflective values. An ordinary middle-gray wall, for example, would give a balanced effect with a person standing against it. But suppose the person is standing 4 feet in front of the wall (with the camera 4 feet distant from him): the wall would reflect 1/4 its original value. The camera "eye" would average this, and the person would be over-exposed.

Fortunately, an excellent adjustment feature is incorporated in the meter-shutter mechanism; a ring can be turned through an arc marked off with the equivalent of half-stop and full-stop settings. From "normal" we have two stops toward "lighten" and one stop toward "darken"—in all, the equivalent of a 4-stop exposure control range. In time one learns to judge the contrast of the subject and set the control ring appropriately. As the "eye" strives to average any scene to a Value VI exposure, a low-contrast subject will be rendered rather flat and drab at normal shutter position. Here we would advance the control to "lighten." If we were photographing a group in sunlight against a shadowed wall, the "eye" would probably over-expose at "normal"; we would then move the control ring toward "darken." It is all very simple once the principle of the meter-shutter device is understood.

It is important that the film-speed dial be set appropriately for the film used (3000 for Type 107, 75 for Polacolor, etc.).

The above holds true for all of the Polaroid Automatic Land Cameras except the new Model 360. This is fitted with a special electronic flash unit (detachable for charging) which, when attached to the camera and turned "on" disengages the electric-eye shutter mechanism. The flash is provided with louvers which open and close in relation to the focus-setting of the lens (by a direct connection with the focusing controls) and the intensity of the flash falling upon the subject focused upon is appropriately balanced. In addition, there is a "darken-lighten" control on the flash unit which further refines the exposure values.

The Model 360 is extremely efficient for synchro-flash photography. For example, we wish to photograph a figure in shade, standing against a bright sky or sunlit wall. We turn on the flash unit, compose and focus on the figure. Just before making the exposure we *turn off* the flash unit; the "electric eye" then takes over for the proper exposure of the general scene under natural light, and the charge which remains in the flash unit fires the tube at the appropriate illumination value for the near figure in shade. For this approach, I find that I usually set the flash unit at least 1 stop towards "darken"; otherwise, the near shaded subject would be over-illuminated and the effect could be unnatural and disconcerting.

Obviously, with exposure control on the camera shutter and illumination control on the flash unit, the photographer can manage many difficult situations. This technique is equally efficient in black-and-white and color photography (Polariod Types 107 and 108 Land Film). Be sure to set the shutter at the proper ASA speed value and the Lighting Selector to "Bright Sun Only" for Pola Color (ASA 75) and "Outdoors or Flash" for Type 107 (ASA 3000).

CARE OF EXPOSURE METERS

It is essential that meters be given great care in storage and handling. They must not be subjected to excessive heat (such as occurs in auto glove compartments, black cases exposed to the sun, etc.). Their optical parts must be kept clean. The baffle of the Weston IV and V meters must be free of dust. Meters must not be dropped or roughly handled. Meters containing batteries should be checked for

cleanliness of the contact points and the condition of the batteries. Serious damage can be done by disintegrating batteries within the meter (especially the standard 1.5-volt cell used with the S.E.I. meter).

Do not attempt any repair or adjustment of the exposure meter other than routine Zero and battery check.

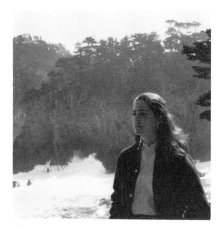

39A. FIGURE AT POINT LOBOS, CALIFORNIA. Made with Polaroid Model 360 Automatic Land Camera, with L-D ring set at Normal. The average exposure value resulted in over-exposure of the sunlit water and under-exposure of the figure.

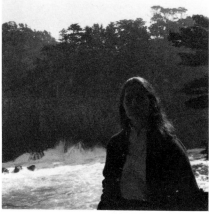

39B. SAME. Setting the L-D ring 1 stop to "darken" gave proper exposure for the water but serious under-exposure for the figure. This situation called for additional light on the figure (either reflected light or flash light).

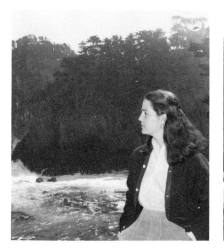

39C. SAME. With the camera set at 1 stop to "darken," the flash on the camera was applied at Normal value. The battery was turned off just prior to exposure which permitted the electronic shutter to operate as for 39B. It is obvious we have an "over-flash" result.

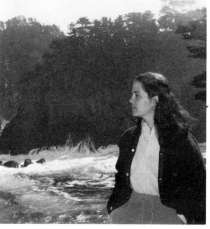

39D. SAME. Here the shutter setting is the same as in 39 B & C but the flash control is set at maximum "darken." The effect is much more pleasing. Focusing on the figure instead of on a plane about 8 feet beyond would have further reduced the flash value. (Focus was set at 20 feet for maximum depth of field.)

81

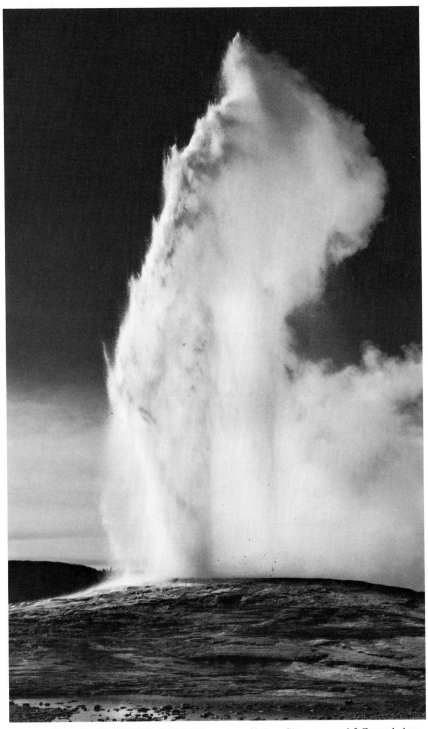

40. OLD FAITHFUL GEYSER, YELLOW-STONE NATIONAL PARK, WYOMING.
5x7 Juwel Camera and 5-3/4" Zeiss Protar lens, Yellow filter, exposed 2 Zones below normal, with Normal-Plus-2 development (to expand textural values).

THE LENS

An enormous variety of lenses are manufactured for all conceivable purposes. The "pinhole" was the first "lens" and expresses the basic optical principles. Modern lenses are incredibly precise (largely the result of refined computer analysis). However, some of the older "classic" lenses—the Dagor, Protar, Tessar, etc.—were very fine and function very well today with modern materials. The basic types of lenses in common use are:

NORMAL. This implies a "normal" focal length (about equal to the diagonal of the negative covered and having an angle of view of about 50°) and a normal "speed" (maximum lens aperture) of around f/2 or f/4 for smaller lenses, f/5.6 of f/8 for medium focal length lenses and f/8 or smaller for very long-focus or process lenses.
Typical Normal Lenses. Graflex Optar, Kodak Ektar, Calumet Caltar, Schneider (Symmar, Xenar and Xenotar), Zeiss (Planar and Tessar), Goerz (Golden Dagor), Rodenstock (Apo-Ronar, Heligon, Sironar, Ysarex). These lenses are available in a variety of focal lengths, any of which would be "normal" when their focal lengths approximate the diagonal of the negative used.

LONG-FOCUS. A lens of several times the focal length of the normal lens Page 102 covering around 36° to 18° angle of view (sees about as much as the eye does of texture and detail, but not more).
Typical Long-focus Lenses. Kodak Ektar, Goerz Red Dot Artar, Zeiss Sonnar.

TELEPHOTO. A lens of very long focal length in reference to negative size Page 102 which definitely shows a larger image and reveals more on the focusing screen or negative than the unaided eye can perceive, and covering at most about 9°. It may be a very long-focus standard lens or a lens of special design giving a considerably magnified image at a moderate "focal length" (distance from lens to film). Many modern telephoto lenses are catoptric in design (actually, small reflecting telescopes). Typical telephoto lenses are as listed, plus the Questar (one of the finest optical instruments available) and certain Japanese and European lenses of high quality.
Typical Telephoto Lenses. Zeiss Tele-Tessar, Graflex Tele-Optar, Schneider (Tele-Arton and Tele—Xenar), Rodenstock Rotelar, Dallmeyer Adon.

RETROFOCUS. Some telephoto lenses have an effective focal length much greater than the actual distance of lens to film, and some wide angle lenses (such as the 40mm Distagon for the Hasselblad) have a greater lens-to-film distance than the focal length indicates. These are known as retrofocus designs. This design is necessary (for the wide angle lens) so that the mirror in the camera will have room to swing upwards. The mirror in the Bronica drops *down,* and the retrofocus design for wide angle lenses is not required; this is an advantage, except that a second auxiliary shutter must be used to shield the interior of the camera (and film) from the light coming through the focusing screen.

WIDE FIELD. A lens of somewhat greater field of view (about 70°) than a normal lens of the same focal length, which allows for greater use of view camera adjustments or will cover a larger format.
Typical Wide Field Lenses. Kodak Ektar Wide Field, Calumet Series "S" Wide Field.

83

SHORT FOCUS. A lens of shorter-than-normal focal length for a given picture size. Not necessarily a wide-angle lens!

WIDE ANGLE. A lens of great coverage (about 80°) giving a very wide field of view or permitting a great camera adjustment range with smaller negatives.
Typical Wide Angle Lenses. Schneider Angulon, Goerz Wide Angle Golden Dagor, Graflex Wide Angle Optar, Zeiss Distagon 50mm.

SUPER WIDE ANGLE. A lens of maximum coverage (90° and more) which gives images of minimum distortion and allows maximum camera adjustments (with negatives of appropriately small size). The 121mm Super Angulon (Schneider) will cover an 8x10 negative on axis; hence, with a 4x5 negative the adjustment range is impressive. Great care must be used to avoid vignetting of the image by lens shades, external or internal parts of the camera, projecting camera-bed or monorail, and the hand when operating the cable shutter release.
Typical Super Wide Angle Lenses. Zeiss Biogon 38mm, Zeiss Distagon 40mm, Rodenstock Gradagon, Schneider Super Angulon, Caltar Wide Field 90mm and Zeiss Hologon (page 86).

FISH-EYE. A lens (or lens attachment) giving gigantic coverage. Fine for special effects, but the inevitable distortions are difficult to justify in many instances. Lenses exceeding 180° angle of view are available.

PORTRAIT. A lens (usually of rather long focal length) with somewhat "soft" definition, especially applicable to conventional portraitures. Some portrait lenses, such as the old Graf Variable (now available as used only), were soft at the larger apertures, but were quite sharp when stopped down.
Typical Portrait Lenses. Rodenstock Imagon, Kodak Portrait.

DIFFUSION (SOFT-FOCUS). Several variations include: a lens which is not chromatically corrected; it brings light of various colors to focus on different planes (before and beyond the negative plane). Residual spherical aberration will also give this effect. The image is therefore diffused; the effect is most pronounced with large apertures, and is reduced to almost optimum sharpness at the small apertures. Typical examples are the single component Portland Soft-focus lens, and the Graff Variable Portrait lens. Supplementary lenses or "filters," placed before the lens, which possess configurations which scatter the light give diffused images of varying degree. An example: the Softar Hasselblad filters; these are available in three "powers" of diffusion, and can be combined for increased effect if desired. Soft-focus effects are primarilly useful in portraiture as they reduce skin textures and the "benefits of time." They can give exciting effects with black-and-white and color images when the qualities of flaring light and scintillation are desired.

PROCESS. Lenses of highest quality designed primarily for extremely sharp close-up work (engraving, precision copying, etc.). Also excellent for enlarging. These lenses have the highest correction and flatness of field. They are usually of rather long focal length with maximum apertures of f/8 or f/11 (hence are hardly adequate for high-speed work or weak illumination situations). They work best at close distances up to around 1 to 5 subject-image ratio, and for direct enlargement of moderate degree. At around 30 feet to infinity we *might* have a focus shift (image must be refocused at small lens apertures).
Typical Process Lenses. Nikon Apo-Nikkor, Goerz Red Dot Artar, Rodenstock Apo-Ronar, Schneider Repro-Claron, Zeiss Apo-Tessar.

84

SUPPLEMENTARY. Single lenses which, when attached to the front of standard lenses, alter their effective focal length and field of view. The quality of the image is quite acceptable but not as good as the image of a fine unmodified lens. Some soft-focus supplementary lenses are available, such as the Hasselblad Proxar 0.5, 1.0, 2.0.

Page 104

SYMMETRICAL. Lenses composed of two similar components (of the same focal length), each of which can be used separately or combined. Separate components have greater focal lengths than the combined lens. The single components should be used back of the diaphragm.
Typical Symmetrical Lenses. Schneider Symmar, Goerz Double-Astigmat.

Page 89

CONVERTIBLE. Lenses composed of two components, each of a different focal length but both greater than the combined lens. As with symmetrical lenses, the single components should be used back of the diaphragm.
Typical Convertible Lenses. Zeiss Protar, Cooke Series XV, Turner-Reich.

Pages 89, 96

ENLARGING. Lenses of "process-lens" quality, designed for the working distances involved in making enlargements and giving a flat field. A simple rule: use an enlarging lens of longest available (and usable) focal length for maximum image quality.
Typical Enlarging Lenses. Nikon EL Nikkor, Goerz Magnar, Kodak Enlarging Ektar, Schneider (Componon, Comparon, Componar), Rodenstock (Omegaron, Rodagon).

PROJECTION. Designed for projection of motion pictures and slides, these lenses are usually of large aperture (for maximum screen brilliance). Inferior lenses will show poor definition, especially around the edges of the field and may have chromatic aberration. Good modern lenses are highly corrected and yield brilliant images. Zoom projection lenses are, in my opinion, inferior to the standard types.

ZOOM. A lens of very complicated design giving a considerable range of image sizes while maintaining focus and aperture settings. Primarily used for 8mm and 16mm motion-picture cameras (some are reasonably successful for the 35mm format). I have not encountered any zoom lenses (taking or projection types) that can give the image quality of a standard lens.

CONDENSER. These lenses relate to enlarging cameras and serve to collimate the light, increasing the illumination and giving images of maximum sharpness. They also accentuate image grain and negative defects and increase the contrast of the image. The ideal condenser system comprises a "point source" of light and allows for adjustment of the condenser lenses in relation to the focal length and extension of the enlarging lens; this to achieve maximum brilliancy and consistent illumination over the entire field of the negative. Such a system gives maximum sharpness and contrast. Variations of light-source and condenser-design give considerable variation of image quality. Condenser lenses are also used in projectors for maximum clarity and brilliance.

While condenser illumination has certain valuable physical properties, I find that the best *image quality* (aesthetically speaking) derives from diffused-light illumination in the enlarger. Collimated light from condensers (involving the Callier effect) distorts the diffuse-density range of the negative, resulting in higher contrast and "blocked" high values.

Page 232

85

PRISMS. These are optically-plane reflecting devices which allow for "right-angle" photography, etc. They can be attached to the lens and/or the finder of the camera. They can also be used on vertical enlargers to produce horizontal images (for those enlargers that cannot be rotated into horizontal position). It must be remembered that when a prism is used the image is reversed; when enlarging with a prism, the emulsion side of the negative faces the light-source instead of the lens.

SPOTLIGHT. Usually of Fresnel design, these lenses serve to concentrate the light from the lamp into a relatively small area. Lenses of ordinary quality may be adequate for black-and-white photography, but for color photography the lens must be clear and colorless. Many spotlights allow for "focusing" of the light in relation to distance from the lens, thereby narrowing or broadening the beam. The light source may be intensified by a back mirror of appropriate curvature.

FRESNEL LENS. Used to enhance illumination of the ground-glass image. As such, it is a flat plate of glass or plastic engraved (or cast) with concentric circles. The circles are designed to simulate a lens which would transmit light from all areas of the image to the viewing eye, thereby rendering all parts of the image with near-equal brilliancy. I find that it makes precise focusing difficult; a central area of fine ground-glass is helpful for that purpose. The ground-glass must be on the focal plane of the negative; the Fresnel plate must lie before the focal plane with the engraved side against the ground-glass. Positioning of the Fresnel plate in reference to the focal plane is critical; only a trained mechanic should attempt it.

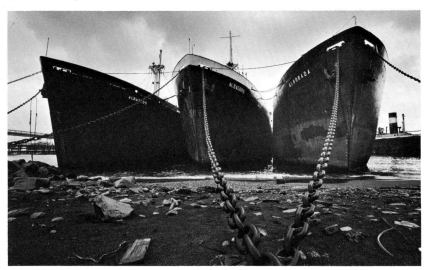

41. THREE SHIPS AND ANCHOR CHAINS (Photograph by Manfred Bauer, courtesy Zeiss Ikon-Voigtlander of America, Inc.). Made with the Zeiss Hologon Ultra Wide camera. This is an extraordinary instrument; camera and lens design are integral. Using 35mm film, the unique three-element, computer designed lens, with a focal length of 15mm, covers 110°. It is fixed focus and operates at f/8 only. The depth of field extends from 20 inches to infinity. A focal-plane shutter with speeds of 1 sec. to 1/500 (and B & T settings) offers a considerable exposure range. The finder is described as a Bright Field Direct Vision Optical View-finder. A built-in spirit level is in direct view beneath the View Finder and can be seen also from the top of the camera.

It may be difficult for the beginner to select the most useful lenses for his view camera or for his 35mm and 2-1/4x2-1/4 camera systems. Apart from the intrinsic quality of the lens (which should be adequate for the kind and scope of the work to be done), the following should be carefully checked:

Focal length in reference to negative size:

(a) The "normal" focal lengths are 50mm for 35mm cameras, 80mm for 2-1/4x2-1/4 and 6-1/2 inches for 4x5. The old "rule" that the focal length of the lens should be about equal to the diagonal of the negative covered at infinity focus is not really important; in my opinion, this "normal" focal length can be somewhat inhibiting in that it does not give sufficient depth of field for near-far compositions and is not long enough to give good "drawing" for portraits.

(b) For near-far compositions with great depth of field a relatively short focal length is indicated (50mm on a 2-1/4x2-1/4, 90 to 120mm on a 4x5, etc.). Wide field or wide angle lenses permit extensive camera adjustments.

(c) For portraits a relatively long lens is indicated (150mm+ on 2-1/4x2-1/4, 8 to 12 inches on 4x5).

(d) A good convertible lens—a Schneider Symmar or a Zeiss Protar (rare)—will offer two or three different focal lengths for view camera work. For small cameras—35mm and 2-1/4x2-1/4—the required enlargement demands greater optical quality than this type of lens may have (unless small apertures are used—implying long exposures). The very sharp Tessar, Sonnar or Planar types are advised for small formats.

Focal length in reference to camera extension:

(a) Obviously, the camera must extend at least as far as the required extension of the lens for close work. This would be (at least) 1.5 times the focal length of the lens at infinity setting; 2 times would be better! With a 2x extension we would have a 1:1 image-subject ratio.

(b) View cameras with long beds must have provision for back-focusing. Otherwise, the front camera bed will interfere with the image when short-focus lenses are used. Some press cameras have the "drop-bed" feature; the front part of the camera bed drops down, and the lens assembly tilts back to parallel with the back; the lens also can be raised to center the axis on the negative. Some view cameras have a fixed front assembly, and all focusing is done by moving the back assembly. Monorail cameras usually allow both front and back assemblies to be moved freely in either direction from center. With short-focus lenses it is important that the end of the monorail does not intrude in the field of view; it is often difficult to see this intrusion on the ground glass.

(c) The longer the bellows, the more space they take up at minimum extension.

Page 51
This inhibits the use of short-focus lenses. If the minimum bellows position is too great for the short-focus lens used, a recessed lensboard is required. While the ordinary recessed lensboard may be satisfactory at infinity focus and normal position, little or no adjustments can be made because the bellows are too cramped to allow movements of front and back assemblies.

The ideal solution to this problem is found in the "bag" bellows of the Sinar and some other cameras; the bag takes up little physical space and allows for a great range of adjustments—even with very short-focus or wide

Page 51
Figs. 25, 63
angle lenses. (See also "Bellows.") The bag bellows works well for all moderate extensions up to about 12 inches. Be certain not to "strain" it by forcing it beyond its limit when focusing.

87

Accessories in relation to focal length and camera adjustments:

(a) With cameras having "fixed" lenses (Contarex, Hasselblad, etc.) the attachments (filters, polarizers and lens shades) are designed to work without interference to the field of view. Some exceptions are:

(1) A lens shade of correct length when used alone will be moved outwards when filters and/or polarizers are added and may vignette the corners of the image. The type of lens shade which will fit *over* filters and/or polarizers is preferable.

(2) A lens shade designed for, say, a 150mm lens will not work with an 80mm or shorter lens; it is easy to make errors in this regard. And, as mentioned elsewhere, the vignetting may be difficult to see in the finder or on the ground-glass focusing screen at full aperture.

(b) With view cameras we must be *very* careful to check the following:

Page 119
Figs. 62, 63, 64, 65

(1) A lens shade suitable when the lens and camera are in "normal" position may seriously vignette the corners of the image when the rising, sliding or tilting front is used (or the back rising, falling or sliding adjustments). The back *tilts* and *swings* (on axis) are permissible.

(2) Filters and filter attachments, polarizers, etc., which extend beyond the front flange of the lens may also cause vignetting when the aforementioned adjustments are used.

(3) Bellows which are old and "tired" may sag and block off a portion of the lens image. If this occurs, the bellows can be supported by a piece of wood or cardboard (placed between the bellows and the bed or rail of the camera) or small hooks can be attached at intervals along the top of the bellows which can be secured to a screw or other projection on the front or back of the camera. A telescoping rod between the front and back assemblies will support sliding hooks to hold the bellows in position.

(4) *Repeat:* Check carefully for intrusion of camera bed or camera monorail within the field of view and for possible bellows sag.

A final admonition: know from the start what the coverages of your lenses are, how much you can use all adjustments, etc. Better to know this through testing than through failures in actual work!

Fig. 61

A quick comment on suggested lenses: recommendations in this domain are very risky because so much depends upon the photographer's direction of work. As stated on page 39 et seq. the photographer should not allow himself to be "typed" by his equipment. When a given lens seems inappropriate to the work at hand, it should be replaced with a more functional or desirable lens. Throughout the *Basic Photo Series Books* I mention various lenses for special purposes, but I do not want the photographer to anticipate the purchase of many lenses. Every serious worker should have one generally useful lens (my choice would be a triple-convertible or a Protar *set* which would offer a variety of focal lengths) and then acquire other lenses for specific purposes only if a real need therefor arises.

However, we must start somewhere, and we can assume that the reader is a serious student who has acquired a 4x5 view camera and must make careful selection of his optical equipment. Having discussed the basic types of lenses, at this point we can plan some optimum equipment and describe its properties.

Page 83

It is my strong personal opinion—based on considerable experience—that the lens of standard focal length, roughly equal to the diagonal of the negative used, is not desirable functionally or aesthetically. The field covered (angle of view) and the depth of field characteristics do not combine for optimum results in interpretation of space and scale. Lenses of shorter, or longer, focal length seem to give superior aesthetic and informational results. This statement is based on

the fact that "straight" photography implies maximum definition throughout the entire field of the image. We should work in the domain of straight photography at first so that our discipline will be more or less complete. Working with subjects favoring differential focus in which we are not concerned with detail in depth (detail in all planes of the subject) is a much less rigorous approach, and the focal length of the lens is not a critical factor.

We are concerned in this book with applications rather than optical theory and lens design. It is true—and rather difficult to describe!—that certain lenses give more "contrast" than others. *Resolution* of the lens (expressed by the number of lines per millimeter discernible in the image) can be evaluated best in the aerial image (not on the ground-glass focusing screen). The *effective resolution* depends upon the ability of the negative to resolve small differences of density; negatives of fine grain structure and high acutance (abrupt microdensity differences) will support the high resolution of the lens. Many physical factors are involved: the type of negative material, the developer and development time, the type of enlarger illumination and print-paper surface—all must be considered. In addition, there are psychological and aesthetic factors to contend with. These are discussed at length in other volumes of the *Basic Photo Series.*

Field of view, perspective, "drawing," two-dimensional effect, scale, near-far effect, coverage, etc., are all discussed in other sections. All these terms are extremely important to the photographer but are usually dismissed after some superficial definitions are noted. We are concerned here with the basic practical meanings—as far as we can carry them without getting into deep philosophical confusions. We should remember that we are primarily concerned with effective informational and expressive work. If we need greater depth of field, we must select the right lens for it; if we need a lens which will give good "drawing" for portraits, we have to use a lens of about twice the focal length of the "standard" lens (this applies also for copying and precise close work).

On the other hand, there is a certain disciplinary effect in working with limited equipment! Perhaps working with a "difficult" lens will reveal solutions to many problems that ideal equipment would automatically overcome.

Page 85 For work involving landscape, architecture and allied subjects, symmetrical lenses (2 similar components of about 1.5 times the focal length of the combined lens) or convertible lenses (2 components of about 1.5 and 2 times the focal length of the combined lens) are highly desirable. The best modern lens of this type made today is the Schneider Symmar. The Zeiss Protar, the Cooke Series XV and the Turner-Reich are available occasionally as used lenses. With the convertible lens we have a choice of field of view (three image sizes) from the same viewpoint, and with the symmetrical type we have two choices. A typical example of the convertible lens would be the Zeiss Protar with components of 22cm and 29cm focal lengths. Combined, they form a lens of 14.5cm focal length. This will cover a 4x5 negative (with minimum camera adjustments or a 3-1/4x4-1/4 negative (with considerable adjustments allowed).

When both components of a symmetrical or convertible lens are used together, the component of the longest focal length should be placed in front of the diaphragm. When the components are used singly, they should be placed behind the diaphragm. Also—and *important*—there is usually a focal-shift as a single component is stopped down, and refocusing may be necessary at the lens stop selected for use. See page 108 for a method of checking the amount of focus-shift. Much of the criticism on poor performance of single components of these lenses stems from the effects of this focus-shift and failure to adjust for it. The computer-assisted designers may overcome some of these problems with symmetrical and convertible lenses in the very near future.

89

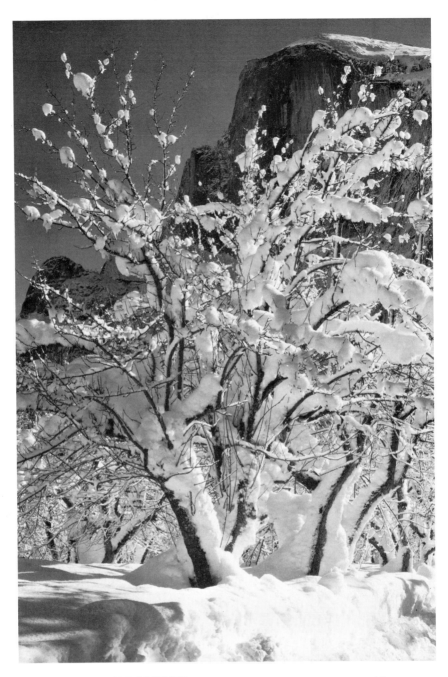

42. HALF DOME, OLD ORCHARD, YOSEMITE NATIONAL PARK, CALIFORNIA. 8x10 camera, 12″ Goerz Dagor, Wratten K2 filter. The camera position was fairly low; The Rising-Front set at maximum. Had the camera been raised about 1 foot a little more of the rounded mountain and of Half Dome would have been revealed. The original composition was horizontal and this camera position was optimum for the horizontal picture.

The low camera position gave a good vista under the trees, which is more apparent in the horizontal image.

Observe that the foreground snow is "blocked"—the result of over-development. Merely "printing it down" results in a gray value, without significant increase in texture.

90

PROPERTIES OF THE LENS

A simple lens—meniscus in form composed of a single piece of glass—will produce an image, but a faulty one in many respects. These faults are termed *aberrations*—inherent defects of optical systems. They are, in effect, intrinsic in all lenses and can never be completely removed. It is a tribute to the ingenuity of lens designers that multiple aberrations can be reduced to a point where, for all practical purposes, the lens functions adequately. Aberrations such as coma, flare, spherical aberration, chromatic aberration, astigmatism, linear distortion ("barrel" and "pincushion"), etc., profoundly affect the performance of the lens, but they are extremely complex to evaluate and control and the practical photographer need not be concerned directly with them. It is enough to know that the lenses we use have been designed and manufactured by experts to perform well for the purpose for which they are intended. Some lenses are designed for special purposes for which all pertinent aberrations are controlled; when used for other purposes, they may perform inadequately. The standard "commercial" lens is designed to work at from 20 or 30 feet to infinity distance and may not function well with close-up work unless stopped down and perhaps refocused. A process lens is especially designed for extremely precise close work (reproduction, engraving, etc.) and may not be useful for distance work unless stopped down and perhaps refocused. Aerial photography demands lenses corrected to give perfect flatness of field and sharp definition over the entire picture at "infinity" focus, functioning at large apertures because of the high shutter speeds and the correction-filter exposure factors required. (Aerial lenses are also chromatically corrected to compensate for the fairly heavy yellow, orange or red filters which are almost always used.)

The slight differences in optical quality of various lenses are usually overcome by the inherent limitations of negative materials.

Photographic lenses, with few exceptions, represent segments of spheres, and a complex modern lens may contain many elements, ground to different curvatures, separate or cemented, with air spaces between. All transparent substances have indices of refraction, and the air spaces within a lens are part of the lens "formula." The combined elements of lenses are cemented with a substance of great transparency and proper refractive characteristics. In older lenses this substance may become yellowish and produce some "warming" effect in color photography. It should not affect the sharpness or the basic optical corrections of the lens. Separation and recementing of the elements are highly technical operations and should be attempted only by experts (the cost is rarely justified).

Design of lenses in the past was a laborious effort of calculation and manufacture which involved repeated ray-tracings manually by skilled experts. In recent years the use of "rare earth" glass and refinements of design made possible by the use of computers have resulted in the production of lenses of great complexity, high performance and extraordinary quality, even in the low-cost *Page 101* range. Perfected optical coating of all air-glass surfaces allows for use of many elements without serious loss of light-transmission, a coated lens of 12 air-glass surfaces (6 elements) transmits more light and creates less flare than does an uncoated lens of 4 air-glass surfaces. Hence, the "speed" of modern lenses is, within practical limits, similar in most designs. There is no need to discuss here the structure of lenses; reference is made to *Lenses in Photography* by Rudolf Kingslake (Garden City Press) and the description of various basic lens formulas in *Photographic Lenses* by C. B. Neblette (Morgan & Morgan), among others.

91

The retina of the eye is curved, but the photographic film is flat (except in some special cameras designed for scientific purposes). The natural image of the simple lens is produced on a curved field (the curvature relating to that of the lens). One of the most important "corrections" in lens design is to produce a consistently sharp image over a flat field. This is quite an achievement, especially with super wide angle lenses! Also, there must be no distortion, such as rendering the image of a rectangular grid with either "barrel' or "pincushion" effect. Geometry will not be denied; a spherical object in the subject will be rendered slightly ovoid near the corners of the field. The wider the angle of view, the greater this effect becomes. If the film were curved, this effect would be minimized. The introduction of an aspherical (hyperbolic instead of spherical form) element can minimize this effect, but this represents a very complex and expensive lens system at this time.

Because light travels farther from the lens to the corners of the film than to the center, there is a decrease of image brightness in the outer areas of the image. That is why, in earlier days, it was advised to use the same lens for both "taking" and "enlarging"—the fall-off of light would be balanced to a certain extent. Today we know it is advantageous to enlarge with lenses especially designed to give maximum definition over a flat field.

Any lens has its maximum angle of view, which relates to its covering power. Some lenses (telephoto type) are designed for a "large image" and a small angle of view; other lenses are designed to encompass a wide angle of view. Apart from the angle of view, lenses of the same focal length will give the same size image. A Tessar-type lens of 6 inches focal length has a limited angle of view but can be designed with a very large aperture (f/4.5 or larger), whereas a 6-inch wide angle lens with twice the angle of view may have f/8 as its largest aperture. When we speak of angle of view, we imply satisfactory image quality throughout the picture area, not the total field of the lens.

The entire image of the lens as shown in Fig. 44 is obviously circular, and the fairly abrupt cutoff is produced by vignetting effect of the lens barrel. The outer edges are not adequately sharp. In Fig. 45 the circle shows the area of adequate sharpness, and the solid rectangles within show the central positions, horizontal and vertical, of a film of 4x5 or 8x10 proportions.

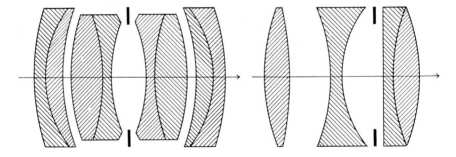

43. DIAGRAM: CROSS-SECTIONS OF SYMMETRICAL AND ASYMMETRICAL LENSES. The symmetrical lens shows 8 air-glass surfaces and the asymmetrical lens shows 6 air-glass surfaces. If the lenses were not coated, the symmetrical lens would give a greater amount of flare than the other lens; if both were coated the trans- mission of each would be practically equal. If the rear half of the symmetrical lens were of shorter focal-length, we would have a *convertible* lens, giving three focal lengths; that of the combined lens, and of the front and back components. It is advised to use either single component *back* of the diaphragm for best optical effect.

44. CIRCULAR IMAGE OF THE LENS.
Made with a 4″ wide angle lens on an 8x10 negative, this indicated the maximum field of the lens (the rather abrupt cut-off is due to the vignetting effect of the lens-barrel). Refer to the diagrams below (Fig. 45) for further clarification of this limitation of covering power.

45. DIAGRAM: MAXIMUM COVERING POWER OF A LENS. In Diagram A we have horizontal and vertical rectangles representing maximum image size (of this shape) within circle of coverage of a lens. In diagram A′ we see what occurs when the rising front is used beyond the covering capacity of the lens. With normal wide-field lenses, the center square might indicate the optimum negative area therefor; such would allow for greater flexibility of adjustments.

In Diagram B the small rectangles suggest the great range of adjustments possible with a truly wide-angle lens. In diagram B′ the maximum adjustment with such a wide-angle lens is shown. The large rectangles in diagrams A and A′ demonstrate the limits of adjustments with a normal lens.

93

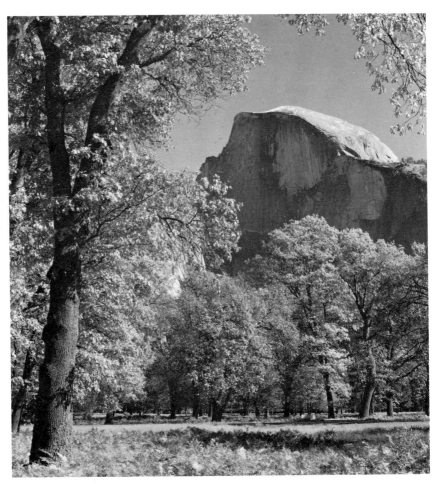

46. HALF DOME, AUTUMN, YOSEMITE NATIONAL PARK, CALIFORNIA. 8 x 10, 10″ Kodak Wide Field Ektar (part of original negative). Wratten G filter. No camera adjustments used, but lens focus set at point between near tree and distant Dome. In practical terms, we can obtain optimum depth-of-field by focusing on a plane about one-third the distance between the near and far planes. If the near object is 6 feet distant, and the far object 15 feet distant, the difference is 9 feet. One-third of 9 is 3; 6 + 3 = 9; hence the optimum focal plane would be 9 feet. Of course, the lens would have to be stopped down to a small aperture, and this would vary with the focal length of the lens and the definition requirements.

In this case the Dome was (practically speaking) at infinity, and 400 feet was used as the maximum distance. The tree was about 70 feet away. Hence, the optimum focal plane was about 180 feet from the lens. It was necessary to stop the lens down to f/22 for adequate all-over sharpness (see page 99).

1. **FOCUS.** As stated elsewhere, the focal length of the lens is the approximate distance from the rear nodal point of the lens to the film plane when the lens is focused on infinity (for all practical purposes, an 8-inch lens has "infinity" setting at about 250 feet and beyond). As subject distance decreases, the lens must be extended to greater distance from the film plane. As the focal distance increases, the image becomes larger and the brightness of any given area of the picture is reduced. This is explained on a simple geometric area-effect. In the next paragraph it will be clarified.

2. **LENS STOP (APERTURE).** The *focal ratio* of the diameter of the lens aperture in relation to its focal length at infinity setting is its f/number. When we speak of an f/5.6 lens or an f/8 lens, we mean that the largest opening is 1/5.6 or 1/8 of the focal length at infinity setting. With an 8-inch lens, a maximum aperture of 1 inch diameter would represent f/8. With a 4-inch lens, f/4 would also be represented by a 1-inch aperture; f/8 would be represented by a 1/2-inch aperture. Both lenses would transmit the *same amount of light at the same f/number setting.* With a lens of 500mm focal length, f/8 would be represented by an aperture 62.5mm in diameter, and so on. Shutters for the Zeiss Protar were engraved in millimeters, and the photographer would calculate the effective lens stop by relating the *mm* marks on the dial to the focal length of the various lens components in millimeters.

As we are concerned with the *area* (through which the light passes to the film) and not just the *diameter* of the lens stop, our calculations must be geometric rather than arithmetic; f/16 therefore transmits 1/4 the light passed by f/8. Lens stops are marked in the following sequence:

Lens stop:	f/1.4	f/2	f/2.8	f/4	f/5.6	f/8	f/11.3	f/16	f/22.6	f/32	f/45.2
Exp. ratio:	1	2	4	8	16	32	64	128	256	512	1024
or:	1/64	1/32	1/16	1/8	1/4	1/2	1	2	4	8	16

Any lens aperture, multiplied by the square root of 2 (roughly 1.4) gives the next highest aperture number (which will transmit 1/2 the amount of light). Dividing the lens aperture by the square root of 2 (roughly 1.4) gives the next lowest number (which will transmit 2 times the amount of light). Some European systems use f/9 instead of f/8; the geometric progression would then be f/9, f/12.5, f/17.5, f/25, f/35 (but the exposure ratios would be the same: 1, 2, 4, 8, 16, etc.).

We will note that EV (Exposure Value) numbers, f/numbers and Exposure Zone numbers are all based on factors of 2; this simplifies calculations, but it takes a little practice to comprehend the geometric progression values of arithmetic numbers!

Now, if an 8-inch lens with a maximum aperture of 1 inch (f/8) is focused on a near object, the lens will be moved farther from the film, and the effective lens stop is altered. If the 8-inch lens is extended to 11 inches from the film, f/8 becomes f/11; if extended to 13 inches, f/8 becomes f/13; and if extended to 16 inches, f/8 becomes f/16 (requiring 4 times the exposure as with the true f/8 setting). The exposure ratio can be calculated by squaring the basic focal length and the extension; dividing the first into the second indicates the exposure factor required.

For example:

(a) An 8-inch lens is extended to 9 inches: 81/64 = about 1.25x basic exposure.

(b) An 8-inch lens is extended to 11 inches: 121/64 = about 2x basic exposure.

(c) A 5-inch lens is extended to 20 inches: 400/25 = about 16x basic exposure.

These factors relate to any given lens stop used. See page 96 for method of calculating the extension factors with the Weston meter dial, also refer to the Kodak Effective Aperture Computer in the Kodak Master Photoguide. It will help to make a table of squares for your notebook, as lens-extension calculation will be frequently required especially with view-camera work. Refer to the Photographic Optics Section in *Photo-Lab-Index* for comprehensive lens formulas.

When single components of symmetrical or convertible lenses are used, the lens stops as marked for the combined lens do not relate to the single elements. Many such lenses have 2 or 3 lines of f/numbers engraved on the "stop plate" of the shutter; each relating to the component used. If such is not marked, we must calculate the effective exposure factor on the focal length of the single element. A 12-inch convertible lens might have components of 19 and 26 inches focal lenghth; the exposure ratio for each would be:

$$361/144 = \text{about } 2\text{-}1/2x$$
$$676/144 = \text{about } 4\text{-}2/3x$$

This relates to the *lens stops listed for the combined lens* which do not relate to the single components. The true position of any given stop number can be engraved on the shutter by a competent mechanic. The true position *can* be estimated with reasonable accuracy; the 19-inch exposure ratio above would place a true f/22 value a little before the marked f/16 stop, etc. Remember: this relates only to *exposure* values; depth of field relates to focal length of lens; it is the same for any given image size at any given lens stop.

The dial of the Weston Meter (and other meters as well) can be used for rapid and *approximate* calculation of lens-extension factors. For example, suppose we have established an exposure of 1/4 second at f/32, and that we are using a lens of 8-inch focal length, extended to 22 inches. Move f/8 to the former position of f/22, then read the exposure opposite f/32—it will be 2 seconds (8x the basic exposure) 8^2 divided into $22^2 - 484/64$—a little less than 8. If we recall that f/22 approximates the true value of f/22.6 (squared = 510), we would have an accurate 8x factor. If our lens were extended to 16 inches we would—on moving f/8 to the former position of f/16—see that we would have an exposure of 1 second at f/32 (a 4x factor, proved by $16^2/8^2$ or $256/64 = 4$).

Page 76 The Sinarsix exposure meter can, by interpolation from a known luminance-aperture situation, give us accurate aperture values.

3. **DEFINITION**. As noted in Fig. 47, the rays of a well-corrected lens focus (come to a point) on the plane of the film or focusing screen. Due to the wave nature of light, this can never be an ideal point; it will appear under considerable magnification as a circle. This is known as the Airy disc, which is due to diffraction effects. The Airy disc increases in size with smaller lens stops and decreases with larger lens stops (hence the "diffraction effect" with very small lens stops). The size of the Airy disc also depends upon the wave-length of light (smaller for blue light and larger for red light). It must not be confused with the *circle of confusion* (see below). Hence, the image of a star—an ideal "point" will be rendered as a very small circle. As the image of any subject is composed of an infinite number of "points" we can understand what is meant by the limits of practical definition. At reading distance the eye accepts a circle of 1/200 inch as a "sharp" point; this is the practical criterion of image sharpness or definition. However, sharpness also depends upon the characteristics of the negative emulsion, type of developer used, degree and quality of the enlarged image and the paper surface used. Textures, values, scale, etc., also influence the impression of definition and sharpness. *A cutance* is a rather difficult term to define; it relates to the *impression* of sharpness.

4. **DEPTH OF FIELD**. In the foregoing paragraph we described definition or sharpness as maximum on the focal plane (ground glass or film). Any part of the image which falls before or behind the image plane will be "out of focus." Refer to Fig. 49 in which the passage of the rays of light from the lens and the circles of confusion at various planes before and behind the image are shown in stylized

96

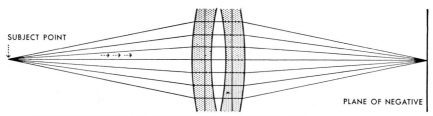

• SUBJECT POINT BROUGHT TO SHARP FOCUS ON PLANE OF NEGATIVE

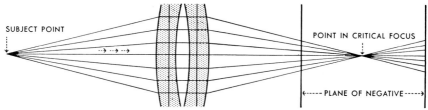

• SUBJECT POINT OUT OF FOCUS WHEN PLANE OF NEGATIVE LIES
BEFORE OR BEHIND PLANE OF CRITICAL FOCUS

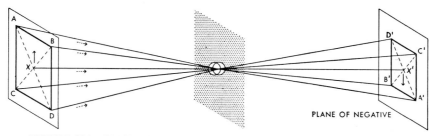

• INVERSION OF IMAGE. LIGHT FROM ALL POINTS OF SUBJECT PLANE BROUGHT TO SHARP
FOCUS IN INVERTED BUT RELATIVE POSITION ON NEGATIVE. GENERAL DIRECTION OF LIGHT RAY IS
NOT CHANGED WHEN PASSING THROUGH LENS: AN OBSERVER AT A' LOOKING THROUGH THE
LENS WOULD SEE POINT A; AN OBSERVER AT X' WOULD SEE POINT X.

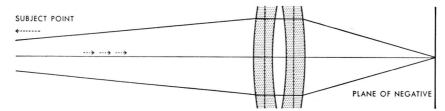

• THE DISTANCE OF THE SUBJECT DETERMINES THE LENS-TO-NEGATIVE DISTANCE.

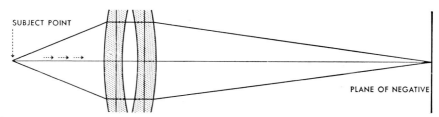

**47. DIAGRAM ILLUSTRATING
SEVERAL OPTICAL PRINCIPLES.** The
second diagram from the top is further
clarified in Fig. 49, page 99 which describes
the effect of lens-aperture size on effective
image definition. Reference is made to
significant books on practical optics, such as
Photographic Lenses by Neblette, *Lenses in
Photography* by Kingslake, etc.

97

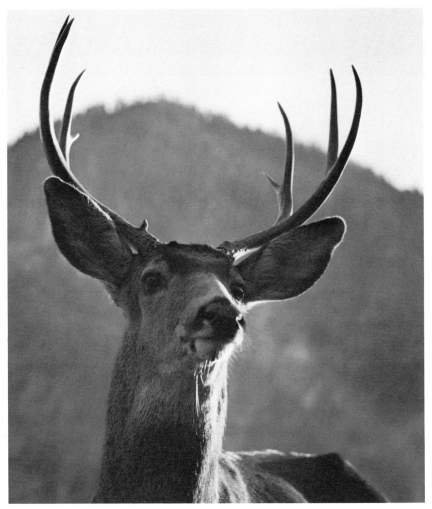

48. DEER, YOSEMITE NATIONAL PARK, CALIFORNIA. Made with Hasselblad 500C and 80mm Zeiss Planar. Here the "out-of-focus" effect (differential focusing) serves to isolate the deer from the background; had the background been sharp the effect would have been very confusing as the values are quite similar throughout.

form. Obviously, as we stop down the lens, the angle of the rays is narrowed and the diameter of the circles of confusion before and behind the focal plane is reduced. The longer the focus of the lens and the larger the lens stop, the greater the circle of confusion at any distance other than the distance critically focused upon. The reverse situation—shorter focal length lens and smaller lens stop— gives us greater depth of field (sharper focus in depth). Actually, as the smallest stops are used, the critical definition on the focal plane may be reduced due to diffraction effects, but the *effect* of approximate good definition over a considerable depth of field is one of all-over sharpness and clarity. Depth of field tables are available for all lenses at all practical stop values.

Depth of focus (actually, "focal range" is clearer term) refers to the distance the lens can be moved from critical focus position while retaining the desired depth of field effect in the image.

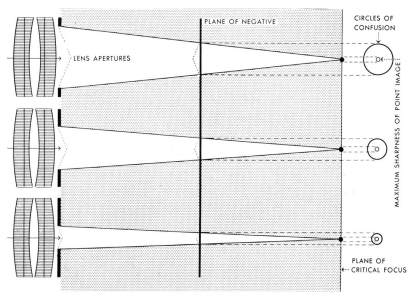

49. DIAGRAM: RELATION OF SIZE OF CIRCLE OF CONFUSION TO DIAMETER OF LENS APERTURE. This shows that as the lens is stopped down the circle of confusion is reduced in size. In effect, as we stop our lens down we achieve finer definition in planes before and behind the critical focal plane. Maximum sharpness is always in the plane of critical focus. Deviation from optimum sharpness is determined by the visual effect of print or enlargement. What would be acceptable in a contact print might be rejected in a 2x enlargement.

5. **HYPERFOCAL DISTANCE.** This is the subject-distance focused upon which will yield maximum depth of field in reference to focal length of lens, aperture used and the criterion of sharpness required. (Refer to the *Photo-Lab-Index* for useful tables.) In practical work we can get maximum depth of field by first focusing the lens on a point roughly one-third the distance beyond the nearest and farthest subject planes. We then stop down the lens, checking the clarity of the image with the focusing magnifier. If we cannot get the extremes in adequately clear focus, we will have to compromise—usually working for greater clarity with the near subject plane. The farther we move the camera from the subject, the greater will be the depth of field obtained. Obviously, decisions are controlled by aesthetic factors as well as practical ones; we may *want* differential focus (the principal subject sharp against a very much out-of-focus background, etc.).

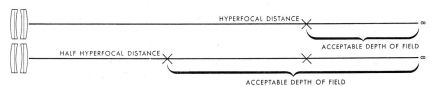

50. DIAGRAM ILLUSTRATING HYPERFOCAL DISTANCE. When the lens is focused on infinity all planes from the Hyperfocal Distance to infinity are in acceptable focus. When the lens is focused on the Hyperfocal Distance, all planes from one-half the Hyperfocal Distance to infinity are in acceptable focus. By "acceptable focus" we mean an "acceptable depth-of-field." Refer to page 110 and to the *Photo-Lab-Index,* for basic optical formulas and descriptions.

99

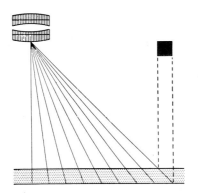 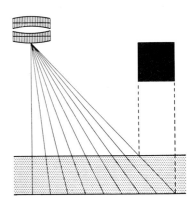

51A. DIAGRAM: Lateral loss of definition by a sharp angle of light on a thin emulsion.

51B. DIAGRAM: Lateral loss of definition by a sharp angle of light on a thick emulsion.

52A. DRAWING: Illustrating the diffuse optical image of a point in a fine-grain emulsion.

52B. PHOTOGRAPH: Illustrating the practical effect expressed in the drawing Fig. 52A (about 40x enlargement).

52C. DRAWING: Illustrating the diffuse optical image of a point in a coarse-grain emulsion.

52D. PHOTOGRAPH: Illustrating the practical effect expressed in the drawing 52C (about 40x enlargement).

Figs. 52 A,B,C and D illustrate the fact that an un-sharp optical image can *appear* sharper in a print from a coarse-grained negative, *if the grains are rendered sharp* in the enlargement.

100

COATED LENSES

Page 92 As stated previously, the modern fully corrected lens is composed of groups of glasses of different thickness and composition, ground to various curvatures and either cemented together or separated by air spaces.

As the number of glass elements of the lens increases, the transmission of light is reduced, both by absorption in the glass itself and by reflection and scattering of incident light at each air-glass surface. One air-glass surface scatters about 4% of the light falling upon it; absorption causes an additional (but slight) loss. With a simple meniscus lens (1 element, 2 air-glass surfaces) transmission is roughly 90% of the incident light. Through a lens of 8 uncoated air-glass surfaces, as little as 70% of the incident light may reach the negative.

Optical coating, by neutralizing reflection of light from air-glass surfaces, increases the light transmission and reduces the scattering of light within the lens, thereby reducing the general *flare* and increasing the contrast of the image. With a fully coated lens—one in which every air-glass surface is treated—transmission is reduced only by absorption of the glass and the cementing material. The scattering of light is practically zero. All coated lenses have, within practical degree, the same transmission values at any given aperture number. With extremely complicated zoom lenses (having 24 or more air-glass surfaces) residual scatter and absorption may be apparent, but such is inconsequential with coated lenses of 4, 8 or even 12 air-glass surfaces.

Light scattered within the lens must go somewhere! Part of the light is directed outwards and part to the negative. The latter appears as *flare* and can produce an overall fog on the negative, or (because of certain factors of lens design and reflection from the edges of the glass elements) it can produce a vague flare spot or ghost image. The latter, of course, is very disturbing and difficult to handle in printing. The over-all flare light may effectively increase the "speed" of the negative material (most apparent in the shadow area), but, of course, the image contrast is somewhat reduced. This general flare is not troublesome with black-and-white photography but can have serious effects with color photography as the flare takes on the dominant color of the subject and affects the overall quality of the image.

A fully coated lens gives maximum image contrast as well as purity of color, especially in the low values. Practically all lenses are optically coated now, and old lenses can be coated by competent technicians (who can replace the elements accurately in the lens barrel or shutter).

When lens-coating was first initiated, all the elements were coated with the same material. However, lens-coatings vary in "color." If the coating appears bluish to the eye, it is transmitting less blue and more long-wavelength light, and the image will be "warmer." If the coating appears yellowish, the reverse effect obtains. Hence, with different lenses different qualities in color photography would result—and this was unfortunate when color slides, etc., required matching. The present procedure is to treat different air-glass surfaces of a lens with "cold" or "warm" coating so that the total light transmitted is balanced to a neutral color. Looking into a fine modern lens we will see reflections from the various surfaces, and the subtle color differences of the coating will be apparent. Hence, we can use any of the fine lenses made for the superior 35mm or 2-1/4x2-1/4 cameras with confidence that the color photographs will be similar in color quality. Lenses for larger cameras are seldom of one make, and the lens-coating effects may vary. In serious color photography this possible variation should not be overlooked, and lenses should be selected for consistent color

101

transmission values. These subtle color effects are, as stated previously, of little significance in black-and-white photography.

At one time photographers felt that lens coating gave a consistent high brightness or contrast but that a certain "smoothness," obtained from a small amount of flare from an uncoated lens, might be advantageous under certain conditions. However, a similar effect of flare—in varying degree—can be pro-

Page 134 duced by pre-exposure of the negative and by appropriate exposure-development control (see Book II—*The Negative*).

LONG-FOCUS AND TELEPHOTO LENSES

Considerable confusion exists between the terms *long-focus lens* and *telephoto lens*. The former is a lens of normal construction yielding comparatively large images; the latter is so designed that it magnifies the primary image *within* the lens system without requiring extreme bellows extension.

The size of the photographic image in relation to the area of the negative is dependent on the focal length of the lens, normally about the same as the diagonal of the negative (because the images will then have a satisfactory coverage, brilliancy and marginal definition and yield a quality of perspective accepted as "normal"). However, accurate perspective effect is gained only when the distance from the finished contact print to the eye is equal to the focal length of the camera lens. The image made by a 6-inch lens, enlarged 2 or 3 times, and viewed at 12 or 18 inches, gives a "true" perspective effect.

This true perspective effect is very seldom achieved, and we must recognize that the impression of depth is conditioned by several factors other than perspective. As the focal length of our lens diminishes in relation to the area of the image, we gain what are commonly known as wide angle effects; as the focal length increases in proportion to the area of the image, we approach more and more closely the effect of eye vision.

The normal visual acuity of the eye enables us to see with clarity an object which subtends an angle of about 5 minutes of arc at a distance of 6 meters (object diameter 8.75mm). Our vision of a scene is composed of a series of sharp images of small portions of the scene organized in time; as the eye views the object before it, it progressively takes in various areas and with both retinal and psychological memory synthesizes the impression of the whole in the mind. Of course, we use the same process in viewing a finished photograph; we must scan it to gain an adequate impression of the whole. Now as the focal length of our camera lens is increased—which means that the size of the image is increased in relation to the area of the negative—the angle of view diminishes. The narrower the angle of view, the closer to visual reality the photographic image becomes, excepting the facility of the "roving eye" to quickly select various areas of the entire field (there are no rectangular borders restricting our vision). If an 8x10 negative is made with a lens of 30-inch focal length and a contact print from it is viewed at a distance of 30 inches from the eye, a maximum illusion of reality is achieved. If the image from a lens of shorter focal length (at the same distance) is magnified to match that made directly by the 30-inch lens, the effect is the same. Whether an image of any given size is produced directly on the negative or by enlargement of the print is of minor consequence visually if the basic image is of good quality.

Psychologically, the great difference lies in the fact that the area of vision is isolated by the borders of the print and the eye is limited, as it were, to this one field of view. Because of this restriction the image *appears* to be magnified,

102

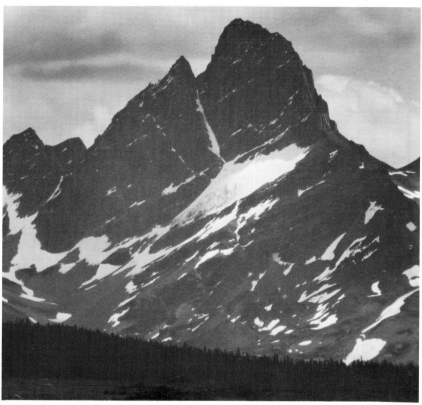

53 A & B. PEAK NEAR TONQUIN VALLEY, JASPER NATIONAL PARK, CANADA. Made on a 6½ x 8½ plate with a 9″ Dagor and the Ross Tele-negative combination (2-1/4″ negative lens behind the 9″ Dagor) as the positive lens. Magnification about 5x. Small plate (53A) shows the image of the 9″ lens, made from about the same distance (but a different position). Camera-telephoto combination was supported by a small second tripod to avoid wind vibration. The slighest camera movement seriously affects the telephoto image sharpness; as magnification increases camera movement effects are exaggerated. A stiff cable-release, ground or machinery vibrations can cause trouble. Both pictures are about 2/3rds the original size.

as through a telescope. If the same scene were photographed with a 30-inch lens on a 20x24-inch plate, one would not get such an impression of magnification, as the focal length of the 30-inch lens would approximate the diagonal of the plate and the field of view would be roughly proportional to that of a 6½-inch lens on a 4x5 negative. But let us isolate a 4x5 area of this 20x24-inch image; we are immediately impressed with the "telescopic" effect. This is accentuated when all parts of the scene are at a great distance from the camera.

We are conscious of true magnification only when recognized objects are rendered in detail beyond the capacity of the eye to perceive from the position of the camera. Magnification beyond normal visual perception should be known as the true telephoto effect, and the lenses used for such purposes should be

103

known as true telephoto lenses. Although lenses which produce images up to normal visual perception should be known simply as long-focus lenses, the term *telephoto* hence is often misapplied.

Some telephoto lenses—such as the Dallmeyer Adon—are of variable focal length. A "negative" (diverging) lens is used to magnify the image formed by the "positive" (converging) lens. The degree of magnification is altered by changing the lens-to-negative distance and the lens is then adjusted to sharp focus by a slight increase or decrease in the distance between the elements of the lens. Such combinations demand that the quality of the positive lens be of the highest order.

The nodes of the true telephoto lens are at some distance in front of the diaphragm; for this reason the amount of back tilt required to correct convergence is not the same as with an ordinary lens. Mathematical explanation is complicated, but a satisfactory approximation of the required tilt is easy enough. Divide the number of degrees of tilt necessary with a normal lens by the magnification effected by substitution of the telephoto lens. The simplest way to make the adjustment, however, is by examination on the ground glass.

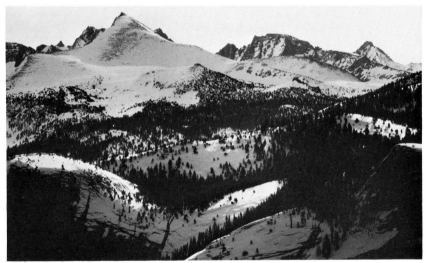

54. THE HIGH SIERRA FROM GLACIER POINT, YOSEMITE NATIONAL PARK, CALIFORNIA. Telephotograph made with a Dallmeyer Adon lens and a Wratten F (deep-red) filter. The magnification is about 12x above the image of a 6-inch lens. The camera was pointed into the sun and the lens was carefully shielded with a long black-paper tube. The red filter effectively cut the intervening haze, but had little effect on the sky, which was very bright and of very low saturation of blue.

Page 85 What is known as a *supplementary lens* may be placed in *front* of a regular lens to modify the effective curvature of its front component and thereby alter the focal length of the lens system. If the curvature is accentuated, the effective focal length is lessened and a wide angle effect is obtained. If the curvature is reduced, the focal length is increased and a larger image results. It must be emphasized that any standard lens is designed and fabricated for maximum optical correction, and the addition of any optical element, no matter how finely made in itself, is certain to invalidate some of the corrections of the original lens. Hence, the most effective telephoto lenses are: (1) the standard long-focus lenses of normal design, which should be used if the extension of the camera bellows permits; (2) true telephoto lenses, requiring normal bellows

104

extension, but of much greater equivalent focal length. Variable-focus lenses cannot give first-class definition because only fixed systems can be highly corrected. Except for small negatives, zoom lenses are not, as yet, optically adequate.

Flare light is one of the most deleterious factors in the telephotographic image. Not only are some telephoto lenses composed of many elements of glass, but only the extreme center of the field of view is used, and flare from internal reflection is often greatest in this part of the image. A long lens shade should be used with these long-focus lenses to keep all extraneous light from the front objectives and from the filter surfaces.

Page 58 For work with long-focus and telephoto lenses, extreme rigidity of both camera and tripod is essential. Considerable torque exists when the bellows are entended to maximum length and a long, heavy lens is added. The slightest movement caused by wind or by operation of the shutter is magnified along with the image, and more failures can be traced to movement than to any other cause. Telephotographic exposures are certain to be long, since the aperture number of the positive lens is multiplied by the magnification, so that the effective aperture becomes very small indeed. (For example, f/32 operating with a telephoto attachment of 10 magnifications becomes an effective aperture of *Page 95* f/320, requiring about 100 times the exposure; see also "Lens Stops.") Not only must the principal tripod be very sturdy and free from vibration, but the camera bed (unless of monorail design) should be supported by a rigid assembly that will prevent sagging. In addition, a second tripod or single support should be placed under the lens; it should have a sufficiently fine adjustment to support the lens securely without moving it upward or to either side. With equipment of this type, landscape photography of great magnification can be undertaken even when a slight wind is blowing.

Except when images of exceptionally high magnification are required, the photographer will find that the use of a standard high-quality lens of moderately long focus yields images which (with fine-grain processing of the negative) permit enlargements of from 4 to 6 diameters, and the quality of the image usually equals—if it does not exceed—the quality of an ordinary telephoto image. As magnifications are entirely relative, let us assume that the photographer is using a 4-inch lens on a 4x5 film. If he applies a 12-inch lens to his camera, he gets an image 3 times the linear size of that from the 4-inch lens. If he enlarges the image from his 12-inch lens 6 times, he is obtaining an image which is 18 times the linear size of the direct 4-inch lens image. A magnification of 18 diameters may not seem impressive in figures, but it is very substantial in actual practice. (Suppose, for instance, that the image of an architectural detail appears 1/4 inch across with a 6-inch lens; an 18 times linear magnification makes this detail 4-1/2 inches across—324 times the area).

An efficient 4x5 view camera should have a bellows capable of at least a 16-inch extension, permitting the use of a 12- or 14-inch lens on distant subjects, as well as on moderately close subjects.

When using variable telephoto lenses where magnification depends on the extension of the lens from the negative, it is helpful to mark the camera bed in inches (or half inches) beginning with zero at the infinity (or usual working) position of the camera back. The scale can then be marked in either direction from zero. If the camera back (precisely, the negative plane) is over the 4-inch mark on one side of the zero mark and the optical center of the lens is over the 8-inch mark on the other side of the zero mark, the lens extension will be 12 inches. This is an important aid when extension beds are added to the camera or for a camera with both front and back focus.

105

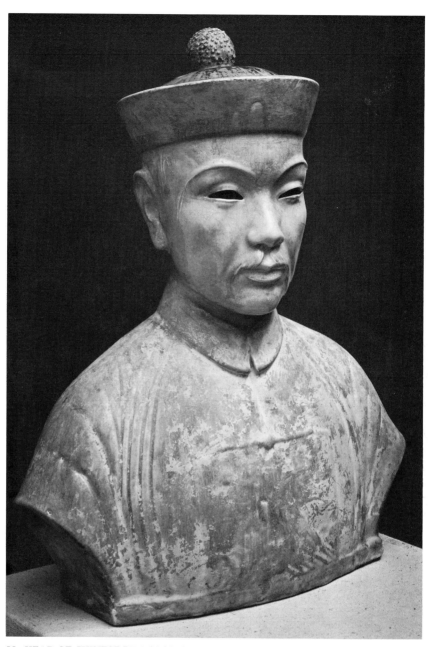

55. HEAD OF CHINESE PHILOSOPHER BY BENIAMINO BUFANO, SAN FRANCISCO, CALIFORNIA. This is a glazed porcelain head of rather subdued coloration. It is a good example of "Museum lighting" which reveals detail in all parts of the subject. For excitement, we tend often to over-dramatize the lighting on works of art and this is sometimes necessary to convey the emotional quality of the object. But at the factual level, the art expert desires maximum information. This was made with diffuse natural light from a window, plus some directional diffused artificial lighting. While the lighting was very soft, the exposure and development of the negative were planned to intensify texture. If required, relatively strong filters can be used to separate subtle colors. With color photography, the quality and color-temperature ($^\circ$ K) of the light must be carefully adjusted to the color response of the material used.

SHOPPING FOR A LENS

The best advice in this instance is basic: acquire the best lenses you can for the uses to which you intend to put them. Whenever possible, acquire a lens from the manufacturer through a reputable dealer. Some highly-reputable firms such as Calumet Manufacturing Company, Chicago, only sell directly to the customer. The advice of a reliable dealer should be followed, especially in acquisition of used lenses and lens accessories. It is impossible to determine by cursory examination if a lens is slightly damaged or poorly mounted in a shutter. Inferior or falsely marked lenses occasionally appear on the market, and only an expert can test for quality and performance. Of course, the ordinary use of the lens will reveal gross defects, and such will be more apparent in enlargements than in contact prints. Certain visible flaws may not be serious; ordinary small bubbles in the glass are harmless (in fact, it is impossible to produce high-grade optical glass entirely free from bubbles). Naturally, if the bubbles were too large or numerous, they would cause some reduction of light transmission, and such a lens would not pass the manufacturer's inspection. Small scratches on the surface of the lens likewise will do little harm to the image, although scratches on the front of the lens may produce flare or a "ghost" image if sunlight or intense artificial light falls directly on them.

Occasionally lenses (or attachments) are produced and sold on the basis of questionable advertising claims for superior performance. No lens can be designed to violate basic optical principles. For example, it is not possible to produce a lens which will give greater depth of field than any other lens of the same focal length used at the same aperture. *Apparent* increase of depth of field may be achieved by sacrifice of definition on the plane of critical focus. All extravagant claims should be carefully investigated. Occasionally a surprisingly good lens or attachment appears at a very low price, so do not equate low cost with inevitable poor quality.

A photographer should buy a lens primarily because it will efficiently meet his requirements. He may also consider a lens as an investment; a fine lens never seriously depreciates in value. This is important, for as he progresses in his work he may wish to trade in one lens for another, and a lens of high quality, in a good shutter, makes such trades more advantageous.

As for the inherent qualities of lenses, we have today—in general—the finest optics ever produced; any good anastigmat made by a reputable firm will form images of excellent quality. However, many old lenses are also of superb design and construction and—with assurance of thorough testing and a guarantee—can be purchased with confidence.

WHAT TO CHECK FOR. Even though it is probably safe to say that the average mass-produced lens of today is equal or even superior to the exceptional lens of 25 or more years ago, this does not mean that we should forego careful checking of lenses, especially used lenses, because they might have faulty mounting or have been damaged in some way. The slightest off-centering of the elements, inaccurate separation of the components, or surface damage can ruin the performance of an otherwise fine lens. Such tests should be conducted by an expert; the photographer is seldom equipped to analyze a lens. Assuming that the lens is of dependable manufacture (and thus can be expected to perform well in the field for which it was designed), the photographer can make the following checks:

Lens surface: does it appear clean and free from abrasions? If a slight mottle

shows in the lens coating, have this checked by an expert; it may have no appreciable effect.

Lens assembly: do the edges of the lens mount appear to have suffered impact, such as if dropped on a hard surface? If so, the lens elements might be a little off center, strained or separated. If cemented elements have separated or disintegrated, such can usually be seen looking through the lens against a dark field. Does the lens "rattle" if shaken? Unscrew each component from the shutter and make this test. But *never* separate the elements of each component. Be extremely careful to replace the components without harming the thread, and be sure both components are firmly seated.

Focus-shift: with the most precise and costly lenses there may be some defect in mounting the lens in the shutter; separation of the components, for example, might not be exactly according to formula. Such could cause a variety of defects in performance, and focus-shift can be one of them. Focus-shift means that exact focus at the largest aperture is not the same at smaller apertures; in other words, the focus changes as the lens is stopped down. Most single lenses (such as

Page 85 the separate components of a convertible lens) must be refocused as the lens is stopped down, but complete combined lenses definitely should not show this defect when used within the distance range for which they are designed. The simple test the photographer can make is this: set up and focus on a distant scintillation—such as the glitter of the sun from a chromium auto bumper. At full aperture, focus with a magnifier on this sharp scintillation. When sharp, close down the lens a stop or two; check again. If still sharp, close down several more stops; even at the smallest stop the scintillation is bright enough to be clearly seen (an ordinary subject would be too dim to evaluate properly). Now, if the lens requires a slightly different focal setting to get a sharp image, we may suspect a focus-shift exists. Set as sharply as possible at the small aperture and then open the lens to near-full or full aperture. Is the scintillation now unsharp? If so, measure the amount of refocusing you have to do to obtain sharpness and submit this data to an expert for confirmation. If obvious focus-shift in a combined lens does exist, the lens should be rejected. Due to diffraction and other causes, there can be a *slight* reduction in sharpness at small apertures, but this is not related to the focus-shift itself. (Zonal astigmatism, especially tangential, is usually the cause of focus-shift.) One of the greatest photographers obtained a single-component Protar of 19-inch focal length but did not know that one had to refocus as a single lens was stopped down, and many beautiful images were unsharp and useless. Hence, a complete lens should *not* require focus adjustment at small apertures (except for depth of field control), but a single lens *may* require focus adjustment.

Correct aperture calibration: we can assume that a good lens is mounted in a

Page 95 shutter on which the lens stops are correctly marked. But it is not uncommon for a good used lens to have been mounted in a new shutter and that some discrepancy in the calibrations may exist as a result. One simple check: make an exposure of a continuous-value subject such as a wall at full aperture, and then another exposure at two stops smaller (4 times the first exposure). If the lens at wide aperture works at f/5.6 and the exposure was 1/100 second, at f/11 the exposure would be 1/25 second. Develop both negatives exactly the same and note if there is any density difference. If there is, it can be due to (1) shutter-speed discrepancy (the shutter should be tested and evaluated) or (2) error in stop calibrations. To correct the latter will require the services of a good optical technician; it is primarily a matter of re-engraving the lens stop positions on the scale. Once any two points are known, the others can be established by geo-

metric plotting (as with focus scales). The Sinarsix can be used to evaluate lens-stop performance, using a white card in sunlight as the "target" subject.

Flare: this is discussed in general on page 101, but the particular flare produced in the lens (seen as a central area of obviously higher density in the negative) can be serious. It is often due to poor blackening of the edges of the lens (omission by the maker—rare) or flaking-off from age or impact. Older lenses may have been "soft-coated" and in the process of repeated cleaning part of this anti-reflection coating removed. Correction of these defects is, of course, a careful technical procedure. After correction, if the flare persists, we can assume the lens is of defective design. It is impossible with any lens to avoid some flare and secondary images when the sun or other bright light sources is included in the field of view. The field of view is the *full circular field* of the lens image, not just the rectangular picture area within it. Hence, the entire surface of the lens usually should be shielded from the sun (and also the possibly reflective inner edge of the lens flange); for this reason a lens shade is *always* advised for maximum image crispness.

One final word: notwithstanding claims for "universal" lenses, there is no such thing available. Remember that lenses are calculated for maximum performance at specific distance ranges. Be sure you know the coverage, function and performance of your lens (or lenses)!

56. RURAL SCENE, CALIFORNIA. Sinar Camera, 121mm Schneider Super Angulon lens, Polaroid Type 55 P/N 4x5 Land Film. (Engraving made directly from the original Polaroid Land Print.) This was a very contrasty scene, beyond the range of the negative material to record without pre-exposure (see page 134 et seq.). The white house registered more than 1000 c/ft² and the dark shadow areas in the foreground less than 6.5 c/ft². Placing the gray logs (reading 50 c/ft²) on Zone V, put the shadows on Zone II (below the threshold of the Type 55 P/N film) pre-exposing to Zone III and giving full development time preserved detail in the darkest shadows, with only a slight weakening of maximum black print values. The high values, of course, were not affected. Pre-exposure may appear as a light veil over the low values of the Polaroid Land print, but can be "printed down" when a negative is used.

109

LENS FORMULAS

The Photographic Optics Section of the *Photo-Lab-Index*, is devoted to essential lens formulas and optical data. These lens formulas relate to lens *usage*, not lens design. For those interested in the more advanced photographic optics, and for general information on the lens types, design and function, I cannot too strongly recommend *Optics* by Arthur Cox.

Remember that formulas may be stated in different ways and different symbols used.

The following particularly helpful formulas are taken from the Photographic Optics Section of the *Photo-Lab-Index:*

FOCUSING SCALES. Calculation and calibration. It is frequently desired to prepare a focusing scale for a given lens. Trial-and-error methods are laborious, time-consuming and inaccurate, particularly for lenses of short focal length. For a lens of any focal length, f, the distance x from the "infinity" mark on the scale is given by the following formula:

$$x = \frac{f^2}{u - f}$$ where u is the subject distance to the lens.

THE POWER OF A LENS. To simplify lens calculations, opticians frequently use the power of a lens rather than its focal length. The power of a lens is equal to $1/f$ where f is in meters, and the unit is called the diopter. Thus a lens of 25cm focal length—.25 meter—has a power of 4 diopters. Since the diopter is a reciprocal term—$1/f$, calculations of lens combinations reduce to the form:

$$P = P_1 + P_2$$

Where P is the power of the combination
Where P_1 is the power of the camera lens
Where P_2 is the power of the supplementary lens

CALCULATION OF DEPTH OF FIELD. Circle of Confusion Fixed. When the camera is focused on a distance u, the depth of field is given by the following formulas:

$$\text{Near limit of field} = \frac{H \times u}{H + (u - f)}$$

$$\text{Far limit of field} = \frac{H \times u}{H - (u - f)}$$

Where H is the hyperfocal distance
Where f is the focal length of the lens
Where u is the distance focused upon

In the *Photo-Lab-Index* numerous problems and solutions are given with the formulas.

SHUTTERS

A shutter is a device which admits light through the lens to the sensitive materials. Most lenses come equipped with shutters. View camera lenses and lenses for all but focal-plane cameras require shutters of some kind. Process lenses may come in barrel only (with diaphragm).

Shutters are so calibrated in their action as to operate at certain conventional "speeds." Formerly the series of speeds was 1, 1/2, 1/5, 1/10, 1/25, 1/50, 1/100, 1/200 (or 1/250), 1/400 (or 1/500) second. The modern geometric

progression (a great improvement) is: 1, 1/2, 1/4, 1/8, 1/15, 1/30, 1/60, 1/125, 1/250, 1/500 second. With this sequence there is a direct geometric relationship over the entire range with the lens stops (which progress one way or the other by a factor of 2 or 1/2).

There are not many shutters that are accurate at all speed settings. The between-the-lens shutter is a very intricate mechanism and the best are costly. Shutters are usually most accurate in the middle-speed range—say from 1/5 or 1/4 second to 1/50 or 1/60 second. As the speeds lengthen toward the 1 second value, they are often longer (slower) than listed; as they proceed toward the fast settings, they also become slower. The important thing is not to try to adjust them to correct speeds (as they probably would not retain them) but to know what the real "speeds" are so that computations can be made with reasonable accuracy. Focal-plane shutters also vary from the precise speed values because of a number of factors inherent in the mechanism.

In terms of exposure it is not the *speed* of the shutter but the *light-transmission* that is important. A between-the-lens shutter must open and close within the stated time interval. Starting with a very small aperture, it opens to full aperture, remains fully open for a part of the exposure and then closes to zero. The focal-plane shutter, on the other hand, is, in an equivalent sense, "open" for the full time of the exposure; a slit of certain width passes across the negative at a certain speed. Hence, it is the most efficient of all shutters and should be the most consistent in performance at all speeds. The efficiency of the focal-plane shutter varies with the distance of the slit from the negative; the greater the distance, the greater the "penumbra" effect and the less efficient the shutter will be.

Figure 57A shows the performance curve of a focal-plane shutter. Note that within the time (length of exposure) there is a relatively large transmission of light. Figure 57B shows the performance of a good between-the-lens shutter at fairly high speeds. Within the same length of exposure the transmission is indicated by a curve. As the shutter opens and closes, there is an increasing, and then a decreasing, amount of light transmitted.

This is a generalization. There are many factors which will modify the performance of any between-the-lens shutter. They are:

Shutter design: some shutters are simply more efficient than others because of their leaf and tension-spring design and operation.

Shutter fatigue: springs get tired, leaves get dirty and the mechanism can deteriorate.

Shutter speeds: if the shutter opens and closes at about the same rate for all speeds, it is obvious that the "peaks" will be more accurate at the slower speeds. But if the "dwell" is sluggish, the exposures will be longer than listed. If the opening and closing rates are sluggish, the speeds may be longer but the transmission less than optimum.

Lens aperture: all the above applies to *any* aperture of the lens with the focal-plane shutter but to *full* aperture of the lens with the between-the-lens shutter. As the apertures are reduced in diameter, the complete curve of the between-the-lens shutter action is not realized. Suppose we are using a lens stop about half the diameter of the full aperture (f/16 versus f/8, for example). Part of the opening and closing of the shutter is not effective in transmitting light. As shown in Fig. 57B, there is a definite cutoff at both ends of the performance curve; there is a greater efficiency, proportional in relation to the diameter of the aperture; the shutter is fully "open" for a *longer proportionate time* than with the full aperture. As the lens aperture is reduced, the efficiency of the between-the-lens shutter increases.

111

Most shutters do not permit settings between speeds except those shutters incorporating air-valves (and at only the slower speeds—1 second to 1/10th second). A practiced ear can judge approximate shutter speeds up to about 1/25 second; higher speeds sound as a "click" and visually we sense only a flash of light.

With many shutters—perhaps with most—the progression of apertures *upwards* (f/8 to f/45) may give slightly different values than when the progression is *downwards* (f/45 to f/8, etc.). This derives from a mechanical situation and is important only with the smaller stops.

SHUTTER OPERATION. Operating the shutter by the finger is hazardous; using a stiff cable release can also jar the camera. With the Hasselblad on the tripod we should release the mirror and auxiliary shutter first and then operate

57A. Diagram illustrating efficiency of focal-plane shutter, In effect, the shutter is fully open for the entire duration of exposure, and there is no difference in efficiency because of lens-stop size.

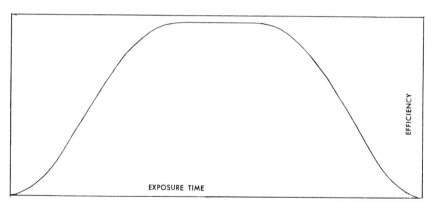

57B. Diagram illustrating inefficiency of between-the-lens shutter. Shutter opens and closes within the exposure time, with varying span of maximum efficiency depending upon speed. Efficiency varies also in reference to lens-stop diameter. An "alive" shutter which opens and closes rapidly is most efficient at the slower speeds. Hence, practical testing of shutters at all speeds is advised.

It should be clearly understood that *exposure* represents the amount of light passing through the lens at a given aperture and at a given shutter speed. 1/8 second at f/8 is (in principle) the same as 1 second at f/22. If we set the shutter at a given speed the curve would vary at different aperture settings; we would be getting different *exposure* values. These curves represent only the *comparative efficiency* of the focal-plane and the between-the-lens shutters.

112

the lens shutter, as this will minimize possible vibration. With pressure button shutter releases (such as the Contarex) we should never "poke" it; give a steady pressure with the ball of the finger supported by the ring surrounding the button.

With cameras having focal-plane shutters the direction of the shutter curtain should be noted. The Speed Graphic curtain moves from top to bottom when the camera is held in normal horizontal position. This is from bottom to top of the *image*. Many 35mm cameras have shutters that move horizontally (when the camera is in normal horizontal position). Experimenting with the effects of subject-motion and direction of the focal-plane shutter curtain movement we should remember that the image is upside-down on the focal plane and the direction of movement thereon is opposite to the actual movement of the subject before the camera. If the movement of the subject is across the field of view or if we follow the subject with the camera, the length of the image will vary depending upon the direction of the shutter-curtain movement (this is modified by the actual shutter speed employed). With a shutter curtain that operates from top to bottom, a moving subject will be inclined forward in the direction of its motion (the bottom part is exposed "early" and the top part is exposed "late"). Various tensions on the shutter curtain alter its actual speed across the focal plane. As a rough example—a shutter curtain that would drop across the focal plane in 1/25 second would give—by narrowing the slit—progressively shorter exposures for any part of the image and enhancing the effect of "sharpness"—but the all-over time lapse would remain 1/25 second and any distortion of the subject would relate to this shutter curtain interval and the speed of movement of the subject.

Following a moving subject with a camera with a between-the-lens shutter does not alter its shape. This may produce a sharper image of the principle subject but the background may show a definite "blur." This effect is rewarding when photographing sports, running game, speeding cars, etc.

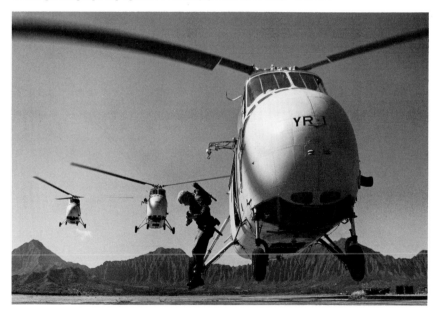

58. HELICOPTERS, OAHU, HAWAII. (Courtesy, the First National Bank of Hawaii.) Made with a Hasselblad 1000F camera at 1/1000 second exposure. Note the curved rotor; an effect produced by the focal-plane shutter.

113

The faster the opening and closing action of the shutter, the more accurate the performance of the shutter will be at various apertures. The true "speed" of the shutter is something which can be determined by photographing a rotating disc; the movement of lines and spaces of known size is a key to the actual speed of the shutter from opening to closing. Unfortunately, we confuse light-transmission values with shutter "speed." With static subjects "speed" would have no meaning; we are really concerned with the volume of light passed through the lens. With light-energy recording devices we can translate the values into "speeds" (in fractions of a second). Hence, when making exposure tests, it is better to keep to the larger lens apertures and use shutter speeds in the middle range of the scale. Ideally, we should use full aperture and a moderate shutter speed only—and vary the actual exposures by moving the light back from the test card (following the Inverse Square Law) and/or using neutral density filters.

Obviously, with time exposures shutter performance is of little consequence. Too-long exposures will, of course, invite the reciprocity effect (Books II, IV and V) and should not be used in our basic testing procedures.

We should not assume that the markings on the lens-stop ring of the shutter scale are correct, especially with small shutters. Before the shutter speeds are evaluated, the apertures should be checked; if possible, the calibration marks *Page 95* should be corrected. The simple definition of an f/stop is: the f/number is the ratio of the diameter of the stop to the focal length of the lens at infinity focus setting. Hence, a lens stop 1 inch in diameter with a lens of 8-inch focal length would be designated f/8. As the transmission of light relates to the area of the lens opening, the progression of lens stops is geometric; each stop, diminishing in transmission by a factor of 2, is given a number about 1.4x that of the preceding stop (actually, the square root of 2, or $\sqrt{2}$). The progression is, therefore, as follows: f/1, f/1.4, f/2, f/2.8, f/4, f/5.6, f/8, f/11.3, f/16, f/22.6, f/32, f/45.2, f/64, f/90.4, f/128. In practice, the decimals above f/8 are omitted. The European sequence uses slightly different numbers (but the geometric progression is the same): f/1.4, f/1.6, f/2.3, f/3.2, f/4.5, f/6.3, f/9, f/12.5, f/18, f/25, f/36, f/50, f/72, f/100, etc. Sometimes the largest stop of a lens (which defines the "speed" of the lens) might be one of the European system numbers; many of the older Tessars, for example, had a "speed" of f/4.5, but the next stop number was f/5.6, and from there on the American system prevailed.

With due consideration for absorption of the glass and the small residual reflections from coated lens surfaces, the 1:1 ratio of subject luminance to image brightness would almost be achieved with a lens stop of about f/0.5 value.

This brings us to consideration of the "t-stop" values. This was an attempt to establish a lens aperture system which related to the true transmission of the lens and not merely the mathematic "ideal" transmission. Before the days of *Page 101* optical coating of lens surfaces, the reflection from each air-glass surface was about 4%, and this resulted in a loss of transmission of 4% for each surface (and an accumulation of lens flare). With a lens of 6 air-glass surfaces there was a loss of about 20% and with 8 air-glass surfaces a loss of about 27%, plus absorption loss. Obviously this seriously affected the accuracy of exposure calculations, but it was possible to evaluate the true transmission and give a stop number which was compensatory. This was fine for exposure but distorted the other mathematical values—depth of field, hyperfocal distance and other optical qualities dependent upon the real diameter of the lens stops. With the universal application of optical coating, all lenses have almost the same transmission values; only the thickness of the glass must be considered, and this is rather a small factor with most lenses in use today. Rather than be involved in a stop system that has some basic optical errors, it would be best, if uncoated lenses were

114

used, to adjust another exposure parameter (such as ASA film speed value) to bring the lens to normal operational values. But do not alter film speeds to adjust for filter and lens-extension factors.

The basic meaning of exposure is simple—it is the amount of light which falls upon the negative within a given time. The negative does not "know" what the subject is—or what its luminance (reflection) values are. It responds only to the light from the subject gathered by the lens and transmitted through the lens aperture used, controlled in time by the shutter. Hence, it is obvious that lens stops and shutter "speeds" should be accurate within reason (around ±10%).

Automatic diaphragms, which quickly close to a pre-set position when the shutter is triggered (just before the shutter itself functions), are a great invention, but if they become sluggish, the shutter will operate before the diaphragm is fully closed. Such assemblies must be kept in first-class condition.

Refer to the *Photo-Lab-Index* for formulas and tables showing required shutter speeds to arrest moving objects. With a focal-plane shutter if the direction of motion of the subject coincides with the direction of motion of the shutter curtain, the subject is elongated; if in opposition, it is compacted. With a focal-plane shutter operating vertically a moving train or car will show distortion; the shutter-curtain slit overtakes the lower part of the image first, and the upper parts are recorded at slightly later moments, causing the moving subject to "lean" forward.

A closing comment: with the focal-plane shutter nearly *all* of the light that passes through the lens stop (aperture) reaches the film, and the geometric properties of the lens stop (in terms of depth of field, etc.) are sustained. With the between-the-lens shutter the shutter itself acts as a diaphragm—first as a very small stop, increasing to maximum and again closing to zero. For part of the time, the practical effect is one of a generally smaller stop than the full opening of the lens would suggest. An interesting experiment: put a lens with a between-the-lens shutter on an old Graflex camera set at f/5.6 or f/8. Make an exposure with the between-the-lens shutter and then another one using the same lens stop with the focal-plane shutter; there will be a marked difference in the focus-differential effect—more depth with the between-the-lens shutter and a strong "isolation" of the plane focused upon with the focal-plane shutter.

CARE OF SHUTTERS. Always keep shutters at the lowest possible tension when they are not in use. Focal-plane shutters should be kept at Tension 1, and between-the-lens shutters left uncocked. Shutters with extra high speeds require a setting on the dial which brings a special spring into action (for example, the Compur shutter on the Super Angulon 121mm lens at 1/400 second); when set, this spring is under tension whether the shutter is cocked or not, and the shutter should never be left for any length of time at this high-speed setting.

Warning! Only an expert should touch a modern lens and shutter assembly for repair or adjustment.

Page 293

SYNCHRONIZED SHUTTERS. For a description of the use of synchronized shutters with flash equipment, see page 282.

Most modern shutters have built-in synchronization settings, but solenoid releases are still available for old-type shutters. In cameras equipped with electric trippers (synchroflash equipment), operation of the shutter through the electric circuit gives exceptionally smooth action. In fact, many photographers using hand-held equipment (such as press cameras, twin-lens reflex cameras, etc.) prefer to operate their shutters with the solenoid releases, with or without flash.

115

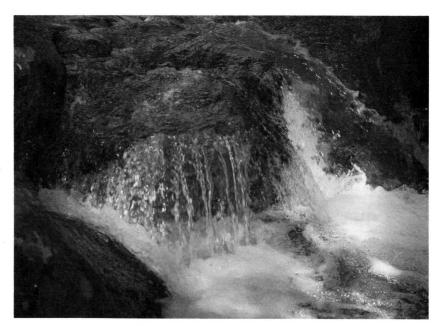

59A. CASCADE, made at 1/250 second,
Hasselblad 500C and 150mm lens. Water is
fairly "frozen," giving a glassy effect.

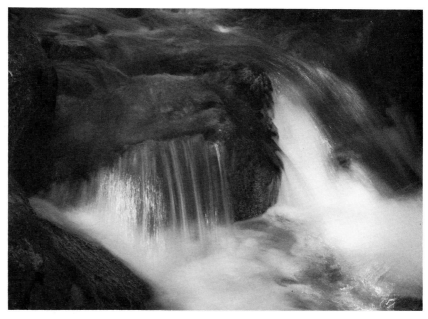

59B. CASCADE, same equipment as 59A,
but with shutter speed of 1/4 second. Water
shows movement, and this is probably a
more realistic effect.

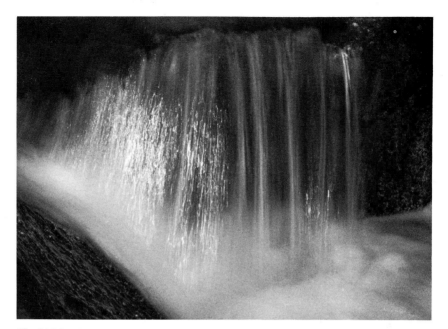

60. CASCADE. Enlargement of section of Fig. 59B. The water shows movement; the degree of which is most clearly revealed by the "trails" of the scintillations. An aesthetic question is involved: do we "freeze" water (thereby giving it the appearance of glass) or do we allow for some impression of movement (which, if not over-done, conveys the impression of fluent motion)? Actually, some impression of what the eye sees is probably the best criterion. Speed, distance, configuration, etc., all influence the validity of the result. A static object, such as a rock, establishes a point of reference.

ELECTRONIC SHUTTERS. At the time of writing, this new approach to exposure control promises great improvements in accuracy and reliability. Many systems are under investigation and a number of devices are in production and use. The theory and design are too complicated to present here. Some devices, such as the Polaroid Automatic Colorpack Land camera "electric eye" shutters are of very high order of sensitivity and encompass a tremendous exposure-time range. Other shutters, some of conventional appearance, are activated and controlled by a variety of electronic systems. At this time it is proper to suggest that the photographer make extensive inquiry into the electronic shutters available. An important point—always be sure that the shutter system offers adequate *control* of exposure values; a purely automatic device is not appropriate to creative photography.

Fig. 38

TESTING SHUTTERS. Devices are obtainable (or can be made up with comparative ease) which—using a phonograph turntable and a chart with properly spaced lines, etc., will indicate actual shutter *speeds.* They do not indicate actual shutter light-transmission, which, of course, is important for accurate exposure values. To check the latter many good photo-technicians and service shops have electronic devices which translate light-transmission into *relative speeds;* at a setting of 1/100 second, the device might indicate 1/80 second (although the shutter might actually open and close within 1/50 second. With this indication, the lens aperture used could be reduced about 1/5th stop to compensate for the actual shutter transmission value.

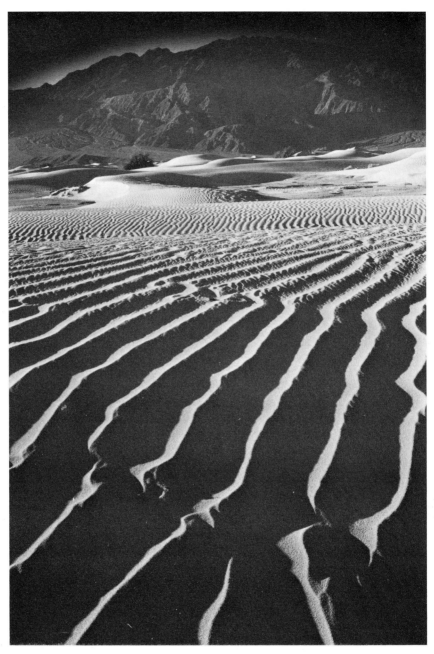

61. SAND DUNE, DEATH VALLEY, CALIFORNIA. This is an excellent example of a frequent disaster! A 5x7 camera and a 5-3/4" Zeiss Protar lens were used. The composition was carefully worked out, using the front tilt to correct for near and far focus. The lens covered the scene very well. Then the lens shade was put on the lens (without checking on the ground glass!). The resultant vignetting ruined the picture. I have included it in this book as an example of the need for constant checking and cross checking of equipment in the field or studio. Refer to page 120 for suggestions on how to avoid such accidents.

118

LENS ACCESSORIES

LENS SHADES

With the advent of optical coating, lens reflections were greatly reduced and the effects of flare from random light striking the lens likewise minimized. However, the direct rays of the sun falling upon the lens and/or bright diffuse light from brilliant surroundings will produce flare unless the surface of the lens is protected by a suitable shield. Modern lenses—many with 8 or more air-glass surfaces—will produce some slight flare even if optically coated. The outer edge or rim of the lens barrel can also catch sunlight and cause trouble.

Hence, the first "rule" is that the direct sun be shielded from the entire front surface of the lens. If we are working into the sun, especially with wide angle lenses, this may be difficult to accomplish without producing a vignetting effect in the top areas of the picture. We can then carefully shield the lens so that the sun does not strike the area of the open diaphragm. In this way we will avoid much of the flare and also the very annoying "hot" image in the shape of the diaphragm (round or hexagonal, depending upon the configuration of the diaphragm's leaves). This applies to the lens stop actually used. If we are working with lenses with pre-set diaphragms, we may have a problem; we will have to release the diaphragm to the desired stop, set the lens shade and then proceed as usual. On small cameras with pre-set lens-stop design but with a release by which we can close the lens stop to the desired position, the problem is simple. Of course, all this implies we are working from a tripod, as the camera position controls the angle of the sun falling upon the lens.

With cameras without adjustments (35mm, Hasselblad, etc.) a lens shade could be designed for every lens which would function to maximum degree for that lens alone. I am perplexed at the scant attention that has been given this important problem by the manufacturers! Most lens shades (that attach to the lens) are round or broadly square; even when they do make a fairly clean cutoff, the inner surfaces are not sufficiently baffled and light is reflected up into the lens with sometimes distressing effect. A bellows-type lens shade is now available for the Hasselblad: this is a very rewarding accessory.

Fig. 64

The exact size of the lens shade (signifying the maximum cutoff at infinity setting when the lens is closest to the film and the angle of view is greatest) is determined when the lens is fully stopped down. We often visually inspect the image on the ground glass or in the pentaprism finder when the lens is wide open and observe no vignetting from the lens shade. However, as we stop down and the depth of field is increased, the edge of the shade may show a very fuzzy and indefinite edge and an obvious fall-off of illumination around the borders of the image may occur. The lens shade must be designed to show no such vignetting at the smallest lens stop.

The interior reflections of the lens shade present a difficult problem. First, the interior should be baffled with the inner angle of the baffle designed so that no light can strike it and reflect to the lens. The outer (forward) angle of the baffles may reflect light to the inner angles, producing a small amount of reflection, but if the entire interior of the lens shade is painted a dark matte black, the performance should be quite good. However, the lens shade should be designed along the lines of Fig. 64, the front part of the correct size to prevent vignetting and the body of the lens shade a fairly large "box" with sloping sides at a non-reflecting angle in relation to the lens. Such a lens shade is most effective—but also rather large and space-consuming in the camera case.

119

With bellows shades for view cameras the units can be raised and lowered (I do not know of any which can be adjusted sideways), compacted or extended to match any reasonable camera adjustment. We must not forget to make such adjustments; we may not be aware of any vignetting effect when looking at the ground glass with the lens wide open, and with the lens stopped down it is sometimes very difficult to be aware of vignetting because of the dim image.

One positive way to check for vignetting by the lens shade is to set the lens at the stop to be used. Then, standing in front of the lens shade, look along one edge through the lens stop to the edge of the ground glass (on the opposite side, of course). If you can clearly *see* the edge of the ground glass, and a bit beyond, you are not vignetting the image. If the edge of the glass is slightly shaded or indefinite, you can be sure that some vignetting will occur. It takes a little practice to be certain you recognize what you are seeing, but it is a positive check against possible vignetting trouble! All edges of the ground glass should be examined through the lens shade and lens if camera adjustments are employed.

Not only will direct sunlight falling on the lens cause trouble, sunlight (or bright artificial light) falling upon the polished monorails of many view cameras or even on the polished wood base of an old-fashioned camera can reflect up into the lens with serious effect. I have frequently shielded the lens carefully from the sun with the dark slide of the film holder only to get a serious flare from the sunlight bouncing up from the monorail rod. Of course, a complete lens shade (not just a top shading device) will prevent such reflections.

Without a lens shade, one can shade the lens from the sun by using the slide from the film holder, or a card. Using the hand is hazardous; the uneven shape might vignette a corner or upper edge of the image. If the card is held horizontally its shadow can be brought down to cover the lower edge of the diaphragm; this will serve to reduce the very obvious flare spots which occur when the sun is near the edge of the field of view.

Filter holders in front of the lens will frequently reflect the sun into the lens; shading the lens itself may not be enough. Glass filters in *front* of the lens can also produce reflections, and as the surface of glass filters is seldom optically *Fig. 37* coated, the reflections can be more than one would expect. Gel filters will also create some reflections of this kind. Filters *behind* the lens give minimum reflection effects (except from the light of the image falling upon the film!). As the filter surface is flat (that of the lens is usually curved and optically coated), such reflections can be troublesome (usually creating a central broad flare in the *Page 122* negative). (See also "Filters.")

The ideal shade is the extendible bellows type (familiar with fine motion-*Figs. 62, 63,* picture cameras). Here we have control of the front opening for any lens used *64, 65* as well as an efficient light-absorbing "box" in the form of blackened bellows, quite large and distant from the lens axis. This is by far the most satisfactory device for adjustable view cameras, as it can be extended and moved to relate to the rising, falling, and tilting front, etc. (available for Arca, Sinar, etc.).

The fixed lens shade (which attaches to the lens) cannot be used with view cameras when adjustments of the front component (rising, falling and sliding front, front tilts and swings) come into play because these displace the axis of *Fig. 61* the lens and create greater lens coverage problems than when the lens is in normal position. Also, the rear component adjustments, such as rising, falling and sliding back, will increase the field of coverage and the lens shade cutoff may show. Rear tilts and swings *on axis* do not displace the image in reference to the axis on the lens. The fixed bellows lens shade must likewise be limited to "on-axis" position; when adjustments are used the extension of the bellows shade must be reduced.

120

62. CALUMET CAMERA AND LENS SHADE. The shade includes a filter holder (see Fig. 65, page 125). In use, the lens shade assembly would be moved back to cover the lens. Note the adjustable design, and support system.

63. ARCA SWISS CAMERA WITH LENS SHADE. This shows the "bag" bellows (see page 51 et seq.). In use, rear part of lens shade would be moved back to cover lens. Sliding "panels" in front assembly permit very precise shielding of the lens and a filter-holding frame can be attached to front or back assemblies.

FILTERS AND POLARIZER

In black-and-white photography the colors of the subject are rendered in various shades of gray, the shade for any particular color depending on (1) the color sensitivity of the negative emulsion, (2) the color and reflectance of the subject, (3) the color and intensity of the light falling on the subject, and (4) the type of filter used. What is generally considered "correct" color rendition is achieved by use of a Wratten No. 8 (K2) filter with Type B panchromatic film in daylight. However, "correct rendition" is one thing and *expression of values* is another; the creative photographer is primarily concerned with the latter and may therefore wish to use filters in somewhat unorthodox ways.

Application and function of specific filters to specific problems are fully described in *Basic Photo Books* II, IV and V and the *Polaroid Land Photography Manual,* but some of the general properties of filters deserve attention here.

COMPOSITION OF FILTERS

A color filter is simply a color screen placed (usually) in front of the lens to withhold from the negative a part of the spectrum of the light reflected from the subject. The amount and color of the light withheld depends upon the characteristics of the filter.

Filters are provided in four general types:

1. **Gelatin films.** I prefer these "gel" filters (thin sheets of dyed gelatin) which are made by Kodak and designated as Wratten filters. They have excellent optical quality and, with care, will last a considerable time (they are lacquered). They are much cheaper than the good glass-mounted variety, but are fragile.
2. **Gelatin film mounted in "B" glass.** (Sturdy, optically adequate and recommended for general work.) In time, optical problems may develop due to strain, nonplanar glass surfaces and defects in the "cementing" substance. The "B" glass is not of sufficiently good quality for use in photography with large-aperture lenses of long focal length (those used in process work, map-making and on large copying cameras), and unmounted gel filters should be used for these purposes.
3. **Gelatin film mounted in "A" glass.** (Extremely flat, optically surfaced glass.) These are precision assemblies of high optical perfection—expensive, but essential in special work such as the making of color separation negatives, high-magnification telephotography, etc. They require the same care as fine lenses.
4. **Colored-in-the-mass optical glass.** (The most durable type.) These filters of stained optical glass (sometimes opticoated) are highly desirable for the more expensive camera systems. They are, of course, of highest quality and permanent. They are also expensive—in the same related price category as fine lenses. But what is the use of buying a fine lens and then diminishing its performance with a poor filter?

All in all, for practical photography I believe the gel filters are best, although for most photographic work good "B" glass filters are entirely satisfactory. Both are obtainable in squares and circles in a wide range of sizes.

In use, a light filter becomes a part of the optical system of the lens, adding to it two air-glass surfaces and thereby contributing to flare and reduced transmission of light—and also impairing the definition of the lens image if not opti-

Fig. 37

cally plane. Gel films are so thin that they have little optical effect, but their lacquered surfaces are reflective.

Tiffen and other manufacturers produce combination lens attachments and "B" glass filters in various sizes and many types, including polarizers. Kodak provides gel filter holders in a 2-piece unit in 2, 3, and 4-inch sizes (square) which can be adapted to the Tiffen accessory series and also manufactures the Pola-Screen in circular 3-1/2 inch size.

There are many makes and types of filters, but unfortunately they are not uniform in characteristics. Two filters of different makes, although appearing the same to the eye, may have different effects on the negative. They cannot be judged by eye, either for color transmission or for optical quality.

EXPOSURE FACTORS AND FILTER DATA

Since a filter withholds some light from the negative, the exposure normally required for a certain subject and a given type of negative emulsion does not suffice when a filter is applied. The normal exposure must be *multiplied* by a factor which depends not only on the filter itself but also upon the color sensitivity of the negative emulsion (as well as on the colors of the subject and of the light falling on it). The exposure factor for a K2 filter in daylight may range from 2 to 4x. A filter which transmits yellow and red light requires a higher factor when used in high mountains where there is more blue light than, say, on the seacoast in late afternoon when light is richer in red. The 29 filter has an approximate factor of 25x with most panchromatic films and cannot be used with orthochromatic film (that type of emulsion is insensitive to red light passed by a red filter).

In *Kodak Wratten Filters for Scientific and Technical Use* (published by Eastman Kodak Company) all of the Wratten filters are listed, and their characteristics (including exposure factors for filters in common use with standard emulsions) and spectrophotometric absorption curves are given. To the prac-

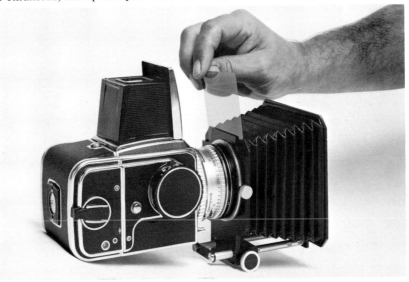

64. HASSELBLAD PROFESSIONAL LENS SHADE. Adaptable to a variety of Hasselblad-Zeiss lenses, it also allows for insertion of 3-inch square gel filters. This type of lens shade is of maximum efficiency. See Figs. 62, 63 and 65.

123

tical photographer these curves are helpful only in a broad general way; their exact values have little application in the usual run of work. The Kodak data book, *B-3, Kodak Filters for Scientific and Technical Uses,* contains much practical information on the theory and use of filters, including Pola-Screens. Since Wratten filters are standard, no others are mentioned here. Other manufacturers' filters are covered in the *Photo-Lab-Index.*

KODAK FILTERS

Wratten Filter No.	Color	Purpose
3	Light yellow	Reduces light haze (aerial photography)
4	Yellow	Absorbs UV, corrects Panchromatic emulsions to match eye response
6	Light yellow	Darkens blue (partial outdoor correction filter
8	Yellow	Darkens blue (standard outdoor correction filter)
11	Yellowish-green	Daylight correction for Type C Panchromatic film. Tungsten correction for Type B
12	Minus blue	One of the best general landscape filters
13	Dark yellowish-green	Stronger than No. 11; tungsten correction for Type C Panchromatic films
15	Deep yellow	Absorbs some blue and green light, darkens sky
23A	Light red	Contrast filter, absorbs some blue and most green
25*	Red, Tricolor	Absorbs blue and green
29*	Deep red, Tricolor	Absorbs blue and green
47*	Blue, Tricolor	Absorbs red, yellow and most of green
58*	Green, Tricolor	Absorbs red and blue; transmits blue-green, green and yellow

*The "tricolor" filters are not sharp-cutting filters; all transmit a small portion of the spectrum adjacent to their main transmission bands. The 29A (red), 61 (green) and 47B (blue) filters transmit much narrower—or sharper-cut—bands of the spectrum.

Photometric Filters (the name is derived from the use for which such filters were originally devised: a laboratory analysis of light from any given source by determining which filters 'of known properties' were required to modify the light to a specific measurable quality):

Wratten Filter No.	Color	Purpose
78	Bluish	Adjusts tungsten light to approximate equivalent of daylight; in other words, changes 2360°K to 5500°K
78A	Bluish	Adjusts 2360°K to 3200°K
80B	Bluish	Permits use of Daylight Kodachrome with photoflood illumination
85	Orange	Permits use of Type A color films with daylight
85B	Amber yellow (salmon)	Permits use of Type B color films with daylight
86	Yellowish	Photometric filter (visual)

Color Compensating Filters (a great variety of hue and density combinations to modify the color of transparencies and color negatives):

Kodak filters are available in yellow (absorbs blue), magenta (absorbs green), cyan (absorbs red), red (absorbs blue and green), green (absorbs blue and red) or blue (absorbs red and green) and in the following densities: .025, .05, .10, .20, .30, .40 and .50. A typical designation would be CC10R, meaning color compensating filter, density peak .10, red.

65. CALUMET CAMERA AND LENS SHADE: Front view, showing filter holder withdrawn, with filter frame attached. A strong light was used to show the interior of the lens shade; note the reflections in the lens, revealing six air-glass surfaces. (Probably eight in all, counting the outer surfaces of the lens.)

125

Light Balancing Filters (filters that balance the *light* rather than control the *color response* of the transparency or color negative):

Kodak light-balancing filters are designed to be used over the lens to change the color quality of the light to obtain the desired color balance with color film—each filter of increasing power in the No. 81 (yellowish) series *lowers* the color temperature of the light by about 100°K, and each filter of increasing power in the No. 82 (bluish) series *raises* the color temperature of the light by about 100°K. The light balancing filters are designated as follows:

"Warming" yellowish filters	"Cooling" bluish filters
Wratten No. 81	Wratten No. 82
Wratten No. 81A	Wratten No. 82A
Wratten No. 81B	Wratten No. 82B
Wratten No. 81C	Wratten No. 82C
Wratten No. 81D	
Wratten No. 81EF	

Some Special-Purpose Filters:

Wratten No. 88A	Infrared (see instructions accompanying infrared film)	Absorbs visual light
Wratten No. 90 (Monochromatic Viewing Filter)	tan	Indicates approximate appearance of subject in monotone values with pan-chromatic film used without filters
Neutral density Filters (available in a variety of densities which can be combined to produce any desired density: 2.00 + .30 = 2.30, etc.)	colorless	Reduces intensities without altering color

POLARIZER

The polarizer is appropriately associated with filters because it definitely affects the tonal characteristics of the photograph. Polaroid is the best known polarizing material and enjoys almost universal use.

Without going into the rather complex theory of polarized light and of the technical nature of polarizing materials, we can briefly describe the effect of the polarizer as follows: light reflected from most surfaces (excluding metals) is polarized; it vibrates in one general plane. The crystalline grid of the polarized material (molecular in size) if set at right angles to the plane of the polarized light will not transmit this light but will freely transmit light parallel with the orientation of the grid. Intermediate settings pass more or less polarized and non-polarized light.

The optimum polarizing angle is 56° to "normal." At this angle we will have maximum polarization of reflected light from glass, water, polished wood, etc.

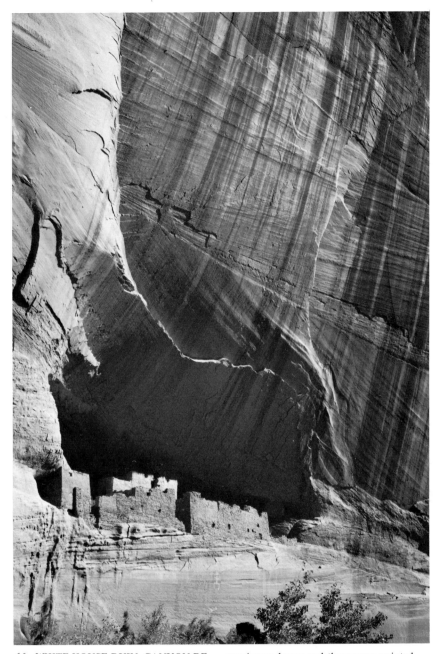

66. WHITE HOUSE RUIN, CANYON DE CHELLEY NATIONAL MONUMENT, ARIZONA. 5x7 Juwel, 7″ Zeiss-Goerz lens, Wratten X2 filter (green). The exposure was planned to hold the deepest shadow value in the cave on Zone II; the high values fell on the appropriate Zones and development was Normal. The Rising Front was used to maximum degree and the camera pointed slightly upwards. Convergence of parallel lines is not obvious as the ruins are not truly perpendicular. The green filter deepened reddish rock values.

127

The polarizing effect is visual as well as photographic, and the film will "see" just what the eye sees *if the polarizer is set at the same angle on the lens.* The polarizing effect can also be seen on the ground glass and in the finders of single-lens reflex cameras.

Maximum polarization of the sky is at about 90° from the sun. The polarizer at non-polarizing angle serves as a neutral density filter with an exposure factor of about 2.5x. As the polarization effect appears in various parts of the image (as we adjust the angle of the polarizer), the transmitted light is reduced for these areas. It is wrong to think of this reduction of illumination as requiring a larger exposure factor; the factor always remains at 2.5x except under certain conditions as described below. If we arbitrarily increased the factor, the non-polarized areas would be over-exposed.

However, when polarizing large surfaces such as water by removing the reflection of the sky, we reveal the details of the stream bed or lake bed or merely lower the value of the body of water (such as a lake too far off for us to be able to see the bottom details). In cases such as this the values of the revealed areas might be quite low, and we should then recalculate our exposures, raising the low values and indicating reduced development because of the elevated high (non-polarized) values. But in most situations the basic exposure factor of 2.5x is applicable.

Aesthetically, we must realize that by removing scintillations and typical reflections we may alter the character of the subject. Frequently partial polarization is superior to total polarization; fortunately, we can *see* the effects we are getting and we are not required to depend upon calculations and formulas (as with color filters).

We can use filters with the polarizer; the effect is one of increased contrast over the use of the filter or polarizer alone. Over-filtration with polarizer and filter can be quite unpleasant, especially if we have lost the impression of sparkle and sharp highlights. Water surfaces and sunlit clouds can become "dead," and skin may assume a flat "waxy" appearance.

With color photography I have found that the polarizer has a slightly warming effect on the color. The polarizer provides the only known way to achieve dark skies in color photography; at 90° to the sun the effect will be quite pronounced. In distant landscapes the polarizer will be quite effective in removing haze (in black-and-white photography, also). With wide angle lenses the sky may show areas of increasing brightness from the area of maximum polarization (90° from the sun).

Polarizing materials can be obtained in the form of plastic sheets or mounted in "B" quality glass or the finest optical flats.

Polarizers should be given the same care as lenses and filters: carefully cleaned and protected from heat.

Page 277
Fig. 133 Cross-polarization is discussed in "Lighting Equipment."

Finally, it is important to repeat that the effects of polarization (as well as of cross-polarization) can be appreciated *visually,* and it is advised that whenever possible the effects be evaluated on the ground glass or in the SLR finder because there might be an inaccurate positioning of the axis of the polarizer when moved from the eye to the lens. While the basic exposure factor of 2.5x is consistant, we can, of course, make adjustments for special effects. As a rule, exposure adjustments are made independently of the polarizer exposure factor.

With cross-polarization the exposure factor is 5 to 6.5x—perhaps more under certain conditions. The axis of the polarizers before the lights must be the same and at 90° to the axis of the polarizer over the lens. Be certain to make a visual check.

128

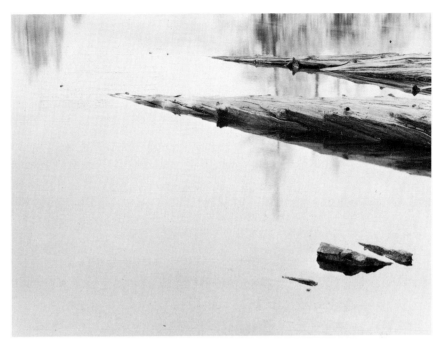

67A. POOL, SIERRA NEVADA, CALIFORNIA. This shows the reflection of the sky. It was exposed to hold detail in the shadow of the log (for the scene as a whole, it is slightly over-exposed).

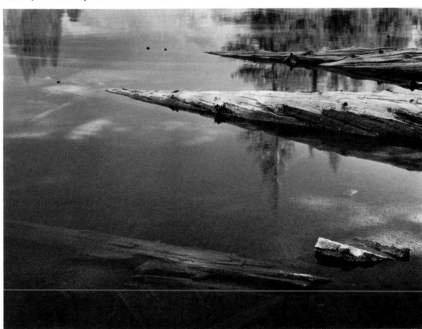

67B SAME. Here the polarizer was used at maximum polarizing angle. The reflection of the sky is practically eliminated, the water deepened in value, and a log lying under the water is revealed. The exposure factor was 2.5x (normal factor for Polarizer).

SELECTION OF NEGATIVE MATERIALS

This subject is properly discussed in other books of the *Basic Photo Series,* but a short listing of some basic negative materials will be helpful here.

Sheet Film: available in a great variety of types and sizes (refer to *Photo-Lab-* *Page 52* *Index.* Sheet film lies flat in the film holder and is therefore recommended with wide angle work (especially in the photography of architecture) where any curvature of the film will result in distortion of rectangular shapes and straight lines. It is superior for copying where a precisely flat negative plane is required. Glass plates are more planar than any film-base material.

Film Pack: available in 2-1/4x3-1/4, 3-1/4x4-1/4 and 4x5. Kodak film packs contain 16 sheets of film. At present, all of the sizes are available in Kodak Tri-X film and the 4x5 size in Kodak Plus-X as well. For all general work the film pack is efficient and functional. It has the definite advantage of light weight, as the adapter for the film pack weighs about the same as a double sheet film holder (thereby taking the place of 8-sheet film holders!). I use 5-film pack adapters, designated for the following development requirements:

Normal	Normal plus 2
Normal minus 1	Special Processing
Normal plus 1	

While I do not advise removing a few sheets at a time for processing, such can be done in the darkroom; if the cap is carefully replaced, there is little chance of fogging the remainder of the sheets. Do *not* tear off the paper tabs if some sheets are to be processed before the entire film pack is exposed.

The Polaroid Land pack cameras (using Types 107 and 108 Polaroid Land *Page 67* film) are simple in operation; packs can be interchanged (with the loss of only one film on each pack).

Roll Film: available in a great variety of types and sizes and in black-and-white and color (again refer to *Photo-Lab-Index*). Selection of film type is, of course, dependent upon the nature of the work to be done. For precise work flatness of the film is important. The 35mm cameras usually are designed for flat film support. Some of the larger roll film cameras (especially those that require a "reverse roll" of the film), may present some film curvature problems. This will be apparent in the rendition of rectangular objects near the edges and corners of the image (and is most apparent with wide angle lenses).

The interchangeable roll-film magazines for Hasselblad, Bronica, Rolleiflex SL66 may be designated for processing as noted for the film pack adapters (see above).

The Calumet roll-film holder (for standard 4x5 view and press camera backs) takes 120-size roll film and provides 10 exposures 2-1/4x2-3/4. With 220-size roll film it provides 20 exposures—all with automatic advance. This roll holder is designed to hold the film on a very precise plane. A special mask is provided for the 4x5 ground-glass focusing screen so that the image can be accurately positioned in relation to the 2-1/4x2-3/4 format. A dark slide permits removal of the roll holder without loss of an exposure. Other roll holders are manufactured for a variety of cameras—the Graflex Rapid-Vance roll-film holder, for example, which can be used with any 4x5 or 2-1/4x3-1/4 camera equipped with the Graflok® back, as well as with the Graflex XL systems. These roll-film holders come in the following formats:

RH/12	2-1/4x2-1/4	12 exposures using 120-size roll film
RH/ 8	2-1/4x3-1/4	8 exposures using 120-size roll film
RH/10	2-1/4x2-3/4	10 exposures using 120-size roll film
RH/20	2-1/4x2-3/4	20 exposures using 220-size roll film
RH/50	70mm	50 exposures on 70mm roll film

(available for use with cameras having the Graflok® back and for the Graflex XL camera systems—Model XLRH/50 70mm).

The cartridge roll film is a recent development and greatly simplifies loading. At the present time it is available for special cameras—mostly for amateur use.

FILM SPEEDS

Film speed can be defined as the measure of the film's sensitivity to light, ASA (American Standards Association) film speeds are based on rather strict technical evaluations, and manufacturers cooperate in stating the ASA speeds and other speed ratings for their films. It is wise to follow the speed recommendations until you have made definitive tests in relation to your own equipment. *Exposure Index* (E.I.) is sometimes used instead of ASA to define the same value. The basic exposure-density relationship is expressed by the shape of the Characteristic Curve (the H & D Curve)—(see Book II)—which is further modified by the amount of development given.

I establish my film speeds by making several exposures on Zone I of the scale and developing for the normal time recommended by the manufacturer. The first exposure would be at the speed recommended; other exposures would be 1.5x and 2.5x, and 3/4 and 1/2 the first exposure given. This would represent the following ASA speeds (if we started at ASA 125):

EXPOSURE	ASA FILM SPEED
Normal	125
1.5x	80
2x	64
3/4	160
1/2	250

Page 247 Upon development, an approximate density of 0.10 above filmbase fog would indicate the effective ASA speed for that particular film used in that particular camera (actually, used with a particular lens and shutter). Hence, a film marked ASA 125 might very well function best at ASA 80, etc.

Full testing procedures are described in Book II *(The Negative)* and in the *Polaroid Land Photography Manual.* In these books film speeds are discussed with reference to exposure meters and their adjustments and artificial lighting in relation to the quality of the lights and the film characteristics involved.

With many shutters we find the speeds uncertain; the true speeds can be determined by electronic testing devices. The basic exposure formula relates to the stated ASA speed, not to the "adjustment speed" as may be set on the exposure meter.

If an ASA speed of 125 assured a negative density of 0.1 for a Zone I exposure, then applying a speed of 250 to this film would move the 0.1 density to Zone II, a speed of 500 would move the 0.1 density to Zone III, etc. To maintain appropriate densities for higher Zone exposures would require increased development (and assure increased negative grain, etc.).

131

THE EXPOSURE RECORD

Page 22 While the *Exposure Record* (Ansel Adams, Morgan & Morgan, Inc.) is primarily a record of luminances and the exposure and indicated development of nega-tives, it also has columns for lens and filter notation. The lens concerns us most *Pages 94, 95* here. It is not so much the basic focal length of the lens that we record but the *extension* of the lens when working with close subjects in reference to the basic focal length, as this gives us the very important lens-extension factor for exposure. We must remember that the lens-stop number represents the quotient of the diameter of the lens divided into the focal length of the lens at infinity setting. A lens aperture of 1 inch with a lens of 8-inch focal length represents f/8 (a focal ratio of 8). In working with near objects we extend the lens, increasing its effective focal length, and this results in the reduction of the *effective* size of the lens aperture. Extending our 8-inch lens to 11 inches and retaining the same aperture would change the previous f/8 stop at infinity to f/11 at the nearer distance focused upon. This represents a 2x decrease in exposure value. The reason is that the *area* of the lens aperture must be considered—not just the diameter—and this involves a geometric progression on the ratio of the square root of 2 ($\sqrt{2}$ = approximately 1.4). We observe the approximate increment of aperture number-values by dividing the square of the basic focal length into the square of the extension; 121/64 = approximately 2. When we extend the lens to twice its basic focal length (thereby setting a 1:1 subject-image size ratio), we must give 4x the exposure: 256/64 = 4. What was formerly f/8 is now f/16 (1/2 the diameter and 1/4 the area). Hence, it is very important that the extension and the extension factor be noted in the *Exposure Record,* as it can make a profound effect on the exposure given.

Some modern 35mm camera lenses are equipped with automatic compensat-ing diaphragms associated with the focus adjustment; as the lens is focused on near objects, the diaphragm automatically opens to compensate therefor. This is a handy device, as it saves us careful measurement and calculation, but it also affects the depth of field of the lens. To preserve optimum depth of field, the next smallest stop should be used (and the exposure figured for normal *at this smaller stop value*). In other words, check to see if the diaphragm opens as the focus is changed for close objects; if so, do *not* apply an increase of exposure based on measurement of the extension—it is automatically taken care of in the lens itself!

Under "Lens" we can write the focal length of the lens used; if no extension was made, just insert dashes in the second and third columns. Dashes will prove that you did not forget to enter an extension! Remember, lens extensions can fool the eye; a 5-inch lens extended to 6 inches represents an exposure factor of 25/36, or about 1 to 1.5. A 50mm lens extended to 60mm would have the same ratio, but one is not usually aware of only a 10mm difference in the length of the lens! A small pocket ruler is a valuable accessory.

The function of the *Exposure Record* charts is not only to document your exposures and indicate processing procedures; it is also *diagnostic* in that if anything goes wrong, you have a reference record with which to check.

It is important to know that the *Exposure Record* can be used to "build" a photograph with artificial light; certain values are visualized, organized on the exposure scale and the lighting adjusted to achieve them in all areas of the subject. A rather extreme example: how would you illuminate the Carlsbad Caverns for an appropriate image? The subject "exists" in total darkness; any

EXPOSURE RECORD

Designed and Copyright by
ANSEL ADAMS

Morgan & Morgan, Inc.
Publishers

PLACEMENT OF SUBJECT INTENSITIES ON EXPOSURE SCALE

SHEET NO.	_SAMPLE CHART_
FILM	_Brand name_ ---
SIZE	---
DATE LOADED	---
DATE EXPOSED	---

Scale reference rows

REL. LENS STOP f/	64	45	32	22	16	11	8	5.6	4	2.8
REL. EXP. FOR V	1/32	1/16	1/8	1/4	1/2	1	2	4	8	16
REL. EXP. FOR I	1/2	1	2	4	8	16	32	64	128	256
WESTON SCALE	-	U	-	-	A	►	C	-	-	-
ZONES	**0**	**I**	**II**	**III**	**IV**	**V**	**VI**	**VII**	**VIII**	**IX**

Placement of subject intensities

NO.	SUBJECT	0	I	II	III	IV	V	VI	VII	VIII	IX
1	Threshold Test (A). Zone I and effective A.S.A. speed		3.2								
2	Test (B) for Negative Density Value V & Optimum Development						(50)				
3	Test (C) for Negative Density Value Control (+ or - Development)					25	(50)				
4	Same						(13)	25			
5	Same						(6.5)		25		
6	Low Contrast Subject, 1:8				Low 13		(50)	High 100			
7	Same, 1:4					Low 200	400	High 800			
8	Same, 1:2						5	10			
9	Landscape subject		13			100	(200)		800	1600	
10	Portrait in Sunlight (with Weston V numbers & equiv. c/ft²)			#9 / 13		200 / 100	#12 / 100	#13 / 200 / 400	#14 / 400		#16 / 1600
11	Relative Values of Arbitrary Guide Numbers for Flash	800	560	400	280	200	140	100	70	50	35
12	Typical Synchro Sunl't — Subj.-skin in sun 400 c/ft² — Dlt Exp Units			2			(200)	32			
12	Flsh Exp Units			+8				+8			
12	(total)			10				40			

Exposure record (per subject)

NO.	FILM SPEED A.S.A.	LENS F.L.	LENS EXT.	LENS X	FILTER NO.	FILTER X	STOP	EXP.	DEVELOPMENT
1	125	8	8	-	--	--	f/16	1/25	Normal
2	125	8	8	-	--	--	f/11	1/25	Normal
3	125	8	8	-	--	--	f/16	1/25	Normal +1
4	125	8	8	-	--	--	f/8	1/25	Normal -1
5	125	8	8	-	--	--	f/5.6	1/25	Normal -2
6	64	8	8	-	--	--	f/11	1/25	Normal +1 or +2
7	32	6	14	5	A	8	f/8	1/25	Normal +2 or more
8	250	12	12	-	-	-	f/16	1 sec	Maximum Development
9	125	8	8	-	K2	2	f/22	1/25	Normal
10	250	8	12	2	--	-	f/22	1/25	Normal -1
11	--	-	--	-	--	-	--	--	--
12	125	8	8	-	--	-	f/16	1/100	Normal

PHOTOGRAPHER

REMARKS OVERLEAF

68. EXPOSURE RECORD CHART. On the reverse side are spaces for Remarks.

133

installed lighting is quite arbitrary, and because of the great size the Inverse Square Law (the intensity of the illumination decreases as the square of the distance increases) is demonstrated with distressing effect. There is simply no point of reference to the reality of the daylight world; the photographer must start with a black void, exploring the unfamiliar shapes as best he can with pilot lights and visualizing the relationships and values of the unfamiliar natural shapes of the Caverns. Assuming that he would choose to work with near objects, he could indicate on the Exposure Record the Zones on which he wishes certain objects to be placed. He can start with the lowest values, broadly illuminating them to fall on, say, Zones II and III. Placement of the high values is achieved by adjusting the intensity of the lights to create the desired luminance. This same technique can be applied to any subject material—portraits, interiors, works of art, etc.

Remember: We can trust what we see in terms of shape, edge and—to some extent—textures, but we cannot be sure of *values* (because of the great adaptability of the eye) and must rely on accurate measurements of the many luminances of the subject to relate them to the desired exposure-zone placements. And we must be able to relate artificial light intensities and quality to the reflective values of our subjects.

Filters and the polarizer, if used, must be entered in the proper column and the appropriate exposure factors noted. If the filter and polarizer are used together they must be *multiplied,* not added. Hence, a Wratten No. 25A (red) filter with an exposure factor of 8x used with the polarizer with a factor of 2-1/2x would require a 20x exposure factor. Lens-extension factors which might be required also must be multiplied. With the above filter, polarizer and a lens-extension factor of 1.5x, the total exposure factor would be 30x and this might create a reciprocity-effect situation! (Refer to Book II, *The Negative.*)

It is important that we do not adjust for filter, polarizer or lens-extension factors by changing the ASA film speed. It is true that with a K2 filter (having a 2x exposure factor) an ASA 125 film speed would be effectively reduced to ASA 64. Part of our training in exposure determination leads to a precise value for the *basic exposure* (refer to the Exposure Formula, page 70). Once the basic exposure is established, we modify it by use of different lens-stops and shutter speeds (retaining the same exposure value—1/8 sec at f/16 is the same as 1 sec at f/45) and *then* we apply the other exposure factors involved. This procedure leads to a better intuitive awareness of precise exposure.

It is very important to recognize the geometric progression of the Zones and the lens stops. If 8 c/ft² is *placed* on Zone III, only 32 c/ft² can *fall* on Zone V and 125 c/ft² on Zone VII. If 400 c/ft² is placed on Zone VII, only 100 c/ft² can fall on Zone V. Each descending Zone represents one-half the value of the next highest Zone and each ascending Zone represents twice the value of the preceding Zone. It is easy to skip Zones and make false entries. Planning a shadow value to fall on Zone III and a high value to fall on Zone VII is correct, *providing* the ratio of luminances is really 1:16. If the high value fell on Zone VIII, Normal-minus-1 development is indicated (to achieve Density Value VII).

PRE-EXPOSURE DEVICES

As described in Book II (*The Negative*), pre-exposure serves to raise the minimum density of the negative to a level just above the effective threshold density. Subject values of low luminance—too low to record on the film—will, with pre-exposure, be rendered as visible densities and be useful. Values on threshold

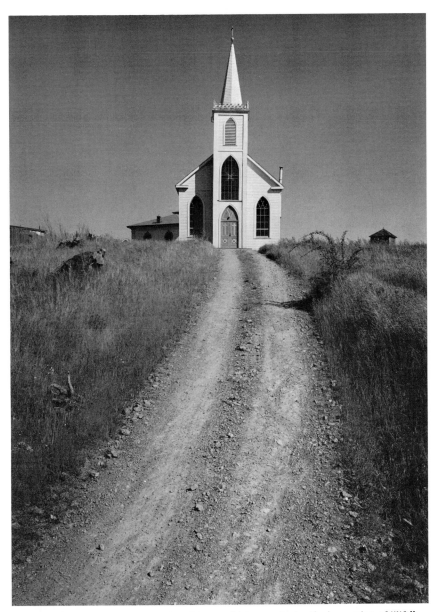

69. CHURCH, BODEGA, CALIFORNIA.
Made with Sinar Camera (with 4x5 back)
and Ross Express Wide Angle (5-inch
focus, f/4) from car platform (see Fig.
30, page 63).

As with the photograph of the Water
Tower (Fig. 72, page 144), the extremes of
the field of view of the lens was employed.
The Ross lens does not have the extreme
coverage of the Schneider Super Angulon
121mm lens and the effects are not so
pronounced, but because of its positioning
near the limits of the field of view the
steeple of the church is slightly elongated

which accentuates the impression of "lift".

The camera was pointed rather severely
down and the back tilted to vertical
position (preserving the accurate
"geometry" of the image). The lens was
tilted to almost vertical position, but with
a slight forward tilt to achieve sharp focus
of the foreground road. The rising back
was also used.

The light was fairly flat; exposure was
normal-minus-2 and development normal-
plus-2. A Wratten No. 12 (minus blue)
filter was used with Kodak Plus-X film
pack, developed in Edwal FG-7, 1:15 water.

(and about one-half that intensity) will be recorded, and values of a stop or two more exposure above threshold will be strengthened. In many cases, where the lowest values fall on Zone I or Zone II, while the high values are one or two Zones higher than desired, the exposure can be reduced to favor the high-value placement and the low values retained by proper pre-exposure of the negative. I adjust the ASA speed of the negative so that an exposure of a single luminance on Zone I will yield a density of 0.1 above filmbase-fog. Pre-exposure should be sufficient to give this density, although we can pre-expose to Zone II. Pre-exposing higher on the scale merely produces an effect of fog (with loss of contrast). Methods of pre-exposure include:

1. Flashing the negative to a fixed-value light in the darkroom. Unless we have very sensitive light-control apparatus and are ready to do some precise calculations, it is best to approach this method empirically. With a weak light (say 10 watts) about 20 feet distant, give several exposures to different areas on a strip of film. (For example—1 second, 2 seconds, 4 seconds, etc.). Develop these for "normal" time and see which one shows the density of 0.1 above filmbase-fog. The exposure which gave this density can be considered basic; under similar conditions of distance, light, environment, etc., it can be repeated, and also can be adjusted to films of different ASA speeds. This system is good for sheet film, but requires that a roll of film would be unwound for the pre-exposure and then carefully rewound back on the spool. This method is not feasible with film packs.

2. Exposing the negative in the camera to a Gray Card (Kodak Neutral Test Card of 18% reflectance) or to a smooth neutral card of any reflectance. There is no need to use a white or light-gray card; in fact, a light card in bright light would require an extremely short exposure at Zone I or II placement (small lens stops and high shutter speeds can be quite inaccurate). The lens should be set at infinity focus (we do not require any texture to show) and at that setting the lens stops have their true value. For example, if our test card read 25 c/ft^2 and this luminance value was placed on Zone I of the exposure scale, the basic exposure would be 1/400 at f/8 (with a film of ASA 64 speed). The actual exposure given could be 1/100 second at f/16, or 1/50 second at f/22, etc. A card of much lower luminance value should be used for fast films. Of course, we can extend the lens to twice its focal length, requiring 4x the basic exposure value. Or we could use neutral-density filters to cut down the light to the desired degree. Be certain the card is large enough to more than cover the field of view of the lens, that it is evenly illuminated, that it shows no glare within the angle of view and the shadows of hand, meter or camera do not fall upon it (while using the meter or making the exposure).

3. Using standard flashlight (torch) equipment, such as the Ray-O-Vac, No. L-229 hand flashlight. This has been modified to hold several layers of colorless diffusing plastic. For daylight color photography a Wratten No. 78 filter should be sandwiched in between the plastic layers; this would change the light from the lamp to approximate daylight quality. The device is held against the meter cell of the Weston, or the Pentax Meter can be used. Caution—due to differences in the color response of different meters it will probably require some preliminary testing to establish the true luminance value of the light in reference to panchromatic or color film. The exposure meter will give a certain reading which can be interpolated into pre-exposure values. Say, that the Pentax Meter registered No. 7. This would represent an exposure of about 1 second at f/8 with a film speed of ASA 64 (for Zone V exposure). For a Zone I pre-exposure this would be 1/16 second; for a Zone II pre-exposure it would be 1/8 second. The pre-exposure device is used as follows: after the picture is visualized and the basic exposure calculated, the pre-exposure is made by holding the device

against the front of the lens (avoiding extraneous light) and giving the desired pre-exposure. Then, the actual subject-exposure is made. Important, if there is a lens-extension factor involved, do not fail to apply it to the pre-exposure. Do not make pre-exposures with color filters or polarizers on the lens.

There is some confusion as to the effect of pre-exposure on the total exposure scale. An exposure on Zone I represents 1 unit of exposure. On Zone II it represents 2 units of exposure. The entire negative therefore receives 1 or 2 units. Adding these units to the unit values of the other zones, results in a decreasing increment of value as we go up the scale:

ZONES	I	II	III	IV	V	VI	VII	VIII	IX
EXPOSURE UNITS:	1	2	4	8	16	32	64	128	256
PRE-EXPOSURE UNITS:	2	2	2	2	2	2	2	2	2
TOTAL EXPOSURE UNITS:	3	4	6	10	18	34	66	130	258

It is obvious that there is an elevation of values of some consequence up to Zone IV. Thereafter the elevation is slight. Zone V, 16 to 18; Zone VII, 64 to 66; etc. The *contrast* between Zones I and IV (3:10) is less with pre-exposure than without (1:8). But the advantage of pre-exposure lies in that it reveals values which, without it, would fall *below threshold* and would therefore not be recorded at all.

With color photography a truly neutral card is advised. However, if certain special effects are desired in the low values, cards of strong colors can be used; there will be a faint cast of any such color over the entire image, with emphasis, of course, in the shadow areas. With Kodachrome, etc., I pre-expose on Zone II and with Type 58 Polaroid Land film (Polacolor) I pre-expose on Zone II to III. With sheet film and Polaroid 4x5 film, I pre-expose a number ahead of time, under more perfect conditions than possible in the field. The true efficiency of the pre-exposure device can be tested by trials with Type 52 Polaroid Land film: pull out the envelope halfway, then pre-expose. Give more than normal developing time (usually necessary with pre-exposure on Polaroid materials to get a good black value) and observe the pre-exposure print value in comparison with the "black-spread," or unexposed area, of the print.

Too much pre-exposure results in an impression of overall fog, we can print through this to a certain extent with a negative, but we cannot overcome it with color transparencies or Polariod Land prints.

It must be noted that while the effects of pre-exposure are definite and controllable, the aesthetic and emotional effects are subtle and can be disappointing. For example, a generally high-value area of the subject containing small black textural elements may appear to lose "crispness" as the small black areas will be slightly raised in value.

We must remind ourselves, again and again, that the eye comprehends values in the subject far beyond the capacity of the film to record. Subjects in deep shade are seen with a variety of values and with an impression of luminosity, while a brilliant sun-drenched surround is likewise perceived with full awareness of substance, texture, and the qualities of light. (If we move from a very dark environment to a very bright one, a short period of adjustment is required.) Hence, our visualization is based on what we see and we must control the medium to produce the desired effects and image qualities.

137

SOME COMMENTS ON COLOR PHOTOGRAPHY

These books are not directed to color photography, although certain basic similarities in equipment and accessories are obvious. The difference between black-and-white and color photography is primarily aesthetic although we must admit the informational factors are very important. Many subjects of varied but subdued color photograph quite dull in black-and-white—even with the use of contrast filters. It is a matter of appropriate visualization in terms of color composition—which is quite different from visualization in black-and-white. In scanning the subject for black-and-white visualization, the use of the Wratten No. 90 Viewing Filter is very helpful, as it reduces the colors of the subject to a near-monotone and the values as seen through this filter approximate the response of unfiltered panchromatic emulsions.

Page 126

The eye has a great facility of adjustment to varying °K (color-temperature effects), but the color films (daylight or tungsten) have a somewhat rigid color response—which can be modified to a certain extent with the use of light-balancing filters, UV filters, etc. A typical situation: green foilage in sun and shade. With daylight color film, the sunlit foliage would be quite "accurate," but the foliage in shade would have a cyan quality (blue skylight on the green leaves). The warmth and coldness of this combination would be quite apparent, although the exposure of the foliage in shade would be much less than if the entire subject was in shade, and would therefore be sufficiently low in value to overcome some of the cyan effect. But when we give normal exposure for foliage in shade we will be impressed by the definite cyan quality. An *overcast sky* will, of course, give a close approximation of "daylight" quality, but a clear blue sky will favor the cyan effect. Here the use of the UV, skylight and light-balancing filters will remove varying amounts of the cyan color cast. These °K values can be measured only with a good color-temperature meter (such as the Spectra) and the amount of required color correction then determined.

Equipment requirements include:

(a) **Lenses of fine chromatic (and other) corrections.** Most good lenses obtainable today are of high quality in this regard.

(b) **Lens-coatings of neutral color-transmission effect.** In earlier days lenses—even those from the same manufacturer—would have lens-coatings which would transmit varying amounts of either yellowish or bluish light. Hence it was difficult, if not impossible, to get the same color quality with different lenses. This has been corrected by balancing the lens-coatings on the air-glass surfaces to transmit near-neutral light. If you look into a lens under a bright light you will see reflections from the many air-glass surfaces, some will appear purple, others pale yellow. If all the reflections seem yellowish we know that more light at the blue end of the spectrum will be transmitted. If all the reflections appear purplish, we know that more light at the yellow-red end of the spectrum will be transmitted. By balancing the number of air-glass surfaces of both hues a neutral transmission is assured. These lens-coating effects have little or no meaning with black-and-white photography. Old lenses may show slight yellowing of the cement between the elements. Old polarizers may have a slight "warming" effect. Both have no significance in black-and-white photography. But uncoated lenses are, of course, prone to produce flare and reduced image contrast.

Page 101

Fig. 65

(c) **Adequate lens-shades.** Scattered light in black-and-white photography produces less contrast and—at worst—visible areas of flare. But with color photography this scattered light takes on the dominant color of the subject

Page 119

or the light source and can impose a color-cast over the entire image. Hence, lens-shades of maximum efficiency are required.

(d) **The camera** should be as flare-free as possible. All reflective surfaces should be painted with the dullest possible black paint and baffled if necessary. Many surfaces that appear very black at normal angle of view may, at "glare" angles, reflect a considerable amount of light.

(e) **Exposure Meters** should be—as for all kinds of photography—of the best type and highest sensitivity. The exposure scales of color films are much shorter than those of black-and-white film and the placement of subject-luminances on the exposure scale is more critical. Spot Meters (such as the S.E.I. and the Pentax 1°/21°) are superior to averaging meters as they can accurately read small important areas such as the skin values of small heads in a large field of view, etc. For example, several figures against a forest environment of rather low values; visualize the skin values as print values VI or VI-1/2. An averaging meter would tend to place the background values on, say, Zone V or V-1/2; this might elevate the Zone placement of the skin values to Zone VII or higher. By careful evaluation of the skin values with a spot meter we can plan exposure to favor the proper placements on the exposure scale.

(f) **Filters and Polarizers.** Filters have been discussed above in terms of control of the °K quality of light. We should add here that filters can be of glass or of gels (as with black-and-white photography). Kodak, Polaroid, Tiffen, Zeiss, etc., make UV filters and conversion filters. There are not many different *kinds* of filters in common use, but a great variety of manufacturers. We can depend upon Kodak for light-balancing, photometric, color-compensating and conversion filters (among the latter are those filters that convert tungsten color film to daylight color response, adapt tungsten color film to photo-flood light, etc.). The UV and Kodak Skylight filters reduce blue haze in distant landscape work, aerial photography, and high-altitude photography. Certain filters are designated for underwater photography, and a great variety of filters are obtainable for special technical and scientific work. *Kodak Wratten Filters for Scientific and Technical Use* is a valuable book, and the *Photo-Lab-Index* contains a wealth of information on filters of various types and manufacture.

The polarizer offers the only known way of achieving dark skies in color photography. The optimum angle is 90° to the sun. As the amount of polarization is reduced as we depart from this 90° angle it is obvious that with wide field or wide angle lenses uneven skies can result. The polarizer (with the polarizing axis directed to the sun), will reduce distant haze and clarify landscape features. In this respect, the polarizer has a definite "warming" effect. The polarizer can be combined with other filters appropriate to color photography; the exposure factor of the polarizer (2.5x) must be *multiplied* by the factors of the other filters (usually small, but nevertheless significant). For example, the polarizer and the 81B light-balancing filter would have a factor of 2.5x1.3 or about 3-1/4x total factor. Color film is prone to reciprocity effect, and adjustment must be made for longer (and shorter) than normal exposures (using specified filters and increased exposures.)

(g) **Processing equipment.** This is, or course, of special character for color photography. A vast range of equipment is available from the simplest home processing to the most elaborate technical laboratories. The Calumet Manufacturing Company produces an excellent line of equipment, and many other manufacturers list equipment of high quality and great variety. Description is beyond the scope of this book.

Page 69

Pages 125, 126

Page 126

139

(h) **Temperature controls** are *important* as the processing of color materials demands close tolerances of solution temperatures. Water-jackets for tanks and air-temperature controls must not be overlooked.

(i) **Laboratories** which do excellent and thoroughly dependable work are to be found in many parts of the country, especially in the larger cities. Many professionals rely on the laboratories for all their color processing (and many use the laboratories for black-and-white processing as well). Of course, for personal expressive work it is important that the photographer does his own printing, or supervises it. Color printing is not simple, but it is less demanding than the processing of color transparencies and color negatives.

(j) **Polaroid Land Polacolor** is a remarkable process (witness the great work of Marie Cosindas in this medium). Success depends upon careful control of exposure and processing time and temperature. It will be described at length in the new edition of the *Polaroid Land Photography Manual* (by Ansel Adams, Morgan & Morgan).

(k) **The Permanence of Color Images** has always been a problem, and there seems to be no promising solution in sight. Dyes are not permanent on prolonged exposure to light. The Carbro process (a pigment process) is by far the most permanent but it is costly and is seldom used today. Cibachrome, a new color-printing process, promises to have exceptional permanence. All color images—transparencies and prints—should be carefully protected from light, heat and humidity when not on display or otherwise in use.

AERIAL PHOTOGRAPHY

This is a very important branch of photography—one that offers excitement and images of rare beauty. The subject is too involved and specialized to consider in depth in this book, but a few recommendations are given:

(a) The airplane is part of the "instrumentation." A high-wing with windows that can be opened (or door removed with proper safety precautions) will be quite satisfactory with hand-held cameras. William Garnett, the great aerial photographer, pilots his own plane and this gives him precise control of position and viewpoint. Some pilots are well versed in the photographer's requirements and are able to understand and follow his directions.

It is possible to photograph through the windows of airliners, but the results are seldom really worthwhile. There is certain distortion and a lack of contrast caused by the window materials, the planes fly at high altitudes, and seldom bank sufficiently for good oblique views. Vibration in most helicopters can degrade image clarity.

Professional survey and mapping services use precision equipment built into the planes. This is a complex photo-technical field beyond the scope of this book.

(b) Many types of cameras can be used: press cameras, single-lens reflex cameras (Hasselblad, 35mm cameras, Polaroid Land cameras, etc.). Obviously, view cameras would be the least efficient for the purpose. Any camera must be kept out of the slip-stream; bellows have been ripped from press cameras simply by holding the camera a few inches too far from the window edge. The typical aerial camera is a solid construction without bellows. (There is no need for focusing, as aerial images require the lens to be at "infinity" focus.) But they can be as severely buffeted in the slip stream as any camera.

(c) Ideally, lenses designed for "infinity" focus and known as *aerial lenses* (or *aero lenses*) are best for the purpose. They give a flat field with minimum

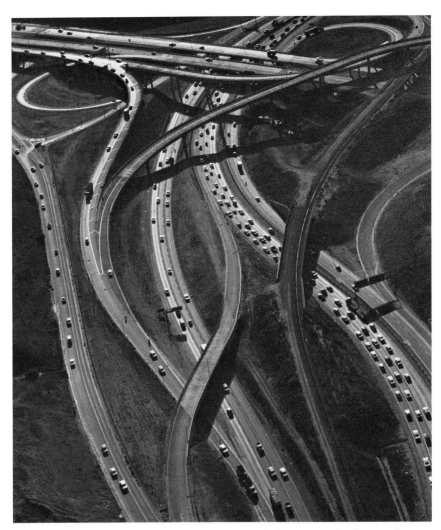

70. LOS ANGELES FREEWAY INTER-CHANGE. Aerial photograph made with Hasselblad Camera and Zeiss S-Planar 120mm lens, yellow-green filter (2x) on Kodak Tri-X 120 Professional Pan roll film. Development, Normal +1 in Edwal FG-7, 1:15 (water). In this exacting situation I requested my excellent pilot to make repeated "passes" at this subject—24 in all as I made that number of pictures to get this decisive one. Visualization must be very fast and is obviously quite uncertain. You "see" the configurations of the subject and you project in the "mind's eye" a variety of organizations. You direct the pilot, and you hope! Here the average luminance value registered only 150 c/ft². The exposure was 1/500 sec at f/8 (the effective exposure was about 1/350 second). It was necessary to move the camera to counteract the movement of the plane as the image was rather large on the negative. The automobiles were moving at a considerable speed. In effect, the picture is not truly sharp; an 11 x 14 enlargement would prove this. Ideally, a low-altitude aerial photograph should be made at high speed—1/1000 of a second if possible; the lower the altitude the less need for filters. A good lens and well-aligned camera should permit exposures at maximum aperture. With the Hasselblad I suggest the 80mm Zeiss Planar, 100mm Zeiss Planar and 150mm Zeiss Sonar. The higher the altitude, the longer the focal-length of the lens may be. The literature on aerial photography covers these practical facts.

141

distortion over the entire picture area. They are designed for high quality images at wide apertures.

(d) Filters are usually required for black-and-white work; the Wratten 25A is a typical contrast filter—although the Wratten 23A and the Wratten G can be used with low-altitude, clear-atmosphere conditions. The exposure factor for the 25A is 8x; for the 23A, 4x and for the G, 3x with panchromatic film. The 23A performs almost as well as the 25A under normal conditions and at only half the exposure factor. Infra-red films and appropriate filters are used for special effects, high contrast, and penetration of atmospheric haze.

In color photography, the filters used are primarily ultra-violet types (Wratten 1-A and 2-A, Skylight filter, etc.) with practically no exposure factor. The Polascreen has an exposure factor of 2.5-3x. Most color film speeds are very moderate (25 ASA for Kodachrome, 64 ASA for Kodachrome-X, 100 ASA for Ektacolor negative film, etc.). Under the same lighting conditions, the exposure for Kodachrome would be, say, 1/400 sec at f/5 or 1/400 sec at f/10 for ASA 100 film. While the factor for filters with color film is low, with black-and-white an 8x factor with 1/400 of a sec would reduce it to 1/50 sec—too long for aerial work. Hence, the need for large apertures—as short exposures are imperative. 1/50 sec at f/22 represents 1/400 sec at f/8, etc.

(e) Obviously, with large lens apertures, the depth of focus is small and the films must lie very flat in the holders and in the film magazines. Otherwise, if the film buckles or sags there will be loss of definition and some distortion. Film packs are not entirely flat; sheet film is quite flat; roll-film sometimes buckles in the magazines. (The Calumet roll-film holder holds the film exceptionally flat.) Advanced equipment has vacuum backs which hold the negative tightly against the back support. Polaroid Land Types 52, 55 P/N, 57 and 58 films benefit by having a light-tight suction tube made for the back of the Adapter; at the moment of exposure the photographer inhales through the tube, withdrawing air and forcing the film to lie flat. This sounds like a crude device, but it works! (*Note:* This is not a stock item.)

(f) If roll-film magazines are used (such as for the Hasselblad, Bronica and Rolleiflex SL 66) a sufficient number should be on hand, loaded with the appropriate film. If possible, an assistant should accompany the photographer, who could change film as fast as used. Air time is costly and aerial work is intense, usually with the need for making many exposures because of the elusive and constantly changing character of the scene.

Infrared photography from the air can give exciting informational and pictorial results because of the unusual sensitivity response to various parts of the spectrum. The results differ greatly from the tonal rendition that we are accustomed to with panchromatic emulsions. Kodak Infrared film can be obtained in sheet-film sizes from 3-1/4x4-1/4 to 8x10 inches, and in special rolls of 50 and 100 ft for small cameras, in both regular and high-speed infrared emulsions. Consult the manufacturer or your dealer for specific information on these materials. It is imperative that the recommended filters be used.

Kodak makes Type 8443 Ektachrome Infrared Aero Film in 20 exposure rolls and Aerial Film. Consult the *Photo-Lab-Index* for detailed information on this material.

Finally, the quality of black-and-white (and color) prints must be considered. With few exceptions, aerial photographs are of relatively low contrast; the greater the altitude the lower the contrast (and the less saturated the colors of the subject will be). In my experience, I would prefer to give normal or normal + 1 development at the most to avoid obvious negative grain, and rely on papers of higher contrast grades for the desired print values.

142

71. RICE FIELDS, SACRAMENTO VALLEY, CALIFORNIA. Aerial photograph made with Hasselblad camera and 150mm Zeiss Planar lens, yellow-green filter (2x) on Kodak Tri-X 120 Professional roll film. Development, N − 1 in Edwal FG-7, 1:15 (water). This represents a rather difficult problem of selection; the project required that rice fields and rice farm be shown together. The only way to show rice fields effectively was to photograph into the sun, so that the reflections from the flooded lands reveal the contours of the rice areas. Several hours were devoted to locating a good combination of field and farm. I wanted to give a solid "rectilinear" impression of the farm structures. Glare from from the flooded fields could have been controlled by a polarizer, but this was not at hand. The only solution to this problem of extreme contrast range was to work for the relatively low values of the farm and apply a Normal minus 1 development. Even then, the extreme contrast presented a problem; further reducing development would have weakened the values of the farm area. Two–

solution development or water-bath development would have helped. The Normal minus-1 development required that, in printing, two contrast grades of paper be used. This implied a variable-contrast paper. Varigam was used with the Codelite; the farm area was printed with grade 4 contrast light and the glaring fields were controlled by burning in with grade 0 contrast light. Conventionally, this could have been done with two filters—the Soft (No. 1) and the Hard (No. 4) with Varigam, Varilour or Poly-contrast papers. The reproduction cannot hold the delicate values obtained in the print.

Should convergence of vertical lines appear with architectural subjects photographed from low altitudes, we can correct this effect by use of the tilting easel and lens-board adjustments possible with some enlargers.

Note that low-contrast subjects usually require films of higher contrast (Kodak Plus-X, for example). Tri-X film, developed for higher contrast, will—with small formats—show disturbing image grain.

143

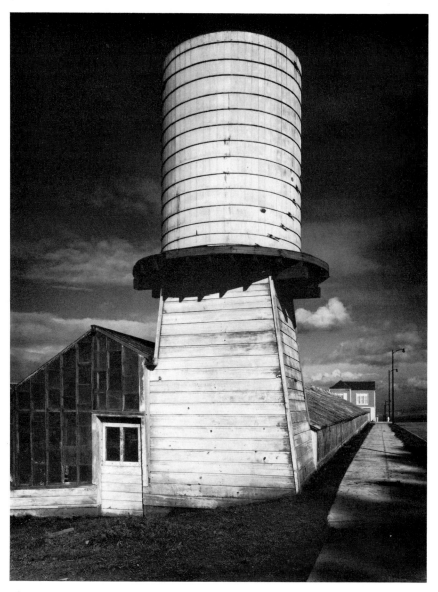

72. WATER TOWER, SAN FRANCISCO, CALIFORNIA. Made with Sinar Camera, 121mm Schneider Super-Angulon lens, on Polaroid Type 55 P/N 4x5 Land film, with a Wratten 23-A filter. The camera was set in precise level position, and the rising front set at maximum height. This served to include the entire tower-tank in the field of view, but as the effect, described below, was desired the camera was pointed *down* (and the back tilted into vertical position). The front was then tilted to be precisely parallel with the back, and the rising front properly adjusted. This brought the tank near the edge of the useful field of coverage of the lens and a slight "looming" distortion of the tank obtains. Note that the curvature of the iron bands shows an exaggerated effect towards the top of the tank. This is a perfectly accurate geometric effect, and can be used for rewarding creative effects.

144

SETTING UP
THE CAMERA

SEQUENCE

It is well worthwhile to practice setting up the camera so that the operations become more or less automatic. As we gain experience, we become intuitive. Nevertheless, there are certain points which must not be overlooked. A typical setting up sequence would be:

1. Select position.
2. Place tripod with one leg on axis (lens axis, or center of field of view).
3. Firmly attach camera to tripod.
4. Check to see if all camera adjustments are in normal position.
5. Make an examination on the ground glass and determine correct camera position (height above ground, direction of lens axis, etc.); check tripod position so that one leg points in same direction as lens axis.
6. Establish accurate horizontal level.
7. Establish accurate vertical level (especially important with architecture, etc.). Of course, for many subjects the camera may be pointed up and down to a considerable degree without disturbing effects.
8. Focus approximately.

Page 174 9. Make necessary adjustments in proper sequence.

 For architectural subjects:
 (a) Be certain camera back is parallel to subject, both horizontally and vertically.
 (b) Use rising front (and falling back if available) to limit if required, but if not sufficient—
 (c) Tilt camera up and adjust tilt back to vertical position.
 (d) Tilt front to vertical position (parallel to back); check overall focus and—
 (e) Tilt front to correct focus differences, if any.
 (f) For horizontal adjustments, use sliding front and/or sliding back to limit, if necessary (lens axis is now displaced in two directions; check opposite corner for possible failure of lens coverage).
 (g) Then, if required, use swings as you would tilts in (c), (d) and (e) above. With subjects which do not demand parallelism of the camera back we have a much greater freedom in camera positioning. General work will often require the use of rising, falling and sliding fronts, and the focus adjustment is simplified by the use of the tilting and/or swinging front and back. Using the tilting or swinging back retains the central lens-axis position, and there is no problem of lens coverage. Of course, whenever we change the plane of the camera back in relation to the plane of the subject, we introduce distortion. In most natural shapes this distortion is not obvious, but when we have rectangles or circles in the subject the problem is not simple.

Figs. 69, 72 With perfect parallelism of the camera back we will, with wide-field or wide-angle lenses, have an obvious distortion of circular shapes toward the edges and corners of the field. Back swings can modify these effects but at the probable cost of some other distortion effect.

10. When all adjustments are made, lock all controls securely.
11. After the picture is made, put all camera controls into normal position.

 With non-adjustable cameras, on tripod or hand-held, we should try to anticipate distortion effects and compensate for them in our visualizations.

145

Many photographic disasters have occurred because of some sequence-failure in operating the camera. A few simple rules to follow:

1. With the tripod in use, be sure to secure leg clamps and lock the tilting and rotating head. If not tight, insertion of the film holder in the camera might shift its position.

2. With a view camera be sure to put all adjustments in normal position before starting to work on a new subject. Remove filters, etc., and open lens to full *Page 51* aperture. Check bellows.

3. When a view camera has been set up and adjustments made, be sure to tighten all adjustments and focusing controls to prevent slippage. When the camera is pointed down, the front or back assemblies (or both!) can creep forward unless tightened in place. Then set lens stop. Set shutter, cock and release to be sure it is functioning properly. Attach required filters, etc., and be certain the lens shade is not vignetting the image. Observe filters factors, and lens-extension factors when calculating exposure.

4. With a hand camera, check for amount of film remaining in camera or in magazine and be certain the proper film is ready for use. With several magazines it is easy to be confused unless the magazines are clearly marked. I find the following system is helpful:

Magazine 1. Panatomic-X Magazine 3. Tri-X
Magazine 2. Plus-X Magazine 4. Color

Note the ASA speeds as well as the type of film, and double-check exposure.

5. As with any camera, check the hand cameras for filters, lens shades, etc., which can inadvertently be left in place from a previous picture session.

73. LEAVES, STUMP, FROST, YOSE-MITE VALLEY, CALIFORNIA. Made with 4x5 Korona View Camera and 9″ Goerz Dagor. Minimum depth-of-field problem; camera was "rotated" over the plane of the subject until the desired composition was seen on the ground glass. This is a "found" subject; the leaves were not arranged.

Arrangement is perfectly valid if the situations justify it. But the most convincing photography lies in the awareness of shape and the potentials of form in the world around us. (See page 17).

146

VISUALIZATION WITH
CAMERA AND LENS

PERSPECTIVE

Fig. 74

True perspective depends upon the distance of the subject from the lens. (Actually, we should say "subjects"—meaning subject planes.) In reference to one subject plane (or point), perspective has no meaning; it relates only to the relationships of two or more subject planes or points at varying distances from the lens (or eye). A converging railroad track, for example, has an infinite number of planes, each imperceptibly separated but all combining to produce the familiar converging effect. Views down a street, up an elevator shaft, along a lengthy wall—all give us the converging effect. Objects of the same size at differing distances from the eye suggest perspective. The closer the near object in reference to the far object, the more impressive the impression of scale and perspective becomes. This "near-far" situation is further discussed on pages 149 et seq.

Granted that perspective is a rather rigid fact of optics, it is modified by two elements: the camera and the lens. We should state first that no matter what angle of view the lens is capable of, all lenses at the same distance from the subjects will give identical perspective. A 2-inch lens, an 8-inch lens and a 24-inch lens mounted on the same camera at the same position relative to the subject will give identical perspective. The important difference lies in the angle of view defined by picture size and covering power of the lens.

A wide-angle lens gives the impression of much greater perspective than does the medium-angle or the long-focus (narrow) lens. In Figs. 84A, B, C, D and E the Hasselblad was set in one position and pictures were made of the same subject with the Hasselblad 500C using a 40mm, 80mm, 150mm, 250mm and 500mm lens. In Fig. 84F we see an enlargement of the 40mm negative to the same size as that of the 250mm negative. We will note that within the respective fields of view the images are identical with only a slight difference in sharpness in the 15x enlargement (40mm to 250mm size).

A wide-angle lens does not have much significance unless the picture size takes advantage of its great coverage. The Schneider Super Angulon 121mm lens will cover an 8x10 film *on axis*. It is then functioning as an extreme wide-angle lens. With a 5x7 format this lens is a moderate wide-angle lens, and on a 4x5 format it is a moderate wide-field lens (the "normal" lens for the 4x5 would be about 160mm focal length. Used without adjustments on a 4x5 camera the 121mm lens would be a rather "short-focus" lens and would give the same image size and perspective effect as any other lens of the same focal length.

Page 51

The significant difference, however, lies in the great range of camera adjustments possible with a lens of this type on a relatively small format. A Tessar-type lens designed for, say, a 4x5 camera, excellent as it is, is not capable of more than a small rising or tilting front adjustment with the camera. The 121mm Super Angulon lens will allow a very great range of adjustments (providing the camera is equipped with bag bellows). And because the 4x5 picture area can be brought near the extremes of coverage, many interesting optical effects are possible.

We should remember that a short-focus lens may not be a wide angle lens, but a wide angle lens of the same focal length is also just a "short-focus" lens when used in the same camera and on axis (without adjustments).

147

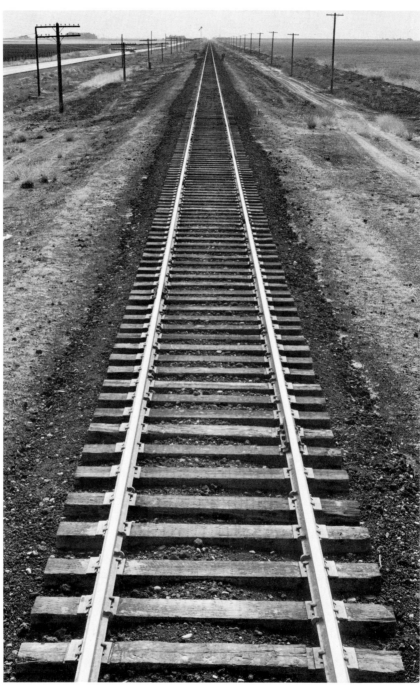

74. RAILROAD TRACKS, CONVERGING TO THE HORIZON. As explained in the text, perspective is controlled by lens-to-subject distance. A steep angle of view (looking down on the subject) intensifies the impression of perspective on horizontal planes. Here the camera was pointed down but the back was *not* put in vertical position; hence there is a strong convergence of the telegraph poles. In this case the convergence accents the feeling of space and distance. The picture was made at a height of about 10 feet (from the platform on my station wagon). (See Fig. 30, page 63).

148

THE NEAR-FAR APPROACH

The near-far approach is very important in creative photography. It depends on adequate depth of field, implying relatively small formats and short-focus lenses. The shorter the focal length, the greater the possible depth of field (with consideration for adequate coverage of the film). With 8x10 cameras and relatively long lenses, the depth of field is limited; with camera adjustments we can augment the impression of depth, but we cannot achieve it as directly with long-focus lenses as we can with short-focus lenses. The 35mm Distagon on my Contarex focuses from about 2.5 feet to infinity at f/22; the 80mm lens on my Hasselblad focuses from about 8.5 feet to infinity at f/22 and the 250mm (10-inch) Sonnar on my Hasselblad focuses from about 40 feet to infinity at f/45.

The Zeiss Hologon and "fish-eye" lenses as well as the 18mm and 21mm for 35mm cameras have enormous depth of field. The "fish-eye" lenses have marked curvature of subject planes and lines which has definite aesthetic value. The Hologon lens is of the super-wide angle type; the lens and camera comprise a unit known as the Zeiss Hologon Camera.

An important consideration: while depth of field is a function of the focal length of the lens (in reference to a given circle of confusion), a 10-inch (250mm) lens for the Hasselblad may be designed especially for a narrow field of view; there are no adjustments on the Hasselblad, and the lens always functions on axis. This allows the lens designer to concentrate on the problems of maximum resolution, etc., within a small field, and the lens works beautifully at the relatively large aperture of f/5.6. The image size is the same as for any lens of 10-inch focal length.

Figs. 41, 56, 81, 83
In any event, the sense of "presence"—the feeling that you can touch the object closest to you in the image—is very important. Most photographs give the impression that the subject was behind a sheet of glass—a window display, for example. It is there, not far away, but you cannot come close enough to touch it—to feel the "presence" of the subject in space. Photography can create this impression of presence, nearness, touchability. The near-far approach relates to presence, scale and space.

Near-far effects can be obtained in the following ways:

1. With non-adjustable cameras or when working with parallel near-far planes, we depend upon the depth of field capacity of the lens. Refer to Coast, Northern
Fig. 135 California, for "near to infinity" focus.

2. With adjustable view cameras:
 (a) Using front tilt only with near objects.
 (b) Using back tilt only because of limited coverage of the lens.
 (c) Using both front and back tilts, assume that the camera must be pointed down, but that the vertical lines in the subject must be rendered parallel: the back must, therefore, be in vertical position. Remember that the image is inverted and that the near parts of the subject are at the top of the focusing screen and the negative. Hence, if the camera is pointed down and the back tilted to vertical, the parallel lines of the subject will be rendered properly and the near-far focus approximately achieved. It would be a coincidence if it were accurate! If the coverage of the lens permits,
 Figs. 76, 88 we can manipulate the amount of camera tilt (down), the rising or falling front and the back tilt to get a truly vertical back position as well as maximum depth of field.

The visualization of Fig. 76 can be described as follows: Dr. Oswald Jonas, (Musicologist, UCR) had an important collection of first editions of the great

149

composers. I wanted to photograph the title pages with sufficient clarity to read them. I also wanted to show the professor and his students in an appropriate environment. It is admittedly a contrived arrangement—but a variation of an actual situation I observed. I could not have secured the aligned image without a tilt-back and an ample rising and falling front and back facility. Without the tilt-back the required depth of field would have been impossible except with a very short focal length lens on a 35mm or 2-1/4x2-1/4 camera. In the latter, with no adjustments, there would have been an obvious geometric distortion of the room itself.

As it is, there is a small distortion (spreading) of the shapes of the near books. This is inevitable when the image relates to the far outer edges of the field of wide angle lenses.

Another problem concerned lighting balance. I did not want the lighting to become brighter towards the back of the picture. However, with the necessary adjustments, the lens-image distance of the near objects was about 1.5x greater than the lens-image distance of the far objects, and the exposure ratio was about 1:2. It was necessary to adjust the lighting to the desired balance. We could achieve this by calculating the required values and using a gray card in different *Page 76* areas of the subject on which to balance the lighting. Here the Sinarsix meter would be invaluable because it would read the actual illumination of various areas on the ground glass. It should be made clear that we could adjust the lighting to read in the desired balance by using the narrow-field exposure meters (Weston Ranger 9, Honeywell Pentax 1°/21°, or the S.E.I. Exposure Photometer), but we would then have to correct for the fall-off of light in the camera due to the differences in lens-to-subject distances. In most work this fall-off is negligible, but with extreme adjustments such as used in this particular picture we cannot overlook it. We can, of course, calculate it, but this is a time-con-

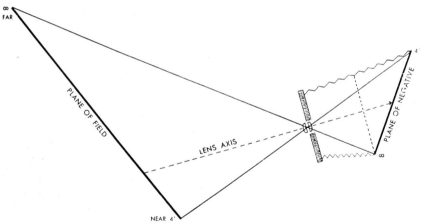

75. DIAGRAM: ADJUSTING NEGATIVE PLANE TO PLANE OF FIELD. Here the camera back is tilted to adjust for focus; as it is not perpendicular, vertical lines in the subject would show convergence. The degree of tilt necessary to achieve the required depth-of-focus increases as the focal-length of the lens increases. Objects projecting above or below the plane of the field focused upon can be brought into focus only by stopping down the lens. We see here that the axis of the lens falls on the center of the negative; the covering power of the lens is not taxed as it would be if the Tilt Front was used to make the focus adjustment. Refer to Fig. 76 (opposite page) where it is was necessary to keep the camera back in vertical position to avoid convergence of the vertical shapes in the background. Here the lens was tilted in reference to the back to get the extreme depth of field required.

150

76. DR. OSWALD JONAS,
MUSICOLOGIST (University of California, Riverside). To avoid convergence of vertical shapes in the background the camera back was set in vertical position. The camera was obviously pointed down, and the lens was therefore tilted in reference to the plane of the back so that adequate depth of field obtained. The falling front and rising back were also used to properly place the image on the ground glass, and a slight adjustment of the front tilt was used to perfect the focus. The picture was made with the 5x7 Sinar and the 121mm Schneider Super-Angulon lens. While the near pages show the "wide-angle" effect (as they are near the limit of the field-of-view of the lens) the faces show no distortion; this is because they are actually near the center of the field. Had the situation been reversed the heads would have appeared slightly distorted (would have been "drawn" into oval shape) by the wide-angle effect.

151

suming task. The Polaroid Land process would clearly show differences of lighting value.

With near-far compositions the problem of parallax is very important with cameras whose finders are off lens axis. The ground glass cameras and single-lens reflex cameras have no parallax, as the eye (through the mirror-pentaprism system) sees exactly what the lens sees. Visualization, however, involves more than simple optical facts. The subtle relationships of shape and line between objects clearly show spatial effects, and the avoidance of "confusions and mergers" all are of the greatest importance. You cannot actually see what the camera is seeing unless you scan the actual image on the ground glass or effectively place the eye at the position of the lens (or at the pentaprism finder of a single-lens reflex camera).

Observing the subject with the eyes a foot or more from the camera certainly does not show us what the camera is seeing, and eye-lens-film "alignment" is vital to proper visualization of the picture. Looking into a twin-lens reflex camera shows us what the viewing lens sees, but with near objects the taking lens will see something else (when images in depth are concerned). Figs. 14A and 14B show what the viewing lens "saw" and what the taking lens photo-

Fig. 18 graphed. We can duplicate what the viewing lens saw by raising the camera a distance equal to the separation of the centers of the viewing and taking lenses.

SCALE

One of the qualities of the near-far image is the exaggeration (or emphasis) of scale. Scale is an important quality of the image and has both realistic and subjective validity. Scale is related to the *known,* to some reference of experience. We may think of scale in three ways (the term "known" signifies a known object or situation):

1. Comparison of known with known or unknown on a single plane.
2. Comparison of known with known or unknown on different planes before the camera.
3. Comparison of known with known and with unknown on different planes, accentuated by strong perspective effects (near-far approach).

In Figs. 78 and 79 we see a fountain taken from the same distance with a 40mm lens and a 250mm lens; were the 40-mm image enlarged to the same size as the 250mm image the physical aspects would be identical (perspective, relative scale, etc.). The 6x enlargement might show some reduction of definition and the presence of some negative grain.

In Figs. 77A and B we see two pictures (Sentinel Rock and Tree, Yosemite Valley). Both were made with the Hasselblad camera with the 50mm Distagon. Obviously, the close position has a tremendous effect on the image of the tree, but the mountain remains the same size. Actually, the mountain is *slightly* larger; as the camera was moved close to the tree, the lens was extended to the hyperfocal distance which brought both near and far objects into acceptable focus (improved, of course, by using a small lens stop—f/22). The lens was focused at 10 feet, a scant 3mm extension; $50^2 - 53^2 - 2500 - 2809$; a ratio of 1 to 1.12 (not enough to have an appreciable effect on exposure).

In Figs. 80A, B, C and D we see four Hasselblad pictures of a fountain made with lenses of 40mm, 80mm, 150mm and 250mm focal length. The negatives showed about the same width of the fountain in each case, and the enlargements were all made at the same magnification. Note the different interpretation of the fountain, as well as the changing relationship to the background building. The camera was at the same height in each case.

152

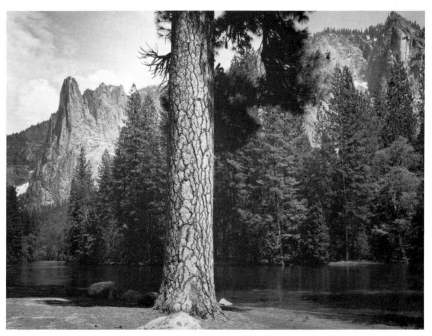

77A. SENTINEL ROCK, PINE TREE, YOSEMITE VALLEY, CALIFORNIA. Made with the Hasselblad 500C Camera and the 50mm Zeiss Distagon lens. Here we have a considerable angle of view and a normal effect of scale. The effect is almost two-dimensional and rather dull.

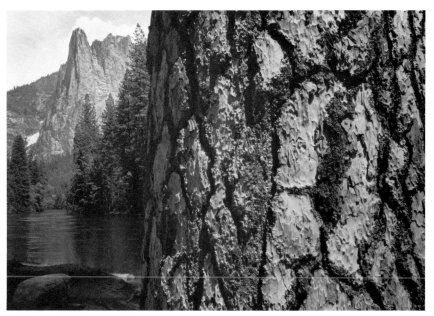

77B. SAME. Moving the camera very close to the tree gives a striking effect of scale and "presence." Observe that the size of the mountain has not changed, only a slight difference in the position of the distant trees and the foreground rocks can be seen. There is one defect of visualization. The shadowed side of the tree blends too closely with the values of the forest. Pre-exposure techniques are indicated in such cases (see page 134). Or, the use of carefully controlled reflectors would help.

153

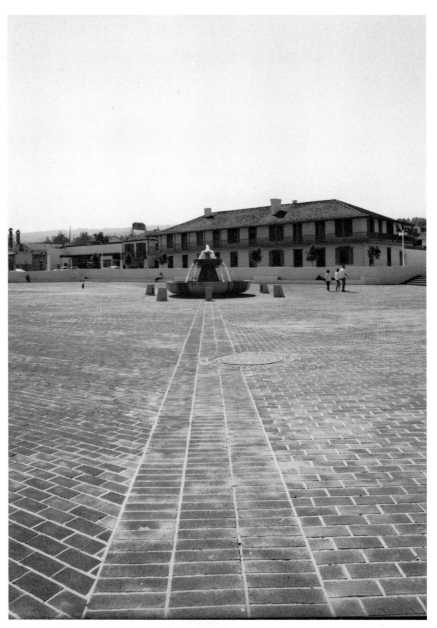

**78. FOUNTAIN, CUSTOM HOUSE
PLAZA, MONTEREY, CALIFORNIA.**
Made with Hasselblad 500C and 40mm Zeiss
Distagon lens.

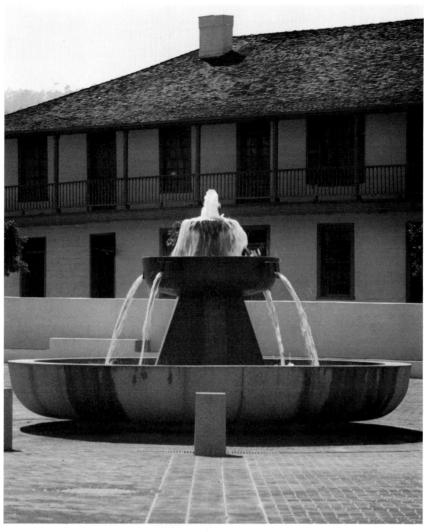

79. SAME AS FIG. 78. Made with Zeiss
Sonnar 250mm lens from identical position
from which Fig. 78 was made.

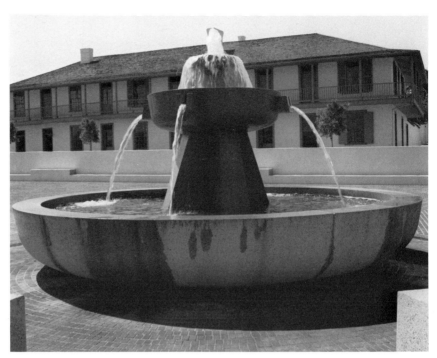

80A. FOUNTAIN. Made with Hasselblad 500C and Zeiss Distagon 40mm lens.
In these four pictures the camera is moved backwards to maintain the same size of the fountain.

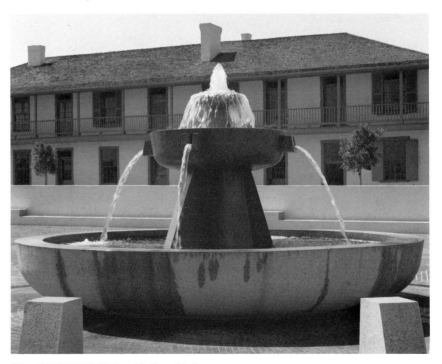

80B. FOUNTAIN. Made with Hasselblad 500C and Zeiss Planar 80mm lens.

156

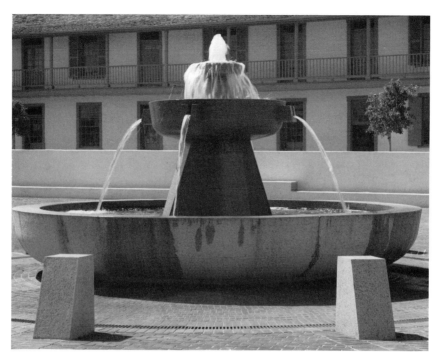

80C. FOUNTAIN. Made with Hasselblad
500C and Zeiss Sonnar 150mm lens.

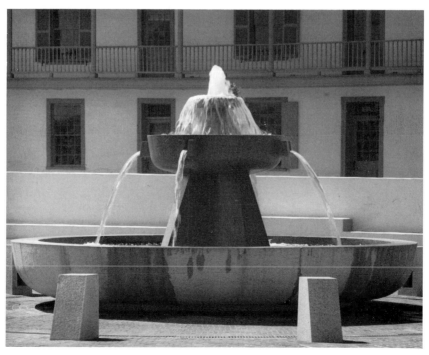

80D. FOUNTAIN. Made with Hasselblad
500C and Zeiss Sonnar 250mm lens.

157

It must be emphasized that "scale" is more than physical relationships. Emotional and aesthetic emphases are exceedingly important and lead to the identification of the "self" (of the photographer and the spectator) with the subject or subjects involved. Hence, it is important that the photographer—in his study of basic factors of technique—does not neglect the all-important emotional and imaginative elements.

One of the noblest examples of effective scale is *A Sea of Steps* (1903) by Frederick H. Evans (illustrated in the Monograph No. 1 on his work by Beaumont Newhall, The George Eastman House, 1964). It is not simply a demonstration of physical near-far effect, but a profound emotional experience.

The eye is very quick to detect a "fraudulent" scale. For example, I recall seeing a photograph of a barn at dusk. The perspective suggested it was made with a 6-inch lens on a 5x7 film. There was a moon in the sky—very large! If my estimate is correct for the basic picture, I am sure the moon was made with a 36-inch lens! (Or it could have been projected from a smaller negative image.) The relative scale was impossible! However, were only a part of the barn shown, the mind might have accepted the large moon and the barn as part of an image made with a very long lens. It was the obvious convergence-perspective confusion that created the false impression.

Scale is partially the impression of nearness or "presence." Yet we know of examples where a distant object, limited to one physical plane, achieves great scale by its placement in the picture format and its strong "shape" elements (which have become "form" elements in the image). A distant mountain against a vast sky, for example, conveys such an impression.

An important point: scale is not limited to material objects. *Space* (that volume objects occupy) as well as *negative space* (the volume they do *not* occupy—the "surround") can suggest scale.

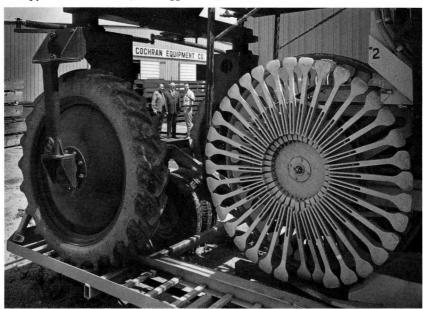

81. FARM MACHINERY, SALINAS, CALIFORNIA. An example of a "near-far" composition. Made with a Hasselblad 500C and the Zeiss 50mm Distagon lens. Some distortion of round shapes is inevitable if they are placed away from the center of the field. Supplementary flash, "bounced" from a reflector, was used.

158

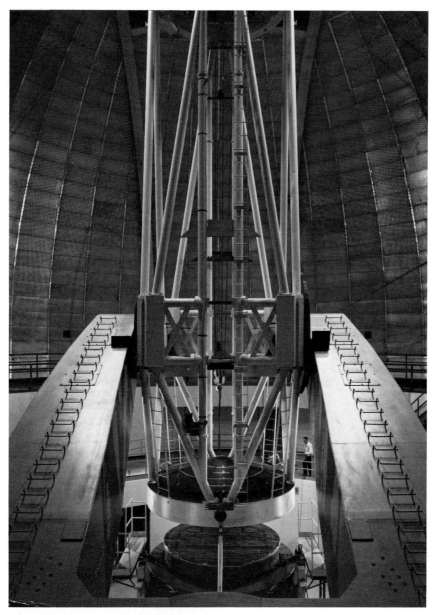

82. 120-INCH TELESCOPE, LICK OBSERVATORY, MOUNT HAMILTON, CALIFORNIA. Here we see the mirror "dropped" for transport to the vacuum aluminizing chamber. This was made with a 5x7 Sinar camera and the 121mm Schneider Super Angulon lens. Available light was used, plus some flood-lights in the "pit." Water-bath development held the extremes of value quite well; the negative can be printed on a paper of normal contrast grade.

Visualization must relate directly to the finished print, not to an agreeable

Page 147 "observation" of subject relationships in visual fields of view. We are familiar with the situation of our awareness and interest in an object and of the ability of our eye-mind apparatus to isolate this object and limit it to its immediate environment. The photograph may be made without consideration for this eye-mind subject-isolation, and the results may be disappointing: *observation* dominated over *visualization*. The scale in the eye-mind mechanism definitely may not be the scale observed in the photograph.

The advantage of interchangeable lenses (of varying focal lengths) is that larger or smaller images of the same subject can be made without changing camera position. However, as the camera position is fixed, there is no change in perspective—only in angle of view. This does not affect the relative *scale* of the objects photographed—only the *size*. Camera position (or, strictly speaking, lens position) is most important in visualizing object relationships, scale, format, etc.

A most helpful device is a simple cutout viewing card. This can be 4x5 (or

Page 28
Figs. 11, 16 any other format desired—full size or proportionately smaller) cut out of a firm piece of black cardboard or plastic (perhaps 8.5x11 inches overall). This device will not only serve as an excellent frame-type "finder" (if positioned over the lens) but also gives a most effective means of scanning the subject for proportion, size and arrangement; we can frame an infinite variety of possible compositions. As we move toward or away from the subject, our angle of view changes and we become aware of differences in the relative scale of the objects to be photographed. As we move the cutout card toward or away from the eye while at one distance from the subject, the angle of view changes but *not* the relative scale. Held at various distances from the eye, it suggests different angles of view, various aspects of the subject, relationships of subject to background and assists in choosing the lens of optimum focal length for a particular situation. When we have decided upon some point of view, however, we do not necessarily put the lens at the precise place of the cutout card! We may have a good idea of what we want, and the next step is to visualize the print and then set up the camera at the appropriate point of view.

"Dry shooting" is another most helpful procedure in familiarizing the

Page 37 photographer with the visualization process.

Some photographers, especially those who use only one camera and few lenses, are able to project upon the field of view an accurate mental "frame" representing the picture area desired. Those who use many cameras and lenses have considerable difficulty with this approach. Compromises are frequent; with the equipment at hand we may not be able to get the scale of the objects to be photographed under control and at the same time manage the desired field of view. In such cases we may use a shorter focus lens (at the optimum point of view) and get an image with a lot of unwanted "surround." But if we have visualized the final result, we will know where to crop the print or enlargement.

Remember: only the subject plane focused upon will be truly sharp. Depth

Page 96
Figs. 47, 49 of field is a compromise within which sharpness is at an acceptable level. Most lenses for small cameras have excellent depth of field scales engraved on the stop-setting rings. With lenses having depth of field tables we can trust these tables for a certain minimum circle of confusion; for sharper images, use a smaller stop than indicated. The eye has an extraordinary ability to sense sharpness or the lack of it. In my opinion, the near objects should be favored with maximum sharpness; the near object relates to our immediate tactile experience. In some cases, the far subject might demand greater sharpness, but as a rule I would favor the near object in this respect. Hence, in setting the focus with the depth of field tables I would "strain" the far focus rather than the near.

160

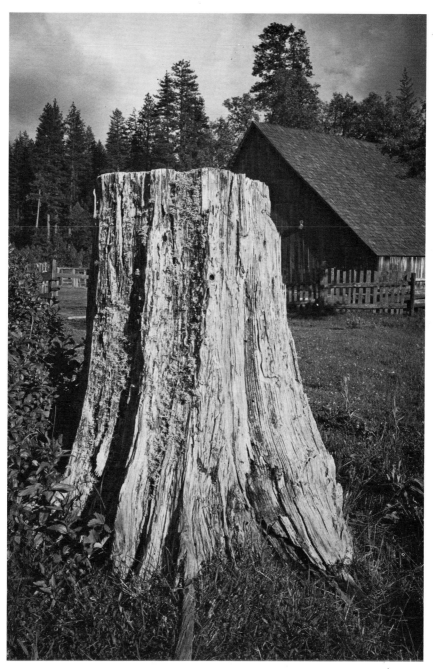

83. STUMP AND BARN, SIERRA NEVADA, CALIFORNIA. Made with a 4x5 Korona View Camera and a 4″ wide-angle Dagor lens. Good depth-of-field and definition, with exaggerated relative scale. A slight adjustment was made by the back-tilt for focus, but the depth-of-field between the top of the stump and the distant barn was controlled only by using the smallest lens stop. The lens was focused on a point about 1/3 between stump and barn.

84A. CARMELITE MONASTERY FROM POINT LOBOS STATE RESERVE, CALIFORNIA. Made with Hasselblad 500C and 40mm Zeiss Distagon lens.

84B. SAME. Made with 80mm Zeiss Planar lens.

84C. SAME. Made with 150mm Zeiss Sonnar lens.

84D. SAME. Made with 250mm Zeiss Sonnar lens.

163

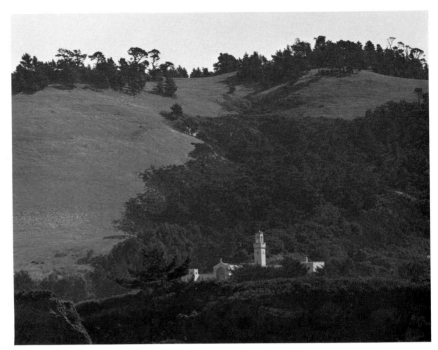

84E. SAME. Made with 500mm Zeiss Tele-Tessar lens.

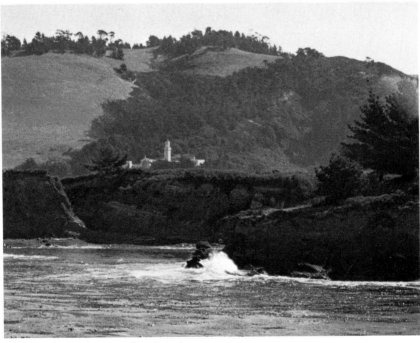

84F. SAME. Enlargement of section of 40mm image to approximate size of 250mm image (Fig. 84D.).

164

SETTING UP THE TRIPOD

Page 58 et seq. Practical and aesthetic factors are involved in this simple (but often misunderstood) operation. First, the camera should be attached to the tripod head with the camera axis parallel to one of the tripod legs. When the camera is being set up on the tripod, or the camera and tripod moved around to new positions, one leg should always point directly toward (or away from) the subject and along the line of the lens axis. Either of the other two legs can be moved to level the camera in a horizontal direction, and the leading leg is moved to level it in an axial (vertical) direction. Of course, with double-tilting tripod heads, the position of the tripod is not so important, but this basic placement of the tripod legs will certainly simplify setting up under all conditions. Obviously, if the tripod top is perfectly level in all directions, the camera can be rotated upon the tripod and remain level. This is very important when making panoramic pictures (either with the old Cirkut Camera, or in a series of pictures with overlapping sections). [*Note*: when making a sectional panorama, the rotating point should be directly under the center of the *lens*; otherwise, there will be distortion of perspective and near objects will not overlap properly.]

When the camera is leveled with the tripod in the basic position, the single leg (on axis) can be extended (or moved out or in from the tripod center) without disturbing the *horizontal* level of the camera. When the lens axis is not parallel to one of the tripod legs, moving *any* leg will throw the camera off level.

When the camera is in place on the tripod, it should be leveled both horizontally and vertically. We can consider this position "normal"; as discussed on page 145, all camera adjustments should be set at normal position at the start of any setup. Beginners, especially, who do not start with everything in normal position will suffer serious confusion. A well-trained photographer always starts with all camera adjustments at normal and the instrument leveled. A two-way level should be attached to the tripod and to the camera bed. Advanced view cameras have levels on the tilting back and front. While leveling may not be of greatest importance with natural subjects, it is absolutely essential with architecture and with scenes involving vertical trees, level horizons, etc. (See also the

Page 170 section on "Leveling.")

Some cameras such as the Sinar may be rotated on their tubular monorail; cameras such as the Arca and the Calumet are on fixed rectangular rails or other-

Fig. 22 wise designed so that they cannot be rotated. These can be tilted horizontally only by the horizontal element of the tilting tripod top. The Majestic tripod, for example, allows for right and left as well as vertical tilting. Many of the horizontal tilts move only from horizontal to about 45° (usually to the left). In rough terrain when the camera is set up but a tilt to the right is desired, the entire tripod must be re-adjusted; as we make the setup, we tilt the top 30° or 40° to the right, our tripod will then be set in a position as desired, but with the additional facility that we *can* tilt the camera more to the right or left if required.

Some tripod heads are of the ball-and-joint variety, giving movement in all directions. This may be an advantage in some cases, but it is hard to maintain a level in one position while adjusting for another position.

The view camera is usually operated at approximately eye level, and the tripod extension should be determined and so marked so that there is no time lost in the first setup. At least, we *start* from the most common position.

It will be well worthwhile to practice setting up the camera so that the operations become more or less automatic. The design of some tripod heads

makes it a little difficult to attach the camera without tilting the head to allow ample room for fingers and hand to manipulate the tripod screw. If we know just how to go about attaching the camera, we will save considerable time. Unless the camera base is "keyed" to the tripod head, it may rotate too freely and be moved out of position by the lateral pressures exerted when inserting or withdrawing the film holder. Some strong "friction" material can be attached to the tripod head (*not* spongy material which might augment vibration). A good mechanic can make a "grooved" camera base to fit the complementary tripod-top receptor, or vice versa.

Page 147 Setting up the tripod is not just a mechanical operation! Referring to the process of visualizing a picture: we perceive something of interest, and we approach it, intuitively seeking the optimum viewpoint for either informative or expressive purposes (or both!). The tripod is positioned and the position is subject to further refinement as the composition is searched for. Edward Weston had a very quick appreciation of the optimum point of view. He would carry his camera (on tripod) on his shoulder, approach his subject slowly enough for contemplation and reaction, and then set the tripod in position; he rarely changed this position except for small adjustments in height and distance (rarely for lateral angle of view!). This implies, of course, awareness of the field of view of the lens, which relates to the focal length of the lens in reference to the size *Page 147* of the negative. As noted in the section on perspective, the focal length of the lens (in reference to image size) exerts a profound effect on scale and depth. With experience and practice one can visualize the rectangle of the field of view superimposed on the scene for any focal length in reference to the size of the negative used. Obviously, myriad impressions are going through the mental computers at one time; the alteration of any one factor of visualization affects all the other factors. Hence, the setting up of the tripod is a very important part of the entire process of visualization. If done carelessly or mechanically, it can profoundly affect the end result of sensitive visualization.

Page 145 In our basic demonstration setup we can assume that we are using a view camera in which the back containing the focusing panel (and the negative) is set perpendicular to the base and that the lensboard in the front assembly is also perpendicular to the base (and therefore parallel to the back). We will also assume that the camera is leveled and that the lens axis is directed to the center of the negative.

Page 174 et seq. Assume the subject is a wall containing windows or other elements of precise vertical and rectilinear shape. In this case, the plane of the focusing screen (and of the negative) will be parallel to the plane of the subject in both vertical and horizontal directions (up and down and left to right). If the plane of the negative is not strictly parallel to the plane of the subject, we will obtain convergence of parallel subject lines. If the camera is pointed upwards, the image lines will converge to the top; if the camera is pointed downwards, they will diverge to the top (or converge to the bottom). Horizontal subject lines will converge towards the direction off axis to which the camera is pointed.

A tilted horizon can be very disturbing. Obviously the ocean is "level," but in yachting pictures a level deck and a strongly tilted ocean may give a powerful emotional effect! Again, the alluvial fans of the American desert areas might show a slight distracting tilt with a level camera. A good motto would be "Observe, Visualize, Adjust!"

It is easy to obtain correct vertical adjustment by making the back of the camera vertically parallel with the subject; a protractor level is very useful when we are working with rectangular objects, such as a painting leaning out from the wall. It is not so easy to overcome convergence of horizontal parallel lines; the

166

camera may be horizontally level, but if the negative is not horizontally parallel to the plane of the subject, convergence will be seen in the image. Horizontal parallel position can be achieved by centering with the eye and by aligning horizontal lines in the image with lines etched or drawn on the focusing screen. If it is impossible to adequately position the camera for this purpose, the lens side-shift may be used, then (if the camera possesses it) the back side-shift—both moved in opposite directions. This would shift the lens axis off center without changing the basic horizontal position. If this adjustment is not sufficient, the back side-swing can be used, which would bring the camera back into parallel position with the wall when the camera is pointed away from central position.

Page 174 et seq. All these adjustments are discussed in the "Camera Adjustments" section. Our basic problem is to get the camera properly aligned in all ways with the subject.

A photograph made with the camera in the ideal basic position—parallel in all ways with the subject—gives a geometrically accurate image of the subject, restricted only by the covering power of the lens in relation to its focal length, the distance of the subject and the size of the negative.

We should think of the basic camera position *before* making any adjustments (and all adjustments must be returned to normal when the camera is closed and returned to its case). Hence, tripod positioning is very important!

In time, we develop an instinctive sense of the adjustments, just as we "sense" the optimum viewpoint and the appropriate lens to use.

85. DR. CLARENCE KENNEDY IN HIS STUDIO, NORTHAMPTON, MASS. Made with a 4x5 camera and a Zeiss 5-3/4 inch Protar on Polaroid Type 52 Land film.

The picture was carefully composed and the available light required no boosting by flash or other means. The print was given less-than-normal development time, which preserved more detail and texture in the low-value areas. With conventional photography a negative would have been given normal-minus-1 development time or, possibly, water-bath development.

167

ORIENTATION

It appears to be a fundamental fact that man is conscious of the stability of the earth on which he stands and the level quality of the horizon. Standing on the earth, subject to gravity, we adjust our posture and the axis of our eyes to a "level" position, and even if we look up or down we seldom disturb our horizontal orientation. When we stand straight and look upwards, lines will naturally converge. When we tilt our heads to more or less unusual positions, we mentally compensate for the unusual aspect of the world. The camera, however, cannot make such compensations. When the horizon (especially the level line of the sea) is tilted, an unconscious mental and physical reaction takes place; an adjustment is required, and this detracts from the aesthetic experience. If we do not want images of unusual or "forced" aspects, we must take great care in the proper orientation of the camera. Confronting the real world, we can compensate to an extreme degree; confronting the photograph which reveals a disorientation of viewpoint, we find it very difficult to compensate and adjust. The so-called "angle shot" upsets our ingrown sense of stability; again, adjustments are required.

It is important to state here that intentional aesthetic and emotional effects may be based upon disorientation of the "realistic" viewpoint; the foregoing statements are intended to serve as a basis of departure from reality if such is desired.

If a subject with parallel lines cannot be composed accurately it is better to have a definite convergence than a slight one, as the latter will give the impression of carelessness. If, for example, it is necessary to have a convergence of lines (when pointing the camera upward at a tall structure), we should have the center line truly vertical (the convergence is then "understood"). If there is no real center line, we should orient the picture so that if there *were* a straight line it would be central. When confronted with simulations of reality (and a photograph cannot escape therefrom as can a non-objective painting!), the physical and psychological instincts dominate, and the aesthetic response is directly affected by the degree of "adjustment" required to re-establish a sense of stable orientation by the spectator.

The initial appreciation of a photograph (or any work of art) is almost instantaneous; the mental "computer" evaluates myriad factors of experience and appearance and creates a total recognition of the picture content (which may be clarified by subsequent observation and study but which seldom changes to any significant extent from the first impression).

To become conscious of camera position, to learn orientation of the camera in relation to subject, we must first be aware of its *axis*. We should think of axis as a line at right angles to the center of the subject field, passing through the lens and impinging upon the negative at the center of the field of the image. We can also think of the axis in reverse—from the negative to the subject. It may help in visualizing the axis concept to relate it to a spotlight beam playing over the subject in strict relation to the movement of the camera; where the beam impinges upon the subject is equivalent to the center of the field of view (and of the center of the image). With a little practice the actual rectangular field of view can be visualized as a widening rectangular tube emerging from the lens and intercepting the area of the subject to be represented in the negative. This facility comes most rapidly when only one lens is used.

If lenses of various focal lengths are used, it is more difficult to envision quickly their respective fields of view. One very simple method of determining the field of view of any lens (in reference to a given negative size) is to use a

wire or cutout rectangle of the same size and shape as the negative placed above the camera lens. With the camera extended to operating position—which depends upon the focal length of the lens and the distance of the subject—and with the eye placed before a controlling aperture at the plane of the negative, the effective field of the lens can be directly perceived. This simple device constitutes one of the best "finders," but for some obscure reason manufacturers avoid it! Parallax must be compensated for when working with near subjects. The important point here is that if the frame over the lens represents the proportions and size of the picture, and if the eye is directed to this frame through a controlling aperture at the plane of the negative, with lenses of any focal length and with subjects at moderate distances, the photographer will have a very accurate revelation of what his lens is seeing. With increasingly close subjects the viewing aperture will have to be raised to compensate for the parallax effect. Perhaps the engineers and designers have made matters more complex than need be in this respect! This system would not apply to some telephoto and wide angle retrofocus lenses having effective focal lengths shorter or longer than the extensions required.

An experiment is encouraged: hold the hand at full arm extension and note the number of finger widths necessary to approximate a given angle of view. Or fully spread the fingers and note the angle subtended from thumbtip to little fingertip (both hands may be used with thumbs together for wider angles of view). Relate this to the angle of view of the focal length of the lens used in reference to the negative size. This is a quick method of selecting the lens roughly appropriate to the subject and negative size at hand.

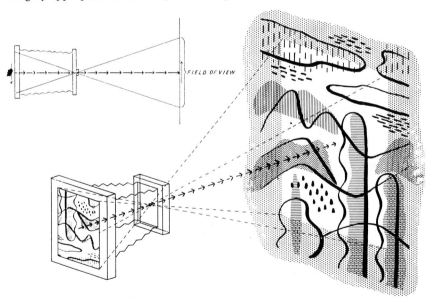

86. SCHEMATIC DIAGRAM: FIELD-OF-VIEW OF LENS. Consider lens axis as central point in field-of-view and in image (lens is in normal position). Practice visualizing the field which the lens covers; observe rectangular image in camera and direct lens axis to center of field-of-view. Try to visualize rectangular image area on field-of-view. Focal length of lens and negative size will obviously affect visualization of picture area. With practice a considerable facility can be developed. Rectangular formats, vertical or horizontal, can be visualized in square camera formats.

169

Hence, we can learn to select (in our visualization) the effective angle of view of our lenses, making reasonably accurate boundaries between the areas of the pictures and the limitless area of the visual world about us.

Few objects are seen from a truly static position. A slight movement of the head or body intensifies the impression of space, depth and scale; this is in addition to the three-dimensional effect of binocular vision. In passing an object we observe different parts and aspects at different moments of time; our concept is therefore the sum of our perceptions in space and time. But we are seldom aware of the time element involved in observation. We recall an object with apparent clarity; returning to it, we may find its aspect from any one viewpoint not the same as the aspect in memory (which may be a composite impression of many points of view observed in rapid sequence). The motion picture camera may simulate our experience in time; the still camera creates its own moment of time.

Hence, we must consider orientation in time as well as in space. Our problem, as photographers, is to create form out of the configurations of chaos.

LEVELING

1. **Hand cameras.** With practice we can learn to hold the camera reasonably level— accurately so for non-architectural subjects such as landscapes and portraits. With architecture and other rectangular subjects we may find it necessary to correct distortions in the enlarger. It is almost impossible to align the camera sufficiently by hand to avoid convergence and distortion of rectangular shapes.

 There is one common and important defect to watch for: tilting of the camera so that the horizon is inclined instead of straight. Many persons suffer from an extraocular muscular imbalance. It can be recognized by a difficulty in bringing stereoscopic images together; one rides higher than the other, and much effort is required to join them. Fatigue and increasing age tend to heighten this condition. Looking through the camera finder with one eye (whether the other eye is open or not) may result in a definite tilt of the image. This can be controlled by having a cross grid of fine lines in the finder field to which we can align horizontal or vertical lines. This defect is so common and so easily managed (by properly designed eyeglasses) that it is surprising that so little mention has been made of it in practical literature.

 Knowing that it is difficult—if not impossible—to achieve a perfectly level position with a hand-held camera, we should then try to "see" as best we can with the convergences we cannot avoid; if a convergence must occur, let it be a definite one and not just a slight distortion. The camera should be as level as possible horizontally; the vertical up-tilt is then more agreeable than an up and side-tilt combined (the body attempts to adjust to the angle of what would be the central vertical line of the image). Optical convergencies, "distortions" of perspective, etc., *can* have expressive value if properly and convincingly applied.

 The Polaroid cameras can provide excellent demonstration of the problems described above, and a considerable amount of practice with one of them will be rewarding. Once the photographer can manage a more or less accurate horizontal level position, the vertical displacements will be easier to control.

2. **Hand cameras on tripod.** Knowing that accurate geometric relationships are possible only if the film plane is parallel to the plane of the subject, we should first establish a vertical-level position. If the tripod top is level in all directions, the camera (in vertical level position) can be rotated through the full 360° and remain vertically aligned. But if the tripod top is not level, any movement of the camera—to left or right—will require a new vertical and horizontal adjustment.

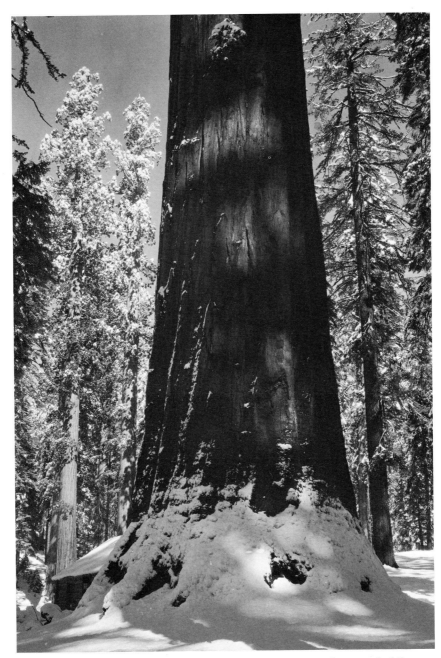

87. WINTER, MARIPOSA GROVE OF GIANT SEQUOIAS, YOSEMITE NATIONAL PARK, CALIFORNIA. Made with an 8 x 10 camera and a 12-inch Goerz Dagor lens. The Rising Front was used to maximum; then the camera was pointed upwards. The convergence may amplify the impression of height and scale. With this camera-lens combination, the fairly limited covering power of the lens would not have permitted rectilinear adjustment; had the back been tilted forward to vertical position, the front (lens) would have had to be tilted to about the same position for adequate focus. The lens axis would have been elevated on the negative beyond the covering power of the lens. There would have been serious loss of definition at the upper corners of the image.

With 35mm cameras, Rolleiflex or Hasselblad type cameras we can do excellent architectural work providing the field of view of the lens includes sufficient area of the subject without up-tilting the camera (which would create convergence of vertical lines). If the coverage is inadequate, we may resort to lenses of greater angle of view; if these do not suffice, we can point the camera upwards and correct the inevitable convergence in the enlarging camera. The Nikon 35mm camera can be obtained with a special lens which can be raised, lowered or moved laterally off axis (duplicating in a way the rising, falling and sliding front of the standard view camera). Many modern cameras are of "streamline" design, and it is hard to find a flat area on which to use a level. To get accurate vertical level, a right-angle level can be placed against the lens flange. To get true horizontal level, the level can be placed against the ends of the camera (which are usually flat). For the Hasselblad camera a level is obtainable which attaches to the accessory bracket; this is especially useful with the new 40mm and 50mm Distagon wide angle lenses. With the Hasselblad Super-Wide camera the special optical finder is equipped with a very accurate bubble level which is viewed along with the finder image (this is very important in overcoming distortion of rectilinear subjects with wide angle lenses). The wider the angle of view of the lens, the greater the evident distortion from off-level camera position.

Fig. 24

3. **View cameras on tripod.** Assuming the view camera has all essential adjustments, we should first set up the tripod with one leg pointing toward the subject along lens axis. We achieve horizontal level by moving either of the other legs and then adjust vertical level by moving the axis-aligned leg. Be sure all adjustments of the camera are set at normal position. If the tripod top is level, the camera bed should be level. If the tilt back is at normal, the ground glass should be truly vertical. If the tilt front is at normal, the lens and lensboard should be parallel to the back, and vertical. Be sure the swing back and swing front are both in normal position (at right angles to the camera bed and perpendicular to the axis of the lens). Side-shift of both front and back assemblies should be set to normal (central) position. It is *very* important to have all adjustments in normal position to begin with. This cannot be over-emphasized!

With non-architectural photography the horizontal level position is most important; convergences are not obvious with non-linear subjects. But with architectural subjects, straight forest trees and the copying of rectangular pictures, etc., both levels must be accurately set and, what is equally important, the axis of the lens must be horizontally perpendicular to the plane of the subject; otherwise, we will have lateral convergence. This is inadmissible in copying a painting. If convergence must occur with an architectural subject, it must be enough to suggest an intentional angular view and not suggest carelessness or inaccuracy!

The *lateral* (horizontal) alignment is, of course, much more difficult to observe and correct. However, it can be corrected as follows: with the camera in level operating position check the vertical alignment of both front and back components. Thus, using a stable tripod tilting head, point the camera down so that the camera bed is *truly* vertical (check this!). The front and back assemblies should be level in the direction of the lens axis, but the *lateral* position may need correction; this is simply done with an ordinary good level placed across the camera back or ground glass. If it is level and in alignment with the front assembly, we can assume that both front and back are appropriately aligned.

Any deviation in alignment can be noted and indicated on the camera by small marks at appropriate places. Lateral (horizontal) settings can be checked as follows:

172

(a) Use of an accurately engraved ground-glass grid (with both vertical and horizontal lines). As the camera is swung from one side to the other, convergence of the horizontal lines of the subject will be noted; at the point where all horizontal lines are aligned with the horizontal grid lines, we can assume the camera is properly placed. If one horizontal line is aligned but other lines are not, we can assume that the camera is not horizontally level. If all horizontal lines are aligned but the image is not centered, we can move the entire camera to left or right and re-level and re-align, or we can resort to the side-shifts of camera front and/or back (the front would be moved toward the center of the field and the back would be moved in the opposite direction; in either case the axis of the lens is moved from the center of the film, and we must be sure the lens will now completely "cover" the field).

(b) Align the camera bed with lines on the floor which are perpendicular to the wall, or if copying a painting, align the camera bed, etc., with a taut cord stretched perpendicular from the plane of the subject.

Constant watchfulness is necessary to see that any one adjustment does not negate the effect of other adjustments or that adjusting for vertical level, for example, does not disturb the horizontal level. It is suggested that a lot of practice in the leveling and adjustment field be done; camera manipulation should be automatic and intuitive; many a fine picture has been lost through the delays in the adjustments or sheer misunderstanding of their application.

While any good 35mm and 2-1/4x2-1/4 camera is built with accuracy and precise alignment throughout, many of the older view cameras are definitely not in alignment and, no matter how good the lens, the overall performance may be poor. A good repairman can put the camera in as good alignment as it can retain, but the front and back assemblies should be carefully aligned with right-angle levels before final adjustments are made. This is especially true when any considerable extension is used; the camera bed can "sag." This cannot happen with the new monorail cameras. However, with *any* view camera the working parts of the front and back assemblies can become worn and the precision of alignments affected.

With the older view cameras it is advisable to use a secondary supporting bed to prevent the basic camera bed from sagging. Even with this additional support, it is wise to check the vertical alignment with levels. (See also "Levels.")

Page 170

A separate camera "bed" can be made of light aluminum (trussed) construction which will accurately support the extended standard view camera. Levels can be attached to this bed and, if the bed is thick enough, space can be provided for many accessories. In effect, this bed can be designed as a little workbench. It can be marked in inches or centimeters, can have spring-clips for small items such as lens caps, lens brushes, extra cable-releases, etc.

What do we do if we do not have a level? An engraved grid on the ground glass is a great help in aligning verticals and horizontals in the image. It is sometimes easier to make the alignments a small distance from the grid lines— say 1/16 inch—than on the line itself (a visual resolution problem). If rectilinear objects are in the environment, alignment thereto with top or sides of the camera body can be done. Some modern cameras are of "streamline" design and it is hard to find a straight edge! The front of the lens barrel is accurate and a straightedge held against it will give an excellent vertical alignment with a vertical subject. A perfectly flat aluminum plate, larger overall than the camera (except at the back) can be mounted between the tripod head and the camera bed. We can take horizontal levels from this plate. A precise "L"-shaped level can be permanently attached thereto.

173

CAMERA ADJUSTMENTS

The purpose of this section is to clarify the use of the basic camera adjustments. Having this knowledge, we will be in a position to employ the adjustments advantageously, and we will also be aware of the limitations involved in using cameras without such adjustments. (In the latter case, certain "corrections" are possible by use of various adjustments of the enlarging camera.)

The basic box camera (as well as the most advanced 35mm instrument) has no means of image control other than by using lenses of varying focal length. (The one exception at present is the Nikon F camera with the lateral movements of the Perspective Control Nikkor lens.) Hence, because of fundamental geometric principles, distortions (such as convergence) are inevitable unless the camera is directed squarely at the subject with the film parallel to the principal plane of subject. It must be borne in mind that convergence is, in itself, a natural aspect; when we look upwards at a building, for example, we note the convergence of the vertical lines, but these are not distracting to the eye since we can adjust for all positions. When this convergence is seen in a photograph, certain aesthetic and logical elements are involved and unless the convergence effect is an intentional element of our composition, it is difficult to "accept" it. Convergence is also a perspective effect and is, in this sense, very important. Pointing the camera up, or *to the side* (when photographing rectangular subjects), will create vertical, or lateral, convergence. Certain adjustments on view cameras can control this situation. With non-rectangular subjects the convergence effect is less noticeable; usually it is quite inconsequential. However, the depth of field problem is a severe one with the ordinary camera. A near and a far subject more or less in line with each other can be brought into acceptable

Page 96 focus only within the limits of the depth of field capacity of the lens (in relation to focal length and aperture used) and with consideration for the degree of enlargement of the negative image. Subjects having near-far elements (such as a close object in the low foreground and a distant mountain near the top of the image) can be brought into balanced focus by the simple back-tilt or front-tilt adjustment of the view camera.

The camera, when in normal basic position, has both front and back assemblies perpendicular to the camera bed and parallel with each other. The lens is centrally positioned in the front assembly, and the axis of the lens therefore impinges on the center of the back assembly (or in the center of the picture area). It is necessary that the *covering power* of the lens be adequate to give a precise image over the entire negative when the axis of the lens is moved away from the center of the film.

1. **THE RISING FRONT** is the most common adjustment in standard cameras. In view cameras the rising front will allow sufficient movement to displace the lens axis about 1/2 the largest dimension of the negative, i.e., about 2-1/3 inches with a 4x5 negative, but in most cases the movement is less. It is used primarily with architectural work, where more of the building height can be brought into the field of the negative (without up-tilting the camera). If the rising front at maximum position is not sufficient to show the top of the building, the camera

Fig. 97 may be moved to a greater distance, or the camera is up-tilted and the tilting back used.

2. **THE FALLING FRONT** appears in a few cameras and works on the same principle as the rising front. Monorail cameras usually allow the back to be raised to the same height above base as the Rising Front; then we have the

174

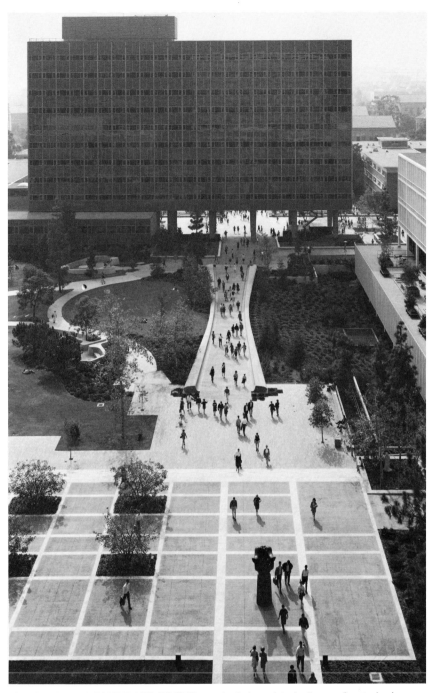

88. SCULPTURE COURT AND SOCIAL SCIENCES BUILDING FROM ROOF OF DICKSON ART CENTER, UNIVERSITY OF CALIFORNIA, LOS ANGELES. Made with 5x7 Sinar camera with 4x5 back, 121mm Schneider Super-Angulon lens. Camera back was in vertical position and raised about 1 inch. Camera front, also in vertical position, was lowered about 1 inch. Effect was opposite from usual "rising-front" effect; the lens axis was lowered and there was no need to point the camera downward to include foreground.

89. CALUMET VIEW CAMERA. In normal operating position. Note that the lens is moved foreward on monorail. This is essential when wide-angle lenses are used so that monorail will not intrude on field-of-view. The long projecting monorail in the rear may cause trouble in focusing. It is not necessary to move the front forward with normal and long-focus lenses. When replacing camera in case, center monorail on bed, and rack front and back of camera close together.

equivalent of the falling front. This is not possible when the back is attached to the camera bed.

3. **THE SLIDING FRONT.** Found on many view cameras, the sliding front accomplishes laterally what the rising front does vertically. Cameras lacking a sliding front can be turned a full 90° (by a tilting tripod head), and the rising front can then be used as a sliding front. As with the regular rising front, if the maximum movement is not sufficient, the camera can be up-tilted and the swing-back used as the "tilting back."

4. **THE SLIDING BACK.** With cameras such as the Sinar, Arca and Calumet the back can be shifted from side to side just as the sliding front is operated. Both sliding front and sliding back used together (but moved in opposite directions) obviously give a greater degree of adjustment, but the covering power of the lens may not be adequate and should be carefully checked.

Note that the rising, falling and sliding adjustments listed above move only parallel with the plane of the negative and perpendicular to the lens axis. If the camera is perfectly level and the plane of the subject parallel with the plane of the film, the image will be geometrically accurate in normal settings or with the four adjustments listed. Of course, an inferior lens may reveal its defects as it reaches the limits of coverage, but this is a separate effect and geometric factors are not involved. Only the axis of the lens has been moved to various points on the area of the negative.

176

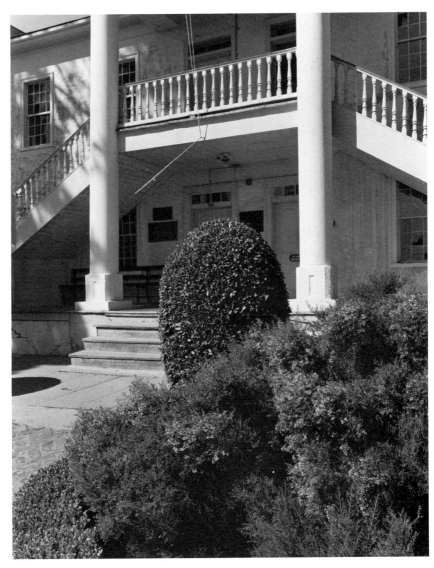

90. COLTON HALL, MONTEREY, CALI-FORNIA. Made with Calumet 4x5 Camera and 215mm Series S Caltar f/4.8 lens.

The camera was placed to get optimum image-arrangement of the subject and was carefully leveled. Front and back were in vertical position and the axis of the lens was perpendicular to the center of the ground glass. After composing, a slight forward tilt of the lens brought the near foliage into focus without altering the "geometry" of the structure. Tilting the back would, of course, have created convergence of the straight lines of the subject. Exception: the camera could have been tilted down a little, the front raised a little, and the back tilted to vertical; the same effect would have been obtained.

Obviously, the foliage is redundant and the building incompletely seen. In the following illustrations the camera controls which will "manage" the image will be described.

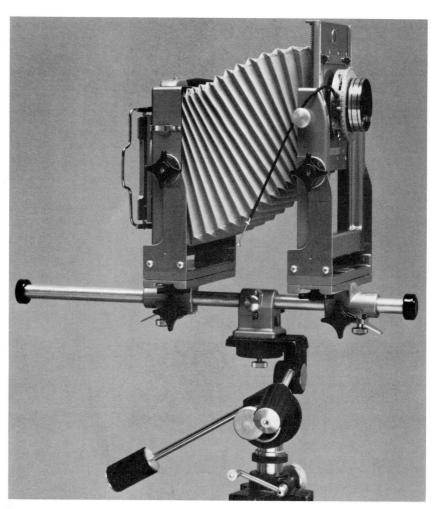

91. CALUMET CAMERA. Same position as in Fig. 89, but with the Rising Front set to maximum. Note that the Front and Back remain in vertical position; hence the "geometry" of the subject remains virtually unchanged. The Tripod is the C-31 (Calumet) with geared center-post. This is a sturdy tripod for 4x5 and 5x7 view cameras.

5. **BACK TILT**. Assume we are photographing a building and that we have used the rising front to maximum degree but have not included the full facade. If we cannot move away from the subject or use a lens of shorter focal length (thereby securing a smaller image which might fall completely within the negative area), we must tilt the camera upwards. (We retain the maximum rising front position.) Up-tilting gives convergence in the image because the back is no longer parallel with the subject. Now, after up-tilting the camera, we can tilt the back forward to perpendicular position, which will remove the convergence effect. We may have to refine the adjustments a little to place the top of the building exactly where we want it to be on the film; with camera up-tilt and swing-back correction the image is "stretched" somewhat. But please note that the position of the lens axis on the negative is not changed by the use of the tilting back, and the covering power of the lens is not affected any more than it

Fig. 93

Fig. 95

178

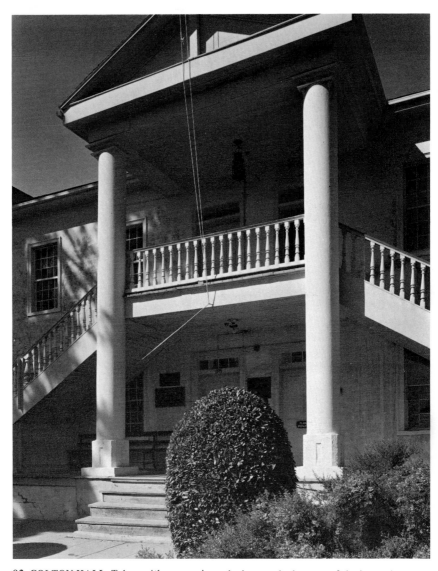

92. COLTON HALL. Taken with camera in position as shown in Fig. 91. Raising the front of the camera slightly changes the point-of-view of the lens; this is apparent in the slightly increased distance between the top of the rounded bush and the door beyond. With objects close at hand there would be an appreciable difference in the near-far relationships (see page 33).

Because of the elevated position of the lens axis, there is a greater distance from the lens to the bottom of the image (top of the picture) than from the lens to the top of the image (bottom of the picture). This produces a very small elongation of the image; the pediment "pulls" slightly up and to the right.

is with the rising front. We might have a *focus* problem for which the depth of field capacity of the lens may not be adequate.

Back tilt for focus. As with the front tilt, balance of focus is easily accomplished with the back tilt. The position of the lens axis is not affected. However, we

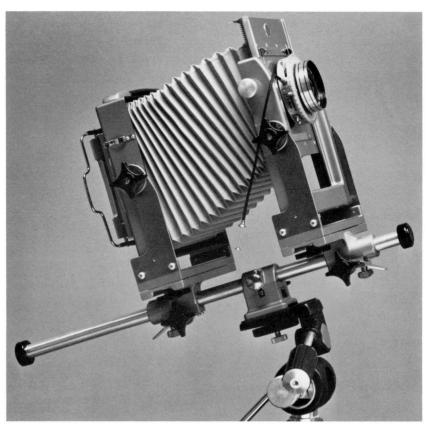

93. CALUMET CAMERA. Rising Front still at maximum setting, but camera pointed upwards. Camera front and back parallel. Horizontal level maintained. Convergence of parallel lines in the subject inevitable.

must remember that when we tilt the back, we are affecting the geometry of the image, and any rectilinear area in the subject will show convergence (or divergence) if the camera back is not parallel thereto. Back tilting for focus adjustments is recommended for most non-rectilinear subjects.

6. FRONT TILT. With the camera up-tilted and the back tilted into vertical position, we note that the plane of the front assembly is definitely not the same as that of the back assembly. If all parts of the subject are at equal distance from the lens, the front and back of the camera should be parallel to achieve good focus throughout. But when we set the front parallel to the back, we note that we have further displaced the axis of the lens (we have already displaced it by the rising front), and the covering power of the lens is severely taxed. However, tilting the lens does *not* change the geometry of the image!

Fig. 95

Fig. 97

Front tilt for focus. With the camera back at normal or tilted position the front tilt can be used to correct the plane of focus with near-far images. Remember: this does displace the axis of the lens and lens coverage must be adequate. Very little movement of the image is seen when the lens is tilted; shift is related to the angular position of the two nodes of the lens, and no geometric change is caused by tilting the lens (except the natural distortion when very large angles of view are concerned).

180

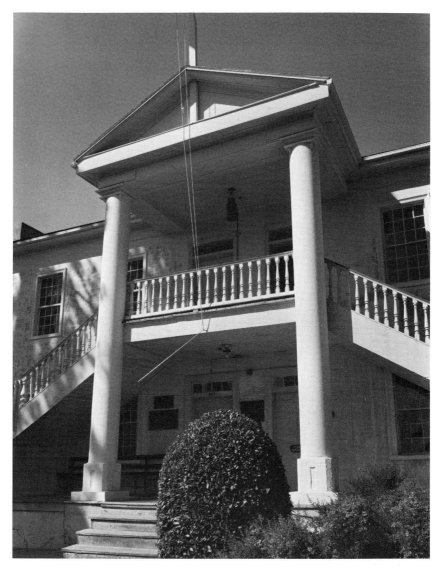

94. COLTON HALL. As the camera, in normal position but with the rising front set at maximum, could not get the entire portico in the field of view, it was necessary to point the camera upward (as in Fig. 93). The results as we see here are as expected—a strong convergence of the vertical lines of the subject.

A purely symmetrical convergence (when the camera is head-on to the subject) is the least offensive, but when the camera is pointed at the subject at some horizontal angle of view, the effect can approach distortion. This effect is minimized if the central part of the image is vertical. The right-hand edge of the window frames on the first and second levels line up vertically; this, at least, provides an "anchor" for the spectator.

With non-rectangular subjects this degree of convergence might not be disturbing in any way.

95. CALUMET CAMERA. With Front raised to Maximum, camera pointed upwards, and Back set in vertical position we have corrected in part the convergence shown in Fig. 94. Note that the lens is much farther from the bottom of the image than from the top than it was in Figs. 91 and 93. The effect is obvious in Fig. 96. This is an extreme example but nevertheless accurate.

When we think about the "focal plane" of a near-far subject, we can visualize a taut string between the near and far limits. We tilt the camera back backwards (or the front forwards) from the top so that every part of the string will be in focus. But there may be parts of the subject lying under or protruding above the plane of the "string." These constitute depth of field problems, and the lens must be adequately stopped down to take care of them. Figure 74 shows a rather simple example of a continuous "focal plane" situation. Figure 34 shows an example of a depth-of-field situation which obtains *after* the extremes of near and far have been adjusted to a focal plane.

What is frequently overlooked is that when we are working with a "near-far" composition, the depth of field in the "near" areas (especially if they are quite close) is less than in the middle or far distance. When we have adjusted the tilting back or tilting front to achieve maximum clear focus in the entire field, the lens is obviously farther from the negative for the "near" subject than for the distant ones; in effect, the focal length is increased and hence the depth of field reduced. Depth of field is a function of focal length and lens aperture; an 8-inch lens, extended to 10 inches, is working as a 10-inch lens.

182

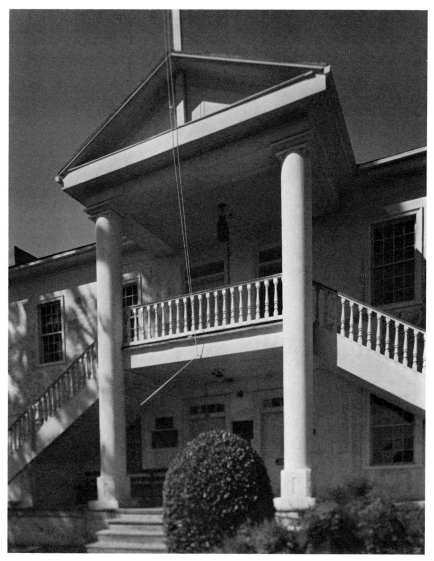

96. COLTON HALL. The result of the position and adjustments of the camera as shown in Fig. 95. Basically, the "geometry" is corrected, but because of the direction of the lens axis to the plane of the image, this is a distortion which is explained below.

The bottom of the image (top of the picture) is considerably farther away from the lens than is the top of the image (bottom of the picture). Consequently, image-size is increased (the farther the lens from the negative the larger the image will be). The focal plane should be parallel to the plane of the tilted front; as we see in Fig. 95 it is not. This results in the effect of "spreading" of the columns, very unpleasant in this instance.

It is also apparent that the lower areas of the picture are out of focus in comparison to the upper area. If the bush were sharply focused upon, the pediment would be out of focus. If the center of the field was set in sharp focus, and the lens stopped down to a very small aperture all of the image might be in acceptable focus.

In addition, when the lens is in a position such as this the upper areas of the picture will be less exposed. This is apparent in the original print of this picture, but may be too subtle an effect to carry in the reproduction.

As the camera adjustments become more extended the need for precise leveling and positioning of the camera is increased.

183

97. CALUMET CAMERA. With Front raised to maximum, camera pointed up, Back in vertical position, and Front also in vertical position, we have the image corrections as seen in Fig. 98.

Note that the axis of the lens is elevated to a point which might well tax its capacity to cover fully the negative (unless it were a wide-angle lens). Unless we have assurance on the covering-power of our lenses we should make careful tests before using them in the field. And we should carefully examine the image on the ground glass.

Proponents of tilting backs which tilt from *base* rather than from *axis* have, in my opinion, a rather impractical approach. Tilting for geometric accuracy remains the same in either case. When the back, for example, is tilted on axis for maximum depth of field, we focus first on the middle distance and a slight adjustment of the back or front will bring both near and far objects into focus, requiring very little lens focus adjustment. With the "tilt from base" system we must constantly adjust the lens focus while the back or front is being tilted. As a concession to both opinions, some recent view cameras have *both* tilting systems. With the "tilt from base" system the front can tilt outward and the back backward, thereby adding 2 or 3 inches to the effective extension of the camera bed! The "tilt from axis" system can then be used in the conventional manner.

7. **FRONT SWINGS AND BACK SWINGS.** These function exactly the same in principle as the back tilt and front tilt (see Figs. 99A through 102B for illustration of their use).

184

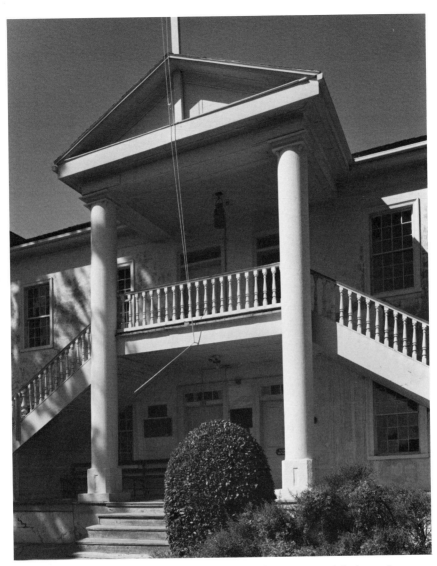

98. COLTON HALL. Taken with the camera in corrected position as shown in Fig. 97. The "geometry" is now normal, and good all-over focus is achieved. There is a slight "looming" effect due to the rather extreme adjustments of the camera. With a longer lens and working at a greater distance, the adjustments would not have been so severe.

This is a good oportunity to discuss a hazard which all photographers with view cameras encounter—the results of inadequate tightening of all camera adjustments and focusing racks, especially under the strain of extreme adjustments. Basically, this photograph should be *perfectly* true and aligned. But the back slipped a little under the strain

of the adjustments and the image shows a slight convergence (which shows along the windows on the right). There is no excuse for this as the camera should have been thoroughly tightened and *checked with a level* before making the exposure.

If we wanted a little more of the steps to show we could drop the rising front without affecting the precision of the image.

If coverage is adequate, we will have good focus over the entire image as the lens axis is perpendicular to the plane of the film.

185

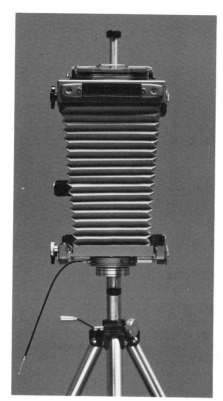
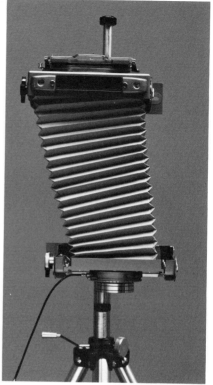

99A. CALUMET CAMERA. Tilted down. Front and Back in normal lateral position. Black object on the left is horizontal adjustment handle for the Calumet C-31 Tripod (as shown).

99B. CALUMET CAMERA. Tilted down. Back and Front in opposed side-shift, but maintaining parallel position (same in principle to Rising Front and Falling Back combination on page 174).

In many situations practically all of the camera adjustments may be in use at the same time. The danger here lies in possible geometric distortions (because of unfavorable position of the camera back) or failure of the lens to properly cover the negative with the application of a combination of adjustments. It is necessary to follow a step-by-step procedure, checking the position of the *back* in reference to the image planes. In free natural subjects—rocks, hills, etc.—the evidence of distortion is by no means as apparent as with rectangular subjects (vertical pine trees can show obvious distortion through convergence about as much as architecture). The horizon should always be *level* (excepting, perhaps, with yachting pictures!). However, convergences and other distortions *can* be used creatively with good effect, and we frequently depart from the "correct" positions to achieve imaginative results. The view camera is, in a sense, an instrument of kinetic "sculpture" of the optical image.

RESUMÉ

An important rule to follow in all cases is *set up the camera in normal position with zero adjustment settings.* Use all the adjustments as little as possible; it is easy to over-adjust without really thinking about what is happening! In all cases where the convergence of parallel lines in the subject must be avoided, the

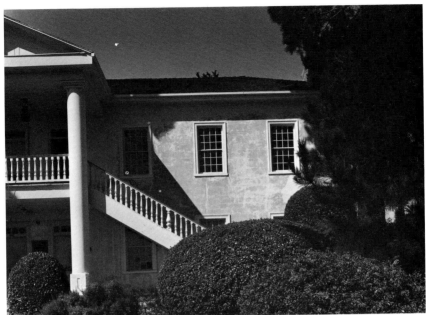

100A. COLTON HALL. Made with the 4x5 Arca Camera and 121mm Schneider Super Angulon lens. Camera Back parallel with facade (horizontally and vertically). Lens axis directed to central window. Camera settings as shown in Fig. 99A. Note: in Fig. 99A camera was somewhat extended with a long-focus lens; Figs. 100A and B (and 102A and B) were made with the Arca camera at about 5-inch extension, with camera Front only 4 inches from front end of monorail.

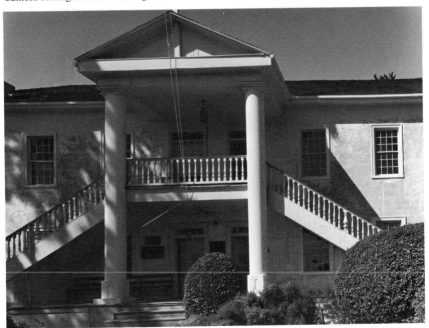

100B. COLTON HALL. Camera was at same position as with Fig. 100A and Sliding Front and Back used as shown in Fig. 99B. Back and Front are parallel to facade; there is no horizontal convergence. The wide-angle effect shows in the slight "pull" of the pediment to the left.

187

101A. CALUMET CAMERA. Tilted
down. Front and Back Swings set parallel.
Without Sliding Front and Back used (Figs.
99A and 99B), we can see that the lens axis
falls well off-center.

101B. CALUMET CAMERA. Tilted
down. Front and Back swings set in oppo-
site position. This setting is useful with
extreme convergence and focus situations.

camera back (the focal plane) *must* be parallel to the plane of the subject. With
cameras having tilt back adjustment: before we tilt the camera up or down, we
should try the rising or falling front (the same for lateral movements of the
sliding back and front). If it is necessary to move the camera to cover the
subject, we must do so—and then tilt or swing the back into parallel position. As
described on page 178, tilting or swinging the *back* does not affect the covering
power of the lens, but with ordinary lenses the rising or sliding front (perhaps
both together) might seriously affect the corners of the image (refer to Figs. 44
and 45 on page 93). With a wide angle lens this trouble will be minimized. If
there are different focal planes in the field of view, we must resort to the proper
Fig. 50 focus point for maximum depth of field, or we can use the tilting or swinging
front (if we must keep the back parallel to the subject). As the tilting or swing-
ing front displaces the lens axis we might have some serious coverage problems.
It is important that we *know* the adjustment limits in relation to our lenses. It is
difficult to see image fall-off with ordinary subjects; we should test with a
brightly, evenly lighted wall, visually checking as best we can and, if possible,
using the Sinarsix to probe the corners of the 4x5 image. [The Sinarsix will not
cover larger sizes although it can be adapted to read the central portions of 5x7
and 8x10 negatives when reducing backs (down to 4x5) are used.]

188

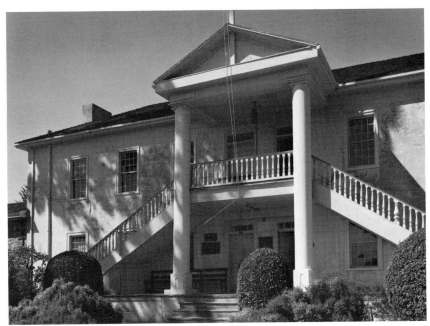

102A. COLTON HALL. The camera (at normal setting) was turned to the left to capture the entire facade of the center and left sections. The camera was in the same position as for Figs. 100 A and B. The convergence is normal and pleasing, and the impression of scale and proportion retained.

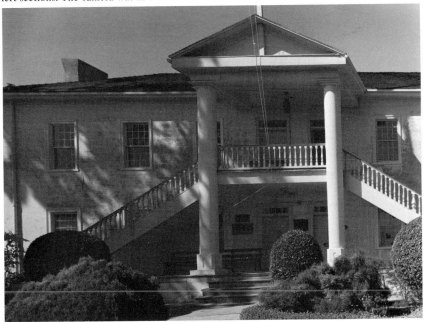

102B. COLTON HALL. Camera at nearly the same position and direction as in 102A. The Back swing was set parallel to the facade. To achieve accurate, all-over focus, the Front swing was set parallel with the Back. Then the sliding Front was moved to the left as far as it would go. It was necessary to move the entire camera back several feet; even then, the entire facade could not be managed in the picture area. The extreme wide angle effect is apparent. The left-hand convergence is due to filmpack negative curl.

189

Technical diagrams of the position of subject, lens and image planes show that extensions of these planes meet at some significant point well outside the camera. As these correlations of planes are very difficult to establish in practice they bear no direct significance to visualization and to camera and lens control.

103. DR. A. STARKER LEOPOLD AND ASSOCIATES, THE MUSEUM OF VERTE-BRATE ZOOLOGY, UNIVERSITY OF CALIFORNIA, BERKELEY, CALIFORNIA. Made with a Sinar 5x7 camera and 121mm Schneider Super Angulon lens. The bag bellows was used which permitted considerable adjustment of the camera with the short-focus lens. The camera was pointed down, and the Back tilted to perpendicular. The Front was tilted a small amount to correct focus.

104. CALUMET CAMERA. Here the camera is shown fully extended (see Fig. 21, page 45) and photographed with a 4-inch lens. Comparing this with Fig. 21, note the "open" view of the inner faces of the Front and Back sections.

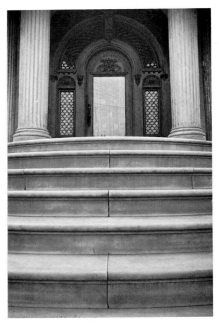

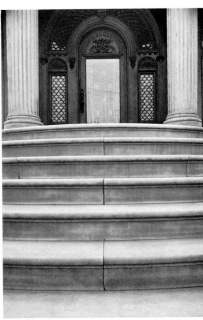

105A. STEPS AND COLUMNS. Depth of field obtained by tilting Back. Note the strong convergence of the vertical columns and the increased size of the near steps.

105B. STEPS AND COLUMNS. Depth of field obtained by tilting Front (Back was perpendicular). Note vertical columns and normal size of steps.

106A. PORTRAIT. Made with lens of normal focal length (8-inch on 4x5 camera). Features are rendered in normal scale and "likeness" is preserved.

106B. PORTRAIT. Made with short-focus lens. Note "personality" difference in these two images due to change of apparent scale of the features.

191

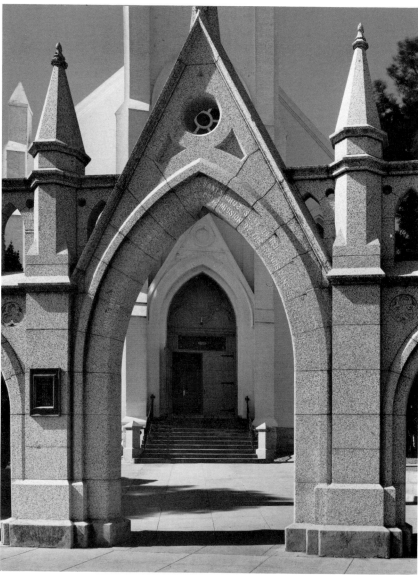

107. CHURCH GATE AND CHURCH, SANTA CRUZ, CALIFORNIA. Made with the 4x5 Arca camera and the 121mm Schneider Super Angulon lens on Polaroid Type 55 P/N 4x5 Land film.

The Gate structure is set at an angle of about 30° to the facade of the Church and the camera was first set up with the back parallel to the plane of the Church facade. There was a distressingly obvious convergence of the Gate. The camera back was then swung to be approximately parallel with the Gate (as far as possible and still retain acceptable depth-of-field). The difference in the size of the finials suggests a rather extreme adjustment.

Adjusting the camera to this degree gave a considerable distortion to the Church in the background but as the Church was mostly obscured by the Gate, the effect is not too distressing. The sliding front was used to a small degree (the lens was moved to the right) to get as much as possible of the Church entrance and yet nqt confuse the structure at the extreme left with the left-hand gate finial.

Adjustments as extreme as this can be made only with lenses of great covering power.

192

LENS COVERAGE

The various examples and diagrams illustrating camera adjustments are, in the main, self-explanatory. However, a most important fact must not be overlooked: the covering power of the lens. All lenses yield circular images; obviously there is a limit to the size of the rectangle (related to its proportions) which can be contained within this circular image. Within a circle 8 inches in diameter we can place a square of about 5-1/2 inches or a rectangle of 4x6-1/2 inches or a narrower rectangle of 2-1/2x7-1/2 inches, etc.

Figs. 44, 45

Were the negative in the form of the inner surface of a sphere—every point equidistant from the lens, as in the retina of the eye—image brilliancy would be consistent over the entire field, and many problems of lens correction would be avoided. In astronomical and technical cameras the negative is sometimes gently curved, but in general photography the negative is flat. One of the lens design problems is to get a truly flat field so that all rectangular lines in the image will be accurate in every respect. Not only must the lens give a flat field but the negative must be held as flat as possible in the camera.

The fact that the negative is flat demands that the lens be so designed as to give an image of adequately sharp focus over the entire area, and this implies that the axis of the lens be perpendicular (at right angles) to the plane of the negative (this is assuming that all of the subject lies at the same distance from the lens). We say that the lens is in *normal* position when its axis, thus perpendicular to the negative, runs in a straight line from the center of the image through the center of the lens to the center of the field of view.

Fig. 86

However, the effective circle of coverage is limited by both the design and quality of the lens; only in special cases can the full image circle be used to good effect. All conventional lenses are segments of spheres and are mounted in barrels or shutters; there is an obvious physical cutoff of the image circle in relation to the focal length of the lens and its design as well as the design of the shutter or barrel. A wide angle lens is designed to give a relatively large image circle (we can say "a large circular field"). This can also be stated in terms of degrees covered: the average lens may encompass a 30° to 40° angle of view, the telephoto lens 5° to 10° and the wide angle lens 90° and more. Certain "bubble" lenses can cover more than 180°. The effects produced by this lens (now known as the "fish-eye") are both exciting and curious, certainly comprising a new vision of the world. The Zeiss Hologon camera (and lens) is superior in this field.

Fig. 41

In actuality, the full coverage of the lens cannot be used, as there is a definite fall-off of definition and brilliancy towards the edges of the field. Certain lenses (such as the Tessar type) can give magnificent results within a quite limited field in relation to their focal length. Obviously, with such lenses the axis of the lens must remain fairly central, otherwise the corners of the image will show poor definition and loss of brilliance. With lenses such as the Dagor the field of useful coverage is much larger, and the axis of the lens can be moved away from the center of the image without loss of image quality. With wide angle lenses such as the Super Angulon the axis of the lens can be moved a considerable distance from the center of the image without loss of quality. This means that the camera adjustments can be employed in varying degree, and considerable control of the image is possible. Given a Tessar of 5-inch focal length we might be able to shift the axis about 1/2 inch off the center of a 4x5 negative. With a Dagor we could shift the axis about 1-1/2 inches. With a 121mm Super Angulon (4-3/4-inch focal length) we can cover an 8x10 negative

193

with the axis on center; hence, we could shift the axis of the lens 2-1/2 inches in any direction on a 4x5 film and still retain fine image quality over the entire area. This wide angle lens, apart from its "wide angle" advantages, can thus be considered a wide field lens for 4x5 or 5x7 negatives, allowing a great range of camera adjustments and favoring near-far compositions with great depth of field.

As in all evaluations of photographic quality, we must think of practical limitations. Ordinary creative photography does not require the high precision of scientific or technical photography; unless we are to produce huge enlargements, we will be entirely satisfied with good normal "production" quality. In the case of engraving and copying (especially in color work) we must have images of great precision and geometric accuracy. Lenses of the process type are designed for this purpose; they yield a relatively small field of coverage even with their relatively long focal length, but within this field the image is extremely precise and sharp. As the light diverges at a rather narrow angle on the negative, there is minimum "scatter" and the sharpness is thereby enhanced.

Most modern lenses of all types are of fine quality in reference to what they are designed to accomplish; selections are therefore made on the basis of *function* and *performance*. With the Hasselblad camera (having no "adjustments") the lenses are designed to precisely cover the 2-1/4x2-1/4 negative with maximum sharpness and brilliancy; they could not be used on a larger camera, especially with view-type camera adjustments.

With a lens of 5-inch focal length focused on infinity covering a negative of 6.4-inch diagonal, the distance from the rear nodal point of the lens to the center of the negative is about 5 inches, while the distance to the edge of the negative is about 6 inches; the ratio of illumination is about $625/1295 = 0.483$. This ratio is calculated on the \cos^4 trigonometric function. Prior to the time that careful attention was given to the design of enlarging lenses, it was recommended that the negative be enlarged with the lens with which it was taken (the "taking" lens). In this way the lower density of the outer areas of the negative would be compensated for by the lower transmission of light from these areas through the taking lens. Illumination differences are apparent in areas of continuous value, such as the sky.

Page 237

Figs. 74, 75

As the subject distance decreases, the distance from the lens to the negative increases. Hence, if the plane of the subject recedes in space, the plane of the negative can be tilted to place all parts of the negative at the proper distance from the lens to achieve sharp focus of a receding subject plane. If the camera back is tilted to achieve this effect, the axis of the lens remains central to the negative and the coverage is not affected. If the lens is tilted to achieve this effect, the axis of the lens is moved off center and the coverage may be affected.

Fig. 61

It is not out of place to mention here that filter holders, lens hoods, etc., which do not cut into the image in normal position of the lens can seriously vignette the corners of the image when the lens is raised, lowered or moved sideways from normal *and* when the lens is *tilted* up or down or swung sideways.

Figs. 44, 45

Let us assume that the field of satisfactory coverage of a given lens is a circle 10 inches in diameter. We can move a rectangle—say of 4x5 inches—anywhere within that circular field and obtain an image of satisfactory quality. The larger the rectangle, the greater the field of view represented—but less movement within the circle of good coverage is allowed. If we move any part of this rectangle beyond the limits of this circle of good coverage, that part of the image lying outside the circle would be of inferior quality and perhaps vignetted by the barrel or shutter of the lens.

The functions of the various adjustments of the lens and camera—meaning those adjustments which change the position of lens, lens axis and camera back

194

from normal—are limited by the covering power of the lenses used *and the accessories placed before the lens.* This is often overlooked, and disaster frequently occurs. Not only is it sometimes difficult to see the effects on the ground glass but the vignetting of the image from lens hoods, etc., is accentuated when the lens is stopped down (the edge of the hood is brought into somewhat clearer focus). Also, visual evaluation of image quality is difficult away from the center of the image—with or without a magnifier.

Pages 119, 120

To make a practical visual test of image quality (sharpness, etc.) focus on some small and brilliant light source, such as the reflection of the sun on a distant chromium automobile bumper. This can be quite clearly seen even at the corners of the image, whereas ordinary surface textures and details are very hard to evaluate. Of course, nothing takes the place of an actual photograph, practically speaking, except that a trained optical technician can thoroughly evaluate a lens on an optical bench.

Stopping down a lens usually increases the area of good coverage (although it does not enlarge the field of view of the lens). Some lenses (especially single components of symmetrical and convertible lenses) have "focus shifts" at smaller than maximum stops; the lenses must be refocused as they are stopped down. Once we know the amount of focus shift at any stop with a given lens it can be recorded for future work with the lens.

Page 108

As lens-to-subject distance decreases (and lens-to-negative distance increases), the area of good coverage is increased; at 1:1 image size the area of good coverage is almost doubled.

EYE-LENS-FILM POSITION

The average person scans the subject, automatically selects the prime element or elements, centers them in the field, and exposes. This is the simplest and most ineffectual approach to composition. Yet most camera finders are designed to work in just that way; *parallax*-compensating devices link focusing and finder apparatus so that the object focused upon is always in the center of view. With the finder on lens axis but above the lens, the corrections are only of the first order—up or down, as the case may be. With finders set to the side and usually above the lens axis as well, fairly complex mechanical adjustment-manipulation is necessary.

However, with the average finder the picture edge is not important. Only the central areas are considered, with a rough approximation of the borders of the picture indicated by the edge of the finder tube or by superimposed rectangles which are often linked with the focusing track to give the approximately correct field of view.

The twin-lens reflex camera is far more accurate; the "finder" lens gives the same image as the taking lens and a parallax adjustment tilts the finder lens down as the lens-to-subject distance decreases, thereby centering the image focused upon in the field of view.

But we must realize now that merely centering the subject in the field is not revealing the accurate positioning of the subject in reference to the background.

Pages 27, 32
Figs. 14A, B

The viewpoint of the taking lens is about 3 inches lower than that of the finder lens; this makes little difference with distant subjects, but at 10 feet or less the near-far relationships are not the same. With cameras of the twin-lens Rolleiflex type or the Hasselblad Super-Wide we must raise the camera to bring the taking lens into the same position as the finding lens; then, even with very close work, the taking lens will "see" what the finder lens "saw." But the composition must be worked out at distant positions, as the parallax finder-tilt with which most modern

cameras, excepting the Hasselblad Super-Wide, are equipped will, at close distances, displace the image in the viewing frame (although the near-far relationships will not be affected). A tripod with an adjustable center post is advised. With practice the photographer can learn how much to raise the camera just before exposure to get on the film precisely what he sees in the finder image.

With the single-lens reflex (Graflex, Hasselblad, Rolleiflex SL66) and most good 35mm cameras what the eye sees through the finder is exactly what the film will see, as the image is produced by the taking lens. This applies to all distances from the lens—infinity down to one inch (or less!). Good range-finder systems in such single-lens reflex cameras work at all distances. The Graflex, Gowlandflex, Hasselblad, Bronica and Rolleiflex cameras are focused by visual examination of the ground glass. The 35mm cameras usually have both a delicate ground-glass circle in a bright Fresnel lens field for texture focusing and a split-field range-finder system at the center. The best 35mm cameras have the pentaprism finder which completely corrects the image both to right-side-up and proper left-to-right position. The pentaprism system is available for cameras such as the Rolleiflex and Hasselblad. With the last-named cameras it also allows eye-level working position which gives a somewhat different view of the world than the standard "navel" position of the usual twin-lens or single-lens reflex camera. The *Figs. 18A, B, C* aesthetic implications of the navel versus eye-level point of view are considerable, especially with near objects. The 35mm camera is used at "eye" position; the 4x5 or 8x10 camera is usually used so as to simulate eye position. But the cameras held against the midriff see the world in a slightly different way.

Fig. 30 Anyone who has photographed in a flat country knows the rewarding effect given by a 6-foot-high car platform—space opens up, surface features take on depth and perspective. A 6-foot platform plus a 5-foot tripod give the photographer an advantage of 5 or 6 feet above normal eye position.

The photographer usually stands to one side or the other of the camera and may not realize that unless he is standing so that his eye coincides as closely as possible with the lens in position and direction the picture will *not* be what he sees from his viewing position.

In visualization procedure camera position (actually *lens* position) is of the greatest importance. The subtle relationships of shapes, textures and edges of near and far objects can "make or break" a photograph. Sometimes moving the camera an inch or so (or "sliding" the lens) will clarify or confuse some important relationship within the picture.

We have the power to make extraordinary visual adjustments; appreciation of the scene before us is subject to most complex physical-psychological reactions. As we scan various elements of the scene, we can lend psychological emphasis to selected parts. The lens will always "see" things in their physical-mathematical relationships of space and scale. Our visualization of the final print may indicate an exaggeration of, say, a near shape; we can achieve this by "moving in or out" until the relationships of near and far elements of the subject truly relate to the visualized image. Many factors are involved. When we *Page 17* have achieved a logical and emotional disposition of the subject *shapes* within the field of the picture, we can say we have created *form*—at least we have established an optimum formal relationship of all possible elements. Negative size, lens focal length, lens-to-subject distance, lens position in relation to subject, camera adjustments and lens stop selection for depth of field are just as important as exposure and development of the negative and subsequent printing. If the original viewpoint concept is not right, all technical procedures have small meaning.

196

108A. CUBE. Taken head-on. All camera adjustments normal. 5-inch lens. Lens axis impinges about one-third down from top edge of cube.

108B. CUBE. Sliding Front used to maximum. Right-hand side of cube near limit of field of short-focus lens. Slight curvature due to curl of 4x5 film-pack negative.

108C. CUBE. Made with 90mm Schneider Super Angulon lens. Axis of lens a little higher than in Figs. 108A and 108B. The perspective effect is exaggerated but optically correct.

197

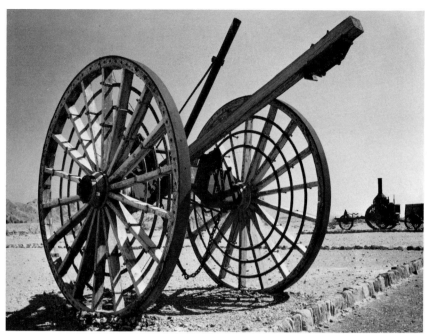

111. AT FURNACE CREEK RANCH, DEATH VALLEY, NATIONAL MONUMENT, CALIFORNIA. Made with a 4x5 Sinar camera and a 4″ Goerz Wide Angle Dagor lens. The focus adjustment was made by swinging the camera back; a certain slight distortion of the wheels is noted. The exposure is less on the left-hand side (a combined effect of sun direction and a greater distance of the film from the lens) because of the rather severe back-swing used. This effect was reduced in printing.

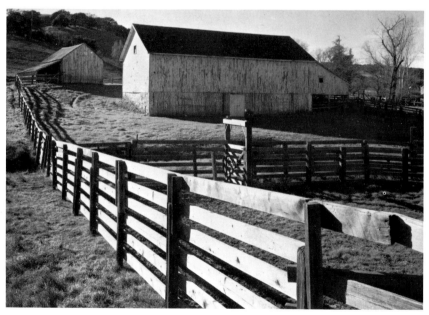

112. BARN, NAPA, CALIFORNIA. Made with a 4x5 Sinar camera and a 5-3/4″ Zeiss Protar lens. Both camera front and back were swung to get adequate depth of field and a very small lens stop was used. This was made on Polaroid Type 55 P/N 4x5 film.

200

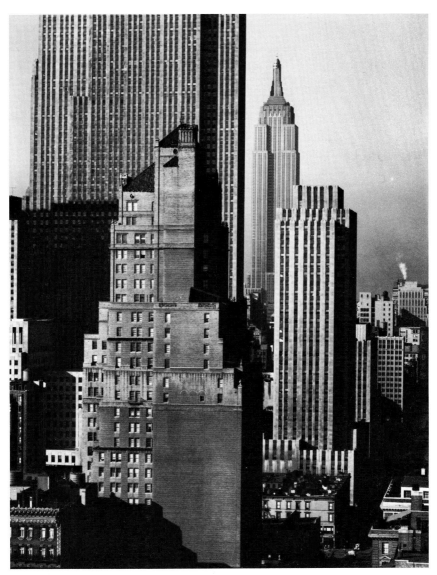

113. NEW YORK CITY. Taken from the Barbizon-Plaza Hotel in the early 1940s, with a 4x5 camera and a 16-inch Zeiss Protar lens. The effect is obviously two-dimensional but the picture is held together by the design of the shadows. Viewing the picture upside-down may accentuate the design elements.

Scale is more implied than directly comparable, although we can use windows as reference points of known size.

The lens was a single component of my Protar set and gave excellent results at medium and small apertures. It was used back of the diaphragm and "barrel" or "pincushion" distortion is absent. However, the single component did have a focus-shift when small apertures were used. Careful re-focusing was required at f/22 and smaller (see page 108 et seq.). Shutters used with a number of components can have stop settings engraved in mm. (Sometimes they are difficult to read.)

201

CAMERA MOVEMENT

Image sharpness depends upon lens resolution and film resolution *and* the stability of the camera during exposure. With modern lenses and films, and high-acutance developers, loss of image sharpness is due almost entirely to camera movement. Of course, faulty focus settings or filters of poor optical quality, etc., can spoil the definition. Camera motion during exposure can be caused by:

1. Nervous tremor or shivering in cold weather
2. Fast breathing or pulse (common after exertion)
3. Inertial effects of mirror release in SLR cameras (see below) and of other devices within the camera
4. Inertial effects of shutter operation, especially focal-plane shutters
5. Operation of shutter release button or trigger (a "poke" rather than a smooth steady pressure will move the camera)
6. Use of cable release with tension on release cable instead of a "relaxed" loop
7. Wind, vibration caused by machinery, etc.
8. Tripod instability or vibration (see page 60 et seq.)

Fig. 29

Page 61

In the section on tripods we discuss the problem of *moment*—vibration inherent in the structure of the tripod or tripod head which is harmonically related to the vibrations set up by the camera. In many cases dampening procedures are required (weights, extra supports, etc.).

The shorter the exposure, the less camera movement will show. A degree of camera movement acceptable in an 8x10 contact print might be highly objectionable in an 8x10 enlargement from a 35mm or 2-1/4x2-1/4 negative. It has been proved time and again that miniature cameras should be operated at speeds not less than 1/250 second when held in the hand. *Any* camera held in the hand during exposure will have a certain depreciation of sharpness because of inevitable camera motion. The size of the image (or the degree of enlargement) defines the limits of allowable camera motion during exposure, but because of the *moment* relatively short exposures on tripods may give unsharp images.

Operation of various cameras is discussed in detail at appropriate places throughout this book, but we can mention here some of the problems of the single-lens reflex camera. This depends upon the action of an inclined mirror which reflects the lens image upwards to a focusing screen which is viewed from above (or, with the aid of a roof-prism, directly at eye level). A hood protects the screen from scattered light, and a magnifier is usually incorporated with it. With the prism finders a rubber eyecup reduces scattered light. In the Hasselblad the mirror moves upwards just before exposure; in the Bronica the mirror moves down. The latter arrangement is efficient because it allows for the use of very short-focus lenses, but it also requires a second auxiliary shutter to cut off light coming through the focusing screen. At operation of the shutter release in the Hasselblad, the mirror swings up, the shutter and the lens diaphragm close to its preset position, the auxiliary shutter in front of the negative opens and the lens-shutter operates at the desired speed. Then the auxiliary shutter closes, protecting the film while the film-transport knob is turned (which also brings the mirror to viewing position and opens the lens shutter as well as putting the diaphragm in full open position). After exposure, any vibration due to these movements is of no consequence, but the internal movements before exposure may cause some vibration and camera movement, especially at the slower shutter speeds. Hence, with slow speeds and/or with long-focus lenses, not only

is a tripod necessary but the mirror and auxiliary shutter (and the lens diaphragm) should be put into exposure position by releasing the button near the film-winding knob. Then the actual exposure (operation of the lens-shutter alone) is accomplished without producing any vibration (providing a cable release is properly used).

Many modern 35mm cameras work on this same principle (but with variations). With some the mirror returns to viewing position immediately after exposure. In the Honeywell Pentax and other 35mm cameras the exposure meter receptor is incorporated in the mirror. Most fine 35mm cameras have focal-plane shutters which make the conventional between-the-lens shutter unnecessary. Twin-lens reflex cameras have no linkages with the taking lens except the focusing system and some parallax field controls. Matched pairs of taking and viewing lenses are available for many models. The shutters are of the conventional between-the-lens type, and very little vibration is created. The film-winding knob resets the shutter on most models.

Fig. 30 Camera platforms on cars vary in stability. In wind, or if people are moving within the car, they can be anything but stable. It is always advisable to stand quietly a few moments before making the exposure.

Perhaps the most precise test for image sharpness would be to take a picture of a distant ridge covered with leafless trees (showing extremely fine branch detail) with the camera leveled to bring the line of trees from one edge of the image to the other. The delicate branches in the image will approach the limits of resolution, and this will reveal much about the optical performance of the lens and the degree of camera motion during exposure.

Figs. 29A, B In analyzing loss of definition the direction of camera movement may be determined by examination of the unsharp image: if the camera moved horizontally (sidewise), the horizontal branches would be sharper than the vertical branches; if the camera moved vertically, vertical branches would be sharper than horizontal or angled branches; if both show unsharpness, we know the camera moved diagonally (or at random). In other words, whatever branches show maximum sharpness indicate the dominant direction of camera movement. Many subjects, such as the side of a shingled house, can be used for this test.

Camera *weight* is important; there is much sales talk about minimum weight, but this can have disadvantages. A fairly heavy camera will always be more stable (in the sense of inherent inertia) than a light one. Of course, the *balance* of the camera and lens is important; the ensemble should be supported in the hand or on the tripod at approximately the center of gravity. Gun stock grips, pistol grips, shoulder and chest supports and monopods all improve stability with small cameras and are especially valuable with long-focus lenses (which naturally exaggerate the effects of camera movement).

Camera movement is a subject of considerable significance. The larger the image (from long-focus lenses, or enlargement of the negative) the more camera movement will show. Apart from the causes of motion described above, we have the method of holding the camera—the "grasp" as it were—to consider. We cannot assume there is only one way to hold a camera! The structure and weight of the hand, the size, shape and weight of the camera, the kind of terrain we are standing on, wind, distractions, etc. all such problems must be solved on an individualistic basis. The main thing is to be as relaxed as possible. With a long lens the center of gravity usually requires that the lens be supported with one hand and the camera with another; "cradle" the lens with the left hand, for example. A weight, resting on the ground with a cord attached to the camera or lens, can serve with hand-held or tripod-supported cameras as a good stabilizing device.

203

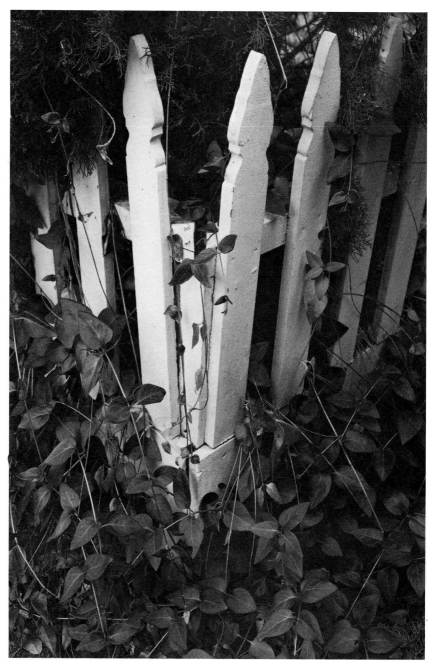

114. PICKET FENCE AND VINES.
Camera pointed down; convergence is
intentional. Made with a 5x7 camera and a
5-3/4-inch Zeiss Protar lens. The relatively
short focal length augments the impression
of scale and depth. Try to visualize this
image "corrected" so that pickets are
vertical—a totally different emotional and
aesthetic effect would result.

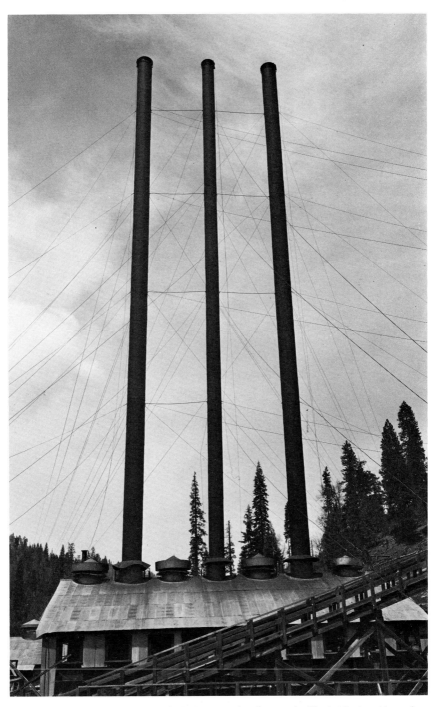

115. SAWMILL STACKS, CALIFORNIA.
The impression of height and scale is augmented by the intentional convergence. Made with a 4x5 Korona View Camera and a 5-inch Goerz Dagor lens. The rising Front was elevated about 1 inch and the camera pointed upwards. The intricate pattern of the guy wires is made more exciting by the convergence of the stacks.

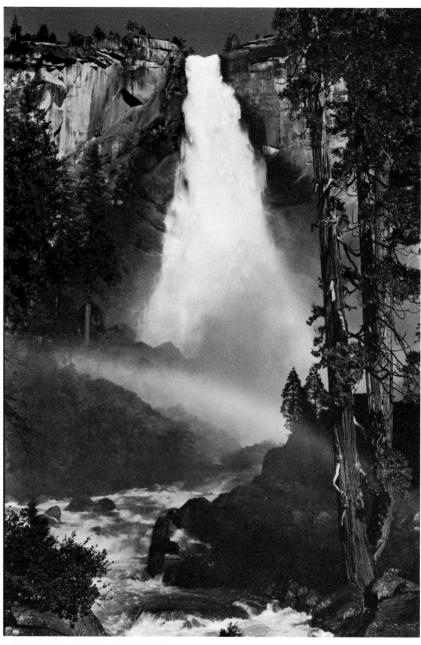

116. NEVADA FALL, YOSEMITE NATIONAL PARK, CALIFORNIA. Made with an 8 x 10 camera and a 10-inch Kodak wide-field Ektar lens. The exposure was 1/100 second. A K-2 filter was used and the exposure was about 2 Zones below normal. The development time was normal + 2. The subject was very "flat" as the sun was directly behind the camera; hence a strong increase of contrast was required. In the original print subtle textures appear in the waterfall that cannot be held in the reproduction.

The rainbow shows clearly; all colors but blue and violet were passed by the K2 Wratten filter. (See page 122 et seq.).

LABORATORY: DARKROOM, WORKROOM AND STUDIO-GALLERY

There is a basic pattern to laboratory design, but within this pattern we find an endless variety in function, plan, size, equipment and cost. It is necessary, I believe, to describe the ideal laboratory—darkroom, workroom and studio-gallery—and then suggest ways and means for practical deviations and adjustments. As in all other practical aspects of photography, the laboratory and its equipment should be planned and acquired on the basis of actual need and purpose. Certainly the darkroom for the all-round professional photographer (especially if color processing is considered) will be far more complex and costly than the darkroom for the amateur/creative photographer. In addition, personal preferences and personal methods of working require modifications of any plan. Before any laboratory is constructed or arranged, it is strongly advised that not only thoughtful sketches be made but actual "mock-ups" of space and equipment positioning be constructed. If you are short, tall, right- or left-handed; if you are adapting an existing space or constructing an entirely new area for your laboratory; if you have good, poor, hot and/or cold water; if you have limitations of electrical input; if you have good or poor ventilation, adequate drainage provision and adequate safety conditions (or not)—all these factors should be considered before you make plans or start construction. One very important factor frequently overlooked: do you have an area adequate for storage of chemicals, mounting boards, papers and other supplies, for camera equipment and for finished work—definitely *not* in the darkroom area? List all of these factors and carefully check them off!

SIZE. Size of the laboratory is an important factor; in a sense, the optimum size depends upon the print sizes you would consider maximum—and the number of such prints you will have in process at any one time. As I must frequently make prints 40x76 inches my darkroom is much more than twice the size I would require for a 16x20 maximum print size. It will be obvious that, once we have determined the maximum enlargement size, we must estimate the required areas of both darkroom and workroom together so that we can be certain the existing available space is adequate. My workroom could be considerably reduced in area with smaller drying screens, smaller mounting and storage facilities, etc., if I did not have to make large prints. Since laboratory design more often than not must be adjusted to the spaces at hand, make a basic plan for *maximum* good function from which adaptations can be made as required.

The laboratory I am describing here is one that would produce up to 16x20 prints (on 22x28 mounts) from negatives not larger than 4x5 or 5x7 inches (an enlarger to take 8x10 negatives requires considerable projection space). It should be a relatively simple matter to interpolate the appropriate plan and scale for limits of 11x14 or 8x10 prints. The space required for negative processing is minor (even if a separate compartment is planned). I am suggesting certain equipment as *typical*; as in all my books and articles, my preferences for certain equipment and materials do not imply inferiority of other makes and brands.

We will assume that we have the *space* available—basement, attic, spare room, barn, etc.—and that water, drainage, electricity and ventilation are accessible. We must first be certain of *safety:* will our plan allow for quick exit in case of fire? Will our electrical supply be adequate and will the wiring stand the

load? Will our plan be in compliance with local building codes and agreeable to our insurance company? And to our landlord? Check all this *first* before actual construction or adaptation is begun. Some communities are *very strict!*

Cost. Accurate cost estimates are not easy to get; whatever construction costs are determined—double them for safety! Equipment costs can be estimated with considerable accuracy—unless you have forgotten something important! Costs for sewer connections and electrical service can be high. The do-it-yourself man who takes over the extra bathroom may have good luck—or he may not! Professional advice and services are usually economical in the end.

Cost of operation is usually quite low (unless you are a busy professional!).

While expense is, of course, a dominant factor (and it is important that the photographer have the space and equipment necessary for his work), the addition of needless embellishments and useless gadgets merely serves to dissipate money, energy and attention.

BASIC PLAN OF LABORATORY

We will divide the working units as follows (noting secondary facilities):

Darkroom	for negative, print and enlarging processes (Figs. 117 & 118)
Workroom	for drying, mounting, spotting, packaging, etc.; also storage of all supplies and equipment (Fig. 121)
Studio-Gallery	for display of work—prints, books, slide or film projection; also have adequate shelf and storage space (Figs. 122A, B)

It is important that the electrical requirements for all areas be *totaled*, as this will define the basic input requirements and the division of circuits, etc. Hot water supply for the darkroom may strain the existing facilities, with hot water failure occurring when supply is most needed. A separate small hot water tank for the darkroom is suggested unless a large supply of hot water is assured.

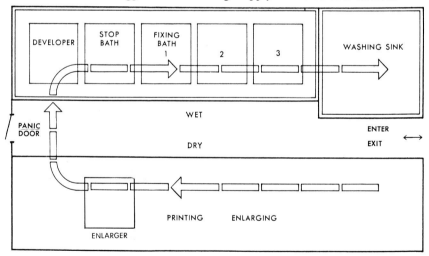

117. DIAGRAM: DARKROOM PLAN.
This shows the scheme of "work-flow" (on left-to-right basis). The Darkroom can connect with the Workroom (a *sliding* door will save space) and there should be a "panic-door" leading to an exterior area. This door must be properly sealed and light-tight and should open *only* from the inside. As described in the text, the "dry" areas are on the left and the "wet" areas are on the right. The passageway between need be no wider than required for comfort and for handling trays, etc. stored under the table and the sinks. In designing the Darkroom, be generous with storage space!

Plan. Based on a left-to-right working pattern, the plan outlined in Fig. 117 shows the two separated areas (dry and wet) with the enlarger-printer at the "far" end of the worktable opposite the far end of the sink. This provides for minimum movement between the enlarger and the first developing tray. The passageway between the wet and dry areas need not be more than 3 feet; 30 inches is adequate. (However, if you plan to have drawers under the worktable, you must have ample space in which to operate them; hence, a 36-inch width for the passageway is probably advisable.) Note that the separation of dry and wet areas will reduce the chance for contamination of the dry areas from splashing such as frequently occurs when the enlarger is *next* to the sink. In Fig. 117 the movement patterns are sketched out; this shows the relative efficiency of the dry-wet division plan.

Ideally for safety, the darkroom should be equipped with a "panic door" opposite the entrance (such as shown in Fig. 120A). Small shelves, hooks, etc., can be attached to this door, providing such does not interfere with its easy operation. Naturally, the panic door should lead outdoors or to some safe area away from a possible fire entrapment.

The simplest layout is a continous worktable on the dry side (to the left as you enter) and a continuous sink assembly opposite. Dimensions are dependent upon the maximum print (enlargement) size contemplated. The sink width should allow for the turning of the trays within the sink; 16x20 enlargements require 18x22 trays which would require a sink width (inside) of 30 inches (Fig. 120C). The worktable can be of the same width (30 inches), even if the sink is narrower; you will need adequate depth for the enlarger, etc. Allowing for a total 3-inch sink-wall construction thickness (with splashboard), the total width of the darkroom would then be about 30 + 3 + 30 + 36 inches or 99 inches (about 8'3").

Length of the darkroom depends on the required sink length. Allowing for three 18x22 trays (placed lengthwise 2 inches apart), a water tray (at least as large) and a print-storage-washing area, we would need 2 + 22 + 2 + 22 + 2 + 22 + 2 + 30 + 2 + 1-inch partition + 36 + 7 (drainage space), totaling 150 inches or about 12'6". If we placed the trays with the 18-inch side towards us and reduced the rinsing space, we could save up to 2 feet. Rinsing space *must* be adequate. For some processes we will need a fourth tray; then the washing area would be used for rinsing. It is very inefficient to skimp on essential space.

The worktable would then be about 12'6" long. Disposition of equipment, storage and work space are suggested in Fig. 117. The vertical enlarger should be so placed as to allow for fresh paper on the left and exposed-print storage on the right. Allowing 28 inches for the enlarger baseboard and 22 inches for the paper space on each side, we have about 6 feet utilized. This leaves about 6 or 7 feet for various uses—storage, negative viewing screen, densitometer, trimmer, etc. The darkroom would then represent a little over 100 square feet. Note that in our measurements we have allowed for "holding space" of several inches for each unit (trays are separated by 2 inches, etc.) and this must not be over-looked. Crowded trays are hard to handle.

Height of darkroom ceiling: at least 8 feet—the higher, the better for ventilation. Height of vertical enlarger, fully extended, must be figured! If ceiling height is limited, the enlarger must be placed on a lower level (which requires a little more complicated table construction), but it must not be so low as to make operation difficult or uncomfortable. Depending upon the construction of

the ceiling, an adequate aperture could be cut out between joists and lined to protect against dust. This could afford an additional 8 to 10 inches in height.

Height of sinks and worktable: strictly personal! I am six feet tall; the bottoms of my sinks are 36 inches above the floor, and the depth of the sinks is 8 inches. My worktable is 36 inches high; the fully extended Beseler enlarger requires about 5 feet; hence, a minimum of 8 foot ceiling height is needed. Working height is very important; before any installations (or plans) are made, set up a mock worktable and sink and rehearse all the motions you will go through in the entire process. Don't give it just a "try" or two; rehearse for at least fifteen minutes so that you will be aware of any discomfort or fatigue which might develop from continued use. Be sure that the sinks and tables are not too low (serious back discomfort can result) and that critical examination of prints in the trays will not create eyestrain. Your height alone does not indicate what the sink and worktable heights should be; the length of your arms must be considered. When I stand straight with arms at my sides, the tips of my fingers are 30 inches above the floor. My assistant is 5'6" tall, and the tips of her fingers when standing straight with arms at her sides are 26 inches above the floor. The sink and worktable heights are comfortable for her, but the sink "railing" (depth) is a little too much. Only by direct trial can the heights be determined for any individual.

Duck-boards are available in stainless steel from Calumet Manufacturing Company and other firms. I use sheets of "corrugated" plastic (such as used for porch covers, light fences, and partitions, etc.). These can be cut to width and length as desired; they are light-weight and easily cleaned.

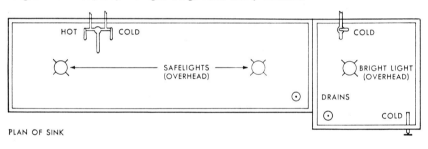

PLAN OF SINK

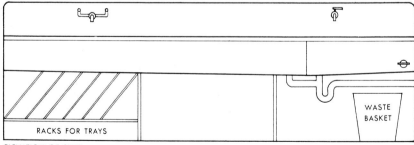

ELEVATION OF SINK

118. DIAGRAM: DARKROOM SINK. This is a very simplified diagram; each photographer will have personal thoughts about his equipment. Size, height, water input and drain, etc., should be first sketched out, then "mocked up." If this is done we can solve many problems of design and construction in advance. Do not overlook the proper tilt of the sinks to the drain corner. The tray racks, if made of wood, should be generously treated with marine varnish. If possible, install a floor sump. Connect sinks with overflow pipes.

210

Electrical Input. The basic requirements are as follows:

1. Master switch (outside darkroom) controlling all circuits and outlets
2. Four switches (inside, near entrance) controlling:
 (a) main room lights (in ceiling) for clean-up, mixing, etc.
 (b) red safelights
 (c) printing safelights
 (d) white viewing lights
 (These four switches can be duplicated at far end of room.)
3. Outlet plugs for:
 (a) 1. enlarger light (its light-switch unit)
 2. enlarger rise-and-fall motor (on the Beseler)
 (b) worktable accessories (anti-static brush, etc.)
 (c) timer(s) and clock
 (d) metronome
 (e) safelights (red, printing and viewing lights) should be on switched circuits and individually operated by *fully insulated* pull-cords. *Caution:* in some areas pull-cords over sinks are prohibited.
 (f) ventilation (exhaust) fan or fans if required. Dust filters may be needed.

Figure total circuit capacity to carry everything on at one time! For example: enlarger—500 watts, safelights—200 watts, other devices—300 watts, or a total of 1000 watts. At 115 volts this equals less then 10 amp. Plan for 12 amp.! My 8x10 enlarger uses 2000 watts at normal output; at full power, 6000 watts. My darkroom is wired for a total of 7500 watts (about 65 amp. total).

Water Input. The following connections are advised:

1. Two overhead hot and cold (mixing) valves. Have these connections on swivel spigot. A temperature control device can take the place of the overhead mixing valve at the right end of the sink (primarily for washing small film, where accurate temperature control is necessary).
2. Cold water input at side of washing sink
3. Hot water input at left end of main sink. Can lead into a temperature-control water jacket

In areas where water is excessively hard or soft or contains mineral or organic impurities, consult the local water department about purifying systems.

Water Drainage. Base of sink must be slightly inclined to corner where drain will be attached. Duck-boards (heavily varnished wood, plastic or stainless steel) should be leveled over the slightly tilting side of the sink and preferably in sections which can be easily lifted out of sink for cleaning sink floor. Washing compartment should have separate drain. The partition between the washing and the main sink should have safety drainage holes about 3 inches from top to prevent overflow.

Drains are usually connected to sewer (mandatory in metropolitan areas). *Where permitted,* drain from *washing sink* (involving water of small chemical content) can go to garden or fields. Drainage from main sink is not healthy for most plants, although few (if any) chemicals used in photography are really harmful in the small quantities involved.

On the basis of experience, I recommend a floor sump.

MATERIALS AND PAINT FOR DARKROOM

1. **Sinks.**
 (a) Can be made of 1-inch wood, properly supported, and covered with a thin stainless steel shell (most economical in the long run).

(b) Can be made of wood (as above) and covered with Fiberglas, can then be left "natural" or painted appropriately. Attach stainless steel front edge (an inverted "U"-shaped strip).

(c) Can be made of wood (as above), lined with marine (waterproof) plywood and painted with appropriate paint or heavily treated with marine varnish. (Copon marine Fiberglas paint is very good.) Attach stainless steel edge.

(d) Can be entirely of stainless steel (Type 316; best and most enduring). (Refer to Calumet Manufacturing Company, Chicago, Illinois, for "stock" items, or can be made to order.)

(e) Can be made of Fiberglas. (Perfect Photo, Inc., 2933 North 16th Street, Phoenix, Arizona 85016, makes Fiberglas sinks in a variety of shapes and sizes and at quite moderate cost.)

2. **Worktable.** Sturdy, with drawers under overhang. Top can be plywood, painted or varnished. Best top material is Formica (dark gray). It is advisable to attach a stainless steel or anodized aluminum edge (a "U"-shaped strip).

3. **Ceiling.** Can be light gray or white (white for up-directed safelights).

4. **Walls.** Can be neutral (18-20%) gray except around enlarger where *matte black* is advised.

5. **Floor.** Should be heavily varnished if wood (a plain wooden floor can absorb chemicals). If linoleum or plastic, should be treated with waterproof, easily cleaned material. If cement, should be properly painted (gray); use of rubber floor mats will be necessary to prevent fatigue and slipping on wet surfaces.

Ventilation. Lightproof louvers to provide adequate air input for fan or fans (also lightproofed). Adequate ventilation is *essential!* I have two exhaust fans over the sink area. In a darkroom such as described here, one fairly large fan over the left-hand area of the sink should be adequate. However, the more ventilation, the better! Input louvers should be screened for trapping dust (keep screens clean!). If air conditioning is available, the ventilation system should be carefully studied; with a closed system we should be certain that fumes (such as from acetic acid) would not be circulated elsewhere in the building. Small and inexpensive air conditioners are now available, and their use is strongly recommended. Aside from cooling, they also feature dehumidification and dust filtration—both rewarding amenities. It is advisable to use air conditioners with fresh air intake and stale air exhaust.

Heating, etc. In certain regions heating and/or air conditioning may present a problem. Central or radiant heating is ideal. Open electric heaters cannot be used in the darkroom when developing film but are "safe" when not exposed directly to papers. Some heaters with ceramic-type elements do not emit light and are presumably safe for darkroom use. Gas and kerosene burners in the darkroom are dangerous and usually harmful to sensitive materials.

Doors. The best door (for lightproofing) is a sliding door, preferably within the wall. An external sliding door will work if properly built and light-proofed (not a simple procedure!). A regular door can be lightproofed by ample casement size and rubber or velvet light-sealing. The "panic" door should be fully sealed, but as it should be seldom used, this should not be difficult. Weather-stripping is good for this purpose, especially if the door opens into a fairly light area.

Lightproofing in general. While it is advisable to have a completely lightproof darkroom, an occasional "glimmer" of light can do no harm if it does not fall directly upon sensitive materials. After fifteen minutes or so in a darkroom, the eye might perceive traces of light under and around doors, ventilators, etc. If such are distant from the areas where the sensitive (negative) materials are developed, etc., no harm can result. But this comment is not an invitation to carelessness!

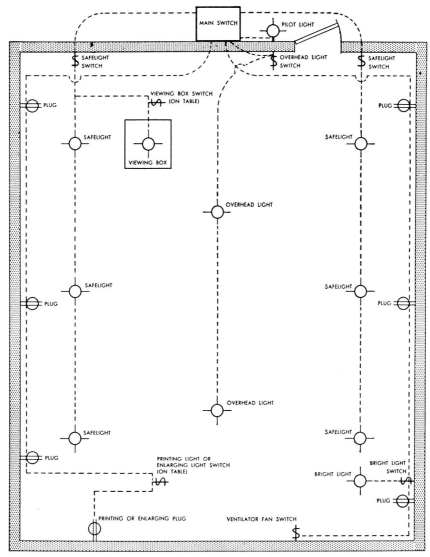

MAIN SWITCH

PILOT LIGHT

SAFELIGHT SWITCH

OVERHEAD LIGHT SWITCH

SAFELIGHT SWITCH

PLUG

VIEWING BOX SWITCH (ON TABLE)

PLUG

SAFELIGHT

SAFELIGHT

VIEWING BOX

OVERHEAD LIGHT

SAFELIGHT

SAFELIGHT

PLUG

PLUG

OVERHEAD LIGHT

SAFELIGHT

SAFELIGHT

PLUG

PRINTING LIGHT OR ENLARGING LIGHT SWITCH (ON TABLE)

BRIGHT LIGHT SWITCH

BRIGHT LIGHT

PLUG

PRINTING OR ENLARGING PLUG

VENTILATOR FAN SWITCH

119. DIAGRAM: ELECTRICAL SERVICES IN DARKROOM.

This is a very simplified sketch which shows essential outlets and fixtures. Nothing is to scale. However, in planning your darkroom you can check off the elements in this diagram, and add or subtract as required. Note that there should be a *main switch* outside the darkroom which controls all circuits within. Note that the *bright light* switch should be so placed that it could not be flicked on accidentally (and ruin sensitive materials).

When you know what you want, consult an electrician for the detailed plans and specifications. Insist on *grounding* for all circuits, double-insulated pull-cords, approved wiring and fixtures, etc. Remember that your insurance may be invalidated if your electrical system is not of fully approved quality. When you know your total wattage requirements check if your building wiring can carry it.

Safety is paramount; with hands in trays or sinks the effects of shock are greatly increased. Watch for loose extension cords, frayed cords, broken plugs, etc. Use of too-strong lamps in safelight fixtures will create great heat; not only will this ruin the safelight filter but it is a fire hazard. The same applies to enlargers; lamps that are of greater wattage than specified may cause serious damage to enlarger and negative.

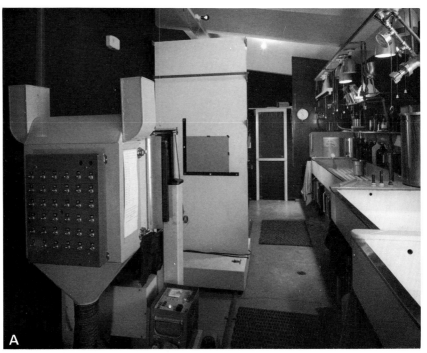

A

120 A,B and C, THE AUTHOR'S DARKROOM. Made with Arca Camera (4x5) and 90mm Schneider Super-Angulon lens. The Darkroom is not as large as it appears in these wide-angle pictures; it is about 30 feet long and 10 feet wide. The ceiling is slanted, supported by curved laminated beams which relate to the structure of the building as a whole.

120A. DARKROOM FROM ENTRANCE. On left the 8x10 enlarger (containing 36 50-watt, 130-volt reflector flood lamps, each on a switch). The lights are controlled by a Colortran Converter which raises the luminance of the diffusing screen from 320 c/ft^2 to 2000 c/ft^2. The lights are cooled by a blower mounted on a separate dolly and connected to the camera by a flexible hose. The camera raises and lowers, and rolls horizontally on "V" tracks.

Beyond the enlarger is the magnetic easel, which is moved along the tracks by an electric drive. The easel is rather massive, with thin sheets of steel attached to both sides by a strong adhesive. Paper is held in place with small magnets; the right-angle "Frame" also is supported by magnets. The rod (pipe) near the top (seen in one of three positions) holds the paper rolls when making large prints. The capacity of the easel and processing equipment allows up to 40 x 76 inch enlargements.

Beyond the easel, but not seen, is the Beseler enlarger, etc. (see Figs. 126, p. 234, and 128, p. 241).

In the distance is the "panic door." To its immediate right is a small table area for loading film, etc. This is separated by a partition on which the timer is attached. Parts of the three sinks and overhead equipment are seen on the far right.

120B. AUTHOR'S DARKROOM. A view of the main processing sink and the 2nd "storage" sink. The large stainless steel container is for fixing-bath storage (25 gal). Containers at the far end are for hypo-clearing solution and print developer (usually Dektol).

Note that the 2nd sink extends farther into the room than the first sink; note also that the division is at an angle which is not a hazard in the dark (as a sharp corner would be). The 1st sink is painted 18-20% gray, the adjacent wall is painted black. 2nd (and 3rd) sinks are painted white as are the adjacent walls. Note the safety drain-pipes connecting the sinks.

120C. AUTHOR'S DARKROOM. View in opposite direction from 120A. Here we see the three sinks and the overhead equipment in greater detail. The long fluorescent tube is the Sunray Products Co. safelight. A GraLab timer is on the shelf, and a movable drum washer is seen in the 3rd sink. When large prints are made, the washer is removed. The 3rd sink is 8 feet long and 4 feet wide, giving ample space for unrolling and examining large prints.

214

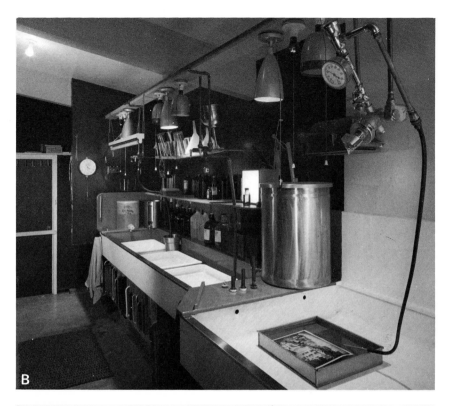

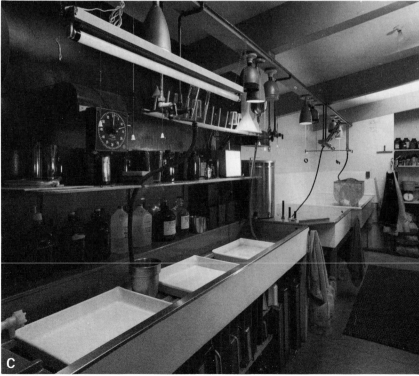

215

Storage in Darkroom

1. It is *not* advisable to store film, negatives and paper in the darkroom.

2. Trays can be stored in slanting compartments under the sink. These can be of plywood or Masonite, heavily varnished, and the surface on which the trays rest (on edge) should be slightly inclined outwards so that any water would drain off and not "puddle." The compartments can be designed to hold trays of the desired sizes. Shelves under the sinks are required for tank storage, bottles, etc.

3. Compartments and shelves under the worktable are useful for equipment, odds and ends, towels, printing frames and easels, etc. [*Note:* Always provide for space between shelves or cabinets and the floor for the feet. Shelves and cabinets should be recessed sufficiently to allow the operator to stand against the worktable or sink without interference.]

Hooks for towels should be placed at both ends of the main sink and at the far end of the washing sink.

If space permits, a shelf can be incorporated back of the sink. Above the sink there can be one or more shelves made of waterproof or heavily varnished materials. These should be sufficiently high to prevent interference with trays when they are lifted or placed on end for washing out.

The far end of the washing sink can be notched to hold a tray (or a suitable piece of plexiglass) at an angle on which prints are placed for drainage. The area should have a "lip" to prevent water drainage onto the floor (it should drain back into the washing sink).

There should be a shelf on the wall near the enlarger on which could be kept the different enlarger heads, the metronome, etc.

Dust is always present (even in the best of darkrooms), and it is advisable to keep equipment under cover or in cabinets, etc., when not in use. A small portable vacuum cleaner is a helpful accessory!

WORKROOM

It is advisable to extend the top of the table to allow for knee-room (if one plans to sit at the table when mounting, spotting etc.). There should also be adequate foot-room; the bottom shelf or the bottom of the cabinets should have several inches clearance above the floor.

A drying cabinet for film is best, but in a clean room a long cord or wire can be stretched for quite a distance (with a middle support from the ceiling). On this cord can be wooden clothespins (the pins with a "threading" hole at the spring-coil area are best). Plastic clothespins are not advised as they do not securely grasp the film. Film-pack and sheet-film hang from the clothespins. Roll film is weighted at the bottom with another wooden clothespin. The height of the cord should be such as to prevent the head brushing the sheet film when walking about the room. When hanging up film, the middle support can be detached, thereby lowering the cord for convenience.

Floor-plug receptacles should be equipped with protective caps. Circuit breakers are superior to ordinary fuse boxes. Watch for frayed cords and loose connections. Ground all electrical equipment.

Again assuming that we shall limit this laboratory plan to the processing of 16x20 prints, the drying racks, worktable, etc., are roughly scaled.

The basic elements of the workroom are:

1. Negative drying space
2. Print drying racks
3. Worktable (for spotting, mounting, etc.)

216

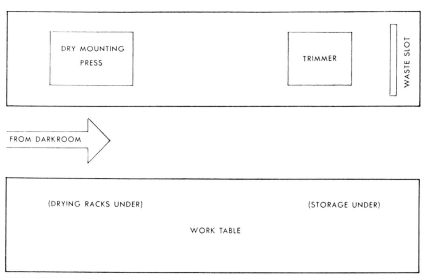

PLAN OF WORKROOM

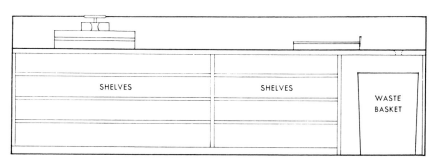

ELEVATION

121. DIAGRAM: WORKROOM PLAN AND ELEVATIONS. As in the preceding diagrams, this suggests the essential requirements. As the photographer works out his own requirements he can refer to this diagram for the few basic elements.

As with the darkroom, dimensions, width of passageways, etc. must relate to comfort and function. It is advisable to keep the dry mounting press, etc., on one side of the room, as this will free the opposite side for small work such as spotting, collating, etc. In the top plan it might be advisable to

have the trimmer on the left-hand end of the bench and the dry mounting press near the right-hand end. It is a matter of preference for left-to-right operation, or reverse. Obviously, the drying racks should be close to the darkroom door.

As with the Darkroom, the Workroom should be expertly wired and every precaution taken for safety.

In designing cabinets that reach to the floor be certain to leave toe-room (and knee-room when sitting at the table or bench). The Workroom should be well-ventilated.

217

4. Storage space

The disposition of the various elements need not be so carefully considered as in the darkroom.

If possible, these elements should be placed for convenient relationship to both the darkroom and gallery, and the plan considers this on an ideal basis. The workroom can have a continuing or a contiguous relationship with the darkroom. These are listed in detail as follows:

1. **Negative Drying Space.** This can be a cabinet, with bottom or top screened ventilation (moderate forced air and/or mild heat can be added). Or, if the room is clean and free from dust, negatives can be dried from a wire overhead to which are attached X-ray clips or plain wooden clothespins (most plastic clothespins have no "grip," and the negative—sheet film or roll film—may slip out). This wire can run the length of the room (over the floor—not over the worktable areas!) and be supported by one or two wires and hooks suspended from the ceiling. Unless a considerable amount of professional work is to be done, a cabinet space of about 24x30 inches is adequate. The hanging wires should run the long way and about 2 to 2-1/2 inches apart. The height of the cabinet can be planned for the photographer's convenience (as can the height of the wires).

2. **Print Drying Racks.** Some people prefer the electric drying drums or blotters, etc., but my preference is for screens made of plastic fly-screen material. These will not rust or accumulate chemical contamination or dust, and they can be
Fig. 121 hosed off at frequent intervals. For good circulation the racks should be spaced, one above the other, at least 3-1/2 inches apart.

Minimum size for the racks would be about 44 inches long and 34 inches wide (not including width of screen frames). This would accommodate 4 16x20 prints or about 6 11x14 prints on each rack with room to spare. The 34-inch width allows for a 1-inch overlap with a yard-wide roll of the plastic screen material.

"Corridor" space must be considered to allow for pulling out the racks to put on and take off the prints. There should be a 5-foot space between the drying racks and the opposite wall or table. A 4-foot corridor might be ample for the rest of the room.

3. **Worktable.** A table about 30 inches wide and about 10 feet long will give adequate mounting space for 16x20 prints on 22x28 mounts. Working from left to right we first have space for stacking and "tacking" the mounting tissue to the print, then space for trimming the print. Next we need space for tacking the print to the mount, then space for the dry mounting press and, finally, space for stacking the mounted prints. Under this table we should have shelves for mounting boards, dry mounting tissue, etc. Shelves can also be placed above the table (high enough to miss contact with the mounting press mechanism and the 22x28 mounts when they are turned about).

As we will not be mounting and spotting at the same time, we do not actually *need* a longer table, but several feet more will be helpful and give us greater freedom of movement. My worktable is 36 inches high.

The dry mounting press should be movable; if we are working with smaller prints, the press can be moved farther to the left so that it will be in more efficient position.

4. **Storage Space.** This is naturally flexible. Chemicals and sensitive materials should be stored near the darkroom entrance; mounting materials can be stored at the other end of the workroom. Most camera equipment can be stored in the workroom, but large equipment (light stands, heavy tripods, etc.) can be stored

in the studio-gallery or other available space.

The workroom plan as in Fig. 121 indicates the approximate relative size of the various elements; as stated previously, a considerable freedom in layout is possible.

ELECTRICAL INPUT

(a) **Lighting**.
1. General lighting: sufficient for most activities in the workroom; preferably indirect or highly diffused from the ceiling.
2. Over workbench: several lights in cone fixtures directed down on bench from over the shoulder of person working at table but placed so as to avoid casting shadows or creating glare.

(b) **Outlets**. Principal outlet (heavy-duty) for dry mounting press. This might carry a load of 2000 watts, plus tacking iron. These, together with minor fixtures off this circuit, might draw up to 2500 watts (20-25 amps), and the wiring *must* be planned for this load. This, added to the darkroom circuits, makes a total of perhaps 35 to 40 amps.

(c) **Extra sockets**. Should be quite a few around the room for vacuum cleaner, copy camera, densitometer, viewing screen, etc. All sockets and connections should be the three-prong "ground" type. I have a strip running along the entire back of the worktable—a heavy-duty circuit which feeds the dry mounting press, tacking iron, etc.

(d) **Ventilation**. Provision should be made for an exhaust ventilation fan or fans if conditions require. The room should be kept clean; dust should be avoided although it is not as troublesome as in the darkroom.

WATER INPUT. No water connections are needed in the workroom. Unless a great quantity of work is to be done, chemicals can be safely mixed in the darkroom; otherwise a separate mixing area is suggested.

SAFETY. Apart from electrical safety precautions, the workroom should be checked for projecting devices, shelf corners, etc. Easy exit in case of fire is important, and a "panic door" should be installed if feasible.

CONSTRUCTION OF DRYING RACKS, STORAGE AND WORK UNITS

1. **Drying racks and stand**. Racks of 1-inch wood, inside corners braced with aluminum or stainless steel "L"-bars (about 2 inches to the side). With a maximum length of about 48 inches, no central crossbar will be required. The stand can be made of 2x3 wood braced across top and bottom with 1-inch runners. Ends should be closed with sheets of 1/4-inch plywood flush with the runners to assure "tracking" of the racks. (Do not have the racks too tight between the runners.) All wood should be heavily treated with waterproof varnish.

 Wrap plastic fly-screen material over the edge of the rack and secure with non-corrosive staples. Stretch plastic material rather tightly.

2. **Worktable**. Construct firmly with ample space for cabinets and shelves. Be certain cabinets and shelf planes are sufficiently recessed to prevent contact with feet and knees. At any area where we know we will sit when working (such as the area where we will spot prints, etc.) the space under the table top should be open; at least, shelves and cabinets should be adequately recessed.

 The table top should be of Formica—white or gray—and the edges also covered with Formica. If possible, "cove" the inner edge of the worktable and have a foot or two of Formica backing. This helps to make cleaning and dusting

Fig. 121

easier. White Formica gives an attractive "clean" surface, but I recommend a gray tone (about 15-20% reflectance) which helps to show off the prints to better advantage than white and is less aggravating to the eyes.

Other substances can be used for the table top—linoleum, rubber, plywood, etc.—but none seems to be as durable and clean as Formica.

3. **Storage cabinets, shelves. etc.** Metal cabinets and shelves are fine—but expensive; 1/2-inch plywood is adequate for shelves and can be painted (or varnished) to suit. Cabinet doors can be painted to match the table.

The workroom walls can be painted gray (about 18-20% reflectance—paints are available for any percentage of reflectance); cool or warm hues can be added. A background or environment of 18-20% reflectance is ideal for viewing prints.

Floors can be constructed as desired, but if of cement, rubber mats will be needed to prevent fatigue.

Heating: Heating when required, is not as critical as with the darkroom heating and/or air conditioning, but the use of heaters which produce fumes or any aerial residue is *not* advised. Sensitive materials and finished prints are susceptible to chemical fumes; even cigarette smoke has a harmful effect. (See also *Page 256* "Safety and Medical Considerations.") Central heating, radiant heating or open electric heaters are acceptable in the workroom and the studio-gallery area. With radiant floor heating, do not keep cameras or sensitive materials (film, papers or chemicals) on, or near, the floor!

STUDIO—GALLERY

This is not essential, but many photographers have use for such a combination, especially professionals. Its size depends upon requirements: a professional illustrator might need considerable space for multiple setups, a portrait photographer usually can manage with much less area and a "field" photographer, primarily in need of display space, needs an adequate wall area with sufficient room space for suitable viewing. Adequate print-storage space is important! Hence, we cannot make any really helpful plans other than to suggest arrangements, lighting, etc.

CONSTRUCTION

Walls can be continuous from floor to ceiling with a "cove" base, or they can rise from the "dado" line to the ceiling; below the dado line shelves or cabinets can be installed. The continuous wall is usually selected for the longest print-viewing distance (necessary for display of large prints).

The walls can be made of materials that will accept nails and brads for print hanging, or exhibit panels can be suspended from picture molding at the ceiling line by stainless steel rods; this allows for flexibility and avoids scarring of the wall from direct-attachment devices.

The tops of the cabinets serve as support for prints, etc., when not on continuous wall display. The top should be grooved for better print support and painted no brighter than about 20% gray. While all may not agree, I believe the medium gray background (about 18-20% reflectance) is ideal for the display of prints. My display wall is of that value, and the panels suspended against it are surfaced with painted fabric of about 12% gray; the darker panel value averages with the white print mounts to about the same value as the walls. The gray, I think, should be slightly on the "cool" side. Warm tones may be distracting.

220

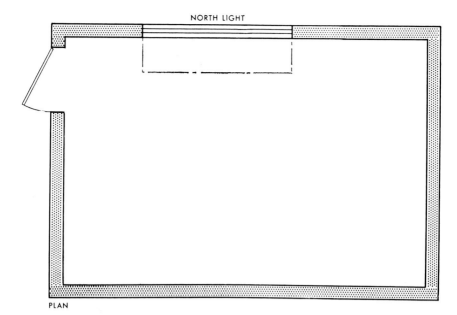

NORTH LIGHT

PLAN

122A. PLAN OF STUDIO-GALLERY.
This is an extremely simple plan.
Each photographer will have his own requirements, depending upon the uses to which this space is put. The plan shows a north window. With the entrance where it is indicated we would have minimum interruption of space; the north and east walls could be used for portrait backgrounds, while the south and west walls could be used for display. Of course, with artificial lighting wall disposition is simpler. Important: do not overlook the need for ample storage area (equipment, backgrounds, supplies, etc).

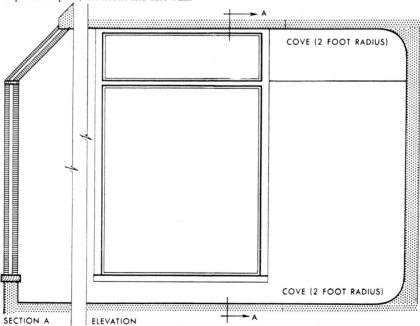

A

COVE (2 FOOT RADIUS)

COVE (2 FOOT RADIUS)

SECTION A ELEVATION A

122B. ELEVATION OF STUDIO-GALLERY. Here we note the "cove" structure between the walls and the floor and ceiling. This minimizes the effect of the "base line" when making full-figure portraits or pictures of large objects.

221

LIGHTING

Skylights of highly diffusing plastic give beautiful illumination, but they should be placed (in relation to ceiling height) so that they do not produce reflections or glare on the prints. It is *very* important to test for the proper skylighting positioning.

As relatively few installations admit skylight, artificial lights are commonly used. Here we have several problems to solve:

1. **Angle to the wall.**

 (a) This is determined by the angle of reflectance in reference to the picture size and placement on the wall as well as the height of the viewer. Personal preferences enter here, but it is safe to suggest that the center of an 8x10 or 11x14 print should be about 60 inches from the floor. The center of a 16x20 print should be about 64 inches from the floor. A short person (eyes about 60 inches from the floor) standing about 2 feet from the print should not be aware of any glare from the top of the print before him (the taller the person and the farther he stands from the wall, the less chance that glare will exist).

 (b) If the angle of illumination is too acute, we will be aware of any small unevenness of print surface and of mount, and the edges of a cutout mount or a frame will cast obvious shadows; if too direct, we will get reflections. Glass, of course, increases the intensity of reflections not only from the lights but from other objects in the room. Anti-glare glass ruins the subtle values of a fine print and should not be used!

2. **Height and distance of the lights:**

 (a) Reflector-flood lamps should be used as spot lights give an uneven illumination on a broad field. The reflector-flood lights obey the Inverse Square Law (intensity of illumination decreases as the square of the distance increases). If the lights are too close, the prints will receive much more light at the top than at the bottom. For example, if the top of a 20-inch print is 30 inches from the light and the bottom around 45 inches, the ratio of illumination is about 30^2 to 45^2 (900 to 2025, or about 1 to 2.25). The bottom of the print is receiving less than half the light the top receives (this is for a $45°$ angle of light; the principle is the same for any angle of illumination). While the eye has an impressive capacity to adjust for differences in lighting, the above example demands the light be at a greater distance from the print—at least 50 inches from the top and at the optimum angle to avoid reflection and glare.

 (b) With an 8-foot ceiling the light could be at about 50 inches from the top of the 20-inch print (and about 65 inches from the bottom); the illumination ratio would then be about 1.7. This is an "adaptable" difference, and the difference would be less for smaller prints. Hence, we can say that for a display area as outlined here our lights can be about 8 feet high and directed to the panel at about a 30° angle. The light should be "pointed" to the center of the print (or a little below); this will better equalize illumination values.

3. **Intensity and number of lights required.**

 (a) Good prints can take, and deserve, ample illumination. The luminance of my wall (20% gray) reads 6 c/ft² and of the white mounts over 30 c/ft² with the Weston Ranger 9 meter (reflectance value, *not* footcandles). Personal preferences vary, but an illumination value of about 80-100 ft-c is agreeable.

 (b) 200-watt lamps spaced at about 4 feet or 100-watt lamps spaced at about 2-1/2 feet should provide ample illumination. Hence, for a 12-foot wall we could have 5 100-watt or 3 200-watt lamps.

 (c) Regular 100-watt lamps can be used in a "trough" fixture (with a highly

reflective inside surface). Fluorescent light can be used, but the tubes should be in a "trough" reflector to prevent light-scatter throughout the room (which causes enveloping reflective glare). I have not found the fluorescent light quality as favorable to prints as tungsten light or daylight.

(d) The reflector floods, because of their design, do not scatter much light in the room. The scatter can be reduced by putting the lamps in cone fixtures (preferably with ventilation provisions), or they can be recessed in a trough or baffle fixture. With more elaborate installations the lighting can be located flush with the ceiling. Attractive rail fixtures are available on which lights can be shifted to any desired position. (These must conform to legal safety restrictions!)

(e) Obviously, the electric circuits required for a lighting installation must be adequate. Within certain limits the lights can be put on dimmers, individually or in groups.

4. **Equipment and accessory outlet plugs.**

(a) For studio work a huge variety of lighting equipment is available: tungsten, halogen, fluorescent or electronic flash. These require varying amounts of power and are usually connected to floor or base plugs (must be grounded). In some cases "spiders" (multiple plug boxes) are used which, when several lights are attached thereto, carry a large amount of current. Hence, the electrical circuits must be adequate to carry the projected loads; heavy-duty circuits are advised for studio installations. Circuit-breakers rather than fuse boxes are suggested.

(b) Wall-base plugs are adequate for most lighting equipment, but floor plugs have definite advantages. Floor plugs are usually equipped with screw-covers flush with the floor.

(c) Unless there are some extraordinary requirements, 220-volt circuits are not advised. Alternating current is practically universal.

Voltage control devices are available but primarily for low power units; for a large input of current they are prohibitively expensive. Do not confuse a *voltage control* device with a *transformer-dimmer* (such as the Variac.) The former automatically maintains a stable voltage, whereas the latter controls the amount of current leading to the fixture as desired.

If there is some fluctuation of voltage or if lighting units will be given heavy use, it is well to use 130-volt lamps. For one thing they last longer! However, if color photography is to be done, the color temperature (°Kelvin) must be consistent, and the advice of an electrical engineer is strongly recommended. To repeat: the amount of current used in darkroom, workroom and studio-gallery requires adequate circuits, and this relates to the total electrical input to the building. If the total input is not adequate, more current must be brought in. If the prime distribution wiring (wiring from the main fuse box) is not adequate to carry the full load, it must be redesigned.

All of the foregoing data on darkroom, workroom and studio-gallery covers the essential design and construction of an efficient photographic plant from advanced amateur status to a small professional installation. I can offer only basic suggestions; each photographer must work out his own plant or system. There has always been a tendency to over-install—and to over-equip. In time, the accumulated equipment (often very expensive) may dominate the procedures and actually affect the photographer's viewpoint. On the other hand, poor equipment is, in the end, more costly than first-class equipment. But the question should always be asked: "is this equipment necessary?" The cost of designing a laboratory for 16x20 prints is not very much more than for an 11x14 maximum. I would not have a fairly elaborate 8x10 enlarger if I did not, professionally, make large prints (up to 40x76 inches), nor would I have the

large trays and sinks required therefor. My darkroom would be about half the size it is if I limited myself to 16x20 prints. But the workroom size and equipment would be about the same. There is nothing more difficult or frustrating than trying to work in restricted and crowded space. It is hazardous to combine darkroom and workroom facilites because of chemical contamination, dampness, etc. Some laboratories are hideously cluttered with what I call the "plywood and cardboard syndrome"; good work cannot be done in a messy, dirty and ugly environment. Photography is a precise art and craft and must be practiced in a clean and well-organized environment. Certain modifications of the basic plans described herein are suggested in describing some specific equipment and processes in the chapters to come. As there is rapid advance in the design and production of equipment and materials, as well as much obsolescence, the ideas and facts presented in this book should be subject to constant check for function and availabilty of equipment.

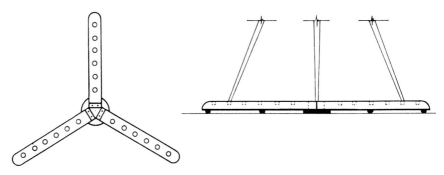

123. DIAGRAM: TRIPOD SUPPORT FOR SMOOTH FLOOR. Some tripods have locking legs or legs which are integral with the support column; these work well on smooth floors and can be moved about with ease. For field tripods a device such as this is handy and secure. The three legs can fold together for transport or storage.

PRINT

GLASS

124. DIAGRAM: METHOD OF DIS-PLAYING PRINTS ON WALLS. The print (with glass if required) rests in the molding (which takes all the weight). It is secured by an "L"-hook at the top. This is an ideal system when panels are used (the panels can be supported by rods from the ceiling molding).

125. JOHN WILEY, SKIER, YOSEMITE NATIONAL PARK, CALIFORNIA. Made many years ago with a Zeiss Contax II camera and a 50mm f/2.8 Zeiss Tessar lens. As seen here the image represents a considerable enlargement (about 14x). The negative was developed in a paraphenylene diamine formula; the grain is apparent but is very sharp, giving the impression of greater optical sharpness than exists. Contrary to popular opinion to the effect that condenser enlargers must be used for small negatives this enlargement was made by diffused light in a Beseler 45MCR-X with the "cold" light head. A 150mm Schneider Companon enlarging lens was used with the enlarger in horizontal position.

LABORATORY EQUIPMENT FOR DARKROOM

TRAYS

The best trays are of plastic or stainless steel. Iron-porcelain trays are not recommended because they chip and the exposed metal will rust with probability of stains on prints (especially when used with selenium toners).

Plastic Trays. Can be obtained in all sizes. Some suggestions (typical):

(a) For negatives:

 (1) 4x5 and 5x7: FR Printray (comes in "nests" of 4 trays)

 (2) for treatment of single 4x5 or 5x7: Yankee Agitray

 (3) for 8x10: 11x14 Yankee Agitray

The 4 Printrays allow 2 trays for developer and/or water bath and 1 tray each for stop bath and fixing bath. When developing a quantity of negatives at one time, the negatives can be changed from one tray to another, each containing the same amount of the developer solution. This overcomes the need for too much solution in one tray (a certain amount of solution is required to develop a given number of negatives—or, putting it another way, a given amount of developer solution will develop a certain number of square inches of negative). Larger trays require more solution than may be needed. The Yankee Agitrays (or similar trays) are available in various colors, which may be helpful in identifying the various solutions. The small Agitray (if white) is good for reduction or intensification, etc., of single negatives.

For the advisable presoaking (in water) of sheet film and film pack negatives, a somewhat larger tray (at least 11x14) is suggested. (The water bath tray *can* be used for the presoak tray.) All trays should be "ribbed" to allow for easy pickup of the negatives; a flat tray base can be very troublesome in this regard. When a batch of negatives are developed and fixed, they can be stored in a larger tray (with gently running water and frequent separation). The fixing bath and developer solutions can be discarded and the stop bath poured into the developer tray and "swished" around. This neutralizes the alkaline developer and effectively cleans the tray, thereby preventing possible stains in future use. Then all trays should be thoroughly rinsed out. Normal protective procedure suggests that the negatives should be put through a second fixing bath (which can be retained as the first bath for the next batch of negatives), then thoroughly rinsed, then put through the hypo-eliminator bath, then rinsed and washed.

(b) For prints:

 (1) For prints up to 8x10, the 11x14 trays are advised; we should have 5 trays and 1 "storage" tray.

 For example:

 (a) Developer A (soft, such as Kodak Selectol-Soft)

 (b) Developer B (normal, such as Kodak Dektol)

 (c) Possible water bath treatment

 (d) Stop bath

 (e) Fixing bath

 (f) Storage: fairly large tray or sink (with overflow drain tube)

 (2) For prints up to 11x14, 16x20 trays are recommended—at least no smaller than 12x15. The darkroom sink may not permit the 5 trays plus storage tank; we would *require* 3 trays (developer, stop bath and fixing bath) plus the storage tray. The sink size should be planned with provision for the essential trays of optimum size.

(3) For prints up to 16x20, trays at least 18x22 are required plus a storage tray as large—or larger. Hence, as discussed elsewhere, the sink for a 16x20-print darkroom *must* be at least 60 inches long—preferably longer—*plus* space for the print "storage" area.

(4) After a batch of prints is made, the same procedure for cleaning the negative trays should be followed; the trays are then ready for storage or for the toning process which, with my personal system, requires trays for plain hypo bath, hypo-eliminator-toner, plain hypo eliminator, then storage.

Trays should be thoroughly rinsed off—inside, outside and rims—before reuse or storage. Badly stained developer trays should be treated with a tray-cleaner (refer to *Photo-Lab-Index*). Thoroughly wash the *bottoms* of the trays; they can pick up contamination from spilled or discarded solutions in the sink.

Stainless Steel Trays. These are readily available in a variety of sizes or can be ordered directly from Calumet Manufacturing Company, 1590 Touhy Ave., Elk Grove Village, Illinois 60007. Stainless steel is expensive but practically indestructible and clean. A good metal-working shop can fabricate trays to specifications, but you must be *certain* all trays, tanks, sinks or sink attachments are of the proper *kind* of stainless steel, commonly known as 18-8 Type 302 or 316 stainless, since some alloys do not resist all acids and salts.

There are few destructive chemicals used in photography. A number of them, including silver, are reclaimed for reuse and danger of pollution is minimal.

All suggestions for care and use as described for the plastic trays apply to stainless steel trays.

Fiberglas Trays. These are excellent but practical chiefly in the larger sizes or as sink units. They can be fabricated by good craftsmen and left plain or painted with the appropriate paint. I have 3 trays about 20x44x6 inches in which I process large prints up to 40x80 inches by *rolling*. (I have a large sink in which the large print can be fully extended for storage and observation). These trays are used for developing, stop bath and fixing bath, then thoroughly washed out and used for the three stages of the toning process.

As stated elsewhere, there is no longer any need to label each tray to avoid "contamination" of one solution with another – provided all trays are thoroughly washed out after each use. This statement applies to practical everyday use; with precise technical and scientific work, and possibly with sensitive color processing, it may be advisable to use trays for specific solutions. A small amount of hypo in a developer solution will do little harm; direct contact of hypo (as by unrinsed fingertips) with sensitive materials before development can be disastrous.

TRAY COVERS

There may be need at times to cover a tray while films are being developed or immediately after films have been put in the fixing bath. One of the best lightproof covers is simply another tray—a little larger than the tray in use and preferably of black material—or a lid with a deep flange or lip, made of plywood and heavily painted with a black waterproof paint. It must be emphasized that negatives (or prints) should not be allowed to stand without agitation in the short stop or fixing bath until they are completely cleared, and then only for a short period of time. Tray covers are indicated when there is a chance of dirt getting in the solutions or when some emergency calls for lights to be turned on.

227

TANKS

Tanks of many varieties are available on the market, new and used. Most requirements can be met with available tanks, but for certain situations special tanks can be designed. The best tanks are made of stainless steel (18-8, Type 302 or 316 is advised). The various types of tanks are:

1. **For 35mm and 2-1/4x2-1/4 roll film:**

 (a) Plastic tanks and reels, self-loading and otherwise. There are too many varieties to list here; any good photographic store will have them.

 (b) Stainless steel tanks and reels. These are the cleanest and most enduring available. The basic Nikor tanks take reels for the 35mm and 120-size film (12 exp.). There are other good makes, and this general type of tank is available for 220-size roll film and 70mm film. The units comprise the tank (or "can"), the tank lid, small cover for the vent of the lid, the reels and the lifting rod (which enables one or more reels to be lifted out of the tank at one time). Tall tanks are available (with appropriate rods) for the processing or washing of a number of reels at one time. I have a washing tank which holds eight 120 reels or a greater number of 35mm reels—or a number of both. The reels must be loaded and placed in the tanks in total darkness, but the processing can be done in full light. In theory, the developer is poured in and out through the light-tight vent, likewise the stop bath and the fixing bath. The vent cover permits the tank to be turned upside down during agitation (see Book II–*The Negative*). I prefer to fill the tanks with the solutions and insert and remove the reels from the developer tank (in total darkness) to the stop bath and then to the fixing bath (the latter two in larger rubber or steel tanks which can hold 4 reels in pairs). When in the fixing bath, after thorough agitation, the tank can be covered with a black tray and the light turned on. In this way a number of rolls can be processed continuously; using two 2-reel developing tanks (with the other tanks holding 4 reels) it is possible to develop many rolls in a comparatively short time. When fixation is complete, the reels are placed in a larger tank of fresh water, agitated about 30 seconds—and frequently thereafter—and then put through a hypo-eliminator bath prior to washing (this can also be done in a large tank holding 4 reels). This procedure requires 2 Nikor 2-reel developing tanks and 4-reel rectangular tanks for stop bath, fixing bath, rinse (storage) bath and the hypo-eliminator bath. These 4-reel tanks can be of ordinary hard rubber, plastic or stainless steel. The washing tank (if it is the tall Nikor tank) will take 8 12-exposure 120 reels on the long rod. I have a water hose (from the temperature control outlet) attached to a stainless steel tube which goes down through the cores of the reels to the bottom of the tank. There is a fine circulation of water upwards through the reels. In addition to the continuous water flow, I drain the tank (by upending while holding the reels in with the left hand) several times during the washing period. I always give two drainings at the start of the washing which removes most of the chemicals. When washing is complete, I give a final drain and then refill the tank while adding Kodak Photo-Flo. After about 30 sec (while gently agitating by moving the reels up and down with the rod). The reels are removed and the roll film is hung to dry (the film is gently wiped with a soft rubber squeegee or windshield wiper right after hanging up). The tanks, reels, rods and tops are all washed off carefully in hot water and dried. It is *essential* that the reel be completely dry before re-use; otherwise, the film will stick to the coil and be damaged.

 (c) Deep tanks. If a large amount of roll-film developing is to be done, a group of 4 stainless steel tanks can be made to order. They need not be the full length

of the roll film in depth; the film can be doubled over a stainless steel rod and weighted with a stainless steel film clip. The solutions are "stirred" by a perforated "tray" which rests on the bottom of the tank to which a rod is attached at one corner and turned over to hook over the edge of the tank. The tray is lifted up and down a few times (which thoroughly stirs the solutions); it is also valuable for retrieving lost films! A water jacket (enclosing all the tanks) with both hot and cold input is important unless the environmental temperatures are consistent. Water from a water-temperature control unit is ideal. The size of the tanks depends upon the length of the suspended roll: a 36-exposure 35mm roll, doubled, is about 33 inches long; add 2 inches for the film clip and clearance and 2 inches at the top for the rod (and ample immersion space), and we have a total depth of 37 inches. Allowing 38 inches overall but filling the tank to 37 inches, the volume capacity of a tank 10x5x37 would be 1850 cubic inches, or 8 gallons (231 cubic inches to the gallon). One standard 120 roll is 32 inches and could be hung without doubling (with a film clip attached to the rod) in this tank. The 10-inch rod would freely hold 4 120 rolls, and the 5-inch-wide tank would safely hold three rods (if all 3 rods were lifted for film agitation together). It will safely hold two rods, and each rod can be agitated separately. A tank 2-1/2 inches wide (or a little less) would safely hold one rod, and the capacity of such a tank would be 4 gallons of solution. This is only a guide; each photographer would have to decide on the size and quantity of film he would want to develop at one time and plan the tanks accordingly. All operations with a deep tank must take place in total darkness. In my opinion, however, the deep tank method is the *safest* and most consistent method of developing considerable quantities of film (although it is not practical if "one-use" developer solutions are to be used). A developer such as Kodak HC110 (with appropriate replenishment) is indicated for the deep tank method. The No. 4 tank (washing tank) should be connected to the water-temperature control unit.

The water jacket would, of course, have a drain valve. When changing solutions, the solution tanks would be siphoned out into the drained water jacket tank, then lifted out for thorough drainage and cleaning. The washing tank would then be siphoned out and likewise removed and cleaned. The water jacket tank could then be hosed off and thoroughly drained. This should take place every time the solutions require changing.

Floating lids are advised for the solution tanks; they prevent evaporation and oxidation.

An installation of this kind seems rather "ambitious," but if a considerable number of rolls of film are to be processed more or less continuously over a long period of time, it will prove efficient and economical. Manufacturers such as Calumet, Burke & James, and Pako make such equipment to order (to your specifications).

2. **For sheet film**: available for 8x10, 5x7, 4x5 and smaller sheet film in all good photographic stores. Calumet Manufacturing Company makes splendid stainless steel tanks with and without water jackets. The Ledal tanks (Burke & James, Chicago) are also excellent products. With these tanks it is necessary to use individual film-developing holders which are available (Kodak, Calumet, etc.) in all sizes, single or multiple frames. It is not advisable to use the rod type (with 2 small X-ray clips from which the film is suspended); these invite digs and scratches, as the film is not held in a rigid plane. Sheet-film tanks are usually used in threes: developer, stop bath and fixing bath. A water jacket is well worth the cost if temperature of the darkroom and of the tap water varies. And, of course, an adequate washing tank is required.

Washing tanks for sheet film are obtainable in a variety of sizes and styles. Calumet makes a fine one with a "quick-dump" facility. In the best washing tanks the water enters at the bottom, sometimes through a perforated pipe running the length of the tank, and overflows at the top. Good circulation is essential for adequate washing, and the films should be agitated, gently hosed off and drained (and the wash water given a complete change) several times during the full washing period. At the final fill add some Photo-Flo, agitate the films for 30 seconds or so and hang them up to dry. It does no harm to start the next batch of film washing in the final Photo-Flo bath of the previous batch. The negatives should be rinsed off, both front and back, with a gentle stream before washing is begun in the washing tank. (See Archival Processing, page 251.)

TANK COVERS

Some larger tanks are equipped with safe covers, but the simplest method of covering the tanks is to have them in a larger "box" with a light-tight lid. Or have large black-painted boxes that would fit over the entire tank and rest on the bottom of the sink. The small roll-film tanks are equipped with caps— usually provided with a lightproof drain. In the case of the Nikor and other steel tanks, be certain that the lids and caps are numbered in relation to the tanks; there may be a slight variation in size resulting in too-loose lids (leaking solutions when the tank is turned upside down during agitation) or too-tight lids causing a "bind" and probable over-development of the film! Should such a "bind" occur, immediately drain the developer through the vent and refill the tank with a mild short-stop (and agitate vigorously for a minute or so to be certain developer action has ceased). Then proceed to remove the cap (with a padded Stillson wrench if necessary). Turning the tank upside down and dipping the cap in hot water may expand and loosen it, but be careful not to heat the short-stop solution to any extent because of the temperature-change effect on negative grain. It is important that all lids and caps fit snugly—but not too snugly!

SAFELIGHTS

Safelights are obtainable in a variety of sizes and fixture-shapes with filters to match. (Refer to the *Photo-Lab-Index* for manufacturers' specifications.) Special safelights designed to put out a large amount of darkroom illumination at certain wavelenghts, which have no effect on sensitive paper materials but create a high visual response, are now available.

The following safelights are typical of those in common use:
(a) Wratten Series 0A (greenish yellow): for all papers except variable contrast
(b) Wratten Series 0C (light amber): for variable contrast papers
(c) Wratten Series 1 (light red) or 2 (dark red): for ordinary and orthochromatic films
(d) Wratten Series 3 (dark green): for panchromatic films

Other safelights are available for special materials, but the above would cover all normal darkroom applications in black-and-white photography. These safe-light filters come in various sizes: circular, 5-1/2 and 2-9/16 inches in diameter, and rectanglar, 3-1/4x4-3/4, 5x7, 8x10 and 10x12. The fixtures are available in types which illuminate the ceiling, attach to walls or hang on cords.

The number of safelights in the darkroom varies with the space and the personal requirements of the photographer. I always develop panchromatic film

in total darkness. When printing, I have some ruby lamps burning in several parts of the darkroom. These have no effect whatever on sensitive paper materials (providing they are of true ruby glass and not just "painted" lamps). It is extremely important that the effects of safelights are understood. A "safe" light has a variable "safeness" depending upon intensity and distance. We test for the safety of the safelight by exposing a piece of the fastest paper to be used at the working distance of the safelight above worktable or sink for, say, 4 minutes, covering a part of the sheet with an opaque object. After giving it full development, we note if there is any evidence of fog (if the uncovered area shows any density above that of the covered area). If no fog is observed, we can accept the safelight as "safe." *However*, once we expose a sheet of paper in the enlarger, we have subjected the entire sheet to a certain amount of flare from the scattered light in the enlarging camera and lens, and this might bring the paper emulsion to or near the threshold point. Such would not affect the actual enlargement, but further exposure to the safelight might result in a slight degradation of the whites of the image. Hence, the *direct* safelight should not be turned on until print development is almost complete; weak, indirect safelights or the ruby lamps should have no effect whatever. This is further discussed in Book III (*The Print*).

Old safelights may show deterioration, especially if the fixture lamp is of higher than normal wattage and therefore produces excessive heat. If any variation in the color or density of the safelight is observed, it should be discarded.

A very handy device for the darkroom is an electric hand torch covered with a safelight of the required type (Series 0C for variable contrast papers, for example). This can be used for setting the enlarger lens, finding misplaced objects, etc., without having to cover up paper boxes or remove a sheet from the enlarging easel. For those who want to watch the timer when developing film, the timer can be placed at the end of a long black tube and illuminated by a small red lamp. Timers with luminous dials are preferred.

While panchromatic film is sensitive to light of all colors, the Series 3 safelight can be used towards the end of development (or directed to the wall or ceiling). If it is strong enough to make the developing negative visible to the eye, it will probably fog high-speed film.

For some purposes (as when reducing negatives) a light under a glass tray (clear or frosted) is very helpful. But any electrical equipment (lights, heaters, etc.) to be used in or near water must be most carefully insulated.

As mentioned elsewhere, the safelights should be on a separate switch. The main room lights, or other bright lights, should also be on separate switches, so placed as to prevent any accidental operation.

Page 211

In recent years special safelights have been developed (for use with photographic papers) which utilize a narrow section of the visible spectrum; a high visual-response area, but beyond the color-sensitivity range of the papers. Safelights such as the Thomas Duplex Safelight (utilizing quartz sodium-vapor discharge tubes) and the Sunray Photolight, Amber (fluorescent tube), give strong but "safe" darkroom illumination, assuring better evaluation of print quality during development.

THE ENLARGER

The enlarger comprises the photographer's most important piece of equipment next to his camera and his lens. Unless we limit ourselves to contact prints from large negatives (as did Edward Weston), we must possess an appropriate enlarger

231

and know how to use it. There is a tremendous amount of literature on enlargers and enlarging—most is either obsolete, redundant or superficial. The techniques of enlarging are presented in Book III (*The Print*); we will limit ourselves in this book to a discussion of enlarging equipment and the functions of various enlarging cameras, lenses and accessories.

We can make an arbitrary grouping of enlarger equipment in terms of negative sizes, with reference to both ordinary and special functions. We can only mention a few typical enlargers; certain equipment is out of production but still available; much is in production or planned for production. To be up-to-date one must constantly consult his dealer—or visit Photokina or other trade shows.

We will first discuss the qualities of the illumination available with various enlargers. Some enlargers have only one source of illumination, while others have interchangeable illumination heads.

1. **Condenser-type enlargers.**

 (a) Point-source illumination. A very small but exceedingly brilliant source of light which, when put through appropriate condensers, gives an enlarged image of maximum sharpness and contrast (and also painfully reveals physical negative defects and negative grain).

 (b) Ordinary tungsten lamp (clear glass). This gives less severe effects than the point-source light.

 With both (a) and (b) above, the condenser systems must be properly focused for even illumination. The procedure: insert, compose and focus the negative on the easel. Then remove the negative and adjust the focus and position of condenser light-source to achieve a perfectly illuminated field. Then replace the negative, give a final focus check, make exposure tests and then the final print. The lens, condensers and the light comprise an optical system and

Page 235 must be reset when different lenses are used or images of different sizes are made.

 (c) Frosted lamp (specific enlarging lamps are available). The source of illumination is now, effectively, a circle equal to the diameter of the lamp, and the harshness of the image is greatly reduced, as are the apparent negative defects. As a rule, the condensers need not be refocused as with (a) and (b) above. This is the most popular illumination today, but not necessarily the most satisfactory.

2. **Diffused-light enlargers.**

 (a) A frosted lamp in an "integrating sphere" lamp house. This is seldom, if ever, a true sphere, but it is a highly reflective housing which delivers diffused even light to the negative and thence to the enlarging easel.

 (b) A "cold light" grid, fairly close to the diffusing screen which, in turn, is fairly close to the negative. The grids come in a variety of shapes and intensities; they are gas-filled cathode tubes which require high-voltage transformers. Tube diameter and voltage control the luminous output. The advantage of the "cold

Page 235 light" sources is that they give a smooth diffused quality of illumination, transmitting the diffused-density range of the negative with little or no Callier effect, and they produce little heat. They should burn for a few minutes before use so that stable output is assured. Present-day tubes or grids have cathode heaters which, once the light is working at optimum intensity, maintain the output at a steady level (without regard to the time the light is on or off, as long as the power is on). Earlier cold light sources required constant burning during the enlarging sessions, as turning on and off gave fluctuating power. With the proper connections the heating unit is independent of the on-off switch.

3. **Other sources:**

 Arc lights and fluorescent and mercury-vapor tubes have been used with considerable succes. The Xenon-pulsed sources are extremely bright. These are

232

special purpose lights and are beyond the scope of this book. In my early days in photography I used a large white enameled reflector set outside my darkroom wall which picked up the light of the sky and reflected it to a ground-glass diffusing screen through a shielded window. The light quality was beautiful and fairly "fast." Shifting clouds caused grave troubles, of course, but thick fog or heavy overcast gave surprisingly consistent results. Daylight enlarger illumination would be quite efficient in sunny areas such as the Southwest. A more elaborate system would involve a clockwork-controlled mirror that could direct reflected sunlight to an appropriate diffusing screen. Such a device has been made, using a special condenser system. Between the hours of, say, 9 a.m. and 4 p.m. in sunny areas such as Arizona, controlled sunlight would be both intense and consistent.

Illumination for color printing is a varied and complex field, and as color printing is not discussed in detail in the *Basic Photo Series,* it will not be included here.

Most standard enlargers, such as the Beseler, Omega, Durst, etc., have interchangeable light sources, condensers, etc., and reference to up-to-date catalogues and promotional material is suggested. It would be inadvisable to list presently available equipment here since, within a few months, many changes and improvements are certain to take place.

Fig. 126 I have used the Beseler standard 4x5 enlarger for years and find it a very satisfactory instrument. I have the condenser head (which I sometimes find essential for small negatives), the standard cold light head, and am now using the Ferrante Codelite system. The Beseler standard can be set at right-angles to the *Fig. 128* base and becomes an excellent horizontal enlarger. I use it extensively in this position, projecting on my vertical magnetic easel. Other enlargers employ optical prisms for horizontal deflection of the image; the negative must be "reversed" in the negative carrier.

[*Note:* of course, the darkroom design for a horizontal enlarger is different from that described on page 209. With that design we could *suspend* a vertical easel from an overhead track which would clear the worktable. Naturally, the height of the enlargement would be limited by the table top to ceiling distance. In horizontal position the maximum height of the lens on the Beseler is about 38 inches above the table top (36 inches above enlarger baseboard). With the lens centered it is obvious that the biggest enlargement we could make (with the table top clearing the vertical easel area) would be 72 inches. With allowance for space for the paper roll, overhead track, etc., we could comfortably enlarge up to 60 inches. With the worktable top at 30 inches from the floor, the ceiling height would have to be a little more than 9 feet.]

THE FERRANTE CODELITE

This is an ingenious and extremely efficient light source which works with both variable contrast and graded papers. It is, basically, a two-grid system (one grid giving a greenish light and the other a bluish light). Both grids are controlled by rheostats; with Varigam and Polycontrast papers the green light gives the softest results (approximately equivalent to Grade 0) and the blue light gives maximum contrast (approximately equivalent to Grade 4). Used together, at varying intensities, an infinite contrast control between Grades 0 and 4 is obtainable. The equivalent of Grade 2 paper is achieved when both dials are set at the same dial number. At equal high or low settings for either dial the color of the light does not change—only the intensity. In recent models grade numbers are placed on

233

the dials; when the numbers match (2-2, 4-4, etc.), these contrasts are achieved. The printing times are about the same for all grades. I usually start with both dials set at 50; for greater contrast I turn the hard (blue) light to a high number; for less contrast I turn the soft (green) light to a higher number. For maximum effect, I may use only the soft or the hard light.

With this device one can "code" image contrast, exposure and other factors of the printing process. A typical entry might be: "SOFT 100, HARD 60, 150mm lens, f/11, 20 sec, plus 30 sec with SOFT 100 in cloud area." Refer to Fig. 71 where the brilliant rice fields were "burned in" with the SOFT light of the Codelight.

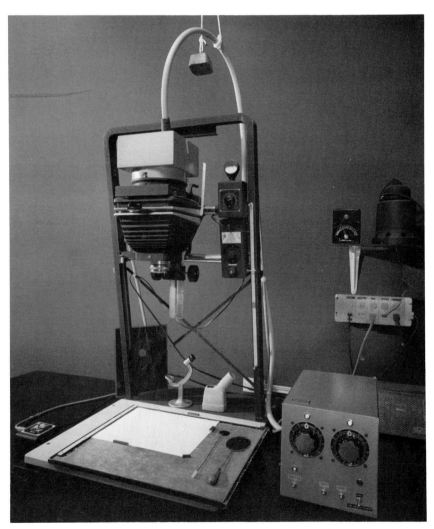

126. THE BESELER 45MCR-X EN-LARGER, EQUIPPED WITH THE FER-RANTE CODELITE. I prefer this model of the Beseler enlarger because it can be put easily into horizontal position (see Fig. 128, p. 241). In this picture we see the Codelite head and the control console. As connecting cable and the head are fairly heavy a temporary counter-weight was attached. The Codelite is described on page 233. Shown, in addition, are my horizontal magnetic easel, two focusing magnifiers, two dodging devices and a burning card, the electric metronome and the Beseler condenser head.

With this versatile control it is possible to treat various areas of the subject for more or less contrast (by "burning" with either the soft or hard light). Of course, this must be done with care and taste; too great local variations of contrast in one area in relation to the whole image may affect the logical and aesthetic tonal balance.

The Codelite offers about the same control as the standard sets of variable contrast filters. Slight differences in effect with the different brands of variable contrast papers may occur; basically, the device is satisfactory for Polycontrast, Varigam and Varilour. For requirements of extreme contrast we must use graded papers such as Kodabromide No. 5 or Brovira No. 5 and No. 6 (these are sensitive only to the blue light component of the Codelite).

Graded papers are insensitive to the soft (green) light but are fully sensitive to the blue light. An extra blue light grid is provided (on a switch only) especially for graded papers. For maximum printing speed use the extra blue light and the main blue light set at maximum intensity.

CONDENSERS

You will note that with the Beseler the lamp house (with condensers) can be raised to various heights above the negative plane. Negative sizes are indicated for optimum performance. Some photographers are confused about this control. If we remember that the light emerging from a condenser system is collimated (that is, projecting in only one direction), it is obvious that if all of the output from the condenser can be concentrated on the negative area, we will have maximum printing speed. Hence, the smaller the negative the farther the condensers can be placed from it.

Light from the condenser system is only slightly affected by the Inverse Square Law (the effective "focal length" of the condenser system is very long). However, with the diffused light system the diffusing glass becomes, in effect, a diffuse light *source* and is definitely subject to the Inverse Square Law. Consequently, any part of the diffusing area has the same brightness; moving the diffuse light from the negative plane lowers its effective value. In addition the light might not adequately cover the negative because of the "angle effect" and *Page 237* edge and corner fall-off can be expected.

It is unfortunate that so many enlargers have condensers of barely adequate diameter to cover the largest negatives for which the enlargers have ostensibly been designed. Unless the negative is exactly centered, poor corner coverage is certain. Some of the best known enlargers I have used definitely will not cover the corners (at least with some of the lenses of conventional focal length)! For what would undoubtedly be only a slight increase in cost the condensers could be a little larger (say 1 inch greater in diameter), and better edge and corner illumination would be assured for the full-size negative for which the enlarger was designed.

The Callier Effect. With a condenser light source each point of the negative is illuminated by the collimated light from one particular point of the condenser. This collimated light is focused (in principle) so that, without the negative, it would all pass through the enlarger lens. It does pass relatively undisturbed through the low-density areas of the negative, then through the lens to the enlarging paper. However, denser portions of the negative not only absorb light in reference to their densities but also diffuse the light which does pass through (we can use the term "scatter" here) so that it is no longer well-collimated. As a result of this diffusion ("scatter") a smaller portion of the light which comes

235

through dense areas of the negative reaches the enlarging lens and the corresponding areas of the enlargement receive less exposure. The result is increased picture contrast (commonly recognized as the "blocking" of the high values. Negative grain and defects are exaggerated with collimated light.

These effects are not observed with diffused-light enlargers or with contact prints made by either collimated or diffused light. In diffused-light enlargers the light is already diffused and so the random deflection of individual light rays through the negative retains the diffuse-negative-density values and the enlargement approximates contact-print quality (with the same paper-contrast grade). In contact printing by diffused or collimated light the paper is in contact with the negative emulsion and although the light rays may be diffused when they leave dense areas of the negative they reach the sensitive surface of the paper.

This subject was investigated by André Callier ("The Absorbtion and Scattering of Light by Photographic Negatives." Photographic Journal, 49:200, 1909 and the effect bears his name.

In practical terms, the higher densities of the negative become effectively higher with collimated light; the *contrast* of the projected image is increased in comparison with the image produced by diffuse illumination. This means that negatives which are to be enlarged with condenser light should be developed to a lower contrast (thereby having a lower density range) than negatives to be enlarged with diffuse light. It is difficult to give any rule of thumb on this because of the great differences of enlarging light quality. I have a personal development indication which is:

(a) For negatives to be enlarged with condenser light: Value V density about 0.65 to 0.7 above filmbase fog density (a total density of about 0.75 to 0.8). (With point source lights the Value V density would be somewhat lower.)

(b) For negatives to be enlarged with diffuse light: Value V density about 0.75 to 0.8 above filmbase fog density (a total density of about 0.85 to 0.9).

The Callier effect becomes apparent at about Density Value V and increases at the higher densities but has little effect with the lower density values. Hence, we must recognize that with less development we are getting less contrast and density in the lower values. This is explained in detail in Book II (*The Negative*), but since it affects visualization to a certain extent, we cannot overlook the character of the enlarging light we are to use.

A diffusing plastic or glass can be placed between the condenser and the negative and will make a considerable difference in the quality of the light. The diffusing material then becomes the light source (and is subject to the Inverse Square Law to a much greater degree than the condenser light alone). As condensers are usually quite close to the negative in some enlargers, the diffusing screen must be even closer, and any dirt or defects thereon might fall within the focus of the lens and would be recorded on the enlargement.

Some modern enlargers have trays for filters, etc., in which diffusing materials can be placed. Such devices relate, usually, to color printing. The variable contrast filters are almost always placed in front of the lens and therefore must be kept very clean. Some variable contrast filters are used in systems within the enlarger head and can be set into position by external controls.

With powerful lamps and an efficient ventilation system enlargements can be made on slow contact printing papers. Some claim that the slow contact papers give greater scale and quality than the relatively faster enlarging papers, but I have never been convinced of this. Heat damage to the negative is a distinct possibility (this includes warping and curling).

ENLARGING LENSES

The focal length of enlarger lenses plays an important part in adequate light coverage of the negative. The lens may perform to perfection optically—that is, render all of the negative from corner to corner with perfect definition and freedom from distortion—but if the "angle of view" of the lens extends beyond the area of illumination of the enlarger light, there will be serious fall-off. A good rule of thumb: the greater the focal length of the enlarger lens, the better the illumination coverage. Also, the greater the focal length, the better the definition of the image. With modern thin-emulsion films this is not as important as with the older and thicker emulsions. Figures 51A and B suggest the effect of a ray of light passing through the center and border of a standard negative; the greater the angle of incidence, the greater the lens sharpness.

Any good lens can be used for enlarging purposes, but with uncertain results, as a "taking" lens (excepting a process lens) is not designed for close work. Various aberrations may appear, the most serious being curvature of field (the center of the enlarged image may be sharp but the edges out of focus). This can be overcome to a practical degree by using a small lens-stop but such requires a considerably increased exposure time. If a "taking" lens is used it is best to reverse it in the enlarger (the rear surface of the lens facing the paper).

If color work is considered, the enlarging lenses must be fully corrected for color. Coated lenses are imperative for maximum contrast and color quality; flare within the lens can produce a slight fog, thereby "veiling" the high values of the print. Hence, as lenses are designed and manufactured especially for optimum results in enlarging, they should be acquired by the serious photographer. Typical of the best enlarging lenses are the Schneider Componon and the EL Nikor lenses.

The focal length of enlarging lenses must be carefully considered. Apart from optimum optical quality we must determine:

(a) **Illumination area size.** If the area of illumination barely encloses the full rectangle of the negative the chances are that there will be a fall-off at the corners and/or edges of the field. The shorter the focal length of the lens, the greater this fall-off will be. It is unfortunate that equipment designers do not provide a reasonable over-size for the illumination areas of their enlargers.

(b) **Negative size** (we assume the illumination source will thoroughly cover the negative). Obviously, the lens must completely cover the negative. A 50mm lens should cover a 35mm negative (24x36mm); a 160mm lens should cover a 4x5 inch negative and a 300mm lens should cover an 8x10 negative, etc.

(c) **Extension of the lens** in the enlarger. Obviously, the focus range of the enlarger limits the focal length of the lens. A 150mm (6-inch) lens must be racked out to about 10 inches from the negative plane when making a 6 x 7.5-inch enlargement from a 4x5 negative; will the enlarger bellows accommodate this? It is possible that the enlarger, at *minimum* extension, would prevent the use of a short-focus enlarging lens (without a recessed lens board). My 80mm Componon covers a 2-1/4x2-1/4 inch negative and permits enlargements of more than 16 x 20 inches with the Beseler; for most work with 2-1/4x2-1/4 inch negatives I use the 105mm Componon. I believe that the longer the focal length of the enlarging lens the better.

(d) **Distance of paper from lens with enlarger at maximum height setting.** This might not be adequate for the desired degree of enlargement with a particular lens. A shorter focal length is indicated *providing* the negative would be covered completely.

237

STRUCTURAL CONSIDERATIONS

1. **Alignment**: negative plane and easel plane *must* be parallel. The geometric integrity of the image will be preserved as with camera and subject parallelism. The axis of the lens must be perpendicular to the negative easel plane. With this positioning the projected image will be accurate and the overall focus precise. Perspective control by tilting the negative and the lens and the easel (or any one or two) is discussed in Book III—*The Print*.

2. **Stability**: most enlargers are well-designed and retain their alignment at any position. The Beseler, Omega, Durst, etc., are unit devices in that there is a basic structural relationship between the base, the supporting column or frame and the camera itself. With enlarging systems where the camera and easel are separate the problems of alignment and stability are considerable. We can assume that we have a firm horizontal camera with the lens axis precisely perpendicular to the negative plane. The easel system *must* be properly aligned with the camera. My easel runs on triangular rails on a concrete floor; the mechanic who installed it used a transit to check the precise level of the rails, and the easel itself was made to close tolerances of vertical and horizontal accuracy. If the tracks were on a wooden floor or suspended from a wooden ceiling, alignment might be more difficult and uncertain. My enlarging camera (actually evolved from an 11x14 studio portrait camera) can be tilted up and down, and this adjustment would take care of any tilt which might develop in the easel. Camera or easel should have a tilting adjustment, but they would be easier to install on the camera support. The perpendicularity of the easel would be established by a carpenter's protractor level, and the negative plane of the camera would be adjusted to the same angle of tilt (if any).

3. **Vibration**: vibration is far more prevalent than one might expect. Ordinary vibration from poorly designed or loose equipment suggests its own corrections. But sometimes vibration comes from without: machinery operating in the building, traffic vibrations or just people walking about. Each problem of this nature needs a specific solution. Engraving cameras are cradled in a spring-suspended carriage; everything moves together, and, as the cameras are very rigid, the images are always very sharp no matter what the environmental vibrations might be. This solution is a fairly expensive one; it is better to check the location of the darkroom before installing any enlarging equipment.

Vibrations within the equipment are far more difficult to trace and overcome. A unit enlarger (easel, support and camera) can develop vibrations from the following causes:

(a) Loose or weak support which throws off alignment of the camera and the easel. In engineering, the term *moment* refers to an inherent tendency of things to revolve around a structural point or axis. This results in what we call inertial vibration. Frequently, in what appears to be a most solid piece of apparatus, a vibration can be set up by a slight pressure or shock, and this vibration can persist for a considerable time. One way to test for such vibration in the enlarger: extend the enlarger to give a large image and examine the image with a powerful magnifier. Touch the camera support (or the camera or lens) and watch through the magnifier; if the vibration quickly subsides, all is well. If it persists, some means of dampening it must be found. Wrapping the support shafts with a firm cloth tape will sometimes work; attaching it to the wall by a permanent fixture, or just a wedge fixture, will usually help. If the vibration persists for, say, 15 seconds, shield the enlarger light for that amount of time after touching the camera before exposing the paper and do not touch the

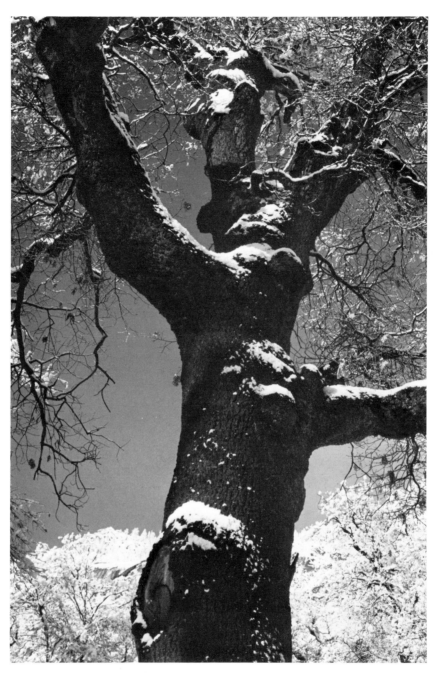

127. OAK TREE, WINTER, YOSEMITE NATIONAL PARK, CALIFORNIA. Made with the Hasselblad 500C camera and the 80mm Zeiss Planar lens. The camera was pointed up at a sharp angle; the only apparent convergence is in the distant snow-covered pine trees. As there are no straight lines in the principal subject the angle of the camera does not create disturbing effects.

This is a good example of visualization of a rectangular format within the square of the camera. The advantages of the square format include: having a square format when needed, and having the facility of selection of either horizontal or vertical formats as desired (which I have no trouble visualizing).

239

camera during the exposure. After my horizontal enlarger is in position and focused, I set an extendible rod between camera and floor which prevents any vibration. Vibration can seriously depreciate the quality of a projected image.

(b) A *moment* in the camera back-enlarger head or in the lens support. Rather infrequent except when caused by vibration on the camera support.

(c) A blower installed in the darkroom wall can sometimes set up a structural vibration or an "air beat" which can be transmitted to the enlarger. The blower which cools my large horizontal enlarger rides on a separate dolly and is attached to the enlarger back with a flexible rubber duct about 4 inches in diameter.

(d) When exposing, it is better to turn the enlarger light on and off (if the type of illuminant permits) than to use a lens cap or a sliding filter frame, as this can cause vibrations. I use a piece of cardboard resting against the lens of my horizontal enlarger; I lift it away from the enlarger but hold it in front of the lens for a few seconds before making the exposure—this allows any vibration to dissipate.

ENLARGING EASELS

A great variety of enlarging easels are available. The following list *suggests* a few types. The photographer should study his requirements and select the easel which will serve him best. Vacuum easels are rewarding but expensive.

1. **Fixed margin easels**: these are designed for paper of standard sizes and give all-around equal margins. A good "4-way" easel is made by the Airequipt Manufacturing Company, New Rochelle, New York. One side has an opening of 7-1/2x9-1/2 (for 8x10 paper with 1/4-inch margin all-around). The other side has openings of 2x3, 3-1/2x4-1/2 and 4-1/2x6-1/2 inches for 2-1/4x3-1/4, 4x5 and 5x7 sheets of paper.

2. **Variable margin easels—two types**:
 (a) Fixed margins on two sides and adjustable slides for desired width of margins on the other two sides. These are designed for *maximum* paper sizes (8x10, 11x14, etc.), although smaller sizes can be used as desired.
 (b) Adjustable margins on all sides, with paper "stops" (recessed flanges) in the easel base.

 Most of the variable margin easels are quite accurate, but some cheaper models have been, in my experience, off true right-angle positioning, and the corners of the prints made on them have not been truly squared.

3. **Easels** with an adhesive base, holding the paper flat without margins.

4. **Magnetic easels**: at the time of this writing I do not know if any are available on the market. I have had one made up which works very well. It does not give print margins but is very fast and positive in operation. The elements are:
 (a) A firm and perfectly flat baseboard 1/2 or 3/4-inch plywood or composition board will do.
 (b) Cover this with a thin sheet of iron or steel (.003-inch thickness) attached to the base by an epoxy adhesive.
 (c) Along two adjacent sides attach a thin (not more than 1/16 and not less than 1/32-inch thick) metal strip, about 1/4-inch wide. Over this attach a thin metal strip about 5/16 or 3/8 inch wide and 1/16 inch thick. This top strip obviously overhangs the first strip and provides a "grip" for the sheet of paper. Note the invert bevel.
 (d) For 16x20 enlargements the easel can be about 18x22; it will, of course, take all smaller sizes. The easel can be painted black, medium gray or white. I

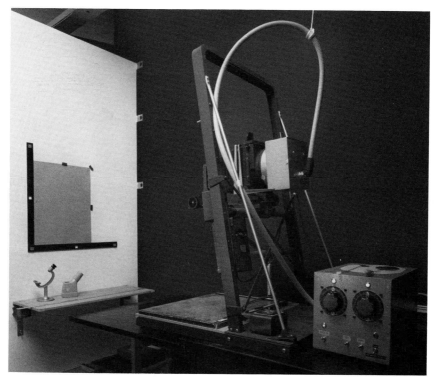

128. BESELER 45 MCR-X IN HORIZONTAL POSITION. Here we see the enlarger equipped with the Codelite head (extra weight supported by a counterweight) and the Codelite console.

The camera is directed to the horizontal magnetic easel. Thereon is seen the right angle paper support (held to the easel by five magnets), a 16x20 card simulating a print, edges fastened by small magnets (one usually suffices at the corner), a shelf (attached by larger magnets), and two focusing magnifiers (the Scoponet and the Bausch and Lomb parallax focusing magnifiers). I have a maximum "throw" of 16 feet from the Beseler to the magnetic easel.

prefer medium gray, as I compose and focus on the back of a sheet of photopaper of the desired size. I can still "find" the image on the gray easel surface. For single-weight paper some photographers prefer a yellow base color. (e) Small "Alnico" (*al*uminum, *ni*ckel, *co*balt) magnets (rough, black surface) serve to hold down the corners or the sides of the paper. Avoid light-value metal or polished magnets, as these can produce reflections. A thin metal or plastic "tongue" can be attached to these magnets which securely hold down the paper but keep the magnet itself at a small distance. Attach this tongue by an epoxy adhesive.

Burke & James, Inc., Chicago, Illinois, makes a magnetic copy board which is rather elaborately scaled and could be used as the metal base described in (b) above.

Figs. 120, 128 For vertical easels the magnetic board works very well. I have a vertical easel (for my large horizontal enlarger), 44x80 inches, with adjustable rods to hold the paper rolls and some sturdy magnets to hold the paper firmly to the base. This easel is precisely vertical and runs on triangular tracks powered by a small electric motor. Both sides of the easel are covered with metal sheets, and I can project a negative with the Beseler enlarger in horizontal position on one side, as well as project large negatives with my horizontal enlarger on the other side.

241

For prints 8x10 and up I have a right-angle paper-holding device held to the large magnetic board by four integral magnets. This can be moved at will to any position on the easel to control the corners and/or edge position of the paper which is held down by small magnets as shown in Fig. 128.

We could attach a metal sheet to the conventional wooden enlarger base (covering it entirely), but this would mean we would have to use a corner-piece, as described in the preceding paragraph, which would move about the board. Otherwise, we would have to use magnets for all sides or corners and we would need some guide to position the paper on the easel. The question arises of how flat the paper will lie supported by 2 edges and a magnet at one corner. This should be quite satisfactory unless the paper is unusually curled and/or the lens is used at very wide aperture. In that event, small magnets on corner and sides should suffice.

FOCUSING MAGNIFIERS

These are necessary for precise work, although the eye does have an astonishing ability to recognize sharp focus at a glance. There are various types:

(a) **The direct focusing magnifier** set at an angle on a frame and adjusted to the eye. Through this we see directly a magnified image as it shows on the easel, and we can focus the enlarger lens until the grain (or a small dust speck) is sharp.

(b) **The mirror-type focusing magnifier** in which a small mirror reflects the projected image upwards at an angle to an optical system. The design of this device must be very precise. It is essential that the eyepiece be adjusted to the individual's eye or a compensating + or − diopter lens be added as required. A reticle on the focal plane must be visually sharp, or the device will not function properly. The Scoponet is a superior example of this type.

(c) **The parallax-type.** This is my favorite because it is free of many possible optical errors. The projected image is reflected from a small mirror, creating an "aerial" image on the plane of a reticle on which some sharp letters appear (a grid would do just as well). The magnification is high; if the eye is adjusted to give a sharp image of the reticle, the projected image will also be very sharp; that is, the negative grain will be sharp even if the optical image of the negative is not. However, the "proof" of accurate focus is not sharpness but the angular "agreement" of the image with the reticle. If the head is moved from side to side, the image, if out of focus (not on the focal plane), will shift under the reticle from side to side. When the enlarger lens is focused until there is no longer any shift, the image is sharp. This system creates independence of the *appearance* of sharpness which the eye can falsify for a variety of reasons. I use the Bausch & Lomb parallax focusing magnifier; as it has no eyepiece adjustment, I use the device with my distance glasses (which "normalizes" my eye).

For large vertical easels, holes bored through the easel (center and near corners), with circles of ground glass mounted flush with the surface, will give exact focusing; ordinary focusing magnifiers, as used with camera focusing screens, will define maximum grain sharpness.

If the enlarging lens is stopped down (1 or 2 stops), the depth of field is such that small curls and bulges of the paper will not produce out-of-focus effects. But it is very important that the negative lies flat on the film plane in the enlarger and that the film plane is exactly perpendicular to the lens axis. The film-to-lens distance is critical! The highest resolution of average enlarging lenses (center as well as edges of the field) is achieved in the f/8-f/11 area. Long enlarging or process lenses work best at smaller stops; my 18-inch Apo-Tessar shows optimum performance at f/22 (but is rarely used below f/16).

242

PRINTING FRAMES

A printing frame is used primarily for contact printing from the negative and is composed of a frame in which rests a sheet of glass supporting negative and paper. A removable hinged back is clamped into the back of the frame by spring-locks. The negative is put against the glass emulsion side up, and the emulsion side of the paper is placed against the emulsion side of the negative. The frame back is inserted and the frame turned over for exposure to an overhead lamp. Or it may be placed over a light box which may be designed flush with the worktable top. This was Edward Weston's method of printing.

Printing boxes are light-tight devices containing a number of tungsten, fluorescent or neon lamps, with a white-painted background (bottom and sides of the box), and (usually) a sheet of diffusing plastic or glass (some have a non-actinic red "locating light"). The negative and paper are placed on the cover glass and the pressure top of the printer pressed down securely (and locked into position). The exposure is then made by turning on the lights in the box. I have an old Air Force printing box with 12 tungsten (100-watt) lamps (and a blower!) and another box with 28 argon lamps (cool light needs no blower); every one of the lamps in both boxes is on a switch, and a certain amount of light control is possible. The large printing box has provision for three sheets of glass (plain or diffused) between the lights and the negative on which cutout pieces of tissue or other materials can be placed—effectively a "make-ready" and a partial substitute for dodging and burning. The paper is held firmly against the negative by an inflated rubber "bladder." These boxes are efficient when many prints are to be made from the same negative. (Refer to Book III—*The Print*.)

An efficient alternative to the standard printing frame is the HP Film Proofer (Hudson Photo Industries, Irvington-on-Hudson, New York). This device has a hinged sheet of glass and a felt base. The paper (emulsion side up) is placed on the cloth base, and the negative to be proofed or printed put emulsion side down on the paper; the glass (heavy enough to assure good contact between negative and paper) is lowered over the ensemble, and the exposure is made with the overhead enlarger light (or an ordinary frosted lamp).

If fast enlarging papers are used for contact printing, the light source can be the enlarger itself. The extension of the enlarger and the lens stop used give considerable exposure control. With overhead illumination dodging and burning are as simple as when making an enlargement.

NEGATIVE HOLDERS FOR THE ENLARGER

Ideally, the negative should be held as flat as possible. The usual system is to hold the negative between two sheets of glass. It is masked by a very thin piece of black opaque paper. Newton's rings may result if the negative back comes in contact with the glass surface. Glassless carries (such as the one for the Beseler enlarger) clamp and *stretch* the negative into good plane position. Only a badly warped negative may not be pulled truly flat. Open negative holders, composed of two pieces of metal (black) with identical cutout openings, clamp or hinge together to press the negative into flat position. For all but the most exacting work this type of holder is good. The openings of these holders are usually too small and cut into the image. The reason for this, apparently, is to prevent any flare light from scattering from the clear edge of the negative. I have my holders routed out so that a mere hairline of clear negative is projected; I have had no discernible flare effect in my enlargements.

243

The problem of Newton's rings (the wavelength effect when two smooth areas are in contact) can be severe, especially when there is high humidity. Anti-Newton-ring glass is helpful when contact-printing in a printing frame, but may produce a slight textural effect if used in the enlarger. The rings develop on contact of the glass with the *back* of the negative. If a glassless negative carrier is not available a narrow metal frame can be used to hold the negative against the front glass. Buckling under heat from the enlarger lamp can occur!

Important: in all printing and enlarging devices glass surfaces must be kept very clean, and proper ventilation is *essential.*

Glass used in printing frames (and in enlargers) must be protected at all times from contact with abrasive surfaces and substances. Minute scratches will show to a distressing degree in smooth areas of the image (such as sky). Glass should be brushed off before wiping so that small gritty particles do not "trail" and cause scratches. Glass cleaning solutions are helpful, and once the glass is thoroughly clean the need for further cleaning is infrequent. Glass and printing frames and "proofers" should be stored in dust-proof boxes.

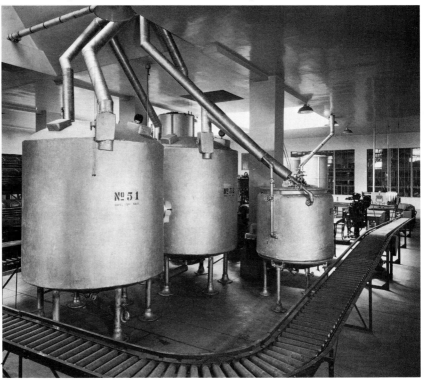

129. TANKS (courtesy, Shewan-Jones, Inc). Made with a 7″ Voigtlander Collinear Wide-angle lens on 8 x 10 negative. The "wide-angle" effect is seen in the distortion of the circular tanks. This was slightly intensified in the left-hand tank as the lens was moved a little to the right to include the transport device .

There were some uneven lighting effects and the upper and lower right corners suffered some loss of brilliancy because of the lens position. This was balanced in the print by appropriate dodging of the affected areas .

DODGING AND BURNING DEVICES

To "dodge" is to hold back light from parts of the print or enlargement, and to "burn" is to allow more light to fall upon certain areas of the image. In expressive photography the "straight" print is a rarity! Some control of illumination, especially around the borders, is usually required. (Refer to Book III—*The Print.*)

(a) **Dodging devices:** usually pieces of opaque cardboard or of red plastic, cut to various sizes and shapes, attached to the end of a thin rod (a bicycle wheel spoke) which can be moved over the surface of the image. It should always be in constant motion, otherwise a "ghost" image of the device will show in the print. If it is moved upward toward the enlarger lens (or the printing light), its "shadow" will become larger and more diffuse. The closer it is to the print, the sharper the shadow edge will be (and the more chance that a "ghost" area will occur). Constant movement of the dodger is essential!

(b) **Burning devices:** the simplest device is the lid of a photographic paper box. A hole of the desired size and shape is punched out or cut into this lid, and it is held between the light and the print, constantly moving as with the dodger. The inside of the lid is usually black and this should face the print, minimizing reflections back to the print which could cause possible flare and fog. If the side toward the enlarger is light gray or white, the image can be recognized and the "burning" will be more accurate. A device is on the market with a series of openings cut into a disk of plastic which is riveted to a firm plastic base with one opening. As the disk is turned, the various cutout shapes can be positioned over the opening in the base sheet.

Edge burning can be done with the dodger moving toward the lens or with a cardboard moved from near-center to each edge of the print.

Only by trial can we determine the appropriate amount of burning and dodging required; no two negatives require the same treatment. To be really effective the print should show *no evidence* of dodging or burning.

BASIC CHEMICALS

Most photographic solutions are made up from prepared chemicals—fixing baths, film and print developers, etc. There is no question but that these prepared solutions are superior in quality to what we can make up ourselves. On the other hand, there are many formulas which are not available in prepared form, and we must mix them. The following itemized list covers most of the chemicals required in ordinary black-and-white work. They are typical rather than specific. I have recommended an amount to purchase at the start, but the quantity you will want will depend on the amount of work to be done.

1. Prepared Formulas:

Kodak Fixing Bath (1 or 5 gal)
Kodak Hypo-Clearing Agent (1 pound)
Kodak HC110 Developer (1 pint)
Kodak Dektol Developer (1 gal)

Kodak Selectol-Soft Developer (gal size)
Kodak Balanced Alkali (1 pound)
Kodak Selenium Toner (1 quart)
Kodak Photo-Flo (8 oz.)

2. Chemicals:

Sodium Sulfite, dessicated (5 pounds)
Sodium Thiosulfate (5 or 10 pounds)
Potassium Alum (5 pounds)
Acetic Acid (Glacial) (1 gallon)
Kodak Elon (Metol) (1 pound)

Kodak Hydroquinone (1 pound)
Potassium Bromide (1 pound)
Potassium Ferricyanide (1 pound)
Sodium Bisulfite (buffer) (1pound)
Sodium Carbonate, Mono. (1 pound)

DARKROOM ACCESSORIES

Graduates, etc. Suggestions:
1. Stainless steel "steam-table" container (1 gallon) for rinsing hands, etc.
2. Stainless steel 1-liter measuring pitcher (32 ounces)
3. Glass, 1 liter (32 ounces)
4. Glass, 250cc (8 ounces) and/or
5. Glass, 125cc (4 ounces)
6. Glass, 50cc (tall) for measuring small quantities of fluid

Scales.
1. A "gross" scale, up to 25 pounds, for measuring bulk chemicals such as hypo, etc. This can be a good household scale.
2. A "lab" balance of three scales: 10 grams in 1/10 gram steps, 100 grams in 10-gram steps, and 500 grams in 100-gram steps, plus 2 extra 500-gram weights.

Containers. The size of these is somewhat dictated by the amount of work done and the time over which the solutions will be stored. Suggestions:
1. A large container for the fixing bath—5 to 25 gallons. Should be stainless steel and equipped with a stainless steel tap and cover.
2. A medium-size container for stock print developer, say a 5-gallon stainless steel container with a stainless steel tap. If only small quantities of developer are needed, a 1-gallon bottle is perfectly good. With the larger containers a floating lid will prevent early oxidation of the developer and dust and evaporation (and odors) in the solutions.
3. Ordinary gallon or quart bottles should suffice for most other solutions used. Be *certain* all containers are really clean before using. For certain solutions, especially those which may stand for quite a time, distilled water is advised for mixing.

Plastic containers are not too satisfactory, especially with developers which react to oxygen which passes through common plastic materials. Be certain all stoppers, caps, etc., are in good condition and clean. Label everything and indicate thereon the date of preparation.

Thermometers. A precise darkroom thermometer is a must! Some of the cheaper thermometers are not accurate. The Weston dial thermometers are usually very good. The Kodak Process Thermometer is about as good as can be acquired; it is a bit bulky, and the glass mercury tube slides up and down in the steel frame (to prevent binding). This should not cause trouble, as two calibration marks—at 68° and 75°—are etched on the glass tube. While accurate temperature is not as essential in black-and-white photography as with color processing, we should nevertheless adjust our negative processing solution temperatures to within 4°F. With miniature (35mm) film we should keep all solutions within a 2° tolerance (including the wash water) for optimum grain.

Static-reduction Brushes. These are always helpful in removing surface charges from glass and film and are essential in areas of low humidity. Small hand brushes with a polonium cell work very well, and there are elaborate laboratory devices which are rather costly. I have the Kodak Static Eliminator Power Unit, Model A2-K, with 2-inch brush (not costly!) and find it an invaluable darkroom aid. There is no doubt that the use of these devices reduces dust on the negative and saves hours of spotting *provided* the glass in printing frames and negative-holders of the enlarger are likewise made dust-free and the interior of the enlarger thoroughly clean. All the areas around the printing and enlarging devices should be frequently vacuumed. (And grounding of all electrical equipment is strongly advised.)

Timers. One of the essential accessories, timers are frequently misused—or may not be very good to begin with. Several categories of timers are:

1. Wall timers: electrical clocks with various dials. Some run continuously, some can be turned on and off, and some have a zero-setting provision. The latter is especially valuable when timing prints in the developer: we do not have to remember that we "put the print in at 6 minutes and must take it out at 8 minutes"; at the moment the new print is put into the developer, the timer is reset to Zero. This is also helpful in film developing. Burke & James makes a fine timer of this type.

2. A variation of the wall timer is the "Laboratory Timer" such as the GraLab (electric); this has 60-second and 60-minute hands. It has a warning buzzer and will activate equipment. It has an on-off switch but not a return-to-zero device.

3. There is a considerable variety of control timers, such as the the Time-o-Lite. These accurately "time" prints and enlargements by activating electrical circuits, but they do not allow for the extra time needed for dodging and burning.

4. There are many small spring timers which are perfectly good but quite limited in that they must be wound up, hand set and *watched* instead of listened to as with an audible timer, such as:
 The Electric Metronome. I find that the audible "tick" of the metronome is far less distracting to work with than visual "clock-watching." It works well in total darkness while developing negatives as with print-making. Set at 60 beats per minute, it serves as a standard timer. If you had a basic count of ten seconds with, say, ten seconds more dodging and burning, you would have no need to glance at the clock—just count! If you desired a little less exposure, while keeping the dodging-burning time in proportion, increase the tempo of the metronome slightly. Some metronomes have a small flashing light in addition to the sound.

 Keep timers clean and free from dust and chemicals. The large pointers (hands) can be painted with "radium paint" (some come equipped with luminous dials and figures). While these might appear fairly bright to the eye—especially when conditioned by an extended time in the darkroom—they will not fog sensitive materials, even films of ASA 500, unless the film is brought within a dozen inches of the dial. The luminous paint is regenerated by exposure to a bright light, and the timer should be placed so that one of the main darkroom lights will cast light directly upon it.

 In areas where power may occasionally be cut off, it is wise to have a standard spring-wound timer or alarm clock on hand to take over when needed. Familiarize yourself with the ticks of the clock per second so that you can count elapsed time. A wrist watch with a luminous dial and luminous second hand can be very helpful under blackout conditions.

Hand Torch. It is helpful to have a small torch with the lens covered with some
Page 231 filter material (see "Safelights"). With it you can set the enlarger lens, find things in the dark, etc., without fogging paper (e.g., Bright Star Film Loading Light, Professional Model No. 590).

 Small pieces of luminous tape can be attached to walls and fixtures for identification in total darkness.

Densitometers. A good negative densitometer, such as the Kodak Color Densitometer, Model No. 1 or Model 10-K, or the S.E.I. Densitometer attachment, is very helpful in making the basic negative tests and is well worth the moderate cost involved. The average worker may not need a reflection-densitometer.

 For those who can use advanced equipment, the Macbeth line of densitometers rank among the best available in the world. Of special note is the

247

TD-404 transmission densitometer which has a "read-out" feature; the log density numbers appear as a digital data display. A companion reflection density device—the RD-400—also has the digital data display feature. Other Macbeth instruments are available at varying price levels.

Very precise and costly devices are essential for various advanced techniques, especially in color printing, but are seldom required in the usual run of work. Consult your dealer for availability of good used equipment.

Vacuum Cleaner. A small vacuum cleaner is a rewarding darkroom item. Dust accumulates from clothing, paper—even chemical dust appears in the best-run darkroom. There is an old photo adage, "You never see the dust until the print is dry!" Blowers are not advised in the darkroom; if you blow out cameras, holders, etc., do so away from the darkroom or workroom.

Miscellaneous. Small objects can be knocked over and broken in the dark and it is helpful to have shelves with raised borders with openings for cleaning.

I keep my Nikor reels in a conventional medicine cabinet; they are quite free of dust. Enlarging lenses, etc., should be kept in dust-free cases.

Projecting rods (wood or non-corrosive metal) can be placed on the wall back of the sink, or on a horizontal strip overhead. These support graduates, funnels, etc., within hand reach.

Needless to say, dust can be a problem when using a printing frame. The room must be as free from dust as possible and the glass surfaces frequently brushed off. A brush attached to a static-eliminator device is strongly advised.

MINOR ACCESSORIES

Stirring Rod. Hard rubber or plastic preferred. Glass is precarious. Thermometer stirring rods are dangerous; in case of breakage, mercury may be set loose in the darkroom, and this is very bad for man and sensitive materials!

Aprons. A light plastic apron is advisable to protect clothes; it can be hosed off frequently.

Towels. A number of low-cost towels should be hung around the darkroom and frequently laundered. It is *very* important that the *hands be rinsed off* after being in *any* solution before wiping on the towel; otherwise, the towel can become contaminated with hypo and other chemicals and result in possible stains on paper, etc. After having my fingers in the developer or hypo, I always rinse off by first passing through the stop bath and then rinsing in warm or semi-hot water. In some industrial plants and laboratories, the use of common towels is prohibited by health laws; heavy paper towels are required.

Gloves. Some people with allergies to photographic chemicals should not put their hands directly into the solutions. If the dermatitis (or other allergy) is severe, by all means consult your doctor. I do not use gloves except when I have a cut or a severe hangnail. Surgical gloves are the best; when removed, clean thoroughly and dry. Turn inside out and treat with talcum powder.

Tongs. Direct contact with the solutions can be avoided by the use of tongs. Some people prefer them; I definitely do not. In some schools and group darkrooms health regulations demand the use of tongs. For those with allergies, tongs do not provide as much protection as gloves.

Racks and shelves. Racks (with protruding wooden rods on which to hang graduates, etc.) can be placed conveniently overhead and in easy reach. They should be heavily varnished. Shelves should also be varnished or made of plastic or Formica. Delicate equipment such as densitometers, enlarging lenses, etc., should be kept in cabinets. Storage of trays is discussed on page 216.

ADVANCED PROFESSIONAL EQUIPMENT

The scope of modern professional and scientific equipment far exceeds the limitations of this book; herein we address the student and serious creative photographer—and to a certain extent, the professional (although all contemporary industrial, scientific and large-scale commercial photography involves selection, installation and operation of complex and sometimes automatic equipment far beyond the needs of the average photographer). However, certain devices are advertised which are undoubtedly tempting to all photographers, and it is only fair that they be discussed here—even if they are not *necessary* in the creative fields.

Mechanical Agitators. Any agitation in a constant direction is dangerous, as it can set up flow patterns in tanks and trays resulting in streaks on the negatives. Again, constant agitation may produce unwanted contrast in negatives (see Book II—*The Negative*). Constant agitation also produces maximum contrast in prints. Prints can lie quiet in the developer (after constant agitation until the image is fully seen) and also can lie quiet in a deep water bath; these procedures reduce contrast, but with smooth areas such as clear sky and smooth walls uneven densities may result.

Stabilization Processes. In recent years stabilization processes have been developed which offer rapid methods of processing prints. Many of these, such as the Spiratone stabilizer, are excellent additions to the busy photographer's darkroom and are not too expensive. Briefly described:

1. A special photographic paper (available in a variety of contrasts and surfaces) is used for contact printing or enlarging.
2. Exposures are made as with conventional materials, employing dodging and burning as required.
3. The exposed print is then put through the stabilizer apparatus (a device with rollers which puts the print through a special solution on a controlled time basis). The print emerges, slightly limp (but soon dries completely). It is developed, fixed and washed—in other words, "stabilized."

For all practical purposes, the print is adequately permanent, but for real permanence the print, after the stabilization processing, should be put through a fixing bath, rinsed, then put through a hypo-eliminator bath and given a thorough wash. The advantages of the stabilization process are obvious when proofs, rapid production of prints, etc., are required.

pH Indicators. While the pH of various solutions is important to maintain, only a fairly well-trained chemist can understand and control it. Many factors are involved. In areas of dubious water quality, distilled water should be used for mixing solutions. Ion-exchange conditioners produce good water for photography. Water filters are necessary with dirty water. When in doubt, use the Edwal Water Conditioner or some similar "sequestering" agent. With severe water problems, consult a chemist or your local water company whose experience should help solve the problem.

Washers. Some rather expensive print washers are on the market, but cost is reflected in materials and workmanship more than assurance of performance.

Page 253

Unless the prints are *constantly separated,* washing will be inadequate. In addition to separation while washing, the corners must not be damaged or the prints buckled or bent. Better to wash prints (after hypo-eliminator treatment) in trays (with a sequence of ten *thorough* changes with constant agitation after a good first rinse) than to trust a washer that will not separate the prints during even a long period of washing.

Photographic Exposure Meters for Enlargements. The use of photometers in determining printing or enlarging exposure time is, I believe, valid only on a purely mechanical level. Personally I consider them unnecessary except when quantities of "record" prints are to be made. Even then, the computations required may take more time than does the "step-test" method. On the principle that the negative corresponds to the musical score and the print to the performance, we should think of the print as an *expressive* effort—an effort which is difficult if not impossible to control through purely mechanical means. If we use one full sheet of paper for a progression of exposure steps (perhaps in 5, 10, 15, 20, 25 and 30 seconds), we can determine the approximately "correct" (let us say "desirable") exposure for many of the print areas, thereby helping to estimate the amount of dodging and burning required. With experience, we can usually get the first "pilot print" with the second sheet of paper used and the optimum print with the third sheet. With the exposure-calculating device we *might* get the "pilot print" on the first sheet, but the time involved in calculation would be considerably more than in making the step-test and then the "pilot print." In creative photography the intuitive factors are of extreme importance. The print must be a *felt* experience. If the negative contains the structure of values and detail representative of the creative visualization of the photographer, the print can convey these qualities—but with the experience one would expect from a musician executing a work of quality and precision. It would be undesirable to restrict the qualities of the print to some accurate but sterile evaluation of the negative values. This would confine photography to mechanical limitations probably devoid of spirit. There is no fixed rule; some may prefer working with mechanical aids—but nothing will take the place of experience and intuition.

With color printing the situation is somewhat different. Not only must the color balance be precisely controlled but exposure times are critical. Here the use of photometers, etc., is practically essential for efficient and consistent results. Many devices of the highest quality are available and the list is constantly growing. Description of this equipment is beyond the scope of this book; reputable dealers and manufacturers can provide information and evaluation of advanced equipment.

TEMPERATURE CONTROL DURING DEVELOPMENT

It is one thing to have all the solutions at the same optimum temperature at the start of development. But temperatures can change *during* development by:

(a) Change of air temperature in room: an enveloping water jacket through which water is circulating at the required temperature is indicated. Perhaps a few degrees lower temperature than room temperature would be needed; one must experiment.

(b) Rise of temperature, because of hands on tanks or in developer trays: this can have a considerable effect. To check, take the temperature of the developer immediately after developing is complete; it may be 2 to 4 degrees higher than at the start of development! Recommendations are:

 1. Rinse fingers, in *cold* water, rather than hot water.

 2. With roll-film tanks (such as the Nikor stainless steel tanks), keep in a deep tray or "battery" box during development with water set at desired temperature (68° or 70°). Keep water line about 1-inch below lid-line. Rinse hands in cold water. Grasp tanks when agitating more by fingers than by the full hand.

3. With sheet-film tanks, the fingers touch only the rods of the film-development hangers and there should be no heat transmission. However, a water jacket is desirable, especially if the darkroom is more than 5° warmer or colder than the solution.

4. With sheet-film, or film-pack film in tray, frequently rinse the fingers in cold water (after every "rotation" of the batch of film in the tray). Keep tray in a "water jacket" tray, in which the developer tray is suspended, (a larger tray with water at the desired temperature but not enough water in it to float the developer tray or spill into it). Experience is required; go through a mock developing session, starting with the solution at 68°. When finished, measure the temperature. If it has raised 2 degrees, start with 66° or 67°. If the room is very warm or very cold, a further adjustment is necessary. A rise in temperature means more-than-optimum development of the negatives; a fall means less-than-optimum.

5. Plastic trays transmit heat very slowly, steel trays rapidly. A water jacket takes longer to affect a solution in a plastic tank or tray, but on the other hand the solution temperature is more stable in plastic containers.

ARCHIVAL PROCESSING

There is much recent interest in archival processing of negatives and prints, the object being to assure maximum permanence. This relates to fixing, hypo-eliminating and hypo-clearing solutions, toning, washing, mounting and storage. Processing details are discussed in Books II and III (and will be amplified in the projected revisions of these books). Here we can properly discuss film and print washing and the equipment therefor.

I have recently received information on the Archival Print Washers produced by the East Street Gallery, 1408 East Street, Grinnell, Iowa 50112. They make 3 8x10 models, with capacities of 10, 20 and 30 prints, or 20, 40 and 60 5x7 prints; they also make 3 8x10 special models, with the same capacities as above, but with an "Easy-Unload" design. They also make 3 11x16 models for 10, 20 and 30 11x14 prints or 20, 40 and 60 8x10 prints, and 3 16x23 models for 10, 20 and 30 16x20 prints or 20, 40 and 60 11x14 prints.

The washers are constructed of plastic, with plastic dividing sheets, each space between holding one print (2 prints back-to-back). The water circulation is so designed that a uniform and efficient circulation on both sides of the print is assured, and *complete* washing achieved in 20-30 minutes at 70-75°F. There is no doubt that this is a most efficient and effective washing device and I warmly recommend it. For large quantities of prints we will be obliged to use the interchange method or a large washing drum. My large drum functions well, but requires a much longer washing time for assured archival permanence.

The East Street Gallery makes a fine Archival Roll Film washer, about 3-3/4 inches in diameter for 2 standard Nikor reels, and the Archival Automatic Washer Control Units. Sheet film in standard developing hangers can be washed in the Archival Print Washer.

1. **Negatives**: After treatment in the hypo-eliminating or hypo-clearing solution, the negatives should be rinsed (hosed off) to remove the greater volume of the chemicals, and then *thoroughly* washed for 30 minutes (10 or 20 minutes might suffice, but why take chances?).

 (a) With roll-film in reels: after treatment as above, put reels into washing tank (I use 2 to 8-reel Nikor tanks; a narrow stainless steel pipe attached to the hose is put down through the center of the reels to the bottom on the tank.

The water circulates upwards through the reels with great effectiveness. Every few minutes the tank is drained (turned over, with fingers preventing reels from sliding out). (The tank is drained 2 or 3 times at the start to remove the greater part of the chemicals). After the final drain, while the tank is refilling, a small amount of Photo-Flo is added. Before the water reaches the top of the tank, the pipe is removed and the reels agitated up and down (and "twirled"). Then, before removing, the tank is filled with water to overflow, and bubbles are removed. The reels are lifted out, the film removed and hung up to drain and dry. First wipe with a clean rubber squeegee, then attach a clothespin to the lower end to prevent curling while drying. When dry, the negatives are cut into groups of four and inserted in chemically pure containers (such as the 3 sectional 12-frame album leaves made by Hasselblad for this purpose. (Similar album leaves are made for 35mm film—which are usually cut in six-frame lengths. Obviously, the negatives should be dusted off before putting in the containers, and white cotton gloves should be worn while handling films to prevent finger marks from oily skin. Films showing such marks can be rewashed or treated with a good film cleaner (follow instructions on this!).

(b) With film-pack films in tray: after treatment, pass films through tray of running water and gently hose films off (both sides). Remove remnants of paper tabs and place in first washing tray. If running water cannot be directed into trays, agitate films thoroughly (passing one over the other four or five times) and place in 2nd tray—following through with the same agitation. Alternate from one tray of fresh water to another for 8 or 10 changes. If running water is available, do as suggested above for 2 or 3 changes; then constantly agitate film in tray with running water for 10 or 15 minutes. At end, drain and refill; add Photo-Flo and agitate for 30 to 60 seconds, then hang up to dry. It is unnecessary to squeegee 4x5 films, as drainage is rapid.

(c) With sheet film: for tray handling, proceed as with film-pack film, taking special care not to scratch the negatives (sheet film is much thicker and resilient and can gouge the negative surface of the film beneath it in the tray. Sheet film developed in tanks (in sheet-film developing hangers) are put through the various solutions (as above), using special care not to scratch adjacent films with the corners of the hangers. Rinse the film (in the hanger) under the tap—both sides—and place in washing tank. There are tanks designed for washing with water jets along the bottom. We must be sure the total area of the negative (front and back) is subject to a constant change of water. If in any doubt, remove film from the tank and hose off both sides frequently. At end, drain tank and add Photo-Flo. Hang negatives to dry, but NOT in the developing hangers! 4x5 negatives do not need wiping off, but it is advisable for 8x10s.

(d) After the negatives are dry, they should be stored in chemically-pure containers, chemically pure papers or acetate sheaths. I use a piece of glassine paper, twice the length of the negative (and the same width) which I fold over the negative, then insert the ensemble in the negative envelope with the open end of the fold at the open end of the envelope. (This allows for "breathing" and is considered better than a sealed envelope.) The joined edges of the envelopes carry an adhesive and this might be hygroscopic and cause serious stains, etc., on the negative. Hence the glassine folder which protects both sides. There is some question now about glassine paper; folds of thin acetate can be used instead.

2. **With prints**: After the proper processing and protective treatment, the prints

should be thoroughly rinsed to remove the greater part of the remaining chemicals, and then washed with great care. Paper retains chemicals to a much greater extent than does film, and washing must be complete. The larger the print, the more uncertain it is that all areas are equally washed—consequently, if there is any doubt, the prints should be frequently removed from washing tank or tray and hosed off, front and back. For this the print should be placed on a smooth surface, such as the back of a tray; after hosing off the front, remove from the tray, *hose off the tray,* and replace print face down for hosing off of back. I use a large drum washer and I am confident that the prints are in constant and effective circulation all during washing. If prints do not constantly move *separately* while washing, the washing process can be considered incomplete.

Most print washers are, in my opinion, inefficient. There may be an adequate exchange of water, and the prints may appear to move about, but unless the prints are *completely* separated at all times during washing, the results will be inadequate. Some "tumbling" drum washers are very efficient, as the prints float free in the water, constantly moving over and under each other. If a good mechanical washer is not available, prints should be thoroughly rinsed off after the last chemical bath, subjected to gentle tap flow on each side, and then put through a number of baths of fresh water—10 or 12—and agitated 2 or 3 minutes in each.

Refer to the Archival Washers made by the East Street Gallery (page 251). Their instruction book is very explicit and I warmly recommend it.

Pages 217, 218 Prints may be dried on heated drums, on ferrotype sheets, between blotters, or—my preference—laid face down on plastic fly-screen sheets, firmly stretched in tight wooden frames. After washing, the prints are drained, then wiped off with a clean foam-rubber sponge or a squeegee, first laid face up (so remaining drops can be wiped off) then turned face down to dry. These drying screens can be hosed off frequently as they do not rust. They are far cleaner chemically than blotters and cloth screens, etc.

3. **Mounting and Storage of Prints and Negatives.** I prefer dry-mounting above all other methods; it is chemically clean and the print is protected to the maximum degree. Archivists protest dry-mounting because *if* anything goes wrong with the print it cannot be removed from the mount for special treatment. However, if the prints are properly prepared, nothing should go wrong with them, and most defects and accidents to prints cannot be repaired with success. The quality of the mount board and of the covering ("slip") sheet is extremely important; sulfur-free boards must be used. Silver loves sulfur, always striving to become silver sulfide, and sulfur in residual hypo, sulfur in mounting materials, containers, etc., must be guarded against.

Slip sheets should be kept between prints at all times when not on display. Ordinary tissue paper is too "hard" and does not absorb small gritty particles which will abrade the print surfaces when under pressure or when prints are slid one over the other. Also, if they fold or wrinkle they can create indentations. A soft-structured paper, such as Strathmore Drawing board No. 61 *regular* surface, seems to offer the best protection. While fairly expensive, it will last a long time and will not fold or crinkle easily. Storage boxes of wooden materials excluding resinous substances are bad for prints and negatives. Ordinary plywood is not suitable for shelves or containers. Refer to the article by Eugene Ostroff (Curator of Photography, Smithsonian Institution, Washington, D.C.). "Preservation of Photographs," Photographic Journal, Vol. 107, No. 10, Oct. 1967, page 309.

253

LABORATORY CLEANLINESS

It is obvious that every laboratory should be kept as clean as possible if only for aesthetic reasons. The construction relates to this in important ways: the walls and work surfaces should be smooth (no matter what color they are) so that they can easily be washed or wiped off; the joining of the walls and floors should be cowled to avoid the difficulty of cleaning around 90° joints; the sinks, if not of stainless steel, should be edged or capped with stainless steel; and splashboards should be back of every sink to prevent water from seeping down between sinks and walls. Dust always presents problems in photography, especially in the darkroom, and doors to dusty areas should be sealed against it. Chemical dust is, of course, quite harmful to sensitive materials. In dry climates dust scatters more readily than under humid conditions, but it should be guarded against with great care everywhere. Hypo crystals on the floor can be ground to a fine dust and result in white specks on sensitive materials. Some developer agents are light and powdery and can float about in the air to a considerable distance. Most prepared developers do not present this problem, but care should be taken not to spill them on the floors or work areas and to thoroughly wipe up with a damp cloth or sponge should spillage occur. Don't just swab—wash and wipe up thoroughly!

Nothing is more objectionable than stowing away trays, tanks and graduates that have not been thoroughly rinsed—inside, outside and edges!— after use. Clean-up procedure after printing, for example, should be somewhat as follows:

(a) Dump the developer and rinse out the tray with water. Pour in the acid shortstop and let stand a few minutes. Dump the acid, rinse well and dry. If there is any developer scum in the tray, a good swabbing with a viscose sponge (used only for such purposes) while the acid is in the tray, is advised. Make a habit of rinsing out all trays *before* use also.

(b) Other solutions can be dumped and the trays rinsed off well (inside, outside and edges) and set to dry.

(c) The sinks should also be cleaned out—the sides and edges carefully wiped off and the bottoms thoroughly flushed clean. Be sure you clean the inner side of the sink front!

(d) Check for solution splash on walls, floors, etc.

(e) Be sure all cords and switches are wiped clean. After thorough rinsing, trays are best stored on edge in compartments under the sinks. Be sure to clean all surfaces of the storage compartments frequently; in time, minute traces of chemicals can accumulate to a troublesome degree.

Fig. 118

All of the above applies to film-developing tanks as well. With film-developing hangers and reels it is *very* important that they be thoroughly washed and dried before reuse. After going through the Photo-Flo solution and removal of the negatives for drying, they should be rinsed in hot water and set to dry.

In the past all trays and tanks were marked "Developer," "Shortstop," "Hypo," etc., with the thought that if they were used only for these solutions, chemical contamination would be avoided. With trays and tanks of modern materials such precautions have little meaning. In fact, a little hypo *in solution* will have no perceptible effect on the developer; some workers have intentionally added a small quantity of 10% hypo solution to the developer with the effect of brightening the whites of the prints. And, of course, we know about the monobath processes where the developer and fixing agent are combined in

one solution. The danger from hypo comes in the "solid" form: hypo dust or hypo-laden fingertips coming in contact with paper or film. White spots and areas will result (as the silver is reduced before the developer has a chance to act). Splashing of acid into the developer results in a reduced alkalinity of the developer and, consequently, weaker action. However, a print placed too early in the acid shortstop can be *thoroughly* rinsed front and back and replaced in the developer with no harm to the print or to the developer. If we touch a print with acid-laden fingers before development, we will undoubtedly get a light spot or area—which may or may not disappear as development is brought to completion. It is therefore essential that fingers be thoroughly rinsed and dried before handling film or papers. A quick rinse in shortstop followed by a good rinse in clean warm water—and then a thorough drying on a dry clean towel—is good insurance. A slight contamination of the negative by fingertips carrying a trace of developer or hypo can show up disastrously in time.

If we carry developer directly into the fixing bath, we reduce its acidity and its rate of fixation as well as its non-staining qualities. Hence, the shortstop prevents stains, preserves the life of the fixing bath, and, of course, immediately arrests development. As stated above, developer action can be resumed if the film or print placed in the acid shortstop bath is *thoroughly* rinsed off. Once in the fixing bath, and cleared, there remains no further silver available for reduction in the developer; only the intensification process will add more density to the image. With these facts in mind we can understand the need for cleanliness and proper procedure, but we need not be concerned about using well-cleaned trays and tanks for a variety of solutions.

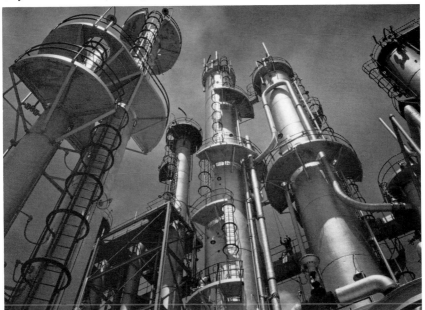

130. OIL REFINERY, CALIFORNIA.
(Courtesy, Wells Fargo Bank.) An intentional and severe convergent effect. Made with a 4x5 camera and a 5-3/4 inch Zeiss Protar lens. The camera was pointed sharply upward but was level horizontally. The center of the image is vertical and the convergence is consistent. Had the camera been tilted from horizontal level we would have had an "orientation" problem, as the spectator would instinctively try to regain balance. The "angle-shot" can produce disturbing effects. While there are always exceptions to the rule, the eye and mind strives for stability and reactions to the "angle-shot" picture can interfere with its aesthetic (and informational) content.

255

Caution: a trace of rust (as in a chipped enamel tray) will, with selenium toner, produce blue spots. Such trays should never be used for toning. In fact, a chipped iron-porcelain tray should be discarded.

There obviously should be no smoking allowed in the darkroom and workroom areas. Not only is it a fire hazard, but the inevitable floating ashes, and smoke, can cause serious damage to equipment and materials.

Some further suggestions: wash off aprons frequently! Rinse viscose sponges in hot water and squeeze out after each use. *Always* rinse fingers before using towels; do not keep towels in use for any length of time—launder frequently. A good motto: "when in doubt, wash thoroughly!"

In the workroom minute specks of dust and grit can cause considerable damage to the print. Such specks on mount or tissue or on the back of the print to be mounted will cause "bumps" all out of proportion to the actual size of the speck! (They are most apparent with glossy-surface prints because of the reflective catch-light effect.) Such particles on the surface of the print or *on the covering cardboard* will produce indentations in the print surface. Remedy: dust off the mount, tissue both sides of the print and the face of the covering board before each print is mounted!

Laboratory cleanliness is the evidence of the careful worker. It suggests the level of technical proficiency.

LABORATORY SAFETY AND MEDICAL CONSIDERATIONS

Safety rules for organizations are usually well clarified and posted. For the individual photographer, professional or amateur, attention should be given to the following safety and medical precautions in the laboratory:

1. **All electrical** installations should meet Underwriters' Standards, and all wires, plugs, sockets, switches, etc., should be in perfect condition. "Master" switches for darkroom and workroom are advisable; turning these off will assure that no equipment (enlarger, mounting press, etc.) is left on. Switches and pull-cords (especially in the darkroom) should be thoroughly insulated. Foot-switches can be dangerous if the floor is damp or wet. All connections should be of the three-prong (grounded) type. Circuits must *not* be overloaded! Consult your electrician and be sure all electrical work is properly installed; otherwise, your insurance may be invalidated. Not only must the circuits and connections be in good order—shock and fire dangers can also lurk in enlargers, electric clocks and timers, dry mounting presses, electric dryers, etc. Persons with some forms of heart trouble are subject to serious effects from even mild shocks.

Fig. 120

2. **All water** connections should be carefully installed. Sinks should have overflow provisions. If the sink is partitioned, be certain drain holes are put into the partition so that if one sink stops up, the water will flow to the other one. A drain sump on the floor of the darkroom can prevent potential disaster from accidental flooding. The cost of a sump is probably less than the damage which is sure to result from a severe overflow!. Hot water connections are certainly helpful. Mixers are necessary for color processing—where accurate temperatures must be maintained—but this implies an *ample* supply of hot water. Sewer connections must meet local health standards.

In rural and country areas the overflow from the washing sink can be directed to sumps or can be used for watering gardens, etc. Only traces of chemicals will be in the wash water, and such could do no harm. However, dumping chemicals into septic tanks might cause trouble; consult your local sanitation experts. A small darkroom uses small amounts of chemicals, and the

alkali developers somewhat neutralize the acid shortstop and fixing baths. Residuals may be harmful to some plants. But under no conditions should pollution of water sources be permitted.

3. **Ventilation** must *not* be overlooked. Lightproof louvers are obtainable which can be installed in small darkrooms and—if conditions are right—may suffice to adequately change the air. There is no doubt that exhaust fans are preferable. The installation must be carefully worked out; if temperature considerations are important, the problem is augmented. But it is absolutely necessary that the darkroom be properly ventilated; some people are very sensitive to certain chemical fumes (see below). The fumes from acetic acid stop baths and acid fixing baths can irritate the respiratory tract—sometimes to a very serious degree (causing spasms of the pleural muscles). And lack of plain fresh air can be debilitating! Thorough air conditioning is indicated in hot humid climates.

4. **Allergies**: certain chemicals, such as Elon (p-methylaminophenol sulfate) or Metol, may cause serious skin eruptions (usually somewhat like an eczema outbreak on the skin). If such should occur, or if any other irritations are noticed, consult your doctor *immediately*. Self-treatment can be dangerous, as skin conditions can invite infection, etc. Protection of the hands by the use of tongs and/or rubber gloves is often necessary. Certain silicone compounds can be rubbed on the skin and offer some degree of protection. People with extreme sensitivity may find that merely entering a darkroom can set off the allergy.

5. **Poisons**: some photographic chemicals are poisonous in varying degree; the worst offenders are the cyanides (although potassium cyanide is seldom used now). All bottles should be carefully labeled, and all warnings should be heeded. One should become familiar with some simple remedies, such as having an alkali on hand for acid burns. (Acetic acid, even in 99% form, is relatively mild, but it will burn the skin unless promptly washed off and is naturally very bad for the eyes; sulfuric acid is, of course, very dangerous and should be stored and used with caution.) It is harmful to inhale certain chemicals; selenium "metal" can be *very* dangerous, and I strongly advise against mixing—use the prepared toning solutions which are safe. However, even with the prepared toners, be sure there is ample ventilation, and if one has hangnails or cuts on the hand, the use of rubber gloves is advised. There is little chance of an adult getting poisoned in the normal run of darkroom events, but children should not be allowed in the area.

6. **All darkroom equipment,** sink and table corners, etc., should be so placed and formed that injuries through contact will not occur. This is especially important for everything at face-level. Immediately discard broken or chipped glass graduates or containers. Secure knives, etc., to prevent accidental contact in the dark. Careless handling of photographic paper (especially in rolls) can cause annoying cuts. With the lights out, the darkroom can be a hazardous place!

7. **Workroom hazards** are not so great, as we can always see what we are doing. Nevertheless trimmers can be a danger; never leave the cutting blade in "up" position. Dry mounting presses can get rather hot but are usually controlled by a thermostat. (In fact, they *should* be to reduce fire hazards—see below.) Watch for objects that protrude into work space and heavy objects that might fall or topple.

8. **Fire:** very few of the materials used in photography are inflammable, but wherever there is paper and/or paper trimmings, the hazard of fire is always present. Smoking should under no circumstances be permitted in the darkroom and should also be restricted in the finishing room and storage area. Modern film material is not combustible, but some cleaners and lacquers are. No photographic chemical in general use can be considered a fire risk. Never have lights

burning in tight areas where fire by prolonged contact is possible. Certain equipment (electric dryers, the dry mounting press, enlarging circuits, etc.) comprise possible causes of fire, but the danger is minimized if all equipment is properly installed, the circuits adequate to carry the loads and the equipment operated under clean and tidy conditions. Ample number and disposition of fire extinguishers is advised.

LABORATORY LABELING, FILING AND STORAGE

LABELS

The proper labeling of all bottles, containers, boxes, etc., is important. Ideally, every chemical mixture should be clearly labeled with its name, dilution (stock, 1:1, etc.) and the date it was prepared (most solutions deteriorate in time). If it is a stock solution, the proper dilutions for use should also be on the label ("dilute with one part water," etc.). If it is a dangerous mixture (poisonous, allergenic or inflammable), it should be so marked. Some workers have a pronounced allergy to certain photo chemicals such as Metol, and if others will be using the mixtures, it might be a good idea to make a label saying: "Contains Metol" (or "Elon"), "Contains Hydroquinone," *"Caution:* Sulfuric Acid!,"* etc. It is always possible that, after a little time, the photographer may forget the contents of some of his bottles! Hence, clear labeling is important and efficient.

Regular laboratory label tape may be purchased. Ordinary label material is not waterproof and should be covered with a spar varnish. The "Dymo" tapes are very good. The surface of the container must be very clean and very dry and the label pressed on firmly. Black Dymo tape (with white letters and numerals) reads well in the darkroom.

Because of the legal requirements, poisonous substances must be labeled in red ink. The red printing is difficult to read under red or yellow lights, and confusion between bottles of, say, acetic acid and selenium toning solutions can easily occur. It is suggested that the words "Acetic Acid" or "Toner" be put on the labels in a bold contrasting color.

FILING AND STORAGE OF NEGATIVES

1. **Humidity.** If severe, damage is practically assured. Air-conditioned areas are best but not always practicable in the home or simple professional studios. Reasonably-priced dehumidifiers are available for small rooms and vaults. Negatives should be given a fair environment by the use of silica gel or a similar dehydrating substance. These should be changed frequently; they can be redesiccated by being baked in a moderate oven, then kept tightly closed until set out for use in the storage area.

2. **Heat.** A *dry* heat is not too harmful if not excessive. Heat and humidity together can spell disaster. Ideally, near-freezing temperatures and a very low humidity (20-30%) would ensure the longest life for negatives, but this would be prohibitively expensive and impractical because of the slow stages required to bring the negatives to room temperature after storage. A practical storage environment would have a relative humidity of 40-45% and a temperature of about 60-65°F.

3. **Adhesives** used for negative envelope seam closures can be hygroscopic and seriously stain the negatives under humid conditions. Also, the extra envelope thickness of the fold can cause pressure marks. I use a glassine folder (for 4x5

negatives cut about 4-1/8x10-1/4); when folded once, it protects the negative from contact with the envelope itself. With these I use manila envelopes with open ends. It would be better to use glassine envelopes. But don't use plastic envelopes or sheaths; they create "moisture traps" and cause condensed moisture to form on the inside of envelopes.

Page 253

4. **Storage boxes** should be of metal or plastic; any resinous uncoated material such as plywood, for example, is not safe (refer to "Preservation of Photographs," *Photographic Journal*, Vol. 107, No. 10, Oct. 1967).

5. **The negative** must *breathe;* sealed or tightly folded envelopes are bad.

6. **For years** I kept my negatives in a bank safe-deposit vault—temperature 60-65°F, with humidity not more than 45%. Too low humidity tends to make films brittle. My present storage vault holds a temperature between 50° and 65°F and the humidity is controlled at around 45%.

7. **Refer** to the *Photo-Lab-Index* for suggestions on the removal of storage stains, etc.

8. **Filing:** I have a simple code which covers the negative sizes I use:

1 = 8 x 10	5 = 3-1/4 x 4-1/4
2 = 6-1/2 x 8-1/8	6 = 2-1/4 x 2-1/4
3 = 5 x 7	7 = 2-1/4 x 3-1/4 or 70mm
4 = 4 x 5	8 or M = 35mm

My central code-letter represents regions or general subjects:

Y	= Yosemite National Park	C	= Compositions (non-regional)	
YW	= Yosemite, Winter	P	= Portraits	
SW	= Southwest	NPS	= National Parks and Monuments	
CAL	= California	H	= Hawaii	

The third part of the Code is the sequential number. A typical example:

1—Y—821 (meaning 8 x 10, Yosemite, No. 821)

Title: Cliffs near Cascade Creek, 1965

Printing instructions, restrictions, credits, etc., can be added as required.

Some photographers put a code number on the edge of the negatives—just in case the negative should become separated from the envelope.

If the photograph presented an unusual technical problem, it is advised that the technical details be put on the envelope. The actual aperture and shutter speed is not very important, but the ASA film speed, the Zone placement and the development formula and time given (plus filter data and the description of the type of artificial light used, etc.) will tell most about the subject and the way it was visualized and photographed.

If several variations of the same subject are filed in one envelope, the best one can be designated by a punch in the margin—or 1, 2, 3 or more punches can be coded as A, B, C, D, etc. (for example, Negative No. 4 - CAL - 346-C would be the negative in this envelope with three punch holes in the margin).

FILING AND STORAGE OF PRINTS

Every serious photographer hates to throw away "less than perfect" prints because, he rationalizes, they may be good for "ordinary reproduction purposes" or as "reference proofs," etc. Hence, in time a huge collection of second-rate prints may be acquired which takes on some importance just because it is so large. A frequent re-evaluation is in order, and large trash barrels should be part of the laboratory equipment.

Be certain to tear up discarded prints; a print just tossed aside may find its way out into the world via the trash collectors, etc., and some embarrassing

displays of poor prints—sometimes nicely framed—may appear in the most unexpected places!

Documentation of photographs is essential! The title and the date should be on all negative envelopes and on the backs of prints (or on the backs of mounted prints). Writing of any kind on the backs of prints should be very light and along the print margin areas. *This is especially important with Polaroid Land prints.*

Rubber stamps are, of course, very helpful. Apart from the usual stamp which gives the photographer's name, address (including ZIP code), usually preceded by "Photograph by," stamps bearing the following legends are useful:

1. **PROOF ONLY: NOT FOR REPRODUCTION OR DISPLAY**
2. **FOR REPRODUCTION ONLY**
3. **DO NOT CROP WITHOUT PERMISSION**
4. **REPRODUCTION RIGHTS RESERVED**
5. **MUST CREDIT:** ..
6. **NEGATIVE NUMBER**...
 TITLE..
 ..
 DATE ..

Some of these can be combined (1 and 3, 3 and 4 and 5, etc.).

Professionals must keep careful control of their prints, especially those made for clients. Embarrassing occurrences may be avoided by clearly stamping *all* prints (fine prints, prints for reproduction and proofs) with the proper stamps and clearly stating the client for whom the picture was made.

Negative envelopes also should carry usage data and restrictions.

One of the difficult problems for any photographer is the proper organization of his good prints. Assuming that strong boxes are used for storing prints, each box should bear a label which indicates by some appropriate classification the prints stored within. When prints are displayed, sent to exhibits, etc., they get mixed up and, accordingly, "lost." It is a good plan to label each box or portfolio with a key number or letter and to place this number or letter on the backs of the prints which belong in particular boxes. Mark this number or letter in pencil on the print so that reclassifications can be easily made when required. A typewritten list of the prints in a particular box (with a duplicate list *in* the box) will save much trouble and effort.

The same general suggestions hold for print storage as for negative storage.

1. **Humidity** is dangerous ("sweating" of the print may result if tightly closed in plastic sheaths).
2. **Plywood print boxes** are not good; an effluent from the wood will, in time, tend to fade prints.
3. **Contact** with pulp papers and cards (materials containing sulfur) is to be avoided at all costs. Silver loves sulfur, and high-sulfite content papers are not good for the permanency of print images when kept in contact (especially under humid conditions).
4. **Dry mounting** of prints is the safest technique, as the print is physically isolated from the mount by an inert material, but if the prints are mounted on sulfur-bearing materials, edge fading will result in time. (And the surface of another mount or of the intervening slip sheet must be considered when prints are stored for any length of time.)
5. **Special materials** such as the Bainbridge Museum Mounting Board favor archival

Page 253

260

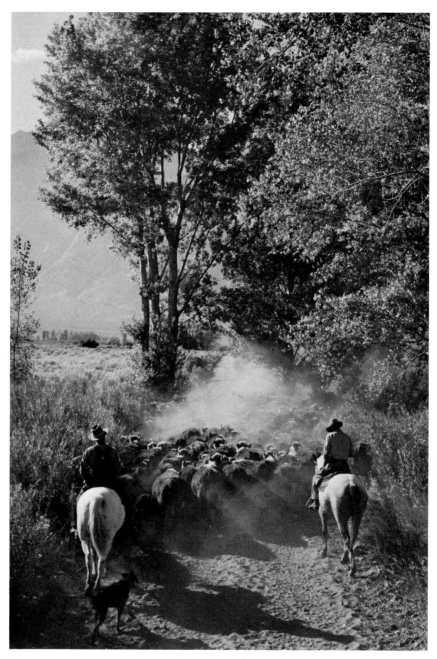

131. DRIVING CATTLE, ROUND VAL-LEY, CALIFORNIA. Made with a Kodak Medalist, no filter, from platform on the station wagon. The focus was on about 40 feet. At f/8 this gave adequate depth of field for moderate enlargement (here, about 2x—format is 2-1/4 x 3-1/4 inches). The finder of the Medalist was approximate, but the lens was very fine; the camera had many superior qualities (and accessories) which might well be reviewed by contemporary manufacturers. The negative was developed in Kodak D-23 which gave good shadow detail but "blocked" the high values. The exposure was 1/100 sec at f/8. Camera was hand-held (from the car platform, Fig. 30).

quality; Strathmore Drawing Boards are excellent. But the illustration boards (pulp interior, faced with rag sheets) may, in time, cause trouble; the pulp effluvia may pass through the inert facing material, and the board will yellow.

6. **Stacking** prints against pulp material will cause trouble in time. Always keep an inert slip sheet between the prints (I use Strathmore No. 61, 1-ply, regular surface, for this purpose). Tissue paper, glassine and other hard surface materials might be all right chemically, but as they have no ability to "cushion" small particles of grit, etc., they will not prevent scratches, etc. if the prints are moved over each other or are pressed tightly together. Hence, the ideal combination is (a) a mounting board of dependable chemical purity, (b) the print mounted with dry mounting tissue, and (c) a slip sheet of soft texture and high chemical purity.

7. **A fine print is a delicate object!** It is subject to scratches and abrasions and if not handled with extreme care will, in time, show wear and tear. Deep scratches are, of course, impossible to repair; slight abrasions can be carefully waxed and perhaps rendered invisible, or the print can be sprayed with an *inert* lacquer (such as Kodak Print Lacquer or a similar substance) which will not attack the emulsion or degrade the brilliant surface of the print.

8. **Prints** should always be displayed under glass (*not* anti-glare glass). Plexiglass is adequate but will show scratches in time and must be carefully protected in adequate storage boxes.

9. **When shipped,** great care must be used to protect the corners; we frequently see what appears to be a well-structured package (at least it did not come apart in the mail), but we find the print corners seriously crumpled. Mounted prints (especially a number of them together) have considerable weight, and when the package is thrown around, the "momentum" of the prints can cause damage. The best way to package prints is to secure them in a "tray"-type carton—where the print corners are several inches in from the carton corner. A blow on the corner of the carton is not then directly transmitted to the corners of the print. One or two prints should be packed between several sheets of corrugated cardboard on each side, the corrugation of each sheet alternating in direction with the corrugation of the adjacent sheet; this gives great strength. And always have the corrugated sheets oversize by several inches all-round. In conventional "salon" print containers protect the print corners with folded foam rubber.

An excellent packing material is what is known to the trade as "door-facing"—a thin veneer of wood; two sheets (of opposing grain) comprise a very sturdy and unbreakable container.

THE DRY MOUNTING PRESS

Dry mounting is the safest, most permanent and easiest method of mounting prints. Ideally, the press should be a little larger than the largest prints to be mounted. It is advised that the press should not be smaller than that which would mount an 11x14 print with one impression. The 16x20 prints can be mounted with two impressions, but it is absolutely necessary that a *thick* protective cardboard be used in order to avoid any marks or "ridges" on the print from application of the hot platen to various areas of the print.

Heat up the entire card and apply pressure to various parts of the print every 10 seconds. A suitable "tacking iron" is needed to heat-tack the tissue to the mount board. Do this gently; forcing the tacking iron between print and tissue may result in cracking or "breaking" the print.

If a dry mounting press is not obtainable, an electric flatiron is feasible. Here

again, the use of a thick cardboard between iron and print is absolutely necessary! If the heat from the iron or the press-platen is applied directly to the print, or through a thin sheet of paper or cardboard, the heated area of the print will expand and inevitably result in bubbles, creases and the "creep" of the tissue beyond the edge of the print. With the thick cardboard the heat is more evenly distributed; in fact, the cardboard becomes the source of heat, and if the print and cardboard are moved together under the platen every few seconds or so for over-sized prints or the iron moved constantly over the cardboard, a more even distribution of heat on the print will result.

If the edge of the tissue extrudes beyond the edge of the mounted print, it can be removed by cutting (with great care) along the edge of the print, angling the blade in slightly. Then carefully lift the narrow strip of tissue off the mount with the point of the blade. If the blade is not angled in under the edge of the print, the cutting "scar" on the mount may show.

Should a print become partially or entirely separated from the mount after cooling, it means the application of heat was not sufficient (or it *could* result because it was too great!), and the print should be carefully remounted. Bend the mount from each corner sharply to test the adhesion after the print has cooled. If a corner does not "crack off," we can assume the mounting is permanent. But if it should detach, *never* use paste, glue or rubber cement to repair it. Always reapply heat. If that does not work, carefully insert a small piece of dry mounting tissue and apply heat with slight pressure (the edge of the new tissue may show as a small ridge on the print, especially with single-weight prints).

Never try to detach a dry mounted print from the mount unless it is obviously ready to detach itself. Remount firmly, and then trim the print with a strong trimmer (and with the print firmly clamped down) and remount on another card. Or, assuming the original mount is damaged, a cutout mat can be made and placed over the print. Leave perhaps 1/4 inch on top and sides and 3/8 inch clear margin on the bottom—or *slightly* overlap the print (about 1/16 inch overall).

Under no conditions use rubber cement or any hygroscopic material for mounting photographs! Disaster is inevitable. Hygroscopic implies the ability of substances to absorb moisture, and this results in chemical change. If sulfur or sulfur compounds are released, the effect on the silver image can be very severe. There are some modern adhesives which may be safe: certain vegetable glues and pastes—and some plastics. But the safest of all is the dry mounting process— there is no question of this—and a suitable press is a good investment. The Seal presses are excellent in every respect.

Very large prints must be mounted with non-hygroscopic material, and it is advised that the services of professionals be obtained in this field. Without proper space, equipment and experience, the risks involved are great.

DRY MOUNTING TISSUE

The two most widely used dry mounting tissues are: Kodak Dry Mounting Tissue, which requires much heat but has dimensional stability and strong adhesion, and Seal MT5 Tissue which uses lower temperatures. When trimming prints with tissue attached they should be clamped to the trimming board near the cutting edge to prevent "creep" of the tissue beyond the borders of the print. Plan, prepare for and install an electrical circuit adequate to carry the load of the dry mounting press (and other devices if they will be used while the press is on).

TRIMMERS

A poor trimmer is a very bad investment! The wheel-knife trimmer (Nikor Safety Trimmer) has many advantages but cannot be used for heavy cardboard, etc. When a print is trimmed very close to the edge, the wheel may not "grasp" the paper properly and buckle it under, giving a bad edge. Many otherwise good trimmers have a smooth bed which allows "creep" of the paper and consequent non-rectangular results. This can be overcome by placing strips of a rough tape, or some semi-adhesive substance, on the trimmer bed and then holding the print firmly down. A sure system is found in those trimmers with pressure bars which firmly clamp the print down near the cutting edge. These bars should be sufficiently wide and "padded" to prevent any marks on the print. My favorite is the Michael Lith "Kutrimmer" with a 28-inch cutting edge and useful adjustments and attachments.

MOUNTS

The size of the mount is, of course, a matter of personal preference. In the ideal sense, each print deserves its own proportion and style of mounting. In the practical sense, if the mounts are cut to established standard sizes, display and storage are simplified. (For example, 14x18 and 22x28 are standard sizes, not only for mounting material but for glass and print cases.) A standard museum size is about 14-1/2 x 19-1/2 for prints and etchings (not a standard glass size).

The mount should be sufficiently firm to hold the print without warping. Strathmore 5-ply is about the thinnest practical material (Strathmore boards have the manufacturer's seal imprinted on one corner; specify that the seal be trimmed off when the basic sheets are cut to the desired size).

Aesthetic factors are important—surface and color of the mount should be carefully considered. Basically, the mount should be of a neutral white color and a smooth, but not highly "plated," surface. The "pebble" and other textured surfaces in common use usually fight with the qualities of the prints. Deckle edges, embossed areas, etc., are aesthetically questionable (but unfortunately very popular!).

When ordering mounts, specify exact dimensions. You may want deckle edges and the Strathmore seal trimmed off; this must be clearly stated in your instructions. Be certain to *insist* on adequate packaging when the mounts are shipped to you; *any* damage to edges or corners ruins them for the purpose. Shippers should be forewarned.

SPOTTING MATERIALS

"Spotone" is an excellent dye-spotting material. For those who may prefer an inert spotting substance, oriental ink-stick, applied with gum arabic, will give a good gloss quality and blend with unferrotyped glossy papers. Ink-stick alone will leave a matte deposit—quite acceptable if the print is to be lacquered. However, it is necessary to experiment; varnish or lacquer may alter the reflectance of the spotting material, and after lacquering it may appear darker than when first applied. The dye-spotting materials such as Spotone sink into the emulsion and do not affect its surface—provided it is not too heavily applied.

The addition of a small amount of Photo-Flo (a drop or two) to the spotting solution will lower the surface tension of the solution, encouraging faster penetration or attachment (especially helpful with glossy, hardened prints).

Good quality brushes of 0 to 000 size should be used—and cleaned after each

spotting session. A fine etching knife is necessary for the removal of small black spots (from small transparent specks in the negative). Removal of specks by etching is certain to show if the print is held at the proper angle to the light (unless subsequently lacquered). There are some products available that locally reduce black specks, lines, etc., on the print, but subsequent thorough washing is required—obviously impossible with mounted prints. Best solution to this problem: spot the *negative* (on the back, if feasible).

VIEWING SCREEN

This can be installed in the workroom and/or in the darkroom and will prove a definite aid in examining and spotting negatives, etc. X-ray viewing boxes are commercially available. A simple viewing box can be made with 2 or 3 fluorescent tubes behind a thorough diffusing glass or plastic. Cutout masks should be made to prevent a disturbing glare when working with a single negative. The viewing box can be a movable item or built in flush with the worktable. If installed in the darkroom, be certain that the switch is fairly remote and could not be turned on accidentally in the dark.

COPY EQUIPMENT

The use of the Polaroid MP-3 Multi-purpose Industrial View Land camera is mentioned on page 266. In the design of the workroom area ample space should be allotted for this device. One of the problems encountered is that of flare or reflections from light sources around the room or from skylights. This is especially troublesome when cross-polarization is used. Shades should be installed on skylights and windows and drawn when using the MP-3 in daylight hours. Or a hood or cage of dull black material can be made to cover the entire camera (keep the material from contact with the lamps!). This reflection and flare problem is common to all copy setups; unless the illumination is very strong, ordinary environmental reflections will affect the quality of the image.

Fig. 132 Another system of copying involves the simple procedure of attaching the subject to the wall and using stand lamps for illumination. These lamps must be equally distant from the center of the subject, at the same height and at the same angle (about 45°) to the vertical plane of the subject. The greatest difficulty is in aligning the camera. Vertical and horizontal *level* is easy to achieve, and if the wall is perpendicular and the back of the camera set parallel with it, there will be no convergence or distortion in this direction. But the horizontal alignment is something else! If the camera points to the left or right of center, lateral convergence and distortion will occur. An "axis" line on the floor and running up the wall (on which the subject is centered) will assist in aligning a tripod (one leg parallel with the line and the camera—with zero adjustments— directly on optical axis). A grid on the focusing screen of the view camera will help. Hasselblad makes a very sophisticated device known as the Linear Mirror Unit which, when used with the Hasselblad 500C, assures perfect alignment.

A variety of small copy stands for 35mm cameras are available, some with quite ingenious adjustments and accessories (such as light boxes for copying transparencies, etc.). Many of these devices (including the MP-3) have attachments for use with the microscope.

Not all lenses will function well with close copies. Special lenses such as the Zeiss S-Planar are designed especially for close-up work. For general reproductions of works of art a good process-type lens is recommended but any fine

265

lens if properly used, is serviceable. (You might have to refocus after stopping the lens down because of a possible "focus shift" which appears when the lens is used at distances for which it was not designed.)

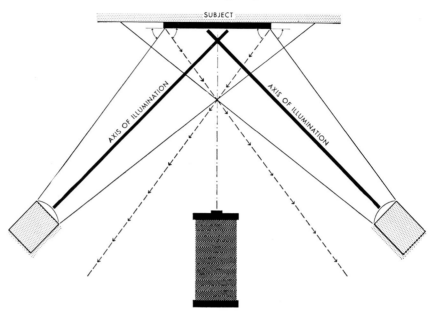

132. DIAGRAM: IDEAL COPY SETUP. It is obvious that in copying we must observe the "law" that the angle of reflectance is equal to the angle of incidence. Certain modifications should be discussed; if we had only one angle of incidence and one resultant angle of reflectance our problem would be simple. However, as the object we usually copy has *dimension* (width in relation to the direction of the lights) we have a broad range of angles of I. and R. We must be *certain* that the extreme areas of the subject do not pick up glare because they enter into the I. and R. angle. We are limited in the field of view because of the angle of the lights and the distance of our lens from the subject. In this diagram we see an ideal situation; no part of the subject reflects light to the lens. The angles of illumination should "cross" (even more than shown here!) A photometer, operated at the position of the lens, can show if the illumination is unequal because of glare or other reason.

THE POLAROID MP-3 MULTI-PURPOSE INDUSTRIAL VIEW LAND CAMERA

A number of excellent "copy" cameras are available, equipped with lights and control facilities and accessories. Most of these are of vertical design which makes the greater part of copy work simple and efficient. In this group the Polariod MP-3 is, in my opinion, the most effective design. It is available with a 38-inch column and a 19x24-inch baseboard, and (the XL model) with a 56-inch column and a 24x27-inch baseboard. It is provided with Rodenstock-Ysaron f/4.7 enlarging lenses in 3-, 4- and 5-inch focal lengths in Prontor self-cocking shutters. Also a special Rodenstock-Eurygon f/5 macro lens is available with a Protor self-cocking shutter and a special bellows extension. With this system direct magnifications up to 10x can be obtained. A lensless shutter and a light-baffle tube are listed for photomicrography.

The ground-glass viewing screen (in a Graflok back) is marked with four film

266

formats (4x5, 3-1/4 x 4-1/4, Polaroid Land Transparency—Type 46L, and 35mm). An adjustable reflex viewing device permits composing and focusing from a variety of positions of the camera on the supporting column. A counterbalance spring permits rapid adjustment of the height of the camera and a knob adjusts the camera front assembly for fine focusing. An ingenious sliding design of the camera head allows for the Polaroid Land 545 Film Holder and any standard sheet-film holder or film-pack holder to be inserted under the ground-glass panel (as with the standard Graflok back). And when the sliding head is pulled out, the Polaroid Land Roll film back (No. 226) or the Polaroid Land Pack Film Back (No. 227) can be utilized. A variety of conventional roll film holders from various manufacturers can be used for 90mm, 70mm, 2-1/4 and 2-3/4, 2-1/4 x 2-1/4 and 35mm film. Lights of various types are also available for special work, as well as trans-illumination screens and X-ray viewing boxes.

The entire camera pivots to 90° horizontal on the column, allowing for copies or large charts, etc. as well as for photography of large objects.

An enlarging head is available (an Aristo grid) which attaches to the 4x5 Graflok section of the carriage and which includes glassless negative carriers up to 4x5. With the 90° pivot capacity enlargements of considerable size can be made on a vertical easel.

I have equipped my MP-3 camera with a special set of four well-vented lamps with which I can use sheets of Polaroid filter material 4 in. square. One sheet is placed before each lamp with the polarizing axes the same. A polarizer is used before the lens with its polarizing axis at 90° to the axes of the lamps. This equipment assures remarkably clear copies without any surface glare. Glare is also eliminated from non-metal surfaces of objects photographed.

Venting of the lamps is very important; Polaroid can be damaged by excess heat. The lamps are on full power only during actual exposure; at other times they are on the "low" switch. The Kodak Pola lights can be used, but we must be sure that the back-scatter of non-polarized light does not reflect from walls and ceiling and produce any glare on the surfaces photographed.

When using the MP-3 in a well-lit room, be certain that a canopy of some kind is suspended over the camera to shield it from scattered light or direct light from windows or fixtures. Sometimes a large cardboard will suffice. In my workroom I have dark window-blinds over the skylights and have no trouble with unwanted reflections.

I find it helpful to place the MP-3 camera on a fairly low table (24 to 30 inches high as, with normal work, the camera head will be in a convenient position for focusing and operation.

In making copies, etc. with the MP-3 camera when strong filters and/or when cross-polarization is used, the exposures may be fairly long and the reciprocity-effect adjustments must not be overlooked. Also, the extension of the bellows creates an exposure factor which must be applied for accurate results. The *Page 76* Sinarsix (which can be inserted under the ground-glass focusing screen) is ideal for exposure determinations for practically all subjects. Specific areas of the image can be evaluated, or a general exposure reading taken from the image of a gray card (the Kodak Neutral Test Card) of 18% reflectance.

The Polaroid Instant Halftone Kit, especially designed for the MP-3 camera, makes possible the production of screened images on Polaroid Type 51 4x5 Land film. It is comprised of the Instant Halftone Kit, four screen plates, and accessories. Detailed text on the use of this equipment will be in the revised edition of Book III (*The Print*) or the *Polaroid Land Photography Manual* (Morgan & Morgan).

267

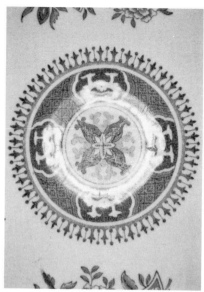

133A. CHINESE PORCELAIN PLATE.
Made with the Polaroid CU-5 Closeup Land
Camera. The ring-light around the lens
produces the obvious reflection from the
vitrious surface.

133B. CHINESE PORCELAIN PLATE.
Same as Fig. 133A but with cross polari-
zation. (A cross-polarization device is
obtainable for this camera.) With any copy
camera cross-polarization is rewarding.

**134. THE POLAROID MP-3 MULTI-
PURPOSE INDUSTRIAL VIEW
LAND CAMERA.** Described on page
267, this instrument is a most
valuable device in photographic labora-
tories, schools and technical facili-
ties. The author has devised a second
set of lights equipped with 4" squares
of Polaroid which can be lowered out
of the way of the standard lights.
These are used for cross-polarization
illumination.

268

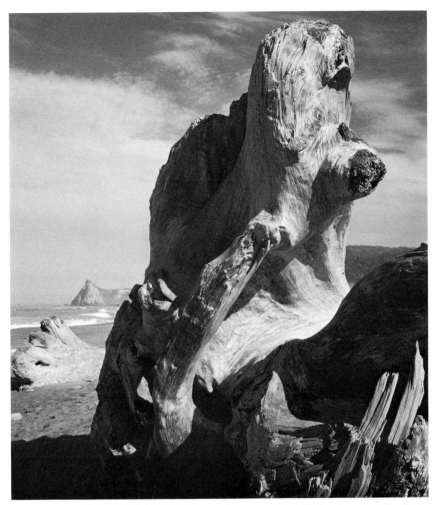

135. COAST, NORTHERN CALIFORNIA. Made with the Hasselblad 500C camera and the Zeiss 50mm Distagon lens. Plane of focus was about 30 feet from lens. Smallest lens-stop was used (f/22).

THE POLAROID CU-5 CLOSEUP LAND CAMERA

An instrument of many functions, the Polaroid CU-5 Land Camera opens up new vistas for both the practical and creative photographer. The camera is of modular design, with lenses of varying focal length (each with its own shutter and electronic ring light). Ratio Multiplyers (camera-body extensions) permit direct magnifications up to 3x life size. Other magnifications are possible with simple supplementary lenses. It operates with a power pack for regular household AC circuits, and a portable battery power pack is available for field work.

The power packs have light-output control (a "Darken-Lighten" dial). Among many accessories, the cross-polarization attachment is very effective (Figs. 133A and B). Special accessories are available for medical and technical photography, and we can explore the minute detail and structure of the world about us—vegetation, rocks, crystals, insects and details of works of art. The CU-5 Close-up Land Camera used Types 107 and 108 Polaroid Land film only.

269

STUDIO-GALLERY

Portraiture can be classified as follows;

1. The casual or "candid" approach which stresses subject aspects over planned or carefully conceived compositions.
2. The environmental approach which strives to organize the subject together with significant objects, etc.
3. The formal "studio" approach where the subject is stressed together with the elements of personal or conventional style.

For 1 and 2 we usually select and organize our "surround," and while we may have lighting problems, we are not concerned with "backgrounds" as such. For 3 we may have problems of wall or panel construction and the acquisition of devices to give us backgrounds of the required tonal values and color. I am not discussing here the old-fashioned "scenic backdrops" reminiscent of landscapes, interiors, etc., which were so popular not many decades ago.

BACKGROUNDS

For those who intend to work in the studio entirely with natural light using windows or skylights, the walls must be considered carefully. Edward Weston used natural light exclusively, and his simple backgrounds were plain walls or lightweight movable screens. With natural light alone the Inverse Square Law reigns without question: the intensity of illumination diminishes as the square of the distance from the light source increases. A wall under a skylight will show a marked lowering of brightness toward the floor, and a wall by a window will likewise show a fall-off of value as the distance from the window increases. It must be stressed that this difference in illumination is usually much greater than the eye informs us, and exploration with a sensitive meter will give us the true values. The placement of the subject in reference to the light depends upon many factors of subject structure and values. The brightness of the background may be greater or less than or similar to the values of the subject; here again the eye cannot be fully trusted to evaluate the various values. Obvious differences in colors may, in black-and-white photography, appear as similar values of gray! We can assume that the wall retains the same value no matter where we place our subject. If we have a light gray wall facing the light and reflecting, say, around 70% of the light falling upon it, and if we place a subject directly against it (or at the same distance from the light), we will have a comparative relationship represented by a Zone VI and Zone VII exposure (skin and background values). As we move the subject closer to the light, its value rises. Of course, if we maintain a skin placement on Zone VI, the wall value will proportionally drop as the subject is brought closer to the light. If the wall is at right-angles to the window, it will show a fall-off, and the subject will have a different relationship to various areas of the background wall. So many variables are found that blinds or shielding screens are needed to control background values as desired.

With movable screens background control is greatly simplified. The screens can be made of lightweight material (thin plywood, tubular frame with stretched canvas, etc.). Small casters or sliding buttons can be used. It is suggested that one side of the screen be painted a light gray (70-80%) and the other side a rather dark gray (around 12%). A second screen with one side matte black and the other about 20% gray would be useful.

It is important that the screens be large enough to serve their purpose, both in width and height. If too small, the edges may show in the photograph (a very

disturbing effect). Of course, much depends on the character of the work to be done, but it is far better to have the screens oversize rather than undersize. They should be smooth, evenly painted, and if made of fabric the material should be tightly stretched and free from wrinkles, sags and sewing lines. Canvas comes in 10-foot-wide bolts. The sheet of selected size can be given a folded border and grommets placed at close intervals. Stout cords will lash the fabric tightly to the frame. *Caution:* the frame should be quite rigid so that it will not bend under the pull of the cords. An "I" beam at least 1 inch wide, or a 1-inch pipe should be sufficient, but as the tension will vary because of size, this factor should be carefully thought out. A solid screen would undoubtedly require two pieces of material joined together; this would require careful smoothing, filling and sanding so that, when painted, no "seam" would show. Any irregularities, variations of tone, etc., are certain to show in a photograph, especially with slanting light. A textured material, such as burlap, may give a mealy, unpleasant background effect.

Background paper can be purchased in large rolls. Properly suspended at the desired height, the paper can be pulled down to the floor, or it can be brought across the floor for full figure or large object work where the usual floor-background line would be distracting.

For those who work with artificial lighting the wall or screen backgrounds can be modified by throwing lights upon them. Accordingly, I would suggest a wall painted a light gray (around 70%) and a two-sided screen: one side a dark gray and the other side a light gray (70-80%). With backgrounds of these values a very great range of tones can be achieved by varying the distance and/or the intensity of the light directed upon them.

As no two photographers will have the same requirements, the above description of walls and screens are only *suggestions*. Many factors are involved, including available space. Start with the simplest solutions to the problem and add equipment as needed.

Light baffles, etc. A number of lighting controls may be required:

1. Draw-shades on windows and skylights. These should operate from both ends of the skylight and from the top and bottom of the window. They should be of dark fabric and, of course, opaque.
2. Light shields can be simple panels or cards attached to a weighted base; these can be moved around to control light on backgrounds and on the subject.
3. Light-diffusing screens can be made of materials such as translucent plastic which can be mounted on weighted stands or otherwise supported; their function is to soften the light, and a great variety of effects is possible.
4. White umbrellas (photo type) can be used as soft reflectors with artificial light.

DISPLAY OF PRINTS

Mounting large prints (murals) directly on the wall might be effective but hardly permanent. It is far better to mount the prints (entire or in sections, depending upon size) on separate panels and then attach these to the wall. The dividing lines can be covered with small "T" bars, and the resulting effect is usually more agreeable than a huge single surface which will inevitably show visible match-lines (which become more obvious in time) as the edges of the prints will tend to curl upwards.

Wraparound mounting may be serviceable for display purposes, but in time the emulsion and/or paper will crack at the bending points or become marred and scratched. Mounting flush on any suitable material is also done for display

271

purposes, but if permanence is a consideration (and good appearance over a long time), such is not advised. Flush mounting is good only if the print is then given a passe partout edging or if it is enclosed with a narrow "L" strip of metal.

Wood frames usually frame the mount, but sometimes prints are framed to the edge. As the frame must cover at least 1/8 inch of the print surface, the trimming of the print must take this into consideration. The trim marks must relate to the revealed—not the physical—edge of the print.

A considerable variety of special frames for photographs is on the market. Some are of plastic or aluminum and are ingeniously designed. The frame must not warp (or yield to the tendency of prints to warp). It must not "sag" or come apart. I am pleased to recommend the frames designed and made by Neil Weston (Route 1, Box 233, Carmel, Cal. 93921). They are of metal (regular or stainless steel) and can be ordered "natural," brushed, or painted. The removeable backs are firmly attached to the frame, thereby strengthening it, yet permitting quick removal for change of prints. The backs will hold wooden hanging bars, grooved to fit over "Z"–shaped hangers which can be attached to the wall in a variety of ways. The grooves can be placed so the frame can be hung at any distance from the wall; a small wooden block of proper size, placed at the bottom of the frame will keep it parallel to the wall.

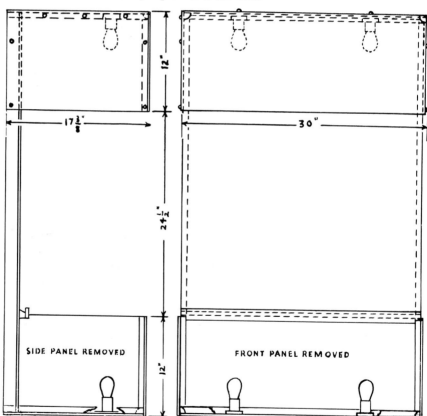

SIDE PANEL REMOVED

FRONT PANEL REMOVED

136. DIAGRAM: PRINT DISPLAY DEVICE. Illuminated display easel recommended by the Photographic Society of America (presented here with the permission of the P.S.A.: designed by John S. Rowan). Recent investigations in the theory of vision suggest new systems of viewing prints and other works of art which will reveal more fully their qualities.

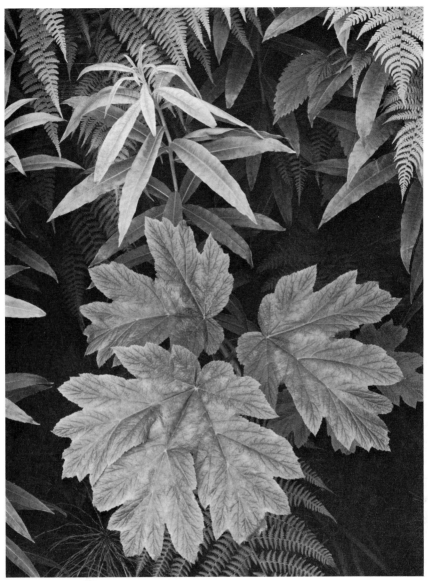

137. LEAVES, ALASKA. Made with 9x12cm Zeiss Juwel, modified to take 3-1/4 x 4-1/4 Graflex accessories, and a 5-3/4" Zeiss Protar lens.

The light was diffused from a clouded sky. The foliage was dense and the depths of this subject were fairly dark, but of much less contrast than is evident here. Foliage green represents that part of the spectrum to which the eye is most sensitive. Panchromatic film registers foliage about 1 Zone lower in value than the eye "sees," it. (Orthochromatic film responds to green about as does the eye).

A green filter (Wratten No. 13 (X2) was used which raised the values of the green leaves and slightly lowered the values of the shadows. However, no filter factor was used and this represented a general reduced exposure and required a normal + 1 development. The smallest lens-stop was used and the focus was one third of the distance between the nearest and most distant leaf in shadow.

273

138. FOUJITA (ca 1933). Made with 4x5 Korona View Camera and 12″ Goerz Dagor lens. Two lighting fixtures were used (similar to that shown in Fig. 140, p. 279). Each fixture contained 1 "finding" or modeling light and 1 flashlamp (in this case the old No. 75 foil-filled lamp). The exposure was by "open flash" with the contact switch attached to the cable release. One fixture was about 4 feet from the subject's right side and the other about 10 feet from his left side. The luminance ratio was about 1:6. The angle of the lighting was such that there are no reflections in the glasses. There are no catch-lights in the eyes (which some photographers may consider a fault).

LIGHTING EQUIPMENT

Problems of artificial lighting are discussed in Book V *(Artificial-Light Photography)*; of necessity we must limit ourselves here to a general discussion of the essential lighting equipment (including its function and performance) which the average creative or professional photographer might require. As we are stressing black-and-white photography, there will be only brief reference to color photography with artificial lighting.

Philosophic considerations as to the aesthetic validity of natural versus artificial lighting aside, we should first think about the difference of approach between the "found" available light and the "contrived" effects achieved with artificial light. There is a third category—"supporting" light—whereby the effects of natural light are augmented and balanced by the judicious use of artificial illumination (synchro-flash falls within this category).

Illumination on the subject can be defined by the following qualities:

(a) the *highlight:* the direct specular or semi-specular reflections from curved surfaces. These may be very broad, as from skin or soft painted materials, or very sharp and intense, as from highly polished or "abrupt" surfaces. Depending upon the subtended angle of the illumination source, highlights will be relatively intense and narrow or soft and broad.

(b) the *shadow.* likewise the shadow edge will vary in sharpness. The full shadow is termed the *umbra,* the partial shadow the *penumbra.* The umbra is "total" (excepting scattered light from environmental sources). The penumbra relates to the angle subtended by the light source *and* the distance of the shadowing object from the shadowed object.

(c) the *general illumination.* a sharp spotlight will intensify texture (because of the acute shadow edge); the broad flood or "bank" lights will soften edges and textures. And there is an infinite variety between these two extremes.

It is obvious that spectacular effects can be achieved with imaginative use of artificial light alone; these effects have nothing to do with the "reality" of natural illumination. Not only the positioning of the lights on the subject, but the relative intensities and—most important—the *qualities* are to be considered. Artificial light quality can range in effect from sharp spotlight to the most broad diffused light, roughly described as follows:

1. **Spotlight, through condensers or from accurately figured polished reflectors.** A point-source light will give the maximum sharpness of shadow edge, and this quality will be retained at considerable distance from the light.

2. **Spotlight, through Fresnel lenses.** Intense, but with broader field and softer shadow edges than in 1.

3. **Spotlight, by "low" position in polished reflector of parabolic design.** This concentrates the light in a somewhat narrow field and gives softer shadow edges than 1 or 2. More accurately, it is a narrow floodlight. Variable spot-to-flood reflectors are available.

4. **Floodlight.** This is a very general term covering a wide variety of illumination. The average "flood" is a tungsten (regular or photoflood lamp) or a halogen (quartz) lamp in a curved reflector, polished or "brushed." The reflector can be a broad bowl, a cone, a carefully figured parabolic or hyperbolic shape. The quality of the floods is somewhat similar, no matter what the shape of the reflector, but the power at different distances of lamp to reflector may vary and the surface of the reflector has a considerable effect on light quality and intensity. What *is* significant is the diameter (and the area) of the light in relation to the distance of the light from the subject; in other words, how many degrees (or

275

fractions of a degree) does the light source subtend? (The sun subtends 30 minutes of arc—1/2°; a floodlight source subtending 1/2° of arc will give the same width of highlight and the same shadow edge as the sun—if the obscuring object edge is the same distance from the shadowed surface.)

5. **Diffuse light.** This is also of great variety; the sky, in an open area, is a prime diffuse light source. Light from broad windows or skylights, from floodlights directed against walls and ceilings—all such produce more or less diffuse light. Hence, diffuse light can be environmental (not planned or controlled) or definitely controlled by reflectors.

6. **Bounce light.** This produces direct light effects or broad diffused effects, depending upon the diameter (area) of the "bounce" illumination. Project a variable flood-spotlight on a ceiling; adjust it, first, to cover the ceiling. Place a subject somewhere except in the center of the room, and next to the subject set a gray card (or any card of diffusing—not brilliant—surface). Take the luminance reading from the card and also observe the lighting effect on the subject. Next narrow the beam of the variable flood-spotlight to cover half the ceiling. The luminance reading from the card will remain about the same, but the lighting of the subject will be more vigorous (with more intense highlight and shadow effect). Then narrow the beam to minimum diameter on the ceiling; the luminance of the gray card will remain about the same, but the subject will be rather strongly illuminated with sharper highlight and shadow effect. If the circle of light on the ceiling were 1/2° in diameter, the subject would have the same highlight and shadow-edge qualities as if it were sunlit (except for intensity!).

7. **Fill-in light.** This relates to supplementary light to reduce the contrast range of

Figs. 39A, B, C, D

sunlit objects when the only shadow illumination is from the open sky. It is also called "synchro-sunlight" when used with flash. An aesthetic problem appears: the qualities of sunlight are established; so are the qualities of reflected light from the sky. Photographing a person in the bright sun and illuminating the shadows with a "bright" reflected or fill-in light produces unnatural and disturbing effects. The reflected or fill-in light produces its own highlights and sharp shadows, definitely not the expected effect of daylight (the combination of sun and sky light). Hence, it is advisable to use as broad a light source as possible for shadow support: a large-area reflector of non-specular (soft) reflective value or a broad source of artificial light. The latter can be approached by use of the white umbrella which, at a moderate distance from the subject (5 to 8 feet), will produce a well-rounded, soft illumination.

8. **Special equipment.** In addition to the more or less standard lighting devices, a great variety of fixtures are obtainable (or can be designed and constructed) for special purposes, such as:

(a) A box or reflector containing one or more lights covered with a diffusing material—frosted glass, plastic sheets, or a "curtain" of glass fabric, etc. This diffuses the light, and its quality depends upon the diameter of the light box and its subtended angle in reference to the subject.

(b) A large area of illumination provided by a number of lights mounted in a reflective enclosure and covered with diffusing material. Again, the larger the angle subtended, the softer the highlights and shadow edges (and the less vigorous the textures of the subject will appear).

(c) Combinations of direct and diffuse light from one source.

(d) "Open" lights (lights burning in space without reflectors) are useful in "pointing up" sharp highlights, catch-lights in the eyes, etc. As a direct reflection, catch-lights in the eye can be produced from a very weak or distant source.

276

(e) Cross-polarization, which involves polarizers in front of the light sources and a polarizer over the lens; the latter is set at right-angles to the polarizers over the lights. Objects can now be photographed head on (with the lens axis perpendicular to the plane of the subject). There is a most rewarding absence of glare and random reflections. Copies of glossy photographs, color prints, oil paintings, ceramics, etc., show a greatly increased depth and solidity of values; surface sheen is eliminated.

With cameras equipped with ring lights, such as the Polaroid CU-5 Closeup Land camera, a cross-polarization system can be made up (or in the case of the CU-5 such a device is made by Polaroid). Figure 133 shows a comparison of with-without effects. *Warning:* cross-polarization increases the exposure factor to 5-6x, and with fixed lens stops and shutter speeds the only way to apply this higher exposure factor is to increase the power used with the flash tube. This is called "zapping the tube" and may result in a brilliant light but short tube life. Consult an electronics expert if you have this problem. Also, flashes repeated at short intervals are not advised under any conditions, as with the tube covered with the polarizer the heating effect will be considerably increased.

The Kodak Pola-Lights are standard equipment and function well under ordinary studio conditions. They comprise a backward-curving light shield for the floodlights (not photofloods, which would create too much heat for the polarizing screen) faced with a circular disk of Polaroid (with the polarizing axis marked by an arrow). For most copy and industrial work, two of these Pola-Lights are required. They can be mounted on conventional light stands. With the floodlights recommended there is good ventilation, but there is also a certain amount of back-scatter of non-polarized light, and in a relatively small light-painted room this back-scatter might have some objectionable effects. An additional shield in the form of a dead-black card or cloth could be supported on stands behind the lights (without cutting off ventilation). A variety of fixtures can be made (and some are probably obtainable) to hold the polarizing sheets in front of the lights for copy stands, etc.

The axis of the polarizer over the lens must be set precisely 90° to the axis of the polarizers over the lights!

(f) Ring-lights. These are electronic flash tubes in the form of a circle mounted around the lens or shutter; they produce a completely flat shadowless lighting which is, at times, extremely useful in probing deep areas of the subject which could not be lit by normal lighting (helpful for those who enjoy close work with flowers, etc.). However, the glare from flat reflective surfaces (surfaces parallel to the film plane) can be extreme unless cross-polarization is used. If used with portraits, the ring-light will produce a "ring" catch-light in the eyes—a rather disturbing effect!

As the ring-light completely surrounds the lens and as all areas of the light are the same distance from the subject the lighting effects can be very flat. This can be overcome by covering one-half or two-thirds of the ring light by a translucent material (of different densities as desired for the optimum light balance). One side of the object will therefore have more illumination and some moderate impression of light-and-shade will be produced.

277

LIGHT SOURCES

We have discussed some basic equipment and accessories, much of which is adaptable to various light sources. We also discussed different types of illumination (flood, spot, etc.). We should now consider different light sources (tungsten lamps, fluorescent tubes, electronic flash, etc.). No matter what kind of light source is used, the principles of illumination, reflection, etc., remain the same. The enormous variety of light sources of all types cannot be described here; reference is made to the Illumination Section in the *Photo-Lab-Index*. Principles of exposure will be touched on briefly (see Books II and V of the *Basic Photo Series* for more complete information).

Tungsten light (regular: 2900+°K). The greater part of black-and-white photography can be done with standard tungsten light. Lamps yielding light of 3200°K are specific for most color films designed for artificial light.

Photoflood lamps have somewhat higher °K output and shorter life; at 3400°K they are designed for Kodachrome Type A but are satisfactory for black-and-white photography and color photography with appropriate filters.

Halogen lamps (quartz lamps) are high-intensity sources of variable color temperature (there is nothing in the design that restricts it to only one color temperature). [*Note:* there *is* some color distortion, however, because it appears that the iodine filling causes the generation of some blue and violet light in addition to the normal spectrum. Some new GE lamps have a bromine filling instead, which is said to eliminate the excess blueness of the iodine lamp.]

All of the above lamps have approximately definite color temperature (°K) ratings at the prescribed voltages. Higher voltage results in higher °K (more bluish light), and lower voltage results in lower °K (more reddish light). Such variations have profound effect with color photography (and require the use of light balancing filters) and also have some effect with black-and-white photography when the output is quite bluish or quite red, thus creating a change in the effective ASA film speed. There is in addition an increase or reduction in light intensity as the voltage is raised or lowered.

Fluorescent lamps are agreeable with black-and-white photography except when the lamp colors are obviously "off white." They are difficult to use with color photography without rather extensive filtering. As the standard fluorescent tubes are long and the area of light source rather broad, this illumination can produce flat high values and indecisive shadow edges when used as *direct* illumination. They are excellent when used as shadow fill-in illumination. However, it must be remembered that a bank of fluorescent tubes covering a 3x4-foot area will give the same effect as a bank of many ordinary lamps filling the same area (although the color and intensity of the light may be different). The subtended angle of the light source area defines the structural character of the subject.

Flashlamps (regular) have varying color temperature (usually around the 3300-3800°K range).

Flashlamps (blue coated) approach daylight in color temperature (around 5500-6000°K) and are ideal for fill-in synchro-sunlight pictures. With black-and-white photography the high color temperature tends toward a slightly softer image contrast (related to the "gamma wavelength" effect).

Electronic flashtubes are, generally, around 7000°K and of quite short flash duration (1/500 to 1/1000 second). For various technical reasons it is usually necessary to give longer negative development with electronic flash illumination than with normal illumination—roughly 1.5x normal development time.

278

139. DIAGRAM: LIGHT STAND. No matter what type stand is used, it is important that all wiring lead to lamp from the base of the stand. This reduces the danger of tripping over the wire and also the danger of the stand being pulled over by a tug on the wire, or the weight of the wire itself.

140. SCHEMATIC DIAGRAM OF LIGHTING FIXTURE. Many fixtures on the market today incorporate modeling lights. Electronic flash systems (professional types) are so equipped in general. The modeling lights should be no stronger than necessary to see clearly the lighting effects.

To repeat: the *source* must be considered in reference to exposure and to the development of the negative. The light *fixture* (the receptacle, lamp, reflector, box, etc.) in which the light source functions controls the effects of direction or diffusion. The "spot" system gives a sharp, direct beam which does not "obey" the Inverse Square Law; the "flood" gives a more or less encompassing illumination, which better observes the law. Highlight and shadow edge quality depend upon the angle subtended by the light fixture (the light producing area) from the subject. Obviously, an enormous variety of effects can be obtained by the mixture of these two basic types of illumination (plus the third type: the broad generally diffuse environmental illumination such as from the sky or from reflections from large interior spaces).

No matter what light is used, it is unfortunately rare that the coverage of the subject is *even*. We can visually observe this by directing the light to a large white wall; not only will there be a fall-off (somewhat inevitable) toward the edges of the illuminated area, but there may be a "hot-spot" in the center of the field. The fall-off is very hard to control, although a partial screening of about two-thirds of the area of the reflector aperture (centered, of course) with a very light diffusing plastic will help. The broader the reflector and the greater the distance from the wall, the more consistent the illumination will be. As for the hot-spot, it can be somewhat controlled by a small shield of diffusing plastic over the area of the lamp. A good compromise solution would be to cover the entire reflector with diffusing plastic or a diffusing glass cloth; this material receives and diffuses the light and, in effect, it becomes the light source. We will recall that the angle subtended by the source controls the highlight and shadow edge effects; the diffusing plastic will have little effect on these qualities, as its area will be of the same diameter as the unshielded light. But it may provide more even illumination. The intensity of the light will, of course, be reduced. If the diffusing material is colorless, there is little effect on the °K of the light.

Ventilation of the reflector is very important! It is advisable to make a support which will hold the diffusing shield 2 or 3 inches away from the edge of the reflector. It must then be of appropriate size to prevent any direct light striking any part of the subject.

279

It will be obvious that a diffusing screen such as described above will deliver an "unfocused" light; as stated previously, *it* becomes the light source, and the Inverse Square Law will apply to whatever distance the light is placed.

When a lamp is directed against a reflecting surface such as a wall, the surface becomes the light source and any "focal length" or beam effect the reflector may have is no longer effective. (See "Metering Artificial Light Values" p. 288).

FLASH EQUIPMENT

Electronic Flash In less than a decade electronic flash equipment has vastly increased in type, power and function. Small assemblies for 35mm and 2-1/4x2-1/4 cameras, some with self-contained power units (rechargeable from standard house current) and some designed for ordinary dry cell batteries, all the way up to elaborate high-power studio and industrial units are encompassed in the flash illumination field. (Refer to the *Photo-Lab-Index*.) The Standard portable electronic flash unit which I have used with satisfaction is the Graflex Stroboflash IV. It is comprised of the flashtube head and connecting cords and the battery-power pack with a 4-way power control switch. The specifications are as follows:

Power Control Selector Setting	1/4	1/2	3/4	Full
Nominal Watt-seconds	50	100	150	200
Flash Duration (approximate)	1/1200	1/800	1/600	1/400
Recycling Time	2 sec.	4 sec.	7 sec.	9 sec.
Kodachrome II Guide Numbers	27	37	45	53

Accessories: extra flashtube head; connecting cords (using 2 lights on the same power unit halves the output of each at any setting on the power pack). Extension cords (20 ft) are available and can be joined in series, with a minimal loss of power for each 20 feet of cord between battery-power pack and lamp. Slave units are available which trigger one or more separate lighting systems from the principal light (a separate power pack is required for each).

Studio and industrial equipment is based on power pack converters attached to standard AC circuits. Rechargeable nickel cadmium batteries have definite advantages but are somewhat more costly than the dry cells.

In every case the photographer should consult with a knowledgeable dealer who can properly analyze his problems and make sound recommendations. Appropriate questions are:

1. Are the shutters for all your lenses (as well as focal-plane shutters) properly synchronized for electronic flash?

2. Have you considered the use of equipment in reference to environmental conditions, operating distances, subject characteristics?

3. Have you studied the availability of power (for direct connection or for recharging batteries)? If, for example, you were planning an expedition into some remote area for wild-animal photography, etc., the only logical safeguard would be to plan the use of dry batteries and carry an extra supply (fully protected against the elements).

Progress in electronic flash equipment is rapid and the photographer is advised to consult other photographers and dealers before making any purchases. I feel that it is very important not to mix flash components of various makes unless it is definitely recommended by the manufacturer. Careful engineering of all components—from power source to tubes—assures a balanced and dependable performance.

OPERATION OF FLASH

Between-the-lens shutters: closing the circuit in a synchronized shutter discharges the electronic flash within an extremely short time. Therefore, this contact is made when the shutter is fully open.

As the effective duration of the electronic flash is usually shorter than the shutter speed (1/500 to 1/1000 second), exposure calculations are based entirely on flash output and lens stop, not shutter speed. However, with moving subjects containing lights or specular reflections, these may be strong enough to make a "trail" in the image. A minimum shutter speed is indicated here.

With synchro-sunlight effects, the basic exposure depends upon the daylight illumination and the shadow luminances in reference to the Zone placement. If we required an exposure of 1/15 second at a given stop to get the proper high-value quality in the subject (and, say, a flash fill-in at Zone III or IV level for desired shadow value), the flash itself (around 1/500 second) might arrest movement, but the actual shutter exposure might not. The effective power of the electronic flash is determined by the power pack input, the distance of the light from the subject and lens stop used. Any between-the-lens shutter speed can be used with the flash alone without affecting its output.

Page 111 et seq Focal-plane shutters: these present a somewhat different problem. Most focal-plane shutters are *fully* open only at relatively slow speeds (around 1/25 second for the Speed Graphic and 1/60 second for the Zeiss Contarex). At higher speeds slits of different widths travel across the negative, and an electronic flash would give a narrow image band on the film. (See page 282 for long-peaking flashlamps.) Hence, we must make certain that we know the highest speed at which our focal-plane shutter gives a completely open exposure. Within this open period the action of the electronic flash is the same as with the between-the-lens shutters.

The "curve" of the electronic flash: at the instant of discharge, the flashtube reacts, and the intensity of the light produced in time can be expressed by a symbolic curve. The "peak" of the flash is, say, of duration 1/500 second but the beginning and the end of the flash consume additional time. The light produced in this period may be of little consequence in terms of diffuse illumination but certainly is of importance insofar as specular reflections are concerned. Hence, the entire duration of the flash might be 1/100 second—which might show movement of specular reflections but not of the details of the subject seen by the diffuse reflections. In the domains of high-power electronic flash we will have extremely short "exposure" times—up to millionths of a second. We do not have this extremely short discharge time with ordinary electronic flash sources. (Refer to the *Photo-Lab-Index* for additional information on various types of electronic flash units.)

FLASHBULBS

These come in a variety of types and sizes. (Refer to Illumination Section of the *Photo-Lab-Index*.) As they require small amounts of current to ignite, they are mostly battery-powered (although some can be fired by normal line current). This is, however, potentially disastrous to certain synchronized shutters; a relay system is essential. The light output in the larger sizes is considerable. The equipment cost is low, but the lamp cost, in time, will exceed that of a fine electronic flash unit. The °K of regular flashlamps is 3300-3800,

while blue-coated flash lamps are 5500-6000°K (suitable for daylight synchronization with color films). For all lamps filter specifications are available for color work (see *Photo-Lab-Index*). With most black-and-white film the blue lamps are specified, as they will give better skin-value rendering. Various types include:

TYPE	TO PEAK	DURATION AT ½ PEAK
GE M2B*	14	9 msec
GE AG-1*	12	15 msec
GE 6	—	27 msec

***IMPORTANT**: The GE 6 is appropriate for focal plane shutters; the long peak extends over the travel time of the shutter slit, giving continuous even exposure. The other flashbulbs listed may work with some 35mm cameras with focal-plane shutters, but to avoid disappointment it is wise to make a test with the flashbulb and camera combination at the specific shutter time that is to be used. Flashbulbs of other makes have somewhat the same characteristics.

Guide numbers are adjusted for shutter speeds, since, obviously, the faster the shutter speed, the less the quantity of peak illumination passing to the film. This is quite different from the electronic flash performance where the flash duration is shorter than any practical shutter speed; the electronic flash guide numbers remain constant at any shutter speed.

Fig. 140 Flashlight units (either flashbulb or electronic flash) are sometimes equipped with modeling or "finding" lights—small, rather intense lamps mounted within the reflector or at its edge—that indicate the character and relative value of the flash illumination. These lights, of course, are powered by line current and are not practical in the field.

SYNCHRO-SUNLIGHT

A generally misunderstood subject; the results are often disturbing because of the imbalance of the light between the sunlit areas and the shadowed areas. With artificial lighting using tungsten or other "steady burning" lamps, we see the basic qualities of the light—or, rather, we see the lighting effects in terms of modeling, highlight and shadow edge configurations, etc.—and we can make adjustments of direction, intensity, diffusion and reflection. But with flash (without modeling lights) we can become acquainted with these effects only through trial and experience. With synchro-sunlight we have the additional problem of *different* light qualities in the same image.

Synchro-sunlight flashlight, with the light at or near the camera, usually falls on the subject from a quite different direction than does the sunlight. (If it were at the same angle and direction, the shadows would not be illuminated!) As most sources of flashlight subtend a small angle in reference to the subject, it is obvious that they will produce highlights and shadow edges much more intense than would the natural sky light or "environmental" light. There is very little difference between a sharp or diffused light; the diameter of the reflector (the light source) controls the highlight and shadow edge quality. This holds in reference to the average 2 to 6-inch reflector at about the same distance as the camera from the subject. A large reflector, or an average reflector when working close to the subject, will, of course, give a more or less "enveloping" effect, and a diffusing screen will favorably modify the quality of the image.

Figs. 39, 141 Because of the great difference in quality between normal diffused daylight and the directed flash fill-in, we have a basic aesthetic problem to contend with.

It relates to both the intensity and the illumination quality. Obviously, on a basis of "realism," we should attempt to simulate the qualities of sky light or broad environmental light. Hence, a broad source is imperative. We can bounce the light from a large reflecting surface, or we can use a white reflecting umbrella; this has a small concentrating effect which is reduced as it is held closer to the subject. Of course, with many outdoor subjects the camera may include a considerable angle of view, and the reflectors cannot be placed too close to the principal subject.

Page 276

We are all familiar with common movie and television lighting effects; it is often obvious that there are one or more lights boosting the daylight. I recall one picture where every object cast two fairly sharp shadows in addition to the sunlight shadow—the effect was definitely distressing! However, in a straight artificial light situation these multiple shadow effects may be acceptable, as we interpret them in relation to the controlled lighting and not to the dominant sunlight-daylight effects.

Some of the worst imaginable effects in photography are produced by the indiscriminate use of flash—especially synchro-flash. If the subject is entirely illuminated by flash, poor exposures can be compensated for somewhat in processing and printing, but with synchro-sunlight the *balance* of illumination cannot be changed effectively in processing and printing. Most tables relating to synchro-sunlight guide numbers are, in my opinion, wrong. They are not based on any principle of visualization, and the results can be disturbing, to say the least. Experimentation is absolutely necessary—first to visualize the *qualities* of the light produced under varying conditions and then to estimate the *quantity* of the light to best represent the desired balance of sunlight and flash illumination.

The best flash equipment has output control; the Graflex Stroboflash, for example, has 1/4, 1/2, 3/4 and full light-output settings. Glass-fabric "bags," diffusing plastics and neutral-density filters can be set before the flash to control the light intensity. The light-stopping power of these devices must, of course, be *known* and this can be determined by placing them in front of a tungsten lamp and taking meter readings from an illuminated surface.

[*Note:* the exposure factor of diffusing screens can be established by lighting a wall from an open lamp, taking the light reading and then taking another reading with the screen before the lamp. Or take an incident-light meter reading of the light from the open lamp, then with the diffusing screen before the lamp.]

Crossed polarizers, rotating one before the other with the transmission values carefully calibrated on the rings, are one of the most efficient light controls for black-and-white photography. The following neutral density filters can be used efficiently:

DENSITY	=	TRANSMISSION
0.20	=	2/3
0.30	=	1/2
0.50	=	1/3
0.60	=	1/4
1.0	=	1/10

For small flash lamps the standard filter frames can be adapted by a good camera mechanic; for larger units the neutral density material must be specially ordered and holders made therefor (perhaps some theatrical equipment would be adaptable).

283

The filtering material must not be flush to the light—the output of heat is considerable and the filters could be damaged. With powerful units, paper and cloth materials as well as inflammable plastics might ignite. With color photography the filtering material must transmit the entire spectrum; otherwise, distortions of color will result. However, when we are using a light-reducing filter for synchro-sunlight pictures, a slight "warmth" of the light might be rewarding; shadows from the open sky, especially at high altitudes, will be bluish. Adding a light-balancing filter (such as Wratten 81, 81A or even 81B) can have beneficial effect. These filters have a slight exposure factor; on the lens they would reduce the exposure about 1/3 stop (x1.3) and, of course, if before the light they would reduce the flash output to the same extent and we would have to figure just what the smaller guide number would be.

One of the inevitable effects of artificial lighting is the production of catch-lights in the eyes. This, of course, occurs in sunlight and open daylight, but the effect is so well-known that we are seldom consciously aware of it. When we apply artificial light, especially in synchro-sunlight, the "intrusion" of an unusual catch-light can be disturbing. When ring-lights are used (in a circle around the lens), the catch-lights will appear as a ring. The catch-light from an ordinary flash, especially if fairly close to the subject, will be larger than the catch-light from the sun. Bounced light from a large surface or a reflecting umbrella, for example, will show as a relatively large, and perhaps diffuse, catch-light in one or both eyes. I recall an advertisement published several years ago showing a mother taking a picture of her baby with a popular small camera on which a single flash light was attached. The accompanying pictures of the baby were obviously of the most professional character; the baby's eyes had *three* catch-lights, and it was otherwise obvious that the baby was enveloped in multiple flash illumination (and over-exposed!).

There are many times when a catch-light is naturally lacking; this may occur with the broad-lighting from a ceiling or the open sky. A small catch-light can be introduced by setting up an ordinary lamp at a considerable distance from the subject—far enough away to give no apparent exposure effect as such. But the inherent brightness of the lamp—a light source—would be picked up as a catch-light at a very considerable distance.

SAFETY PRECAUTIONS

Warning! The voltages accumulated in the capacitors of even the smallest electronic flash units are lethal. *Never* investigate the mechanisms of an electronic flash unless you are a trained expert in the field. Equipment is well-shielded under operating conditions. A powerful electronic flash can put out considerable heat, and the lamps should never be in close contact with inflammable materials; this principle applies not only to electronic flash but to ordinary flashlamps and tungsten, halogen and photoflood lamps as well.

Most flashlamps are shatterproof but do not unnecessarily expose face and eyes to them at close proximity. Before inserting a flashlamp into a lighting fixture, be sure the current is off.

INVENTORY

It is helpful for photographers to keep an inventory of supplies and equipment. Without it, one can find his stock of flashlamps, for example, unexpectedly inadequate for a job. A small peg-board can be used for this purpose; each row of

holes designated for a certain item and pegs inserted to indicate items in short supply.

LIGHTING ACCESSORIES

LIGHT STANDS. It is difficult to decide between lightweight portability and sturdy immobility in the devices designed to support lighting equipment. Obviously, if a light topples and crashes, it can be disturbing to say the least— and very expensive in the case of electronic flash. Professional equipment is usually sturdy, heavy and difficult to transport. Medium-weight stands are perfectly adaptable to ordinary flash equipment but are not entirely stable. The lightweight portable stands and supports have many advantages and will support ordinary fixtures, but the *balance* can be precarious. The balance is disturbed by the attached lamp which tends to pull the extended stand in the direction of the greatest weight. Hence, always have one of the supporting legs pointing in the same direction as the light. Also, with stands having tripod bases point one leg of the tripod in the direction of the input cord; the stand will then be less liable to tip over or lean from the extended cord weight. Trailing wires from the fixture can cause severe imbalance and pull the light over. The wires should lead down the shaft of the stand to a weighted plug or object on the floor. Any pull on the cable then tends to move the light stand horizontally rather than topple it. Elaborate studio equipment includes lights suspended from a trolley device on counter-balanced extendible supports. "Booms" are most helpful; again, they must be sturdy, well counter-balanced and the cable should run along the boom and down the stand to the floor rather than hang from the fixture.

Fig. 139

No matter what light stands are used (excepting the heaviest professional equipment), they should be weighted at the bottom. A piece of metal, with a large hook, can be attached to the lower support of the tripod. For portability a plastic bag or sling, with a hook for attachment, can be filled with anything available—books, rocks, pieces of unused equipment—as the security weight. Many a fine photograph—and a fine piece of equipment—has been ruined by a toppling light stand! Property damage and personal injury can also occur from impact, broken glass and shock.

SPIDERS. These are multiple-outlet devices which rest on the floor and are connected to one wall or floor plug. From these, several cords can extend to the lighting fixtures. *Important:* be sure the circuit to which the spider is attached is adequate for the number and power of the lights used!

LIGHT-CONTROL DEVICES

1. **Dimmers (Variac, Colortran, etc.).** These serve to control the intensity of the lights to which they are attached; they are very valuable in balancing illumination values; for example, when the lights cannot be moved towards or away from the subject. However, two situations arise when dimmers are used: (a) the color temperature (°K) of the light changes and the effective speed of the film changes accordingly, and (b) with color film this °K change will have a profound effect on the color itself, tending toward the yellow and red as the °K is reduced.
2. **Physical controls—louvers, "barndoors," "snoots," vignettes, etc.** These are placed in front of the lights and function as follows: (a) Louvers (strips of metal which can be opened or closed to reduce the

285

amount of light). If these are close to the light with a diffusing screen in front, no bands of light and shadow will show on the subject.

(b) "Barndoors" (flaps, attached to a ring or some other device, which in turn is attached to the light fixture or reflector). They come with 2 or 4 flaps, each of which can be lowered or swung across the light to reduce or shadow the illumination on various parts of the subject. With spotlights the shadow of the flaps may be abrupt enough to be disturbing; with flood-lights the shadow is so broad that no definite edge may be observed. A "barndoor" bottom flap can be very helpful in reducing the light falling on a near object which, because of the Inverse Square Law, might be rendered far too bright.

(c) "Snoots." These are tubes, usually round (although they can be of any shapè), which are attached to the front of the lights and reduce the area of illumination.

(d) Vignettes. A vignetting device is a cutout opaque shape, placed at some distance from the light, which gives a gently defined cutoff of the light on the subject.

(e) Lamp shields. When a lamp is burning in a large reflector, two qualities of illumination are obtained: (1) the broad illumination from the reflector—by far the greater amount of light—and (2) the direct light from the lamp.

Reflections from flat surfaces or catch-lights in the eyes may show a diffuse area with a lighter or darker spot in the center. Do not shield the lamp with an opaque substance; rather, use a diffusing glass or plastic shield just large enough to hide the lamp from view.

3. **Remote controls.** Present advanced equipment for professional use employs a great variety of controls. One of the most helpful items is the "slave" photo-tube which, when attached to one electronic flash unit (and in the line of sight of another unit), will trip the first unit as the other unit is fired. An ideal arrangement would be several electronic flashlamps, self-contained with power-pack and "slave," which would eliminate the use of con-necting cords from a central power pack.

4. **Synchronized shutter operations.** Most shutters today are equipped with built-in synchronization (with adjustments for various types of flash lamps). Needless to say, the instructions for use should be carefully followed. Consult your camera mechanic for effective devices to synchronize old shutters lacking the built-in connection.

FIELD OR STUDIO REFLECTORS. A crinkled aluminum or a satin surface gives much better light quality than a polished sheet of aluminum. A flat white enamel-painted board or a bright (not glossy) cardboard is good. Stretched glass or plastic fabric of high reflectance is excellent (refer to the umbrella reflectors now in common use in studios and in the field). Curved reflectors are inclined to concentrate the light.

RECAPITULATION

The foregoing descriptions of the various types of lighting and lighting equipment are, inevitably, incomplete; consult the most recent catalogues and magazines and discuss problems with a competent dealer. If we think about the effects produced and recognize the limitations, it will be clear that we can visualize our end result with the same precision as with natural light situations. In fact, we

141. SPANISH AMERICAN GIRL (TUTORIAL PROJECT, UNIVERSITY OF CALIFORNIA, BERKELEY). A typical synchro-flash picture, made with the Hasselblad 500C camera and the Graflex Stroboflash IV. The situation was one of extreme contrast; dark surrounding forest and the camera pointed towards the sun. Ideally, the exposure should have been about 4x that given (for daylight alone) with normal -2 development. While this picture conveys subject-information it does not interpret the light or the mood of the scene; it is an example of "over-flash."

have a greater control because we can modify artificial lighting in so many ways, achieving the gamut of effect from "realism" to a full "departure from reality." The experienced professional acquires a certain, but not total, ability to judge the lighting effects visually. He can also rely on personal formulas for the placement, etc., of the lights and their relative intensities. The fact remains that the eye "sees" quite differently than does the sensitive film; true visualization depends upon accurate evaluation of the luminances of the subject.

I believe many will agree that it is extremely difficult, if not impossible, to simulate available light by artificial means. The most elaborate and costly professional equipment for television and motion picture production rarely approximates reality. We can, however, "boost" the qualities of available light if we know how to apply diffuse light of the right quality and intensity.

At the other extreme, we have the total disregard of natural light qualities and can use the intentional and creative contrivances which artificial lighting permits.

The horizons of photographic experimentation and creativity are limitless. Artificial light offers fantastic constructions and creates new images in color photography. Harold Edgerton's high-speed spark photography reveals aspects of the world completely beyond the ability of our vision to comprehend.

METERING ARTIFICIAL LIGHT VALUES

Page 69 et seq The standard exposure meters can be used with complete satisfaction with all artificial lighting situations except flash. Certain adjustments of the ASA film speeds may be required depending upon the °K of the illumination. With flash we resort to tables (it is hoped that individual tests and trials have been made!) Some metering devices are available to detect the actual illumination output of flashtubes—certainly a helpful addition to the equipment list.

Measuring the light output from a given lamp in a certain reflector does not indicate that at varying distances from the subject the Inverse Square Law will hold! If the lamp were burning in space or set against a straight reflecting surface, the Inverse Square Law would hold; but when a light is in a curved reflector (intended to restrict and concentrate the light toward a certain field of view), we have a "focal length" effect which modifies application of the Inverse Square Law. A simple test follows, requiring an accurate exposure meter and sufficient room space for some reasonably distant measurements: first, set up the light in the reflector to be tested. Direct it to a wall and take the luminance reading of the wall at 45° thereto. Say that at 4 feet from the lamp in the reflector you get a reading on the wall of 8 c/ft². Move the light to 8 foot distance; what is the reading? According to the Inverse Square Law, it should be 1/4 the first reading, or 2 c/ft². In all probability it will be around 3 c/ft² simply because the reflector is concentrating and focusing the light, not merely reflecting it. Move it on to 12 feet; the luminance should now be 1/9, or less than 1 c/ft². Suppose that we say the reflector has a "focal length" of 1 foot; the first position would be, *in effect,* 5 feet from the wall (although the lamp was actually 4 feet distant). Now move the lamp to 10 feet from the wall; if the luminance reads 2 c/ft², we now have a "focal length" of the reflector of 1 foot. Simply start by adding 1 foot to any actual physical distance of this lamp.

142. CALUMET FLASH METER. Flash meter readings compensate for lamp, reflector characteristics, environmental reflections, etc. Experiments should be made to relate the readings to personal concepts of lighting, exposure values, etc.

288

Another example: you are 7 feet from lamp to wall; add 2 feet in your mind. The reading in this case might be 2 c/ft². Move the lamp to a distance of 18 feet; the reading will then be 1/2 c/ft². You have, with this reflector, an effective "focal length" of 2 feet. It is wise to test your reflectors in this way rather than to rely on the conventional Inverse Square Law. With reflectors holding small flashlamps or with the sealed electronic lights, it may be difficult, if not impossible, to test in this way. When tests are made, be certain the test lamp is the same length and shape as the lamp to be used; the position of the lamp in relation to the curvature of the reflector can make a great difference in the "output" and beam width of the light. In general the narrower the beam, the more intense the light at any distance—and the longer the "focal length" the reflector may have. Direct evaluations are possible with sensitive meters.

Fig. 142 The Calumet Manufacturing Company produces an excellent Flash Meter which I find accurate and dependable. The accompanying instructions are very clear. Other flash meters are appearing on the market; a full evaluation of these meters is beyond the scope of this book.

GUIDE NUMBERS

Standard exposure meters cannot read the illumination value of flashlamps, electronic or otherwise. A very dependable system for flash evaluation is the guide number concept. The guide number takes into consideration the power of the lamp, the ASA speed of the negative, the distance of the lamp from the subject and the lens stop and shutter speed. (Refer to the *Photo-Lab-Index*.)

However, there are variables which cannot be neglected: the shape and reflective power of the reflectors, the environment and the true characteristics of the shutters.

The guide number formula is a simple one, but nevertheless confusing because the numbers are of geometric-progression values (as they relate to the lens stops). The formula:

$$\frac{\text{distance of lamp from subject}}{\text{guide number}} = \text{lens stop}$$

$$\frac{\text{guide number}}{\text{lens stop}} = \text{distance of lamp from subject}$$

Examples: A lamp of 220 guide number at 10 feet from subject requires f/22.
A lamp of 110 guide number at 10 feet from subject requires f/11.
A lamp of 160 guide number at 10 feet from subject requires f/16.

Notice that at 10 feet distance guide number 220 relates to f/22 and guide number 110 relates to f/11 (a 4x difference of illumination). The guide number values progress lens stop by lens stop on a factor of $\sqrt{2}$ (approximately 1.4), as the following table (for a given distance) shows:

LENS STOP NUMBER	GUIDE NUMBER	EXPOSURE INCREMENT
f/5.6	55	1
f/8	80	2
f/11	110	4
f/16	160	8
f/22	220	16
f/32	320	32
f/45	440	64

289

Note that *every other* guide number doubles. When making calculations, never overlook this geometric progression characteristic. Half-stop values are obtained with a multiplying (or dividing) factor of approximately 1.2.

The published tables may show slight variations in this progression at various film and shutter speeds, largely, it may be assumed, because of the need to balance flash peak characteristics and shutter performance. But these differences are inconsequential; for all practical purposes, once the proper guide number is established for a given ASA film speed at a given lens stop, the numbers for other stops can be calculated and depended upon. But as the between-the-lens shutter speed shortens beyond the effective duration of the flash, the guide number is reduced.

The amount of illumination projected by the reflector used depends upon its shape and surface (polished or "satin" finish; for satin or fan-fold reflectors multiply the guide number by 0.7). If the reflector has a shape which produces a quasi "focal length," the Inverse Square Law will not hold unless all measurements of subject distance take this "focal length" into effect.

The environment considerably affects the efficiency of the flash illumination. (It also affects any non-flash artificial light illumination, but as we measure the light reflected from the subject, this environmental increment is included.) Maximum environmental effect occurs in small, light colored rooms; minimum effect occurs outdoors or in a large, dark structure. The light falling upon the subject also spills over onto the "surround" and bounces back and forth between the total enclosure and people and objects within the area. Light objects near the principal subject can affect subject values—especially in the shadow areas—to a surprising extent. Mirrors unexpectedly can reflect direct light upon the subject. Highly reflective objects in the background can give very disturbing effects.

These environmental effects must be anticipated. The guide numbers are based on "medium values" of walls and ceilings; for large or dark rooms, move the lights 3/4 to 1/2 nearer the subject or use 1/2 to 1 stop larger. This is, however, a casual way of approaching the problem. With Polaroid Land photography accurate lighting relationships can usually be determined.

CARE OF LIGHTING EQUIPMENT

It is common practice to toss lighting stands around carelessly or pile things on them in cars, etc. They can become bent or weakened and eventually cause trouble. Always protect them against rough treatment.

A disturbing fact of life is that adjusting screws and clamps on light stands and tripods are seldom "tapped in" and consequently frequently fall out and are lost. It is *always* advisable to carry extra items of this kind (including extra tripod screws). Strong spring clamps and a plentiful supply of wide (at least 2-inch) tape will quite often "save the day."

Some fixtures are provided with strong spring clamps; these will hold fixtures of moderate weight, but we must be careful that they do not slip off slightly curved or angled supports (or mar polished surfaces). C-clamps are, of course, the most secure, but it is very important that the areas to which they are attached be protected by pieces of thick firm rubber or plastic.

When transporting reflectors, etc., be sure to protect the reflective surfaces and do not subject the sockets to shocks or strains. The lamps should always be protected in shock-absorbing cartons which separate the bulbs from each other (and be sure to carry extras!).

Ordinary flash or tungsten lamps can be used with standard lamp cord. Electronic flash requires special shielded multi-circuit cords and sockets; they carry a very high voltage and must *not* be worked on except by experts. Photoflood and high-wattage lamps require heavy-duty cords (with heavy-duty switches and connections). All cords should be of the highest quality to avoid fraying and shorting (to say nothing of creating a fire hazard!). A good rule: check with a capable electrician or electronics expert on *all* equipment, including cords, plugs, connections and house-circuit capacities.

Periodically check *all* wires and sockets, and when on location be sure to carry a supply of extra fuses—but remember that a fuse of greater amperage than the circuit for which it is designed constitutes a fire hazard.

Extra bulbs should be available—of the same wattage base and bulb size as in the fixtures originally. Lamps that are approaching the end of their life will usually show a black deposit on the glass; they have undoubtedly lost some of their intensity and may cause trouble in color photography because of a change in the color temperature (°K).

Vibration is not good for sensitive electronic equipment or lamps. It is important that cases for lighting equipment be adequately padded, especially for shipment by common carrier. A good padding on the floor of the automobile will take care of moderate vibrations. Vibration, such as experienced in some helicopters (especially when landing), can be intense.

Some happy-go-lucky people "throw a lot of stuff into the old bag" and off they go on location—with a good chance of photographic disaster! A check list of lighting equipment should be made up (and kept up-to-date). It should include basic equipment, such as:

Light(s) Fixtures
Stands
Cords (ample extension? do they match?)
Connections (do they match?)
Plug adapters. There are several types of plug outlets in factories, hospitals, etc., and it is wise to be prepared with a set of various adapters. Check carefully on the power (110 or 220 volts) and on the ground devices.
Extra Lamps (regular or blue? photoflood and/or flash?)
Extra Batteries
Clamps
Extra Small Items
Pliers, Screwdrivers, Tape
Fuses
Synchronizing Cords (do they match?)
and notations, such as:

Approximate life of lamps remaining (subtract use from rated life)
Did you test synchronizing circuits?
When was CdS battery (or batteries) last charged?

Just because the case appears full does not mean *everything* needed is on hand! AC current is universal, but a few DC systems remain. Check on location current before you start out. Check on the distance to the nearest outlet!

Keep all connections, plugs and switches clean. Check on battery terminals. At the slightest sign of wear of any cord or connection: replace.

Liability and property damage insurance is strongly advised, but if your electrical equipment is not approved, the insurance may be invalid.

291

CARE OF EQUIPMENT IN THE FIELD

It is most important that the photographer understand some of the hazards encountered in everyday use of his equipment. Cleaning and general care (discussed for specific items at appropriate places throughout this book) should become routine, and one should always be alert to situations in the field which could damage equipment and sensitive materials.

1. **CAMERA CASES.** Tradition still favors dark (or black) cases and leather bags. These may be waterproof and dustproof, but they are not heatproof. While the external covering may vary, it is certain that any ordinary case left in the sun will accumulate heat, and this heat can cause damage to film and exposure meters. Under humid conditions we have the augmented effect of dampness along with heat which, in time, may have a bad effect on lenses and shutters as well.

 The ideal case is of sturdy lightweight material, painted a brilliant white outside and suitably partitioned and padded inside. We must decide if the case is for permanent storage—or perhaps shipment—of equipment and if the locks and hinges are secure, or if it is for transient use such as a case for back-packing, short trips, field work, etc. The latter does not require the construction or the security of a principal case; it should be as light as possible, waterproof and, of course, painted white.

 The design of cases is discussed on page 63. When the case has been well-planned and then built to specifications, the surface should be properly sized and brushed or sprayed with a bright enamel heat-resistant and heat-reflecting paint such as Trim Color White #130, manufactured by Pioneer Paint & Varnish Co., 438 West Congress, Tucson, Arizona. If the case is covered with aluminum sheeting or aluminum fabric or treated with aluminum paint, the heat will be somewhat controlled. But in my experience nothing is as effective as hard white enamel paint. The bottom of the case should also be painted or covered with a light aluminum sheet; in the desert the ground can become hot enough to create considerable heat within an unprotected case.

 If you have any doubts about the advisability of the white paint, take two identical boxes or cases of ordinary materials, paint one and let both stand in the sun for, say, one hour. Put a thermometer in each and read the thermometers together when the cases are opened.

2. **CAMERA BAGS.** Sometimes called "gadget bags" because they are usually filled with a collection of accessories, as well as miniature cameras, etc. If leather, they should be painted white. They can probably be made of (or faced with) a white fabric or plastic. Some photographers have a white fabric or plastic sheet which they throw over cases and bags when exposed to the hot sun. (And you do not have to be in the desert to experience hot sunlight!)

3. **CAMERAS.** We have mentioned protection against heat for cases, etc. Under severe conditions the camera itself—on the tripod or suspended from the neck—can become quite hot. I recall once in the Grand Canyon around the first of June when it was about 105-110° in the shade in the lower levels; the camera, carried by a neckstrap and alternately exposed to sun and shade, became quite hot to the touch. Some workers, when carrying the camera in the field (on a neckstrap or tripod), protect it with a white plastic bag with drawstrings. On walking or camping trips it is wise to keep all equipment and supplies in water-

292

proof white plastic bags with drawstrings or zippers. But never "seal" a camera in a plastic bag when very high humidity prevails.

4. **LENSES.** In tropical areas lenses can acquire a fungus growth which is quite damaging. Under such conditions cameras and lenses should be kept in cases with humidity-absorbing materials (such as silica gel). Dust is a grave threat to lenses; before wiping with lens tissue, the dust should be thoroughly blown off and the lens gently brushed off with a soft camel's-hair brush. Then the lens tissue can be gently applied. Keep the lens caps on at *all* times when the lens is not in use (on both front and rear components). Taking the lens from a warm room into cold air may result in precipitation upon the surface—not only the outside surfaces but the inner surfaces facing the diaphragm. The air-glass surfaces sealed within the front and rear components of the lens are seldom if ever affected by temperature changes as far as precipitation is concerned. All lenses, when subjected to severe heat, may suffer disintegration of the cementing material bonding the glass-to-glass surfaces. Subjecting a lens suddenly to extreme cold may very well cause the outer elements to contract, and until the temperature is equalized, the quality of the image may be impaired. I have had this happen to me on several occasions in wintertime in the High Sierra. The effect is most apparent with small lenses with relatively large apertures.

5. **SHUTTERS.** Dampness, dust and shock seem most damaging to shutters. Under very cold conditions both between-the-lens and focal-plane shutters may become sluggish. Modern between-the-lens shutters carry very slight lubrication, and the focal-plane shutters on many miniature cameras are of metal, which usually react less to cold than do fabric shutters. Do not lubricate shutters!

6. **FILTERS AND POLARIZERS.** These demand the same care as fine lenses. Cemented filters are sensitive to sudden heat and cold and to shock; they may lose their optical precision because of "strains," cracks and the failure of the cementing material. They are also susceptible to scratching from dust, and since they are usually placed in front of the lens, their abraded surfaces can produce damaging glare in the image. This applies equally to glass-mounted polarizers. Glass filters and polarizers should be optically coated.

 Gel filters and polarizing plastic are easily abraded by dust and handling. They should be carefully dusted off before and after use and suitably protected in storage. I use the small plastic print albums for my gel filters; in each folded album leaf I place a piece of white cardboard and the filters rest on each side of it; their color can easily be seen, and the number of the filter can be attached on a piece of Dymo tape to the album leaf or written on the proper side of the cardboard. I do not advise attaching a piece of tape to the gel filter itself; it will probably cause a slight warping. When the surface of a gel filter or plastic polarizer becomes abraded, it is wise to discard it. Gel filters can be mounted on the back of the lens (in view cameras); this presents less chance of flare from the filter surfaces.

7. **EXPOSURE METERS.** These are sensitive instruments and deserve great care. Carry them whenever possible in padded compartments. Do not allow them to "bang around" and experience shocks. Dropping one in water implies immediate shipment to a repair station! Do not attempt any other adjustment but the Zero setting. Heat is truly damaging to the sensitive cell. Protect from the sun and from prolonged exposure to hot artificial lights. Be especially wary of glove

293

compartments and trunks of cars; a very considerable heat will develop in these areas if the car stands for long in the sun (the darker the car paint, the more heat will be generated within). As we all know, a closed sedan can develop a surprising amount of heat when the car stands in the sun with tightly closed windows.

Security: to leave equipment in an unlocked automobile is rash indeed. Since a trained thief can easily break into any automobile, exposure of any equipment within the car is a sure invitation to trouble. If cameras, etc., must be left in a car, they should be well-cased and well-covered with other objects, rugs, etc. Best of all are the storage areas under the floorboards of modern station wagons, but a trained thief will anticipate the possibility of such storage and surely not overlook it. The same general security rules apply to hotel, motel, apartment *Page 295* and home storage and to tent storage when camping. Adequate insurance is essential!

Fire: there is little chance of fire starting within camera equipment as such (excepting possible short circuits in lighting systems). There is always danger of fire in buildings from the usual causes. Repeat advice: be fully insured!

CHECKING FOR LIGHT LEAKS

A good bellows is something of a work of art and should last for a long time. However, light leaks will develop, especially at the corners of the folds and sometimes at the points of attachment to the camera body. These can be detected by taking the camera into the darkroom, fully extending the bellows and exploring the entire bellows with a flashlight held close to the interior bellows surfaces and folds. A flashlight with a right-angle head permits bringing the light very close to the material. Putting a dark cloth over the open back of the camera will cut out scattered light and make slight light leaks more visible.

While checking for bellows light leaks, it is wise to check also for leaks in both the front and back assemblies of the camera:

(a) Check carefully for any trace of light leaks around the lensboard. Sometimes we find the lensboard has warped or has been chipped. Check also for any leaks around the lens flange and shutter. This may require a strong light within the the camera and a completely dark room.

(b) Under the same conditions employed for checking the lensboard, carefully examine the back of the camera: (1) the ground-glass supporting element which attaches to the body of the camera; (2) the film holder contact with the camera back. Number two is the more important; here is where the majority of light leaks may occur. The light-trap groove in the camera back may be battered, roughened or contain dirt which would prevent accurate seating of the holder (perfect seating of the flange of the holder in the groove of the back). The flange on the film holder may be dented or the holder warped. The surfaces against which the holder rests may not be smooth. The surfaces of the camera back and of the front of the holder may not be sufficiently black and light-absorbing. In any event, a strong light within the camera should reveal significant leaks.

In addition, the spring of the camera back (providing pressure to hold the ground glass in place) may not be strong enough to press the film holder tightly against the back. This is especially important when the Polaroid Land Film Holder is used, as this device is fairly heavy and can be pulled away from the back by gravity or by pressures exerted in use. The clamps of the Graflok® back (and similar types) serve to secure the holder tightly against the back. However,

294

with some cameras the knobs, etc., controlling the back adjustments, as well as some finder attachments, may conflict with the roller housing of the Polaroid Land Film Holder and prevent complete seating. With some reducing backs (4x5 from 5x7 or 8x10, for example) the focusing screen assembly is not far enough away from the back, and the roller housing of the Polaroid Land Film Holder will "ride" on the back with serious light leaks resulting.

A light leak within the film holder can usually be traced from the edge of the film (the light-trap through which the slide is inserted is the prime cause of such leaks). A light leak from *outside* the holder does not show at the *edge* of the film but starts a little distance from the edge (actually shadowed by the holder frame). Light leaks around the camera back will also show this shadow effect.

Light leaks in the bellows may produce a secondary "pinhole" image but usually produce an overall fog. Holes in the lensboard will usually produce a secondary "pinhole" image. For the same time of exposure within the camera, the faster the film, the more pronounced the light leak effects.

While you are testing for light leaks, you can also examine the action of the shutter. Direct the camera towards a bright surface, remove the back of the camera and operate the shutter at the various speeds. Observe:

(a) Does the shutter completely close after operating at any speed?

(b) Does the shutter "bounce" after operation at any speed?

If the shutter remains open (even at a "pinhole" aperture) a fog or secondary image will result. If the shutter "bounces" after operation, you will get a second image—not too important if the camera is on the tripod and the subject is static but serious with hand-held cameras and/or moving objects.

Focal-plane shutters are more difficult to check; a fine camera mechanic should do it.

It is surprising (and depressing) how many light leaks can be found even in superior equipment. Checking of bellows and all the other possible sources of leaks should be a frequent duty.

INSURANCE COVERAGE

All-risk insurance of photographic equipment (and also negatives, prints, books, etc.) which will cover you both on and off your premises is a legitimate and worthwhile expense. Depending upon many factors of locale, regional insurance laws and customs, etc., a full protection can be secured which covers loss by fire, theft, accident, breakage, etc. Wear and tear, vermin damage, etc., are, of course, not included. The photographer is obliged to take all reasonable care to protect his equipment and not expose it unduly to fire or theft hazards. It is important that all insured equipment be precisely defined, lens and camera numbers always given and the actual cost established. Replacement value is not the same as new value! This should be thoroughly discussed with a competent insurance broker or agent.

Loss of equipment is one thing, but loss of *use* over the sometimes considerable time needed for proof of loss and replacement can be distressing for the serious photographer—especially the professional. This should be fully discussed with your broker. The same applies to fire damage to darkroom or studio; the direct loss is one thing, but the loss of time and profitable use can be much more serious.

List every piece of equipment: every filter, meter, anything of any value whatsoever. Very often equipment suffers total loss (such as by fire), and it is distressing to see how much is involved in the many small items gathered over a

period of time and which must be replaced. Report loss or damage without delay to your broker, and be prepared to exhibit damaged articles if possible.

Darkroom and workroom insurance is usually subject to property restrictions (residential or industrial areas, etc.) and, of course, all electrical installations must be carefully checked and conform to local building codes. If a fire occurs and it can be proved it was caused by faulty electrical work (work not properly installed on permit and inspected), the insurance can be invalidated. Investigate every possibility for potential trouble!

Personal insurance (health and accident) is important, but general liability insurance is most important of all, especially if a studio and laboratory operation involves other people. Again, consult your broker or agent on all ramifications of an adequate insurance program. The problems of the amateur are relatively simple; those of the professional are complicated and sometimes obscure.

LEGAL ASPECTS OF PHOTOGRAPHY

The best advice to give anyone is to consult a competent lawyer and explore all the possible legal hazards of one's vocation or avocation. This is especially important with respect to the right of privacy, for the law varies greatly from state to state and is now in considerable flux besides. However, a few basic problems may be noted:

1. **RIGHT OF PRIVACY.** Photographing anyone is, in a sense, an invasion of privacy, and permission should be requested. Casual pictures of people in groups or crowds are seldom questioned. Similarly, pictures taken for their news value enjoy a certain amount of privilege. Use of anyone's picture in advertising, or for gain through sale or reproduction, is subject to prior agreement and fee; if such use comes to pass after the picture is made, the subject must be consulted before final arrangements for use are made. Otherwise, the photographer—amateur or professional—is open to legal liability. Photographs used for news purposes (magazines, newspapers, etc.) do not ordinarily need releases, but if there is any suggestion of an invasion of privacy, libel, defamation of character, etc., the photographer (and the publisher) may be in trouble. The law of defamation contains many pitfalls for the unwary. Therefore, in the event of any doubt, procure legal opinion *before* publication.

2. **RELEASES.** For professional purposes, releases are obligatory. Standard release forms are obtainable, but there is some disagreement as to the proper wording. A lawyer should be consulted in this to be certain that the releases are fully protective and will be clearly understood by all parties concerned.

3. **RIGHTS IN PROPERTY.** Photographing property and possessions without permission is both unethical and legally dangerous. The fact that trespassing without physical harm, or the photographing of dwellings, factories, etc., is seldom questioned does not eliminate the possibility that legal problems *may* develop. Advance written consent is desirable if doubts exist.

4. **LIABILITY FOR INJURY OR DAMAGE TO PROPERTY.** Causing any injury in the act of photographing—equipment falling on people and things, people tripping over wires, tripod legs, etc., accidents indirectly caused by the photographer, etc.—is certainly subject to damage claims (and suits), and the photographer should be amply covered with adequate liability insurance.

296

5. **ETHICAL CONSIDERATIONS.** The American Society of Magazine Photographers (ASMP) has established codes of ethical procedure and pricing. Every assignment presents its own problems, and the photographer-client relationship must be clearly defined from the start. Unless specifically stated to the contrary in the contract, the photographer retains control of the negatives and will make prints as required on terms mutually agreed upon. Prints for advertising and promotional use will usually be made on different terms than are prints for sale or for reproduction in a book for general sale. The photographer should protect the client by including in the contract or agreement assurance that in the event of death, injury or inability of the photographer to make prints from the negatives, the negatives will be released to competent persons for printing (usually selected in advance by the photographer). The client should, in turn, protect the rights and the *quality* of the photographer's work. The photographer should never use any photographs made for a client in any competitive way. Any use should be subject to the client's approval. Any violation of the agreement or contract should be immediately protested; delay or failure to protest any violation sometimes affects future rights. Should some embarrassing conflict of interest, inadvertent misuse of a picture, etc., occur, an immediate statement and apology should be made—the "cards laid on the table," so to speak.

6. **DAMAGE IN SHIPMENT.** One of the most painful experiences a photographer and/or client can have is to receive prints in the mail which are hopelessly ruined for any purpose. It is the photographer's responsibility to pack his prints with the greatest care, using truly strong materials—oversize to protect corners of mounts and prints. In turn, he has the right to demand equally thorough packing for return and—if clearly stated in correspondence— to hold the shipper liable for any appropriate damage. In the case of fine prints, the value should be maximum for direct sale and discount value when a gallery or museum is concerned; in the case of prints for reproduction, a fixed per-print charge to cover cost-time expense in making them should be clearly defined. *All* prints cost something in materials and time; a fixed fee of $10.00 to $25.00 per damaged print would not be excessive. And this *in addition* to any *use* fee. Stipulating such a charge in advance for damaged prints usually results in very careful packing!

7. **PROTECTION BY IDENTIFICATION.** Copyright of an individual photograph is of value only if there was no possibility that any other person could have been on the scene and also photographed it at the same time and place. Without witnesses this is hard to prove. It is usually adequate to write or stamp on the back of the print such terms as "All Rights Reserved" or "Reproduction in any form forbidden without consent of the photographer," etc. Credit lines to photographers and clients must always be stated on the photograph; omitting them in some instances may invalidate future protection. A stamp should read: "Credit *must* be given to............" In order to assure proper use of a particular print, stamps such as "Proof only—not for reproduction" or "For reproduction only" will be helpful (and explicit). Another stamp could read as follows:

Photograph by John Doe
Address

Title .
Negative Number .
Date Taken. .
Credit to client .

297

In any event, *always* put your name and address on the back of all prints or print mounts and *sign* the fine print (usually just below the lower right-hand corner). Identification is important, and it is an affectation to avoid it! *Dating* work is essential!

The serious photographer obviously must be aware of the legal aspects of his profession. Perhaps the *ethical* aspects are more important in that if his conduct is ethical, he need have little fear of the law.

As time goes on, the photographer will increasingly have acute contact with the world about him; his responsibility will grow and his potential for human service will expand. He should be aware of this from the start of his serious effort.

[*Note:* I am appreciative of the legal advice given me on this section by Messrs. Richard M. Leonard, Stuart R. Dole and George Duke of Leonard & Dole of San Francisco.]

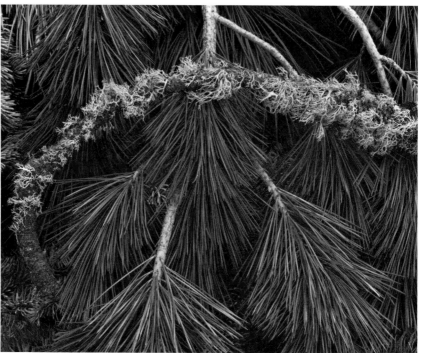

143. PINE BRANCHES AND LICHEN, YOSEMITE NATIONAL PARK, CALIFORNIA. Made with Sinar camera and 8″ Kodak Ektar lens on Polaroid Type 55 P/N 4x5 Land film. Illumination from open sky.

BIBLIOGRAPHY

Adams, Ansel *Basic Photo Series*
(5 volumes), Morgan & Morgan,
Hastings-on-Hudson, New York
 Book II, *The Negative:
 Exposure and Development,*
 4th edition 1968.
 Book III, *The Print: Contact
 Printing and Enlarging,* revised
 edition 1968.
 Book IV, *Natural-Light
 Photography,* 5th edition 1965.
 Book V, *Artificial-Light
 Photography,* revised edition
 1968.
─────, *Polaroid Land Photography
Manual,* Morgan & Morgan,
Hasting-on-Hudson, New York,
1963.
─────, *Exposure Record,* Morgan &
Morgan, Hastings-on-Hudson, New
York, 1968 (loose-leaf).
─────, *These We Inherit,* Sierra Club,
San Francisco, California, 1962.
Adams, Ansel and Edwin Corle, *Death
Valley and the Creek Called
Furnace,* The Ward Ritchie Press,
Los Angeles, California, 1963.
Adams, Ansel and Nancy Newhall,
Death Valley, 5 Associates,
Redwood City, California, 4th
edition 1970.
─────, *Fiat Lux, The University
of California,* McGraw-Hill Book
Company, New York, 1967.
─────, *The Tetons and the Yellow-
stone,* 5 Associates, Redwood City,
California, 1960.
─────, *This Is the American Earth,*
Sierra Club, San Francisco,
California, 1960.
─────, *Yosemite Valley,* 5 Associ-
ates, Redwood City, California,
1963.
Adams, Ansel and Virginia, *Illustrated
Guide to Yosemite Valley,* Sierra
Club, San Francisco, California,
1963.
Boucher, P. E., *Fundamentals of Pho-
tography,* Van Nostrand, New

York, 4th edition 1968.
Kingslake, Rudolf, *Lenses in Pho-
tography,* Garden City Books,
Garden City, New York, 1951.
Morgan, Willard D., *Leica Manual,*
Morgan & Morgan, Hastings-
on-Hudson, New York, 14th
edition 1963.
Neblette, C. B., *Photographic Lenses,*
Morgan & Morgan, Hastings-on-
Hudson, New York, revised
edition 1971.
Newhall, Beaumont, *The History
of Photography,* Museum
of Modern Art, New York, 1964.
Newhall, Nancy, *The Eloquent Light*
(Biography of Ansel Adams,
Vol. I), Sierra Club, San Francisco,
California, 1963.
Newhall, Beaumont and Nancy,
Masters of Photography, Braziller,
New York, 1958.
Pittaro, E. M., *Photo-Lab-Index,*
Morgan & Morgan, Hastings-on-
Hudson, New York (Note: This
1,600 page book is up-dated with
four supplements per year and
reprinted annually. Available in
loose-leaf and bound version. For
additional information on micro-
fiche and other retrieval systems
write directly to the publisher.)
White, Minor, *Zone System Manual,*
4th revised edition 1968,
Morgan & Morgan,
Hastings-on-Hudson, New York.
Zakia, Richard D. and Hollis N.
Todd, *101 Experiments in
Photography,* Morgan & Morgan,
Hastings-on-Hudson, New York,
1969.
*Filters for Black and White and Color
Pictures,* AB-1, Eastman Kodak
Company, Rochester, New York,
7th edition 1970.
*Kodak Wratten Filters for Scientific
and Technical Use,* B-3, Eastman
Kodak Company, Rochester, New
York, 22nd edition 1968.

299

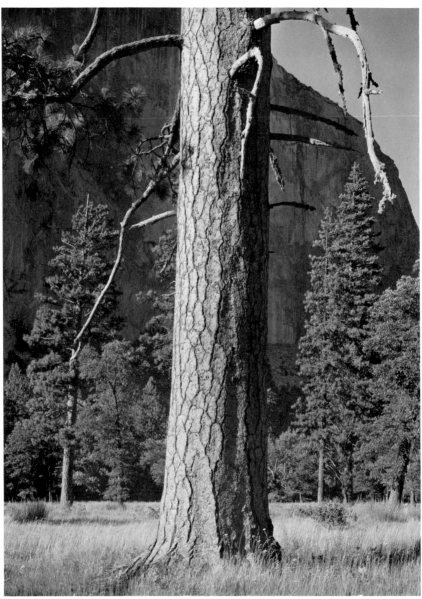

144. YELLOW PINE, YOSEMITE NATIONAL PARK, CALIFORNIA. The camera (8x10) was accurately leveled. It is apparent that the level line of the meadow is kept thus by the horizontal level of the camera. The camera was level vertically as well; the apparent tilting of the distant trees are real–they have responded to the prevailing westerly wind. The lens (12" Goerz Dagor) was raised to the maximum the camera would allow. The camera was then tilted up but the back and the front were put in perpendicular position. In other words, the camera was in "Normal" alignment except for the elevated lens axis (see pages 182 and 184). A green filter was used (Wratten No. 13) which favored the grass and trees while reducing the blue-sky and shadow values. The reflection from the green meadow on the lower shaded part of the tree has been slightly elevated by this filter, but the shadow of the upper part of the tree (illuminated by blue-sky light) has been reduced in value. Ideally, the camera could haven been moved a foot or two to the left; the left hand branch would not have "merged" with the distant pine tree.

INDEX

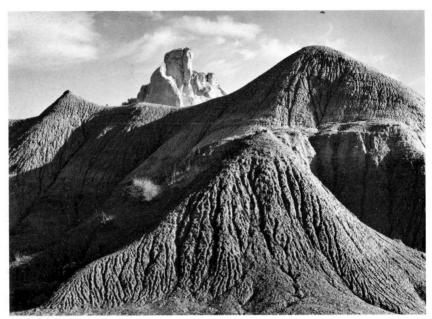

145. MUD HILLS, GHOST RANCH, NORTHERN NEW MEXICO. Made with 5x7 Juwel and 7″ Zeiss-Goerz Dagor lens. A yellow filter was used without applying its exposure factor, as the earth and filter were of about the same color; this reduced the value of the sky. Developer was in Ansco 47, normal + 1 development time.

COLOPHON

Design: Rostislav Eismont
Text type: 9 on 11 Press Roman set with an IBM Selectric Composer
Headings: IBM 11 point Univers Bold caps, 9 point Press Roman Bold caps and 9 point Press Roman Bold
Main headings: 24 Helvetica set with a Phototypositor
Captions: IBM 8 on 9 Press Roman
Book title: Haas Grotesque
Composition: Morgan Press Incorporated, Hastings-on-Hudson, N.Y.
Offset lithography: Murray Printing Company, Forge Village, Mass.
Binding: Charles H. Bohn & Co., New York, N.Y.